TEMPORARY
architecture

Lisa Baker

TEMPORARY architecture

BRAUN

CONTENTS

P

PREFACE

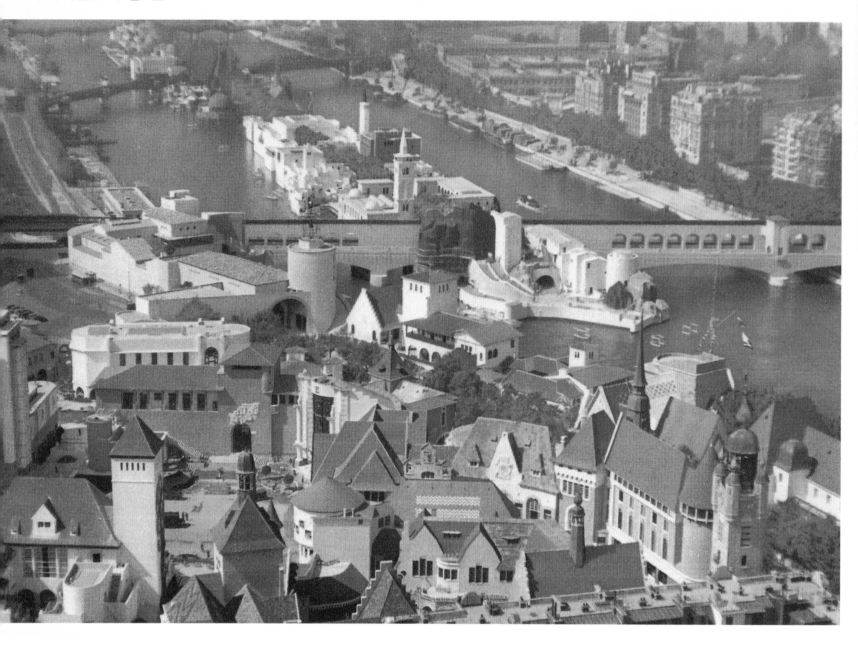

Temporary buildings are an important part of architecture, but for various reasons receive little attention. This is partly due to the fact that temporary buildings are often not lovingly designed, or indeed barely designed at all – simple pavilions and tents without any imagination. This volume is intended to counteract this. It proves that good design is worth the trouble, even for short-term structures. These don't even necessarily have to be more expensive than their more simple counterparts. Another important point is that these ephemeral buildings disappear relatively quickly, so that many architects don't realize they are part of such a long tradition. Such structures can be traced back to the ancient world or the Middle Ages: arenas, theaters and other event spaces sprung up everywhere but today exist only in documents and there is little visual evidence. Such event-oriented architecture experienced a rise in popular-

ity from the 15th to 17th centuries with temporary triumph arches to welcome royal processions (picture page 7 below: triumph arche build for pope Benedict XIV 1741, engraved drawing Fernando Fuga). Large ephemeral buildings were built of canvas spanned across a wooden frame, or buildings constructed of plaster, clay, paper or even confectionary. These had a similar appearance to 'real' architecture and were often designed by artists such as Peter Paul Rubens (1634/35) to welcome, for example, Cardinal-Infante Ferdinand to Antwerp. Architectural theory also concerns itself with temporary buildings from the past, although it focuses mainly on the question of how well the building was suited to the context: time of year, type of celebration, and the status of the person to be honored. The imagery used (allegories, emblems, inscriptions etc.) were often designed by and adapted to the person honored and the

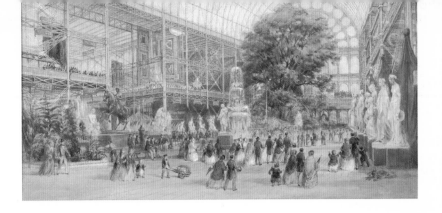

Temporary architecture must suite the context.

occasion, which meant that none of the designs could ever be reused. For really special occasions, entire squares or streets were decorated with examples of temporary architecture. Towards the end of the 18th century, the Enlightenment resulted in the end of such pompous occasions. When Friedrich II. von Preußen marched in Berlin in 1763, he considered a gate built specially to honor him as an unnecessary expense.

100 years later, this type of design was rediscovered (Jakob Burckhardt: The Civilization of the Renaissance in Italy. Basel 1860) as temporary buildings became increasingly popular in the second half of the 19th century: This marked the beginning of the era of World Fairs (picture page 6: Expo in Paris, 1937) and the construction of temporary buildings for the Olympics. These buildings no longer focused on one person, but rather were built to accommodate large audiences. Examples of legendary temporary buildings include London's Crystal Palace (Joseph Paxton, 1854, picture

above by Thomas Abel Prior), the Barcelona Pavilion by Mies van der Rohe (1929), or Le Corbusier's Phillip's Pavilion in Bruxelles (1958), one of just a few examples where music is translated into architecture.

The 20th century witnessed the rise of architecture biennials, academic research pavilions, corporate architecture, temporary theaters and exhibition buildings; as well as buildings in extreme locations, and last but not least emergency housing that investigates the topic of building in an extremely short timeframe. From the 1950s to 1970s, numerous temporary buildings were constructed of extremely durable materials – concrete in particular. This volume also presents a wide range of building materials. "Temporary Architecture" is a collection of very different types of buildings that are very conscious of their own mortality but are nevertheless preserved in the pages of this book.

7

TEMP

TARGETED

THOUGHTFUL

TEMP

TERRIFIC

THEATRICAL

TING

TERMINABLE

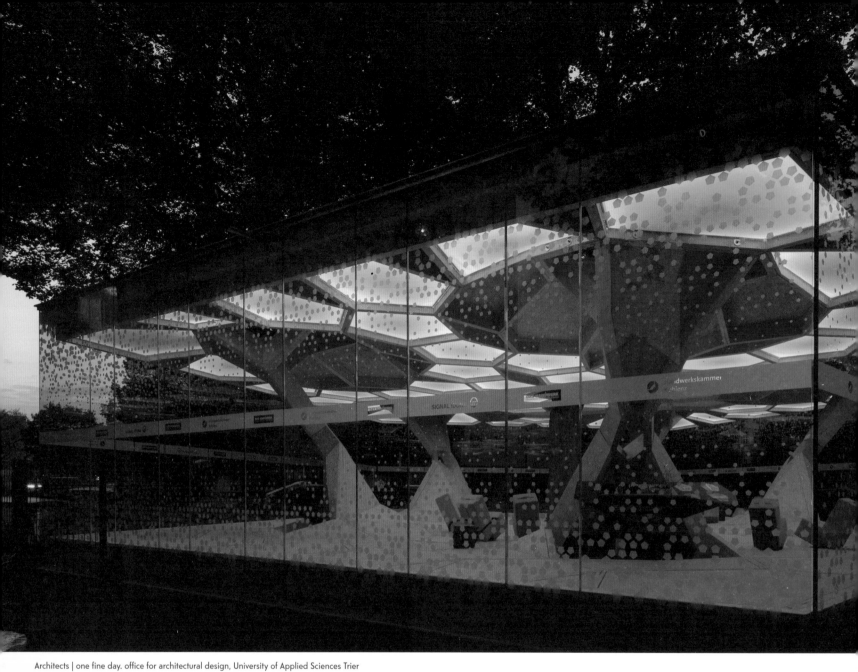

Architects | one fine day. office for architectural design, University of Applied Sciences Trier
Project address | Koblenz, Germany
Client | Handwerkskammer Koblenz, Dipl.-Des. Christoph Krause
Gross floor area | 156 m²
Existed | 15 April 2011–ongoing

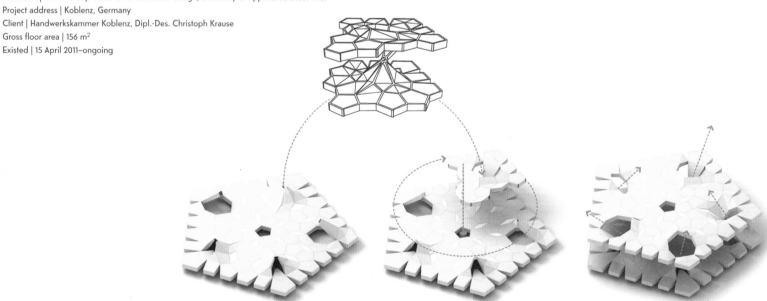

TREEHUGGER

Using state-of-the-art technology to blur the
boundary between nature and man-made.

The treehugger pavilion was built for the National Garden Show in Koblenz, Germany,
and is the result of a research project initiated by Christoph Krause. Designed by
the Department for Digital Design at the University of Applied Sciences in Trier, and
one fine day, Düsseldorf, the project explores recent developments in computational
design. The pavilion is structured like a tree canopy, with a network of pentagon-
shaped cells giving the roof the necessary support. The entire structure is encased in
a glass box, successful blurring the boundary between inside and outside, nature and
the man-made.

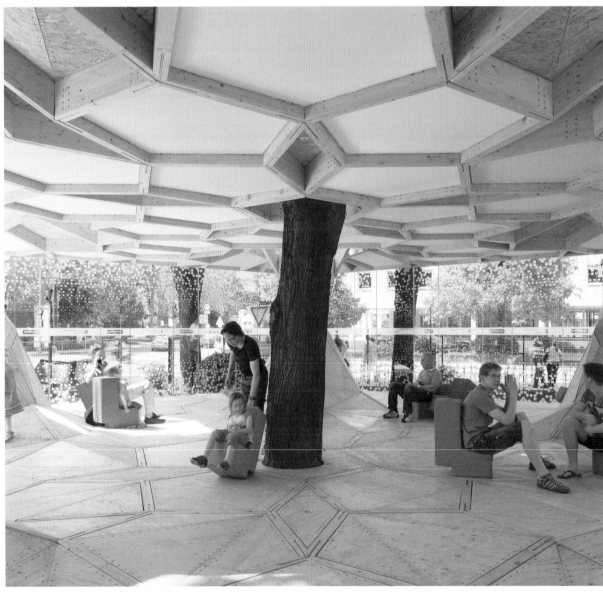

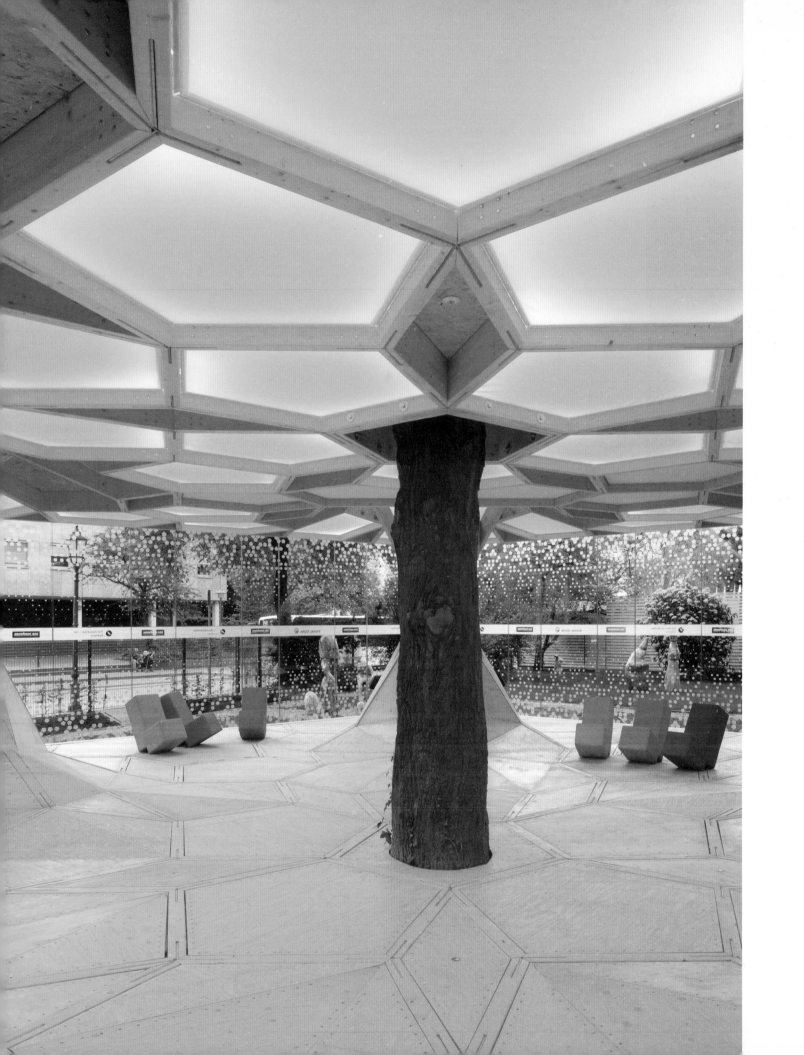

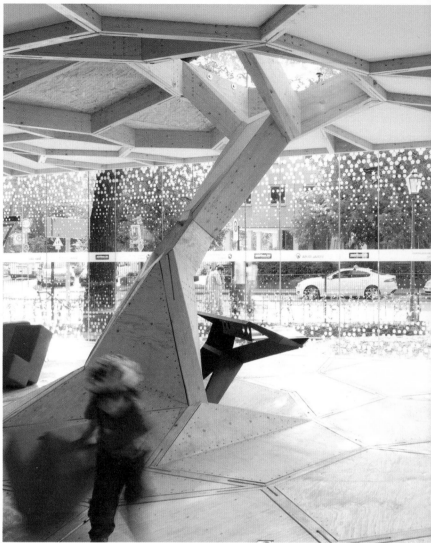

13

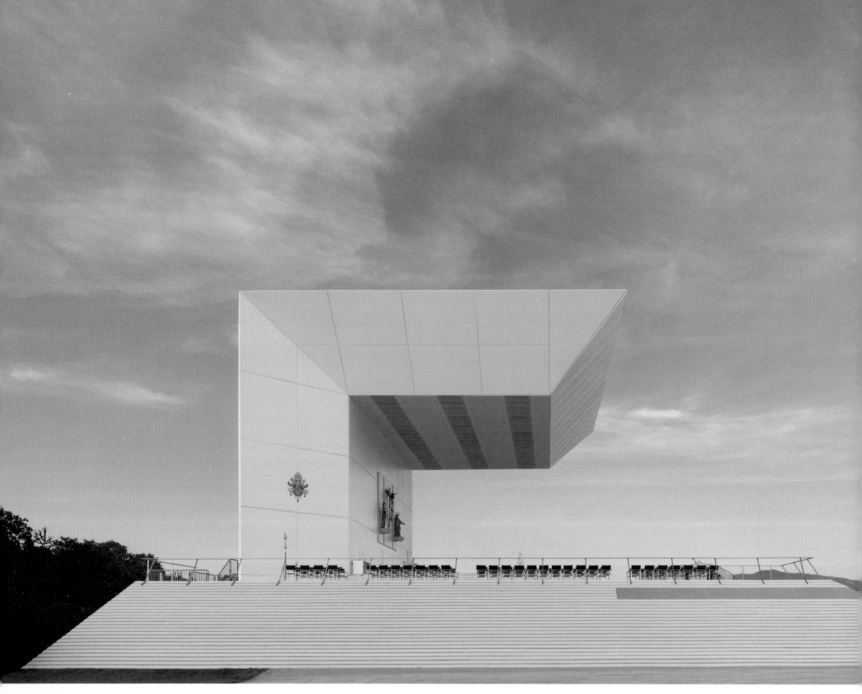

ALTAR ISLAND FOR
POPE BENEDICT XVI

An island in a sea of humanity, this stage is
a striking architectural statement, built to
honor an iconic figure.

This roofed altar island was designed by Werner Sobek for the Pope's visit in 2011.
The altar island was designed to enable the continued use or recycling of most of
the construction materials after the island had served its purpose. The materials
were not welded or glued; all parts were connected by screws, clamps and clamp
connections. This enabled not only a fast construction timeframe, but also ensured
easy dismantling and separation of materials. The supporting structure comprised a
steel frame with a cladding of wooden slats. The roof projects 20 meters outwards,
but despite this it required no special roof supports and was constructed with stan-
dard rented parts.

Architects | Werner Sobek
Project address | Flugplatz Freiburg, Am Flughafen 8, Freiburg im Breisgau, Germany
Client | Erzbischöfliches Ordinariat Freiburg
Gross floor area | 2,030 m²
Existed | 22–27 September 2011

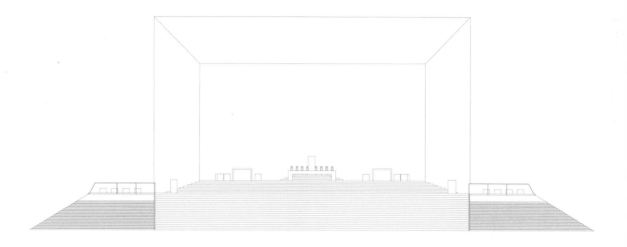

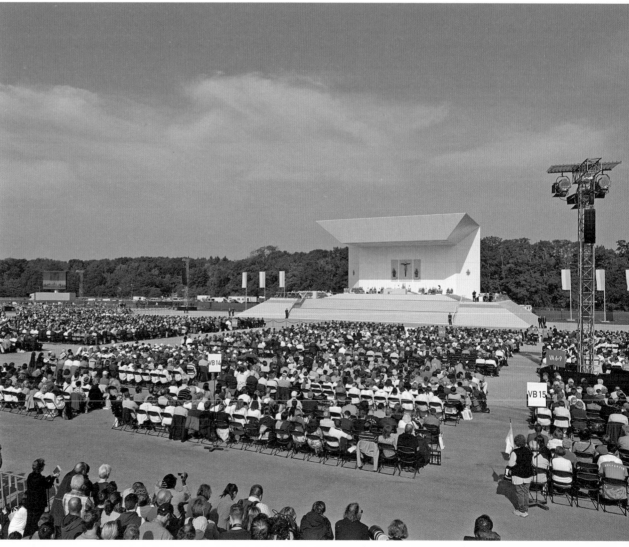

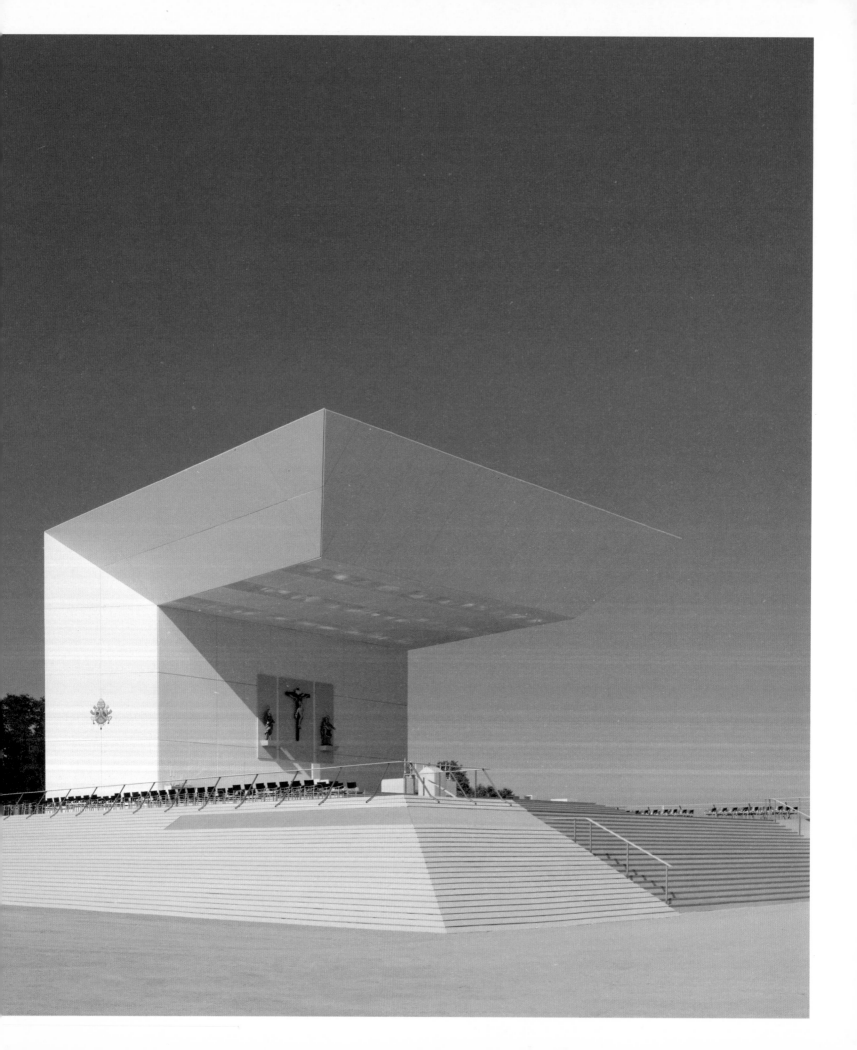

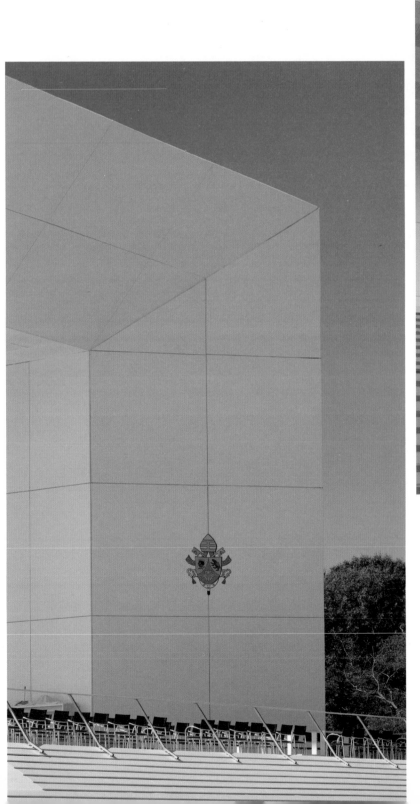

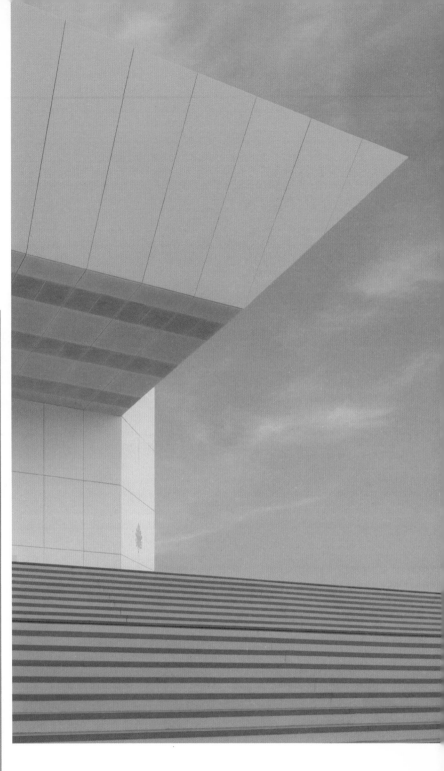

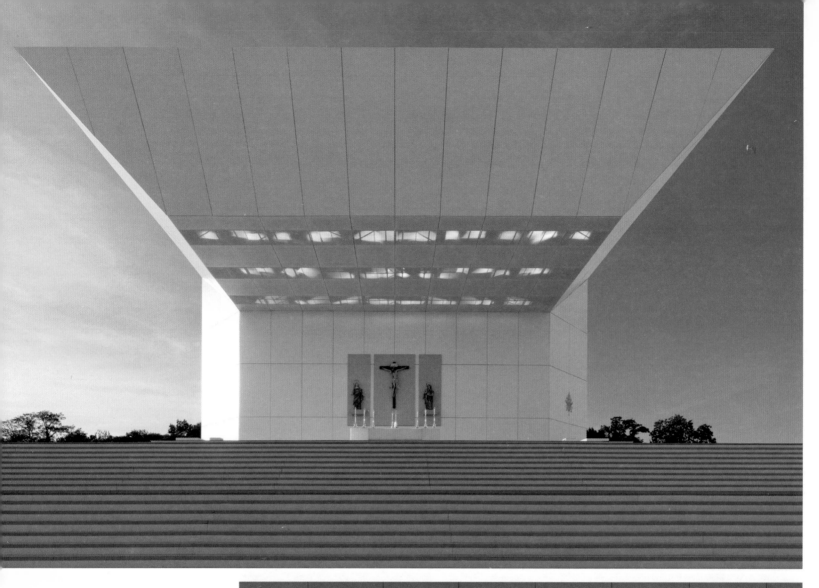

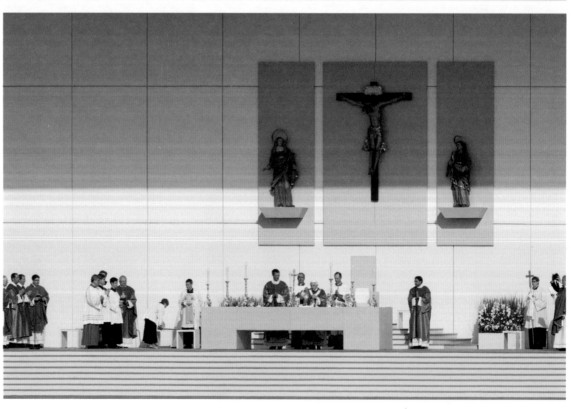

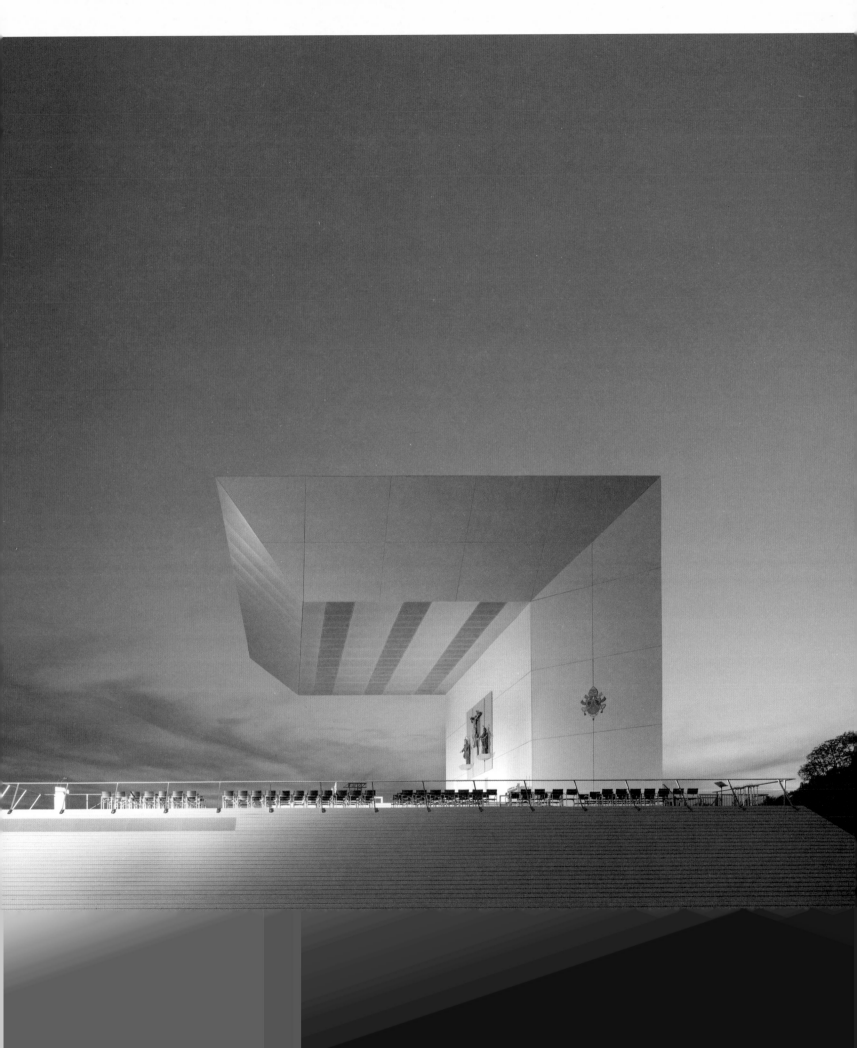

OR2

White is transformed into color when this sculpture is kissed by the sun's rays. Have you ever seen such artificial beauty?

Architects | Orproject
Project address | Belgrave Square, London, United Kimgdom; Cà Laghetto, Milan, Italy
Client | Italian Cultural Institute, London
Gross floor area | 20 m²
Existed | 2010

Or2 is a single surface roof structure that reacted to sunlight. The polygonal segments of the surface react to ultra-violet light, mapping the position and intensity of solar rays. When in the shade, the segments of Or2 are translucent white. However when hit by sunlight they become colored, flooding the space below with different hues of light. During the day Or2 becomes a shading device passively controlling the space below it. At night Or2 transforms into an enormous chandelier, disseminating light that has been collected by integrated photovoltaic cells during the day into the surrounding areas. Special software components have been developed in order to create the shapes and to generate the cutting schedules. The individual elements were then automatically numbered and water jet cut. The beauty of Or2 is its constant interaction with the elements, at each moment of the day Or2's appearance is unique.

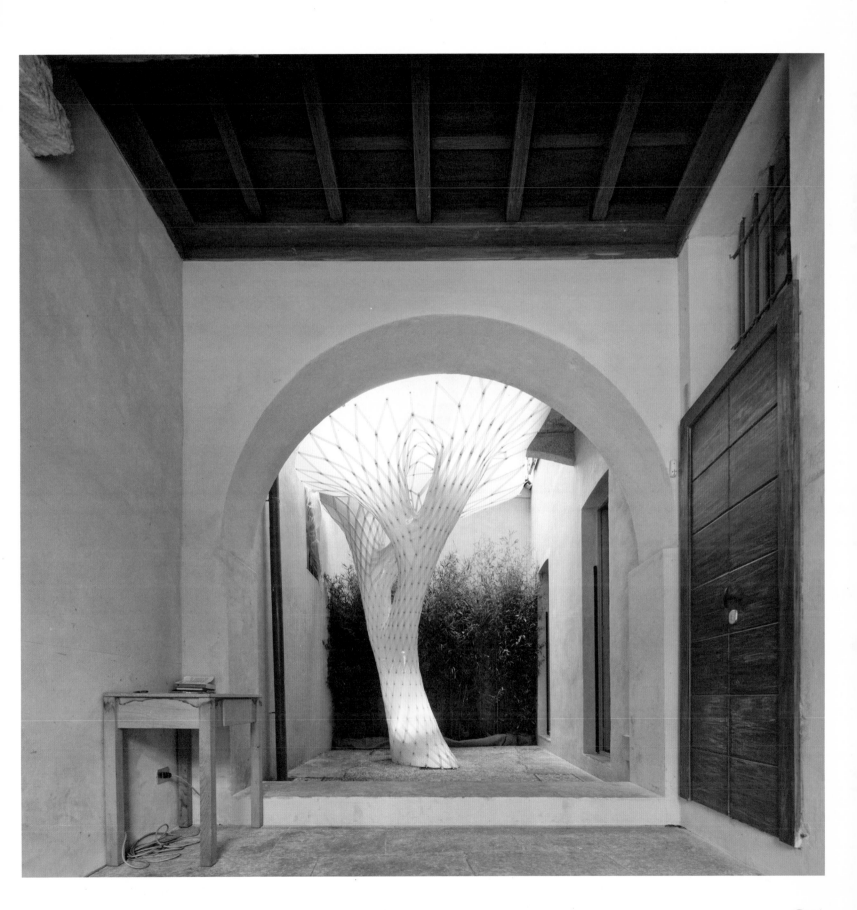

21

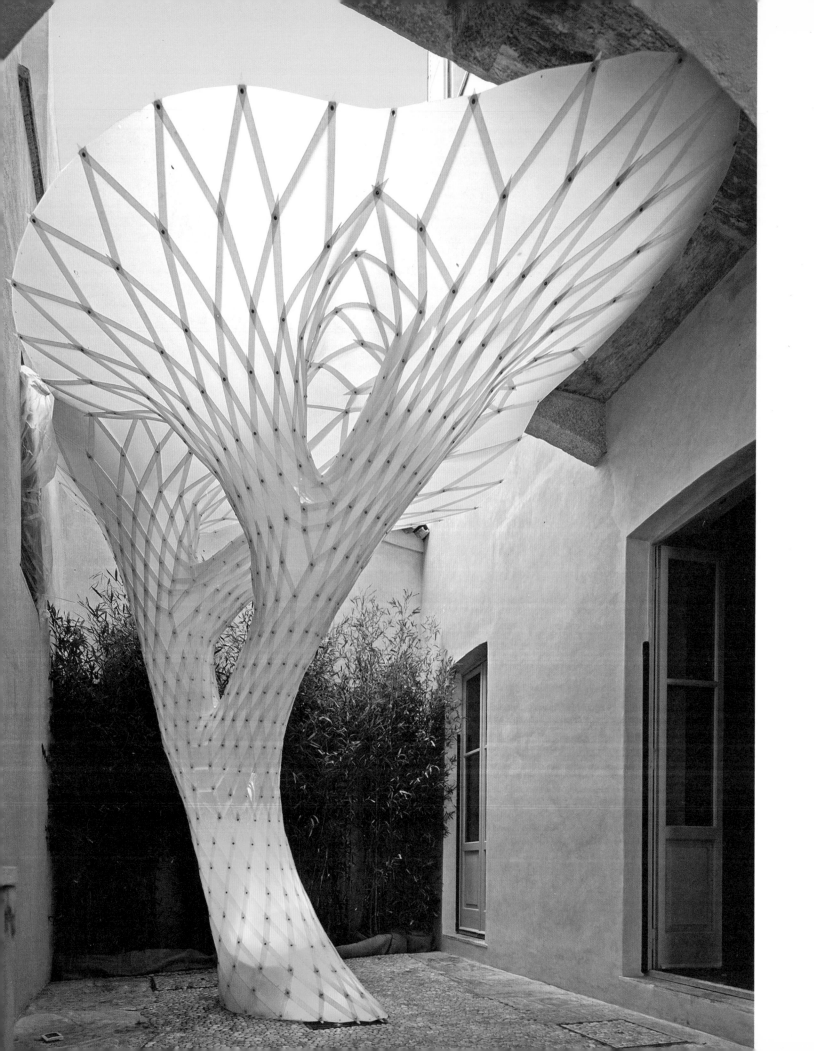

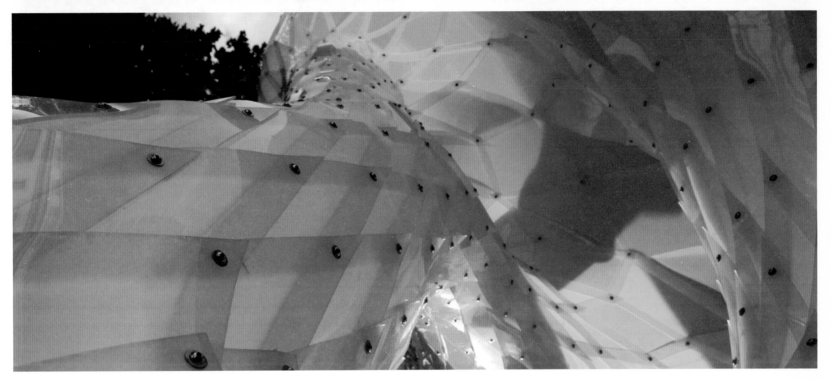
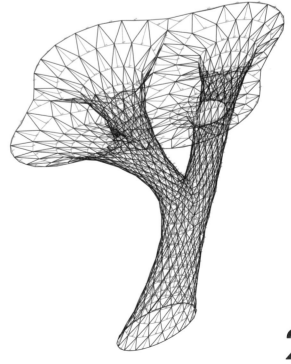

23

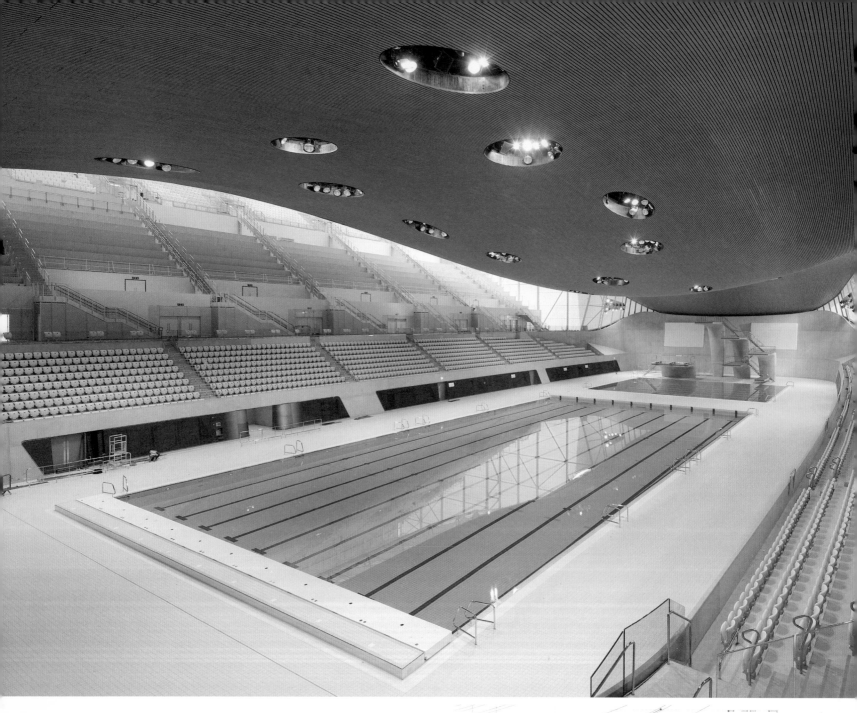

The architectural concept of the London Aquatics Centre is inspired by the fluid geometry of water in motion, creating spaces and a surrounding environment in sympathy with the river landscape of the Olympic Park. The London Aquatics Centre is designed to have the flexibility to accommodate the size and capacity of the London 2012 Olympic Games, whilst also providing the optimum size and capacity for use in Legacy Mode after the 2012 Games. The overall strategy is to frame the base of the pool hall as a podium by surrounding it and connecting it into the bridge. This podium element allows for the containment of a variety of differentiated and cellular programmatic elements. The wings housing the temporary seating were removed after the the 2012 Olympic and Paralympic Games leaving a capacity of 2,500 seats for community use and future national/international events.

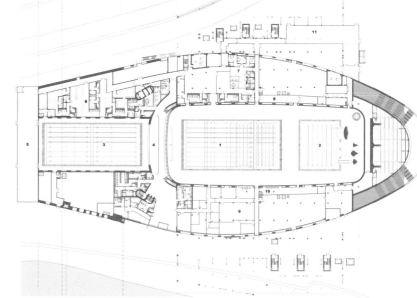

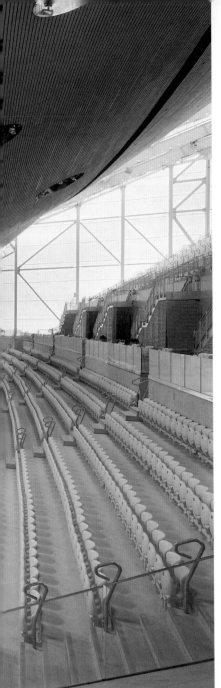

LONDON AQUATICS CENTRE

With removable wings, curving lines, and flowing appearance, this is pure architecture in motion.

Architects | Zaha Hadid Architects
Project address | London, United Kingdom
Client | Olympic Delivery Authority
Gross floor area | 15,950 m²
Existed | 2011–February 2014

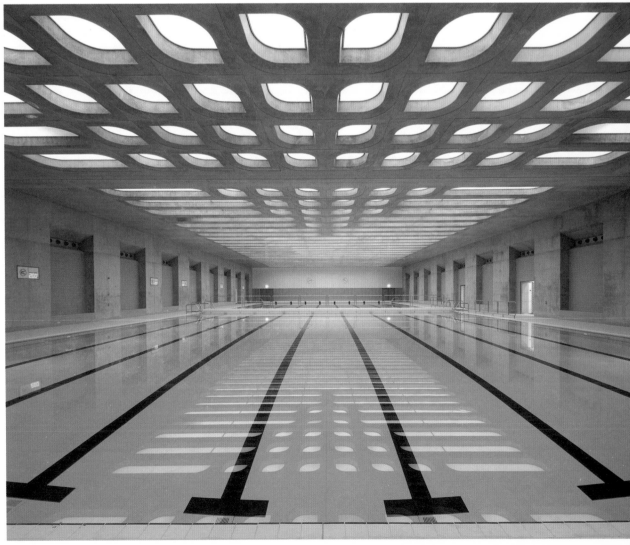

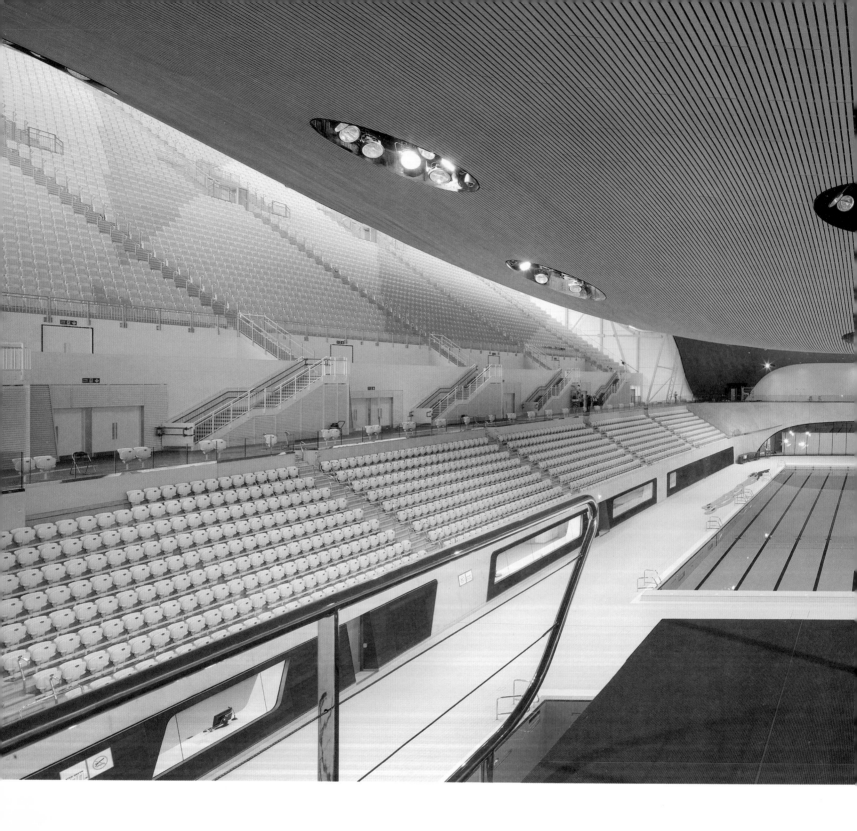

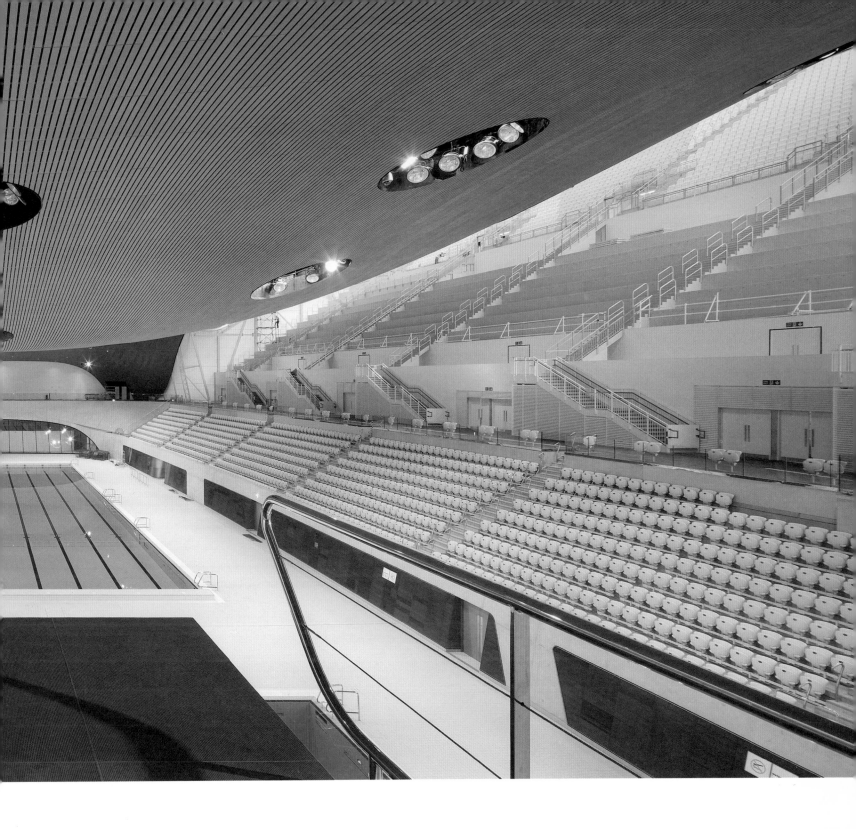

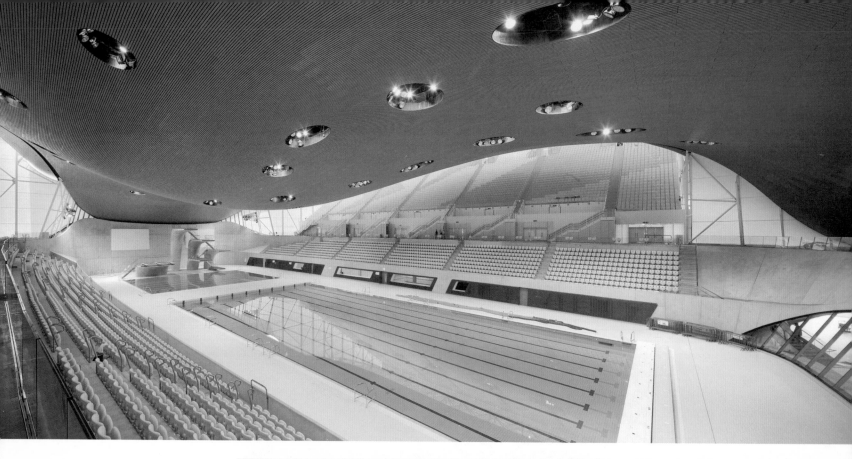

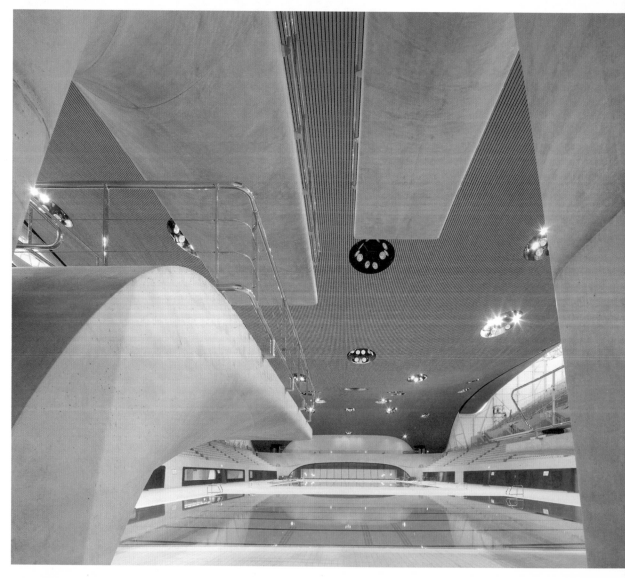

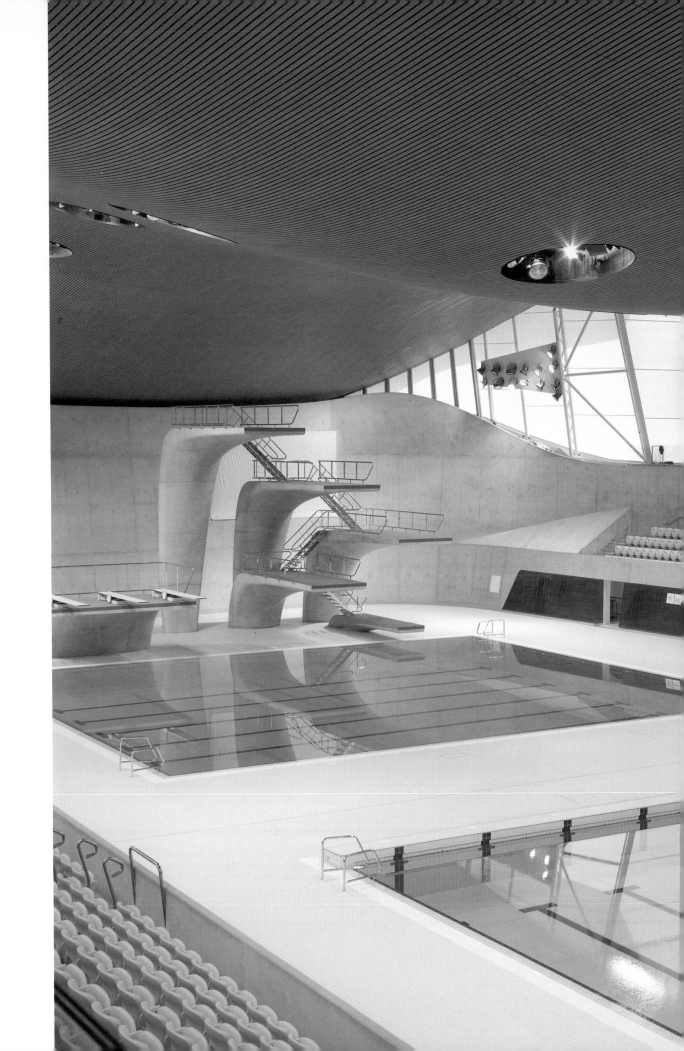

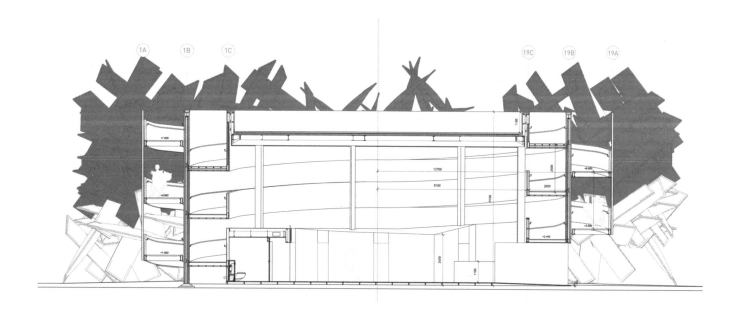

COCA-COLA BEATBOX

The Coke Beatbox Side of Life. Refreshing and cool, the perfect place to get with the groove.

Architects | Asif Khan and Pernilla Ohrstedt
Project address | London Olympic Park, Stratford, London, United Kingdom
Client | Coca-Cola
Gross floor area | 1,000 m²
Existed | June 2012–October 2012

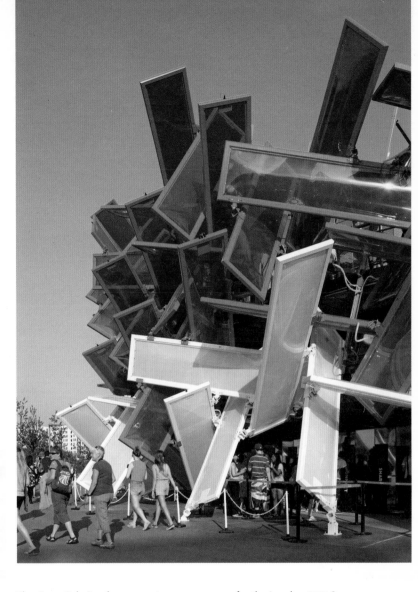

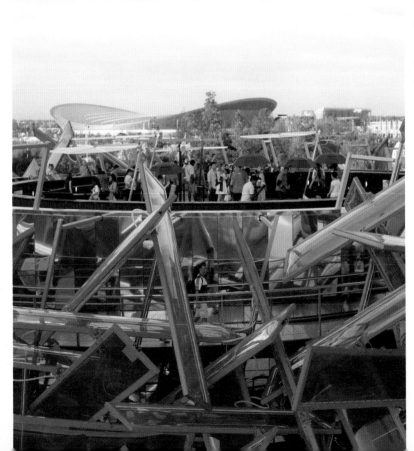

The Coca-Cola Beatbox was a temporary venue for the London 2012 Summer Olympic Games, it welcomed 200,000 visitors during the Games and was seen globally by four million people. The building offered a multi-sensory visitor experience combining sound, light and touch and was inspired by Coca-Cola's global campaign for London 2012, Move to the Beat, which aimed to connect young people to the Games through music and sport. Significantly the building did not feature a Coca-Cola logo, the first time in Coca-Cola's 125-year history. Using the strength of the brand, the building used a faceted but instantly recognizable building envelope made up of over 200 red and white inter-locking ETFE cushions. Innovative sound technology was embedded within the cushions creating an interactive sound journey and piece of architecture that could be played by the visitors like a musical instrument.

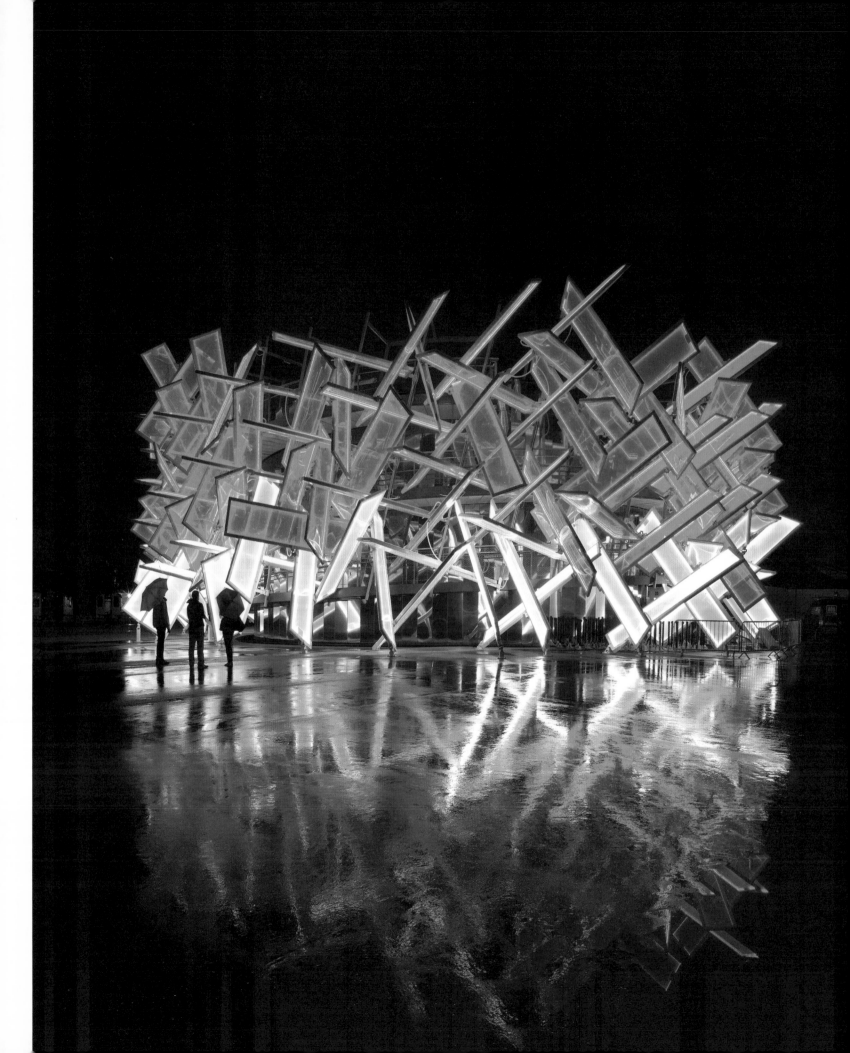

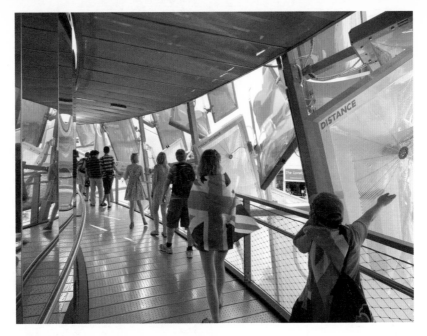

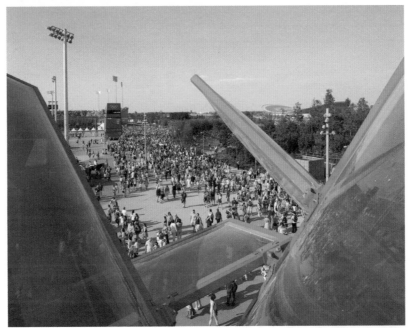

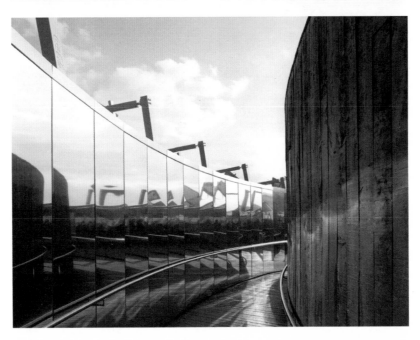

FRESH FLOWER PAVILION

Fresh as a daisy, this giant yellow flower blooms in the midst of the urban jungle.

Architects | Tonkin Liu
Project address | four different sites in central London, United Kingdom
Client | Corus (Tata) Steel and London Festival of Architecture
Gross floor area | 100 m²
Existed | 2008–2010

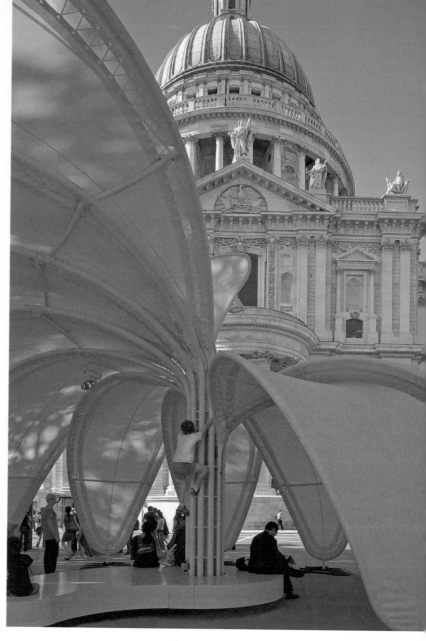

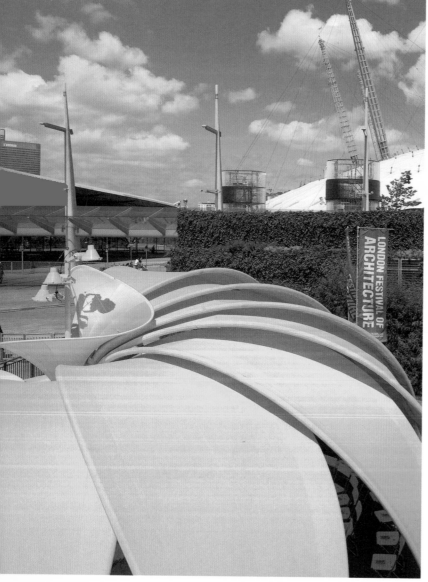

Fresh Flower was a pavilion that traveled to four different hubs in central London, hosting events for the London Festival of Architecture. Eleven petals arched to create shelter beneath, gathered at the center around which a stage was set. Visitors were able to enter the pavilion between the petals from every direction; the spaces increased in size around the structure. Rain fell with the curves of the petals and was gathered by the central flue and transported to the void inside the columns. Sunlight made the petals glow a bright yellow. Lights rising from the central stalk illuminated the pavilion. At each hub the stacked petals arrived, unfurled, and were erected creating an architectural event.

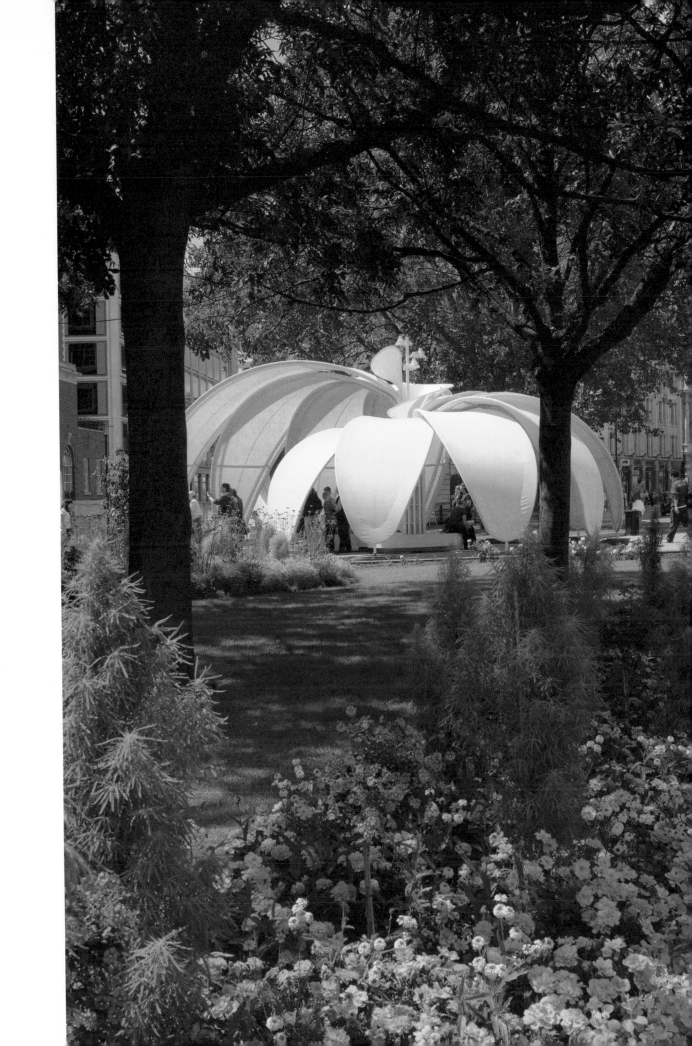

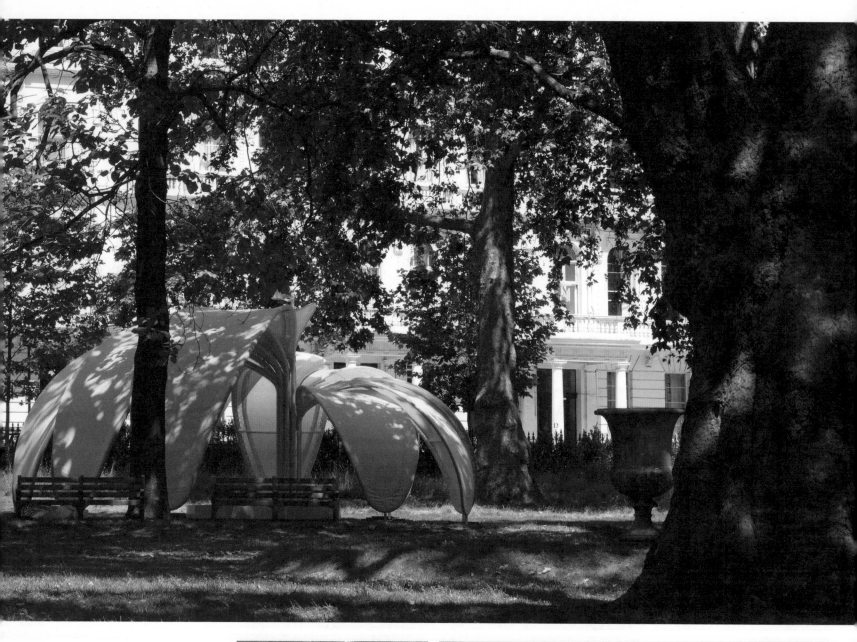

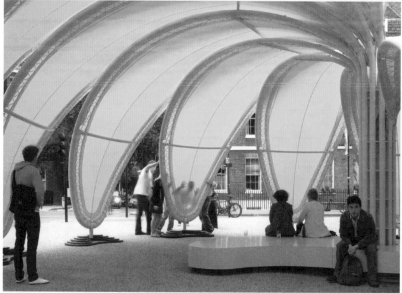

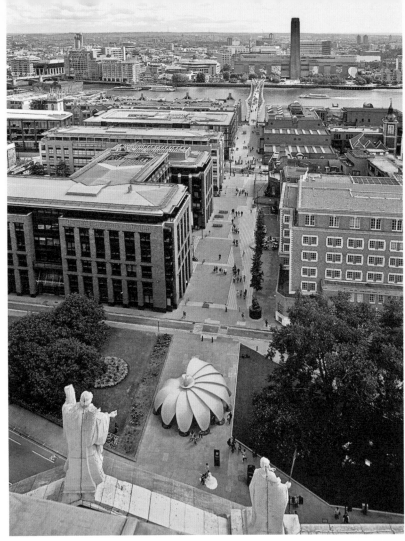

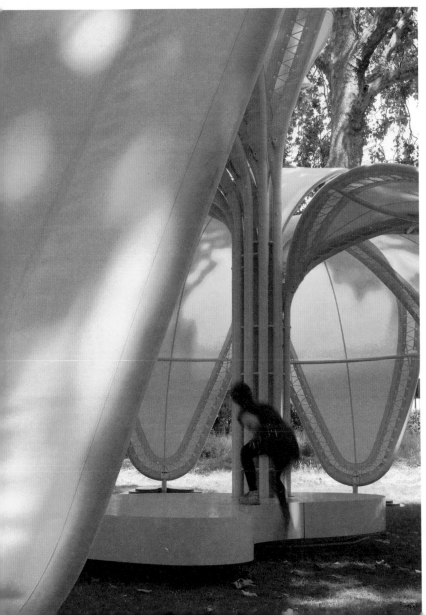

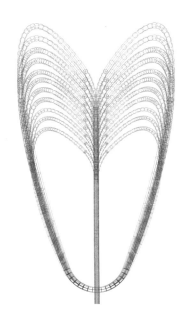

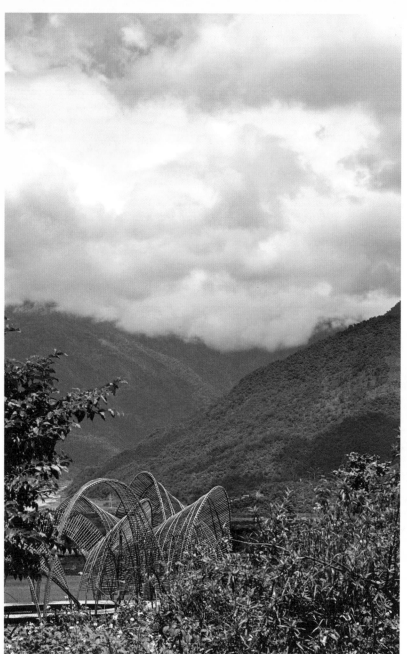

This Forest Pavilion serves as a shaded meeting and performance space for visitors to the Da Nong Da Fu Forest and Eco-park in Hualien province, Taiwan. The project was conceived within the context of an art festival curated by Huichen Wu of Artfield, Taipei, for Taiwan's Forestry Bureau to raise public awareness of a new-growth forest that is threatened by development. This new gathering space emerges from the ground in a series of eleven green bamboo shading vaults, organized in two rings around a void. The design is inspired by the rings of a tree, and the different form of the vaults by growth patterns in nature. In recognition of the cultural diversity of the region, the pavilion's vaults sought to formalize this diversity and suggest an opportunity for unity in support of a greater environmental benefit. Bamboo fabrication for the pavilion was undertaken by the local Amis tribe, masters of bamboo construction.

FOREST PAVILION

At home in the forest, the Forest Pavilion unites ancient building techniques with a modern cause.

Architects | nARCHITECTS
Project address | Da Nong Da Fu Forest, Hualien, Taiwan
Curator | Huichen Wu, Artfield
Gross floor area | 314 m²
Existed | May 2011–ongoing

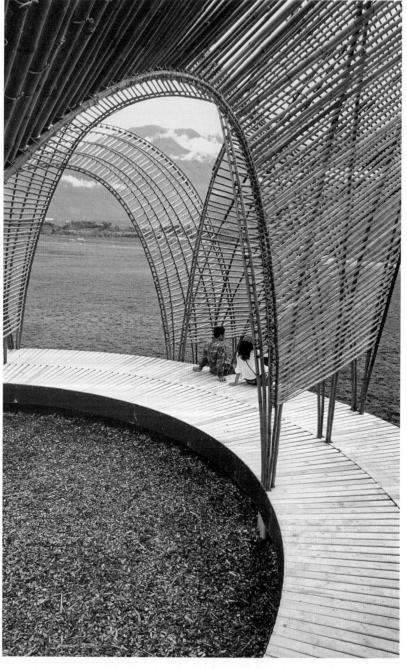

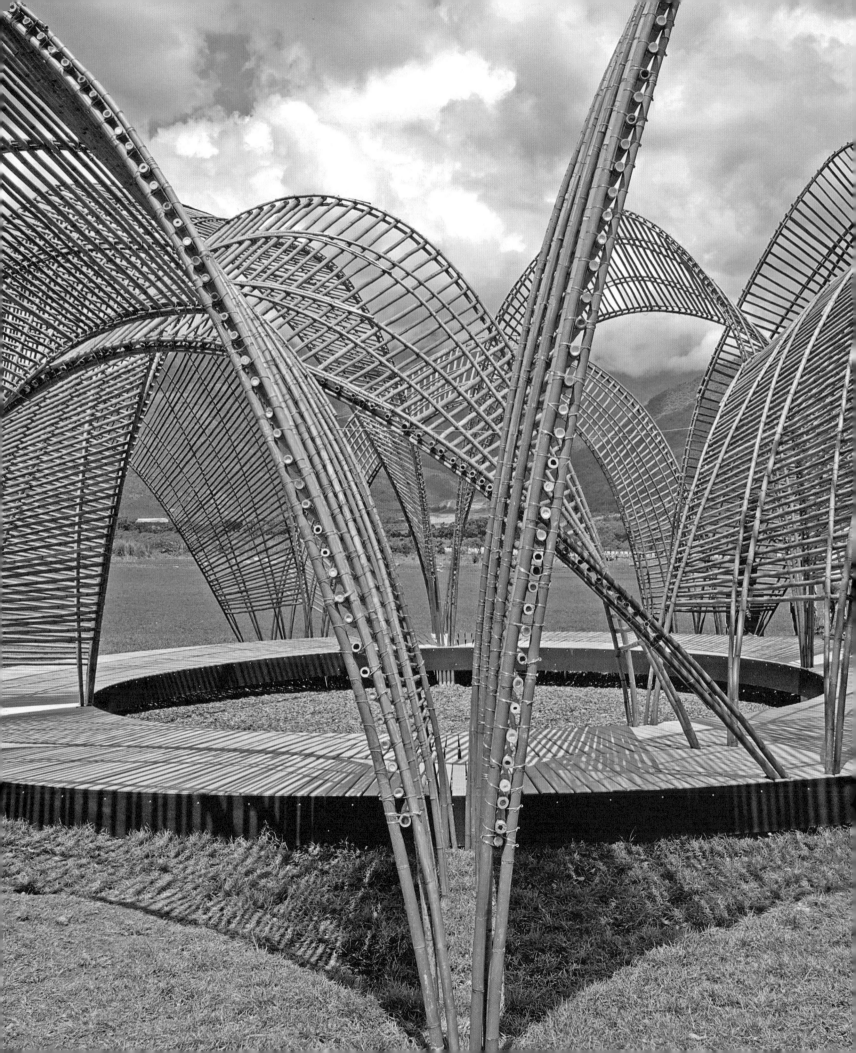

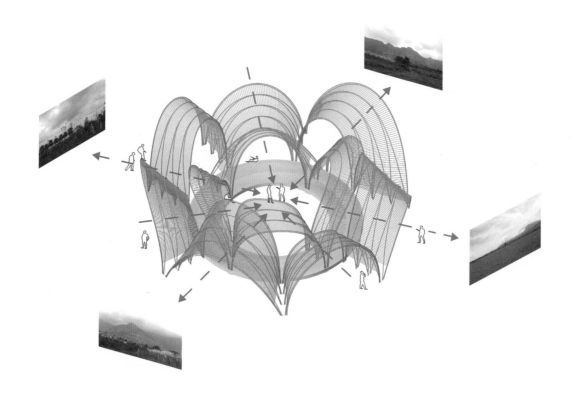

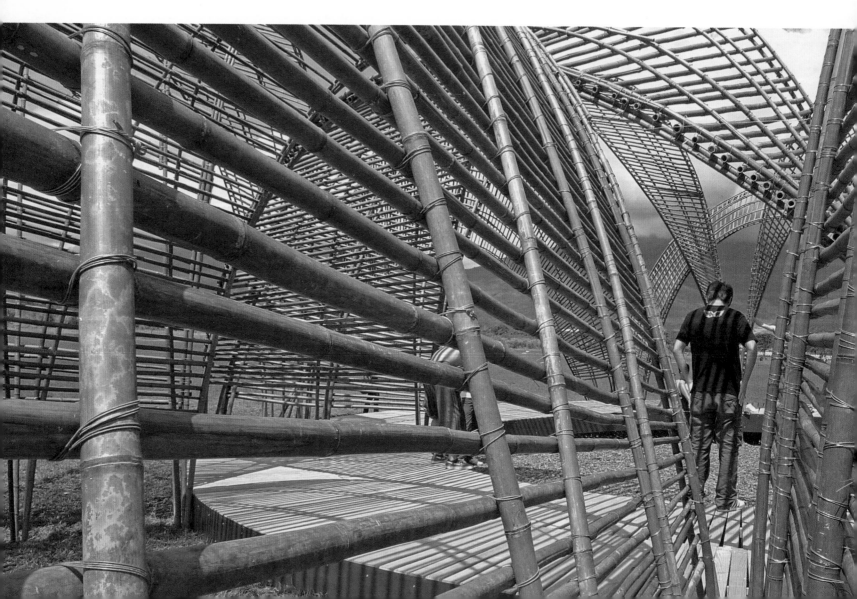

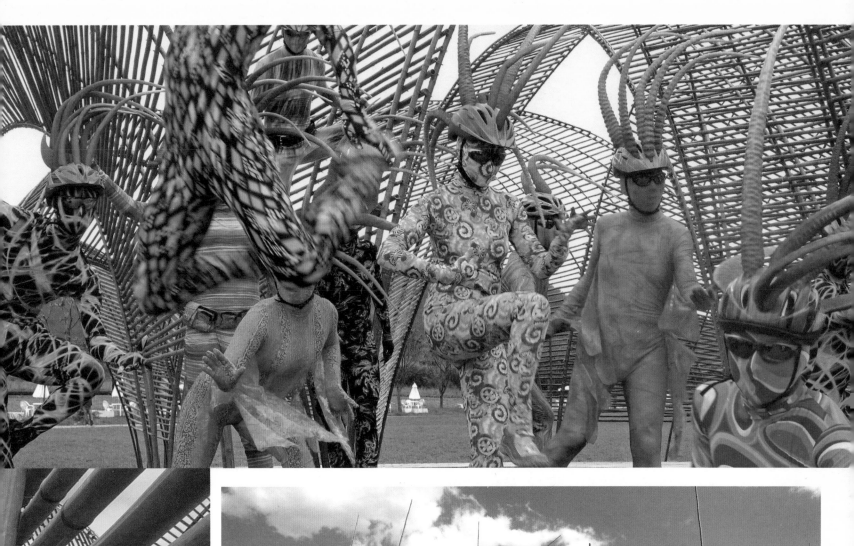

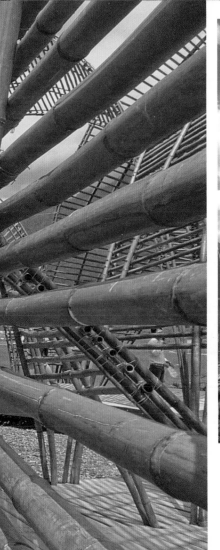

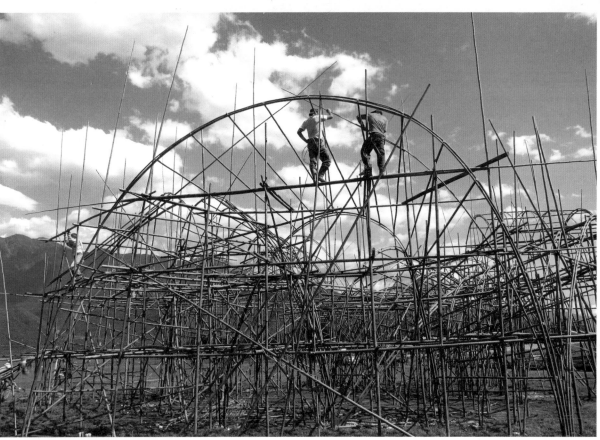

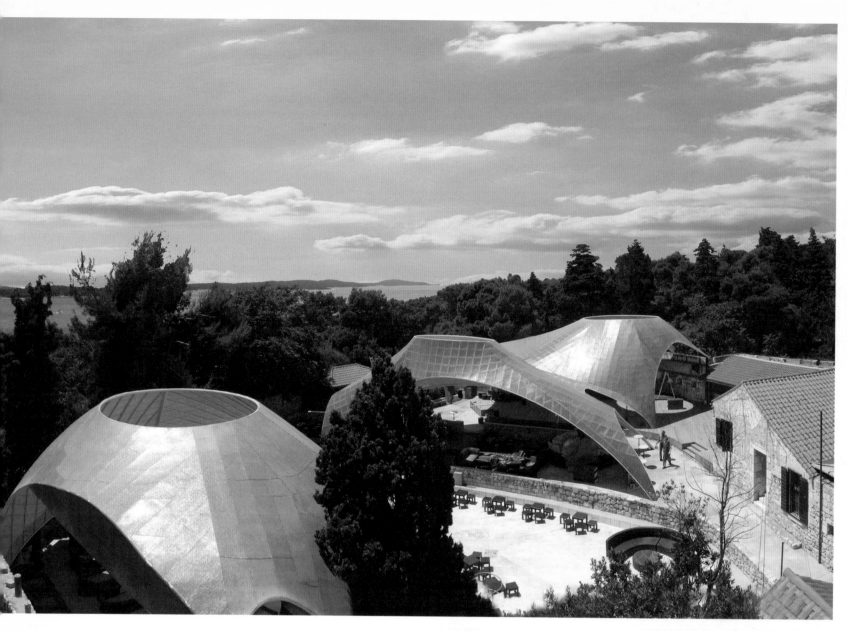

Located on the island of Hvar in Croatia, between old city defenses and an old chapel, the design for this multi-activity center was based on the slogan "We are one love". The new dome roofs structure and connect a variety of spaces at different levels. Although the design simultaneously also gives the individual areas a certain independence, without loosing the visual connection or compromising the available space. Various events and activities take place under the light roof constructions: yoga, massage, capoeira, sound healing courses in the chapel, and seminars. Evening events such as theater, concerts, and club nights complete the program.

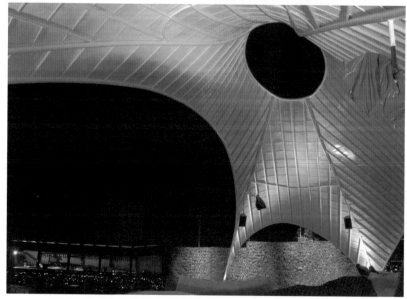

V 528 MULTI-ACTIVITY CENTER

We are one love. Community feeling and local events all united in one place.

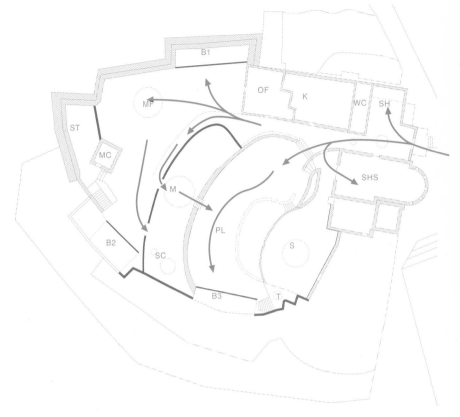

Architects | fabriK°B Architekten, Berlin; fabriK°G Arquitectos, Mexico
Project address | Hvar Island, Croatia
Client | Makart Hotel d.o.o., Zagreb, Croatia
Gross floor area | 1,500 m²
Existed | 2010–ongoing

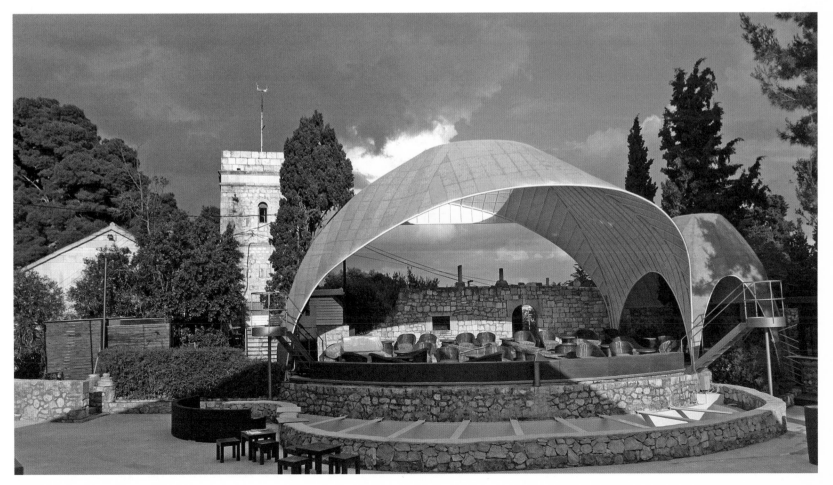

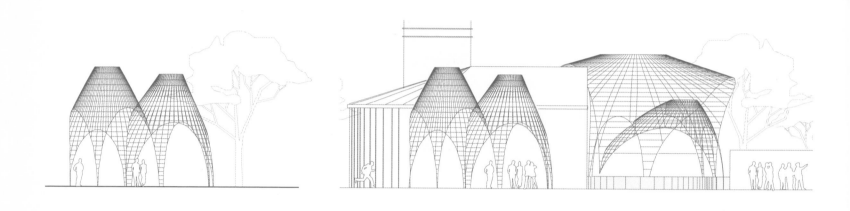

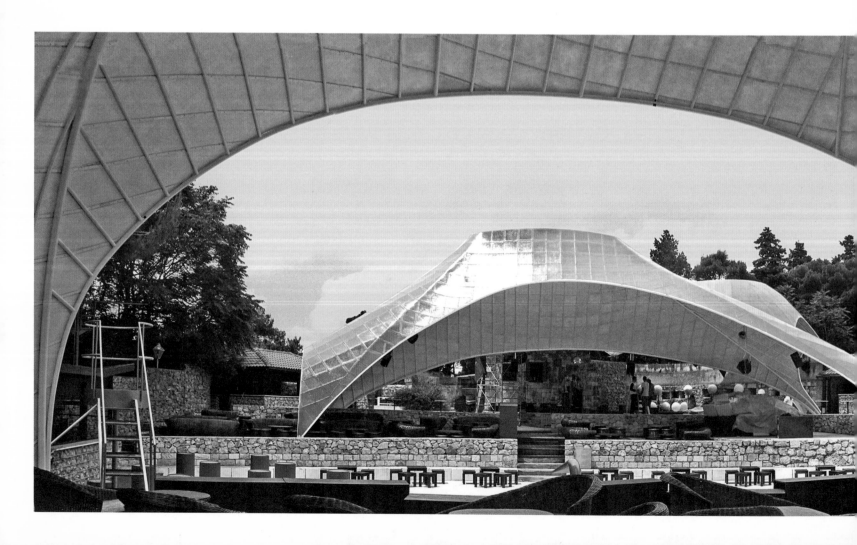

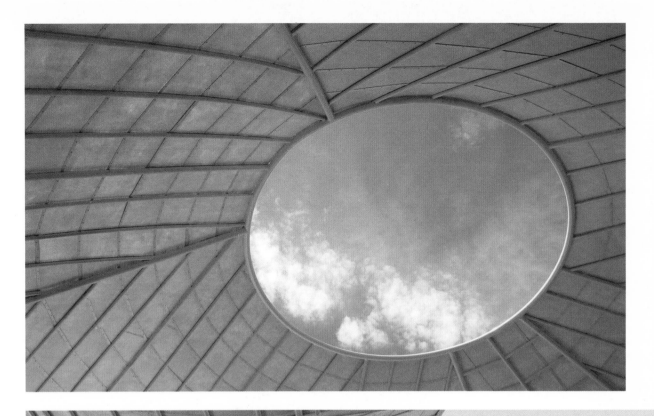

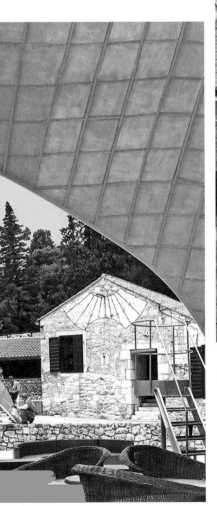

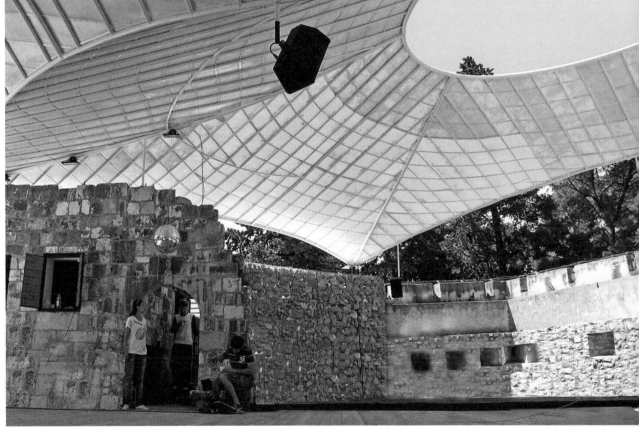

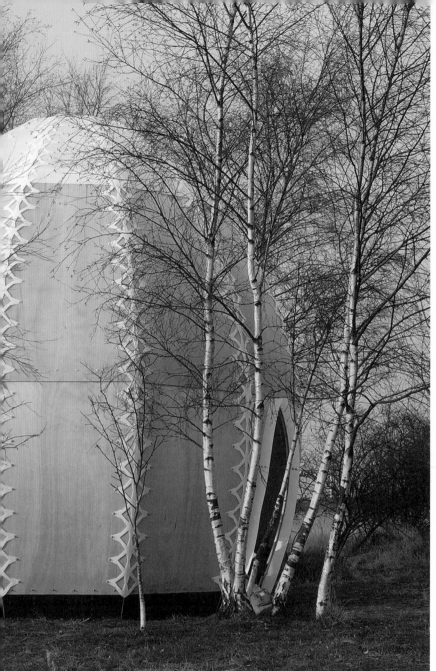

Architects | Shjworks
Project address | Sydhavnstippen, Copenhagen, Denmark
Gross floor area | 11.34 m²
Existed | 5 January 2013–12 December 2013

Fire Shelter: 01 was located at Sydhavnstippen in Copenhagen. The starting point for the design emerged from a fascination of the location and the desire to celebrate this place. The design was inspired by ethnic and nomadic architecture. One hole in the top allowed smoke to exit and two openings at the bottom created the human entry. The main materials used were plywood and polycarbonate, fabricated using CNC technology. The walls comprised thin and bendable shells, which were tightened together with bolts and a piece of two-millimeter-thick polycarbonate. The bottom of the shelter was made of plywood and inside a bench surrounds a hearth. The shelter was designed, produced and paid for by the firm Shjworks. The assembly, done without the use of ladders, was made possible by assistance from Christian Bøcker Sørensen and others.

FIRE SHELTER: 01

At one with nature and inspired by ethnic and nomadic architecture, this shelter celebrates the location and the practice of holding social gatherings around a fire.

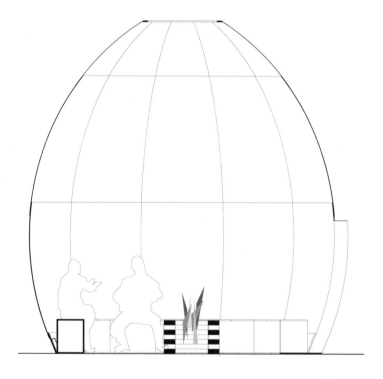

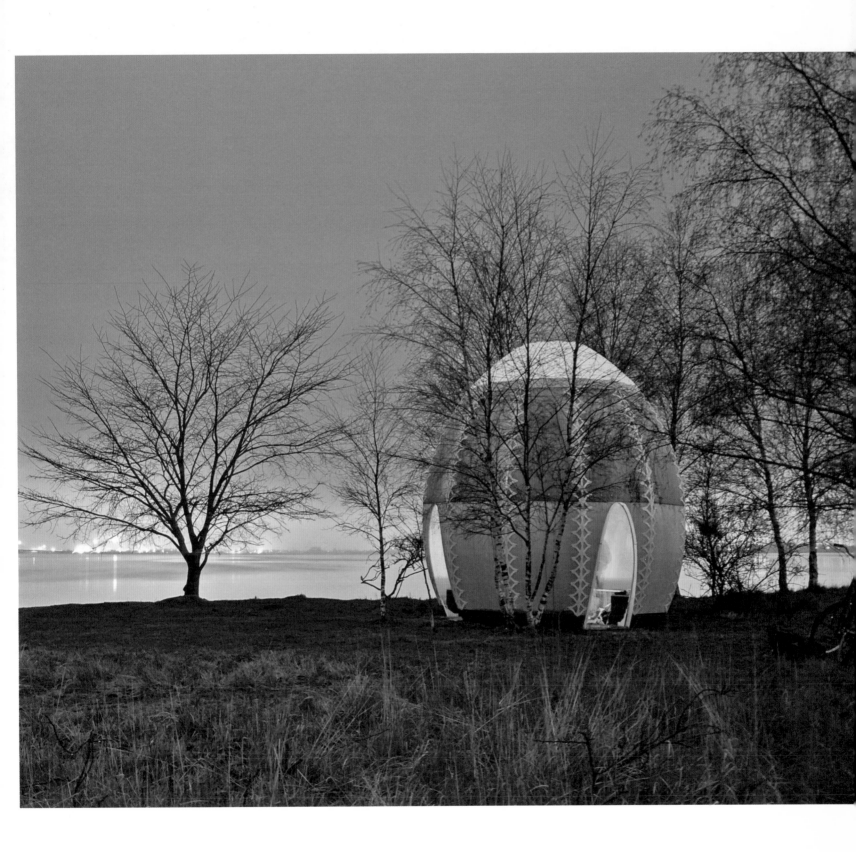

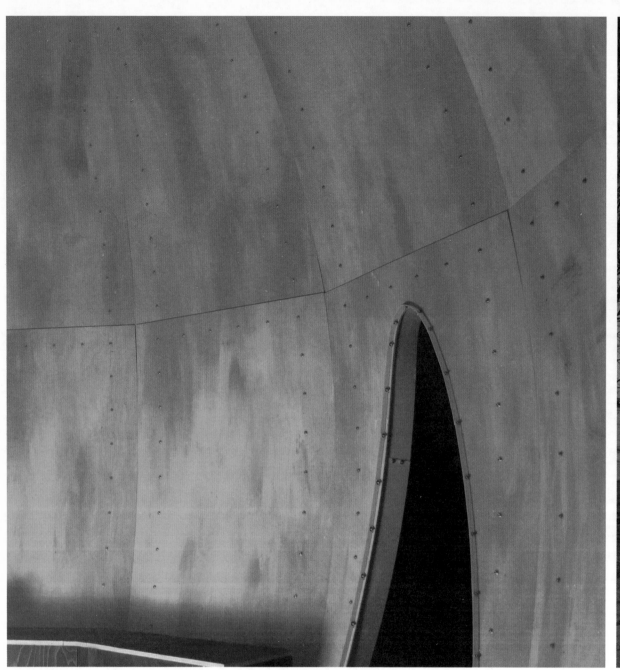

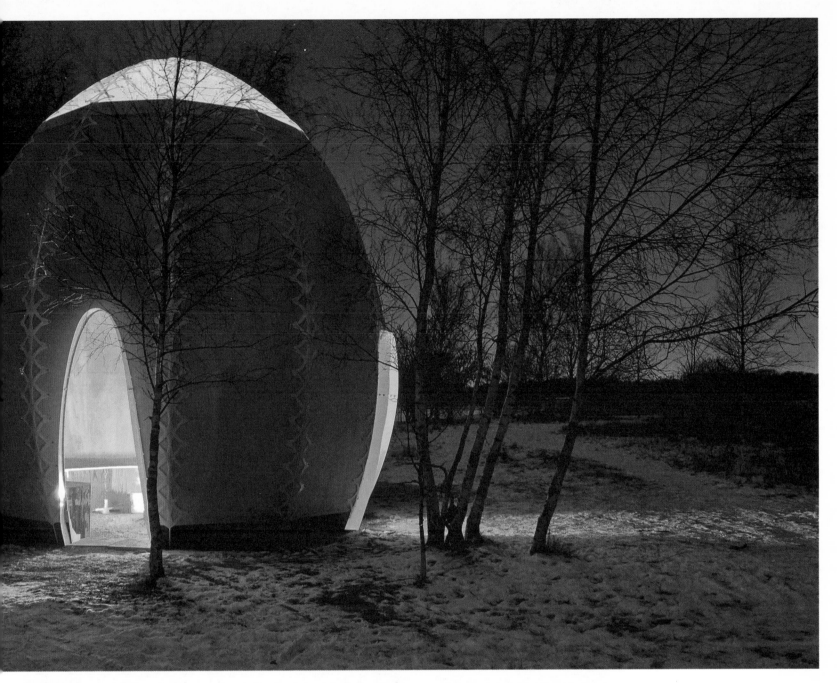

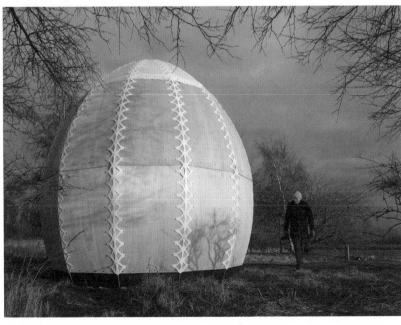

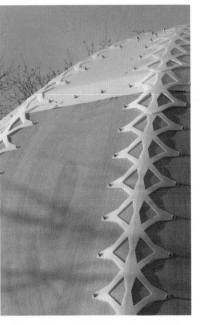

49

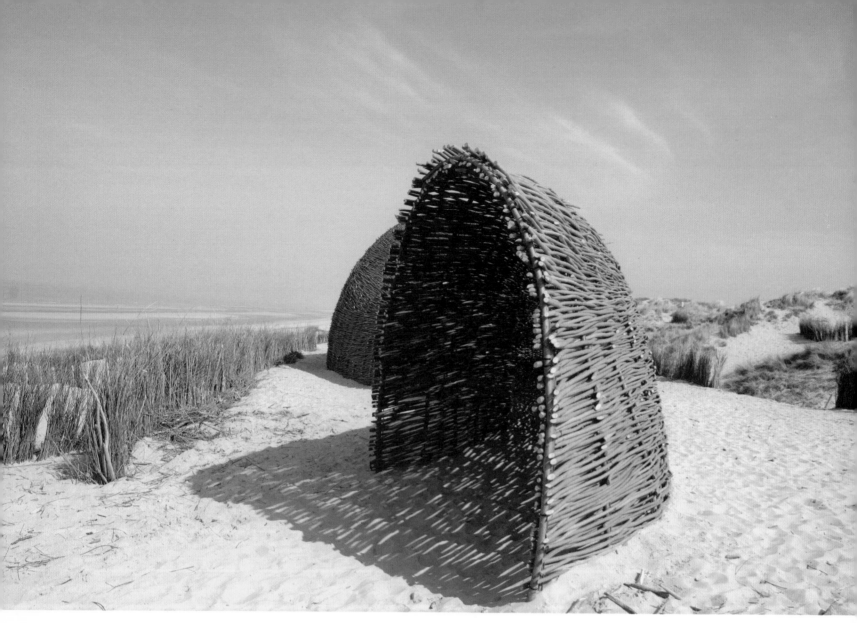

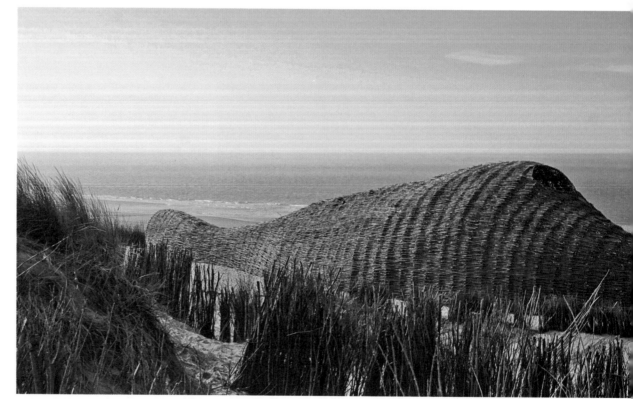

50

SANDWORM

Weaving its way along the sandy shore, the Sandworm is a part of nature, a willow cathedral where one can celebrate the wonders of nature.

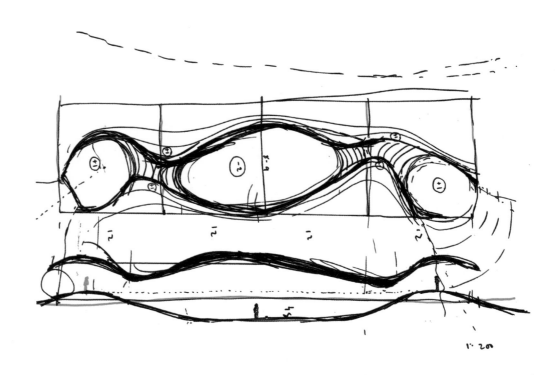

Architects | Marco Casagrande
Project address | Wenduine, Belgium
Client | Beaufort Triennial
Gross floor area | 32 m²
Existed | 31 March–30 September 2012

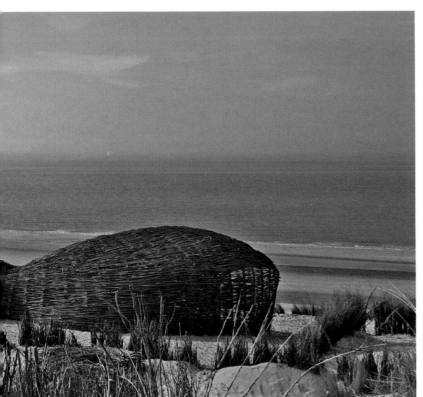

Sandworm was an organic creation realized on the dunes of the Wenduine coastline in Belgium, as part of the Beaufort Triennial, curated by Jonas Vandeghinste. The structure was made of willow and combined architecture with environmental art. Environmental artist and architect Marco Casagrande describes the work as 'weak architecture' – a flexible structure that becomes a part of nature through its organic presence. The Sandworm can be viewed as a willow cathedral, finely tuned to celebrate the site specific conditions of the Wenduine tidal beaches.

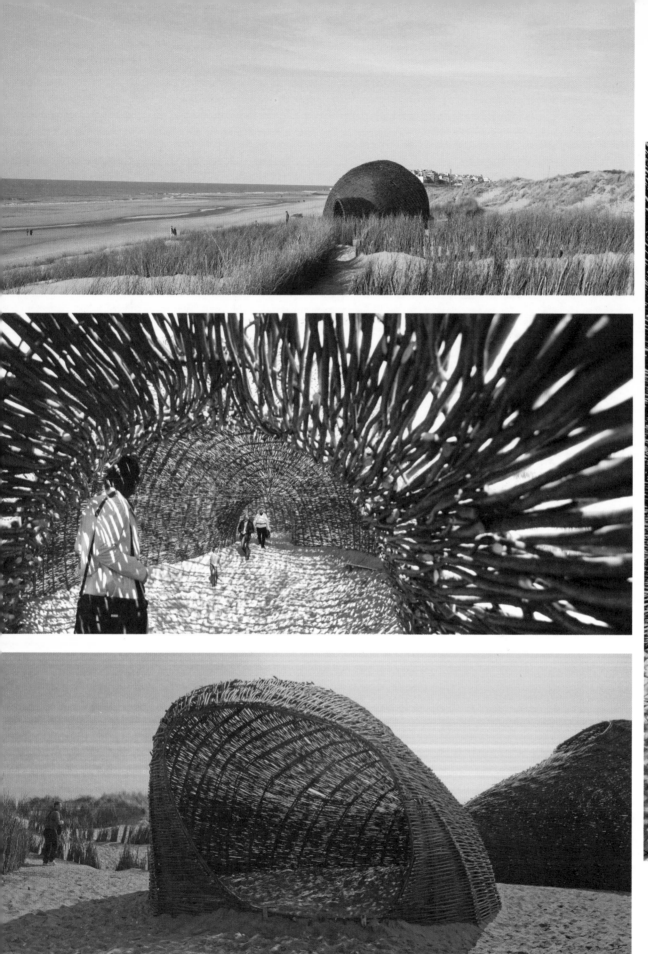
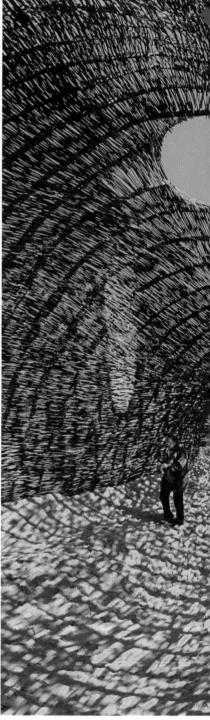

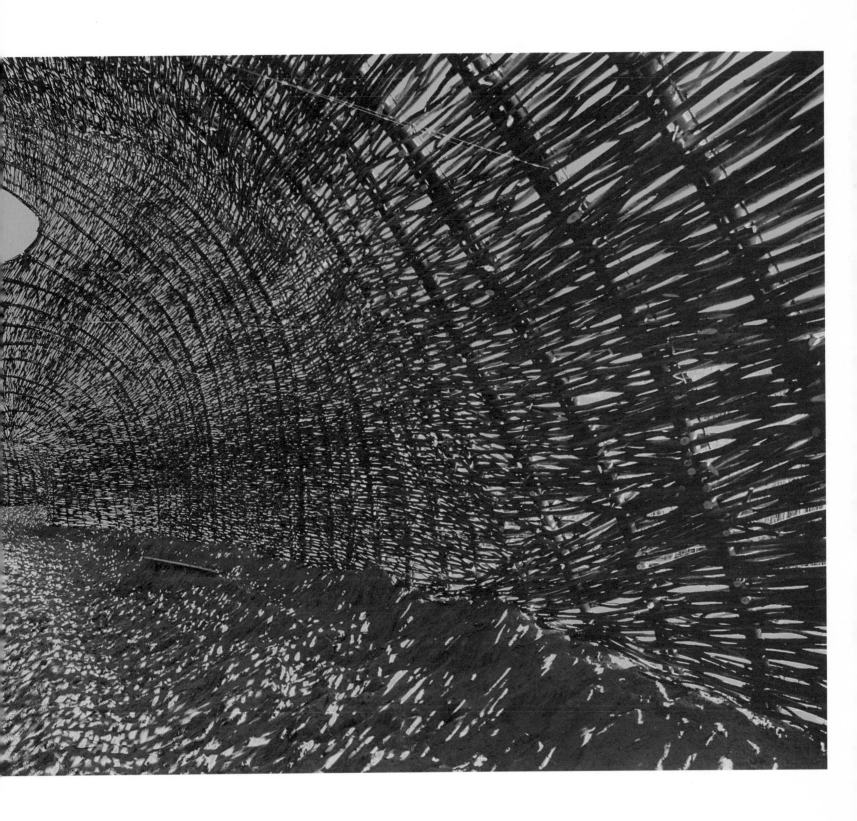

TEMP

ELABORATE

ENTER

Architects | a.gor.a architects
Project address | 702, Moo 4, Tha Sai Luad, Mae Sot,
63110 Tak, Thailand
Client | Mae Tao Clinic
Gross floor area | 72 m²
Existed | June 2012–ongoing

These temporary dormitories are located in Mae Sot, Thailand and are the result
of a collaboration between Albert Company Olmo, Jan Glasmeier, Line Ramstad,
Alejandro Buzo, Maria Nuñez and Eduardo Novo. Armed conflict in Myanmar has
resulted in a large number of refugees flowing from the country into neighboring
Thailand. Numerous schools and orphanages have sprung up along the border and
one of these, the Child Development Center, accommodates more than 500 pupils.
These dormitories are a low-cost and easy to assemble solution that provide the
center with more space to house the ever-increasing number of children. The first four
dormitories were built within a timeframe of just four weeks and are open, light and
airy, offering semi-private living space for up to three pupils.

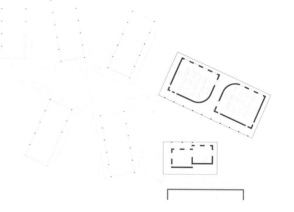

TEMPORARY DORMITORIES
FOR MAE TAO CLINIC

Big bang for the buck. Temporary architecture's
contribution to humanity.

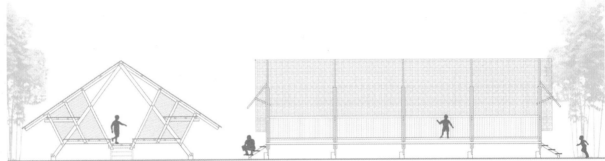

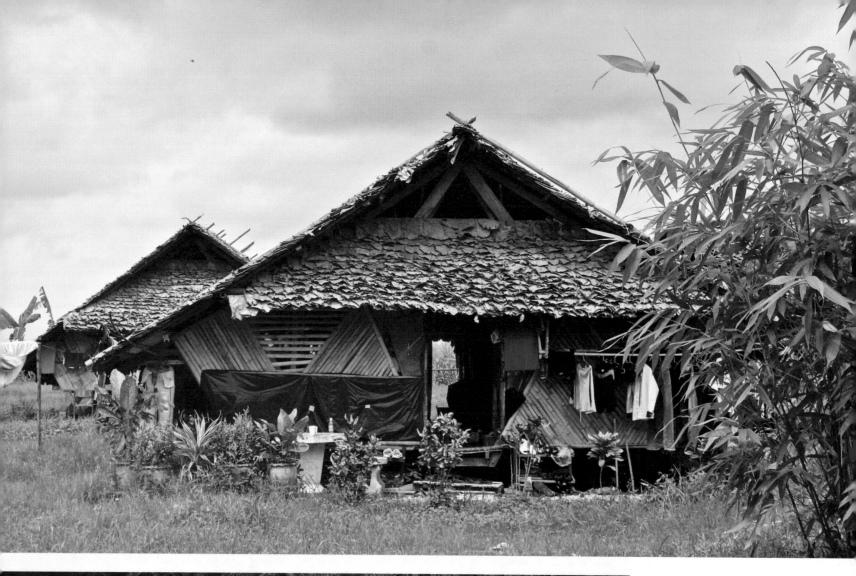
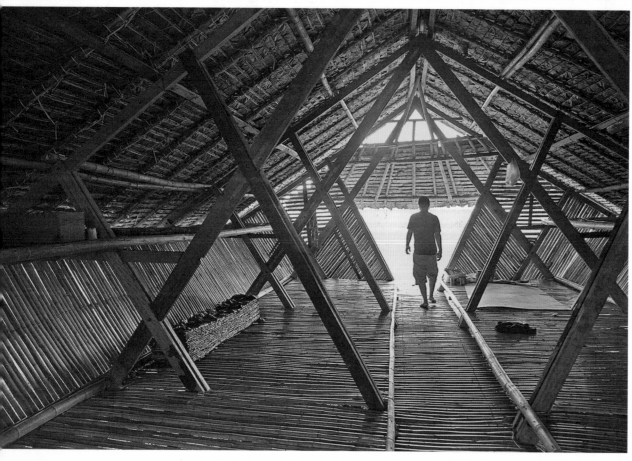

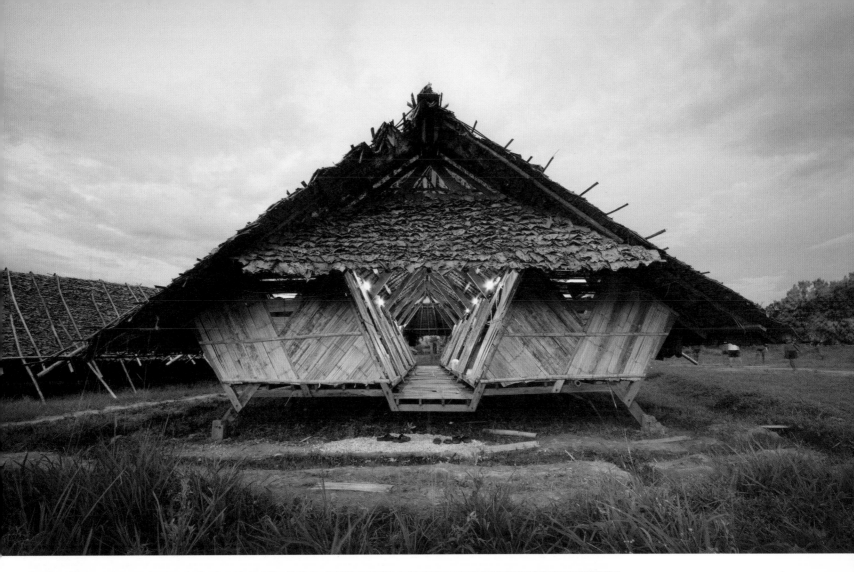

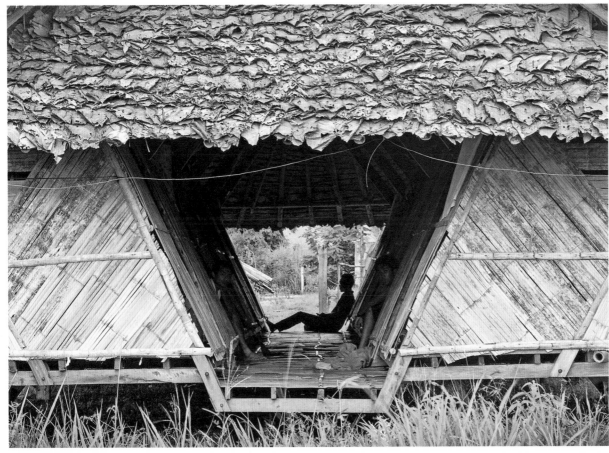

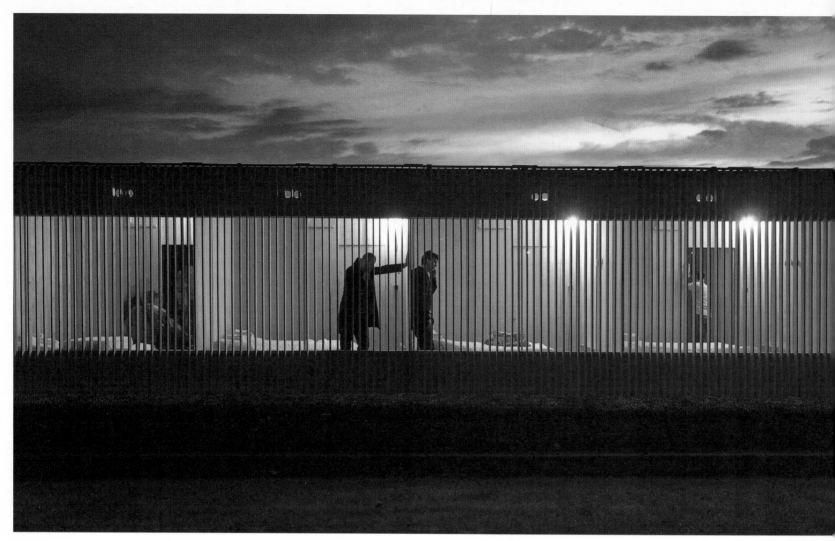

NIGHT AT THE MUSEUMLAAN

Be part of the stage. An exciting experience mixing hospitality, design and art.

This pavilion was designed for the Grenswerk art festival in Roombeek, the district in Enschede that was rebuilt after the firework catastrophe in 2000. The young architects invited two Polish artists to work with them on the design. The result was a hotel for festival visitors, but also a possibility for locals to spend a night in this renowned district. This temporary project comprised five rooms with a view over the Museumlaan. The appearance of the hotel is either opened or closed, depending on the perspective of the viewer. The hotel was not only a place to sleep, but also served as a piece of art. People who stayed in the room became a part of the stage.

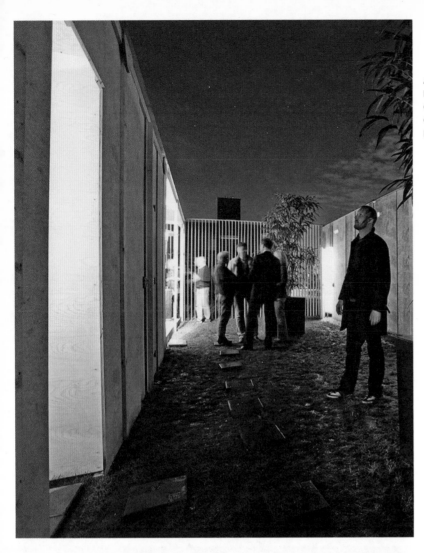

Architects | Rick Bruggink & Marko Matic (IAA Architekten)
Project address | Museumlaan, Enschede, The Netherlands
Client | Architectuurcentrum Twente and Grenswerk festival
Gross floor area | 150 m²
Existed | 25 September–12 October 2010

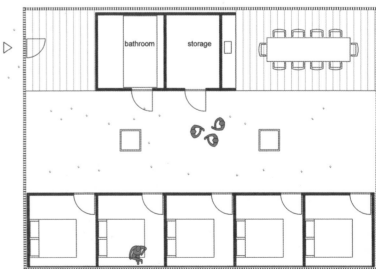

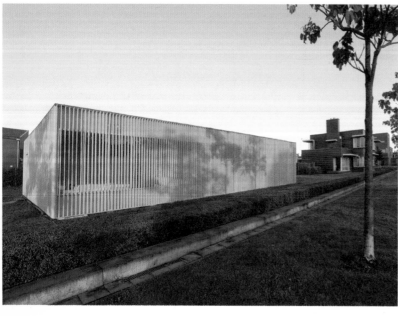

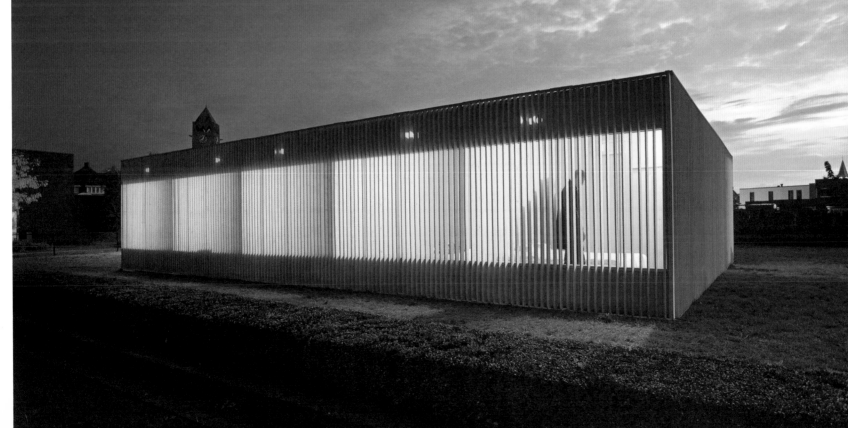

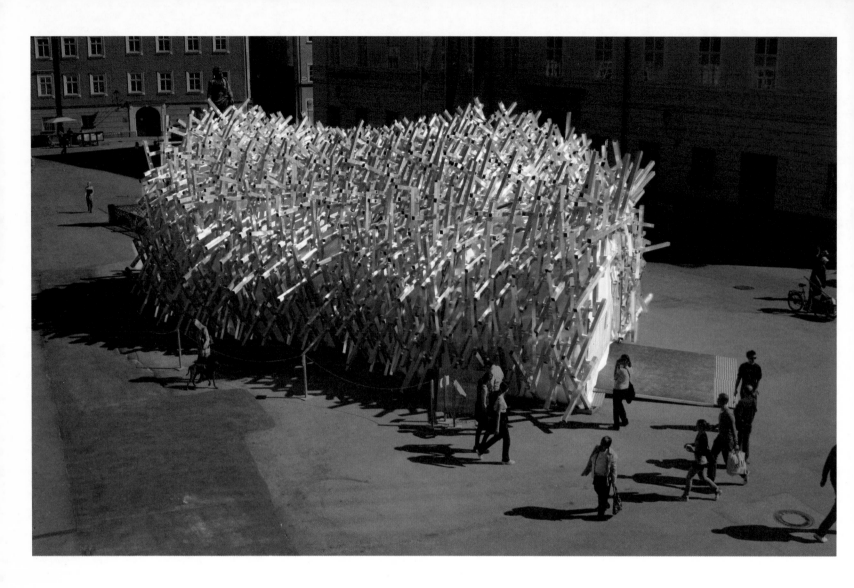

This temporary pavilion creates a unique venue for contemporary art productions in Salzburg, a city known predominantly for its classical music. The pavilion was erected for the first time in March 2011 for a period of three months and housed various events such as contemporary music concerts, video screenings and exhibitions. The architectural concept is based on a theme that is inherent to architecture as well as music – rule and variation. The aluminum profiles produce an irregular mass-like conglomerate that changes its appearance during the day, according to the different light conditions. The structure allows an ambivalent reading as single members and as a merging whole, depending on the distance it is viewed from.

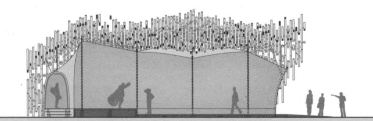
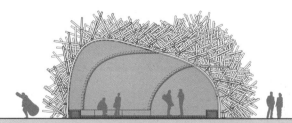

VAGUE FORMATION

With its interlocking aluminum panels and organic style, vague is on vogue.

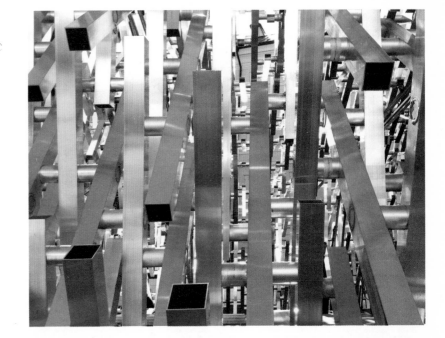

Architects | soma
Project address | various
Client | Municipality of Salzburg
Gross floor area | 140 m²
Existed | 2011–ongoing

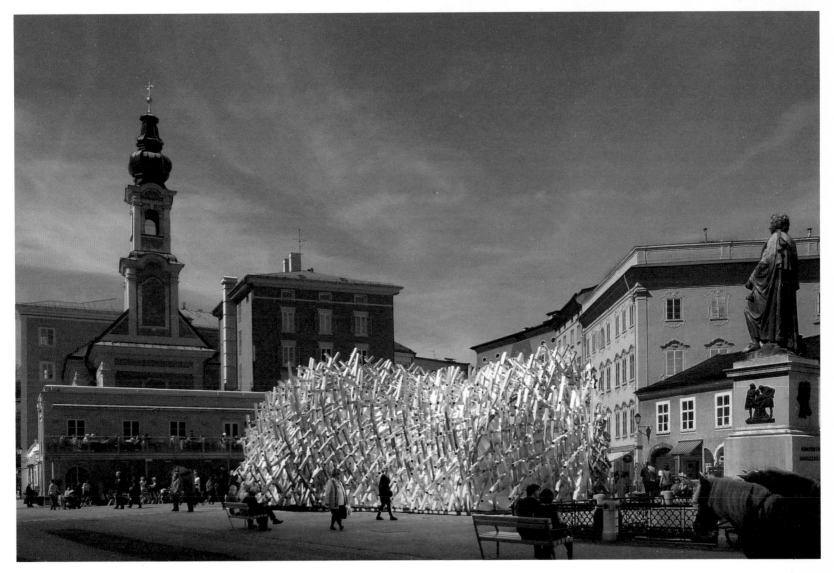

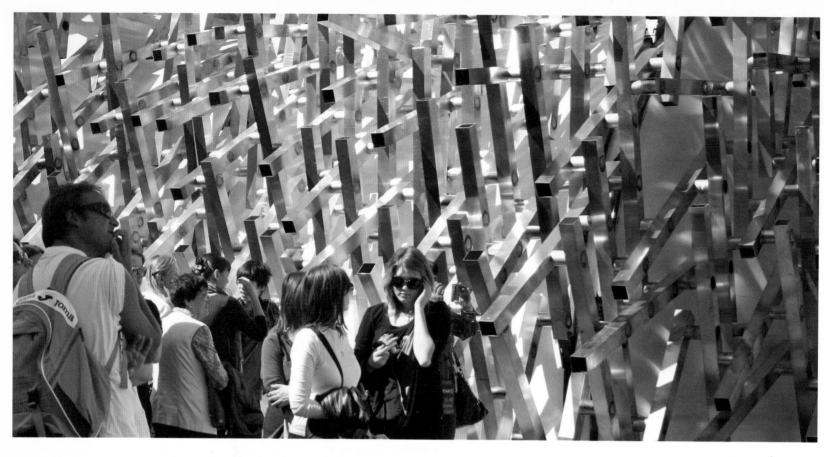

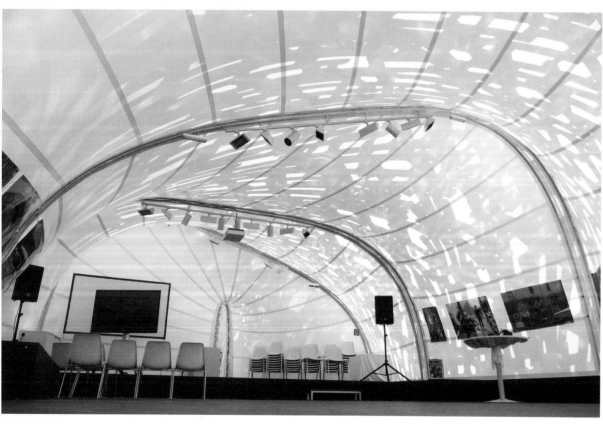

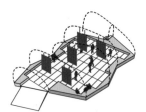

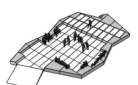

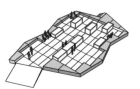

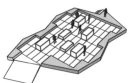

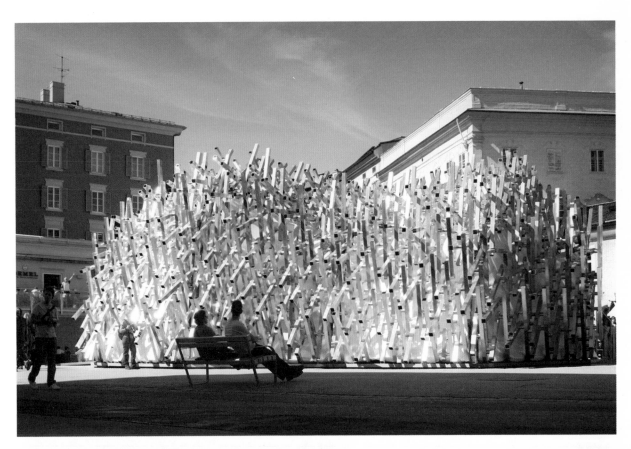

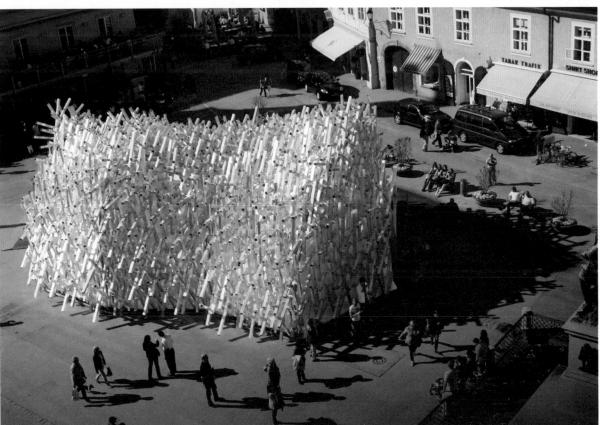

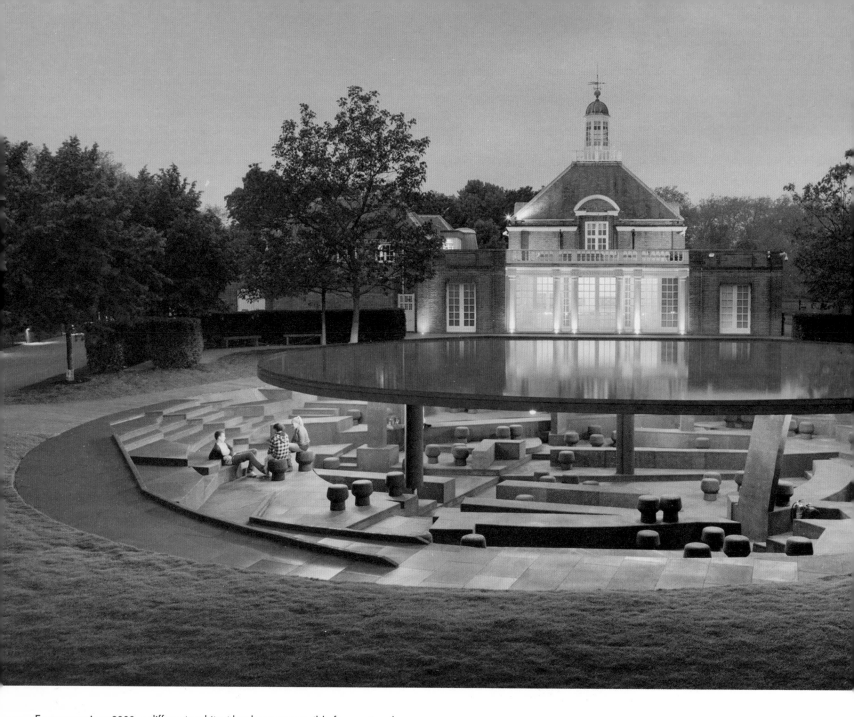

Every year since 2000, a different architect has been responsible for creating the Serpentine Gallery's Summer Pavilion. This contribution was the twelfth. So many pavilions in so many different shapes and out of so many different materials have been conceived and built that the architects tried instinctively to sidestep the unavoidable problem of creating an object, a concrete shape. A hole was dug down to reach groundwater. As the hole was dug, the architects encountered a diversity of constructed realities such as cables and the remains of former foundations. These were identified as fragments from the previous eleven pavilions. The former foundations and footprints formed a jumble of convoluted lines. The roof was supported by 11 loadbearing elements. It floated a few meters above the grass of the park, so that everyone visiting could see the water on it, its surface reflected the infinitely varied skies of London.

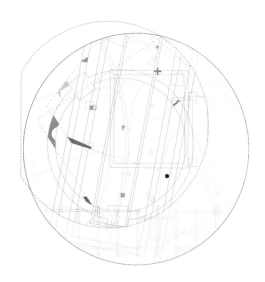

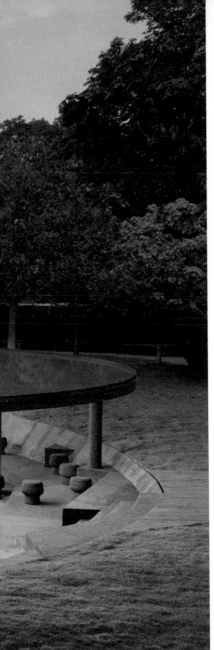

SERPENTINE GALLERY PAVILION, 2012

Using the past to create the present. A convoluted
jumble of lines pays homage to the Serpentine
pavilions of the past.

Architects | Herzog & de Meuron, Ai Weiwei
Project address | Kensington Gardens, London, United Kingdom
Client | Serpentine Galleries
Gross floor area | 415 m²
Existed | 1 June–14 October 2012

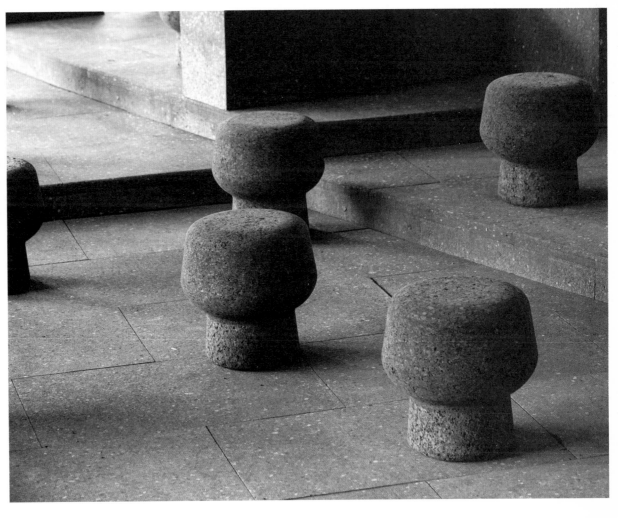

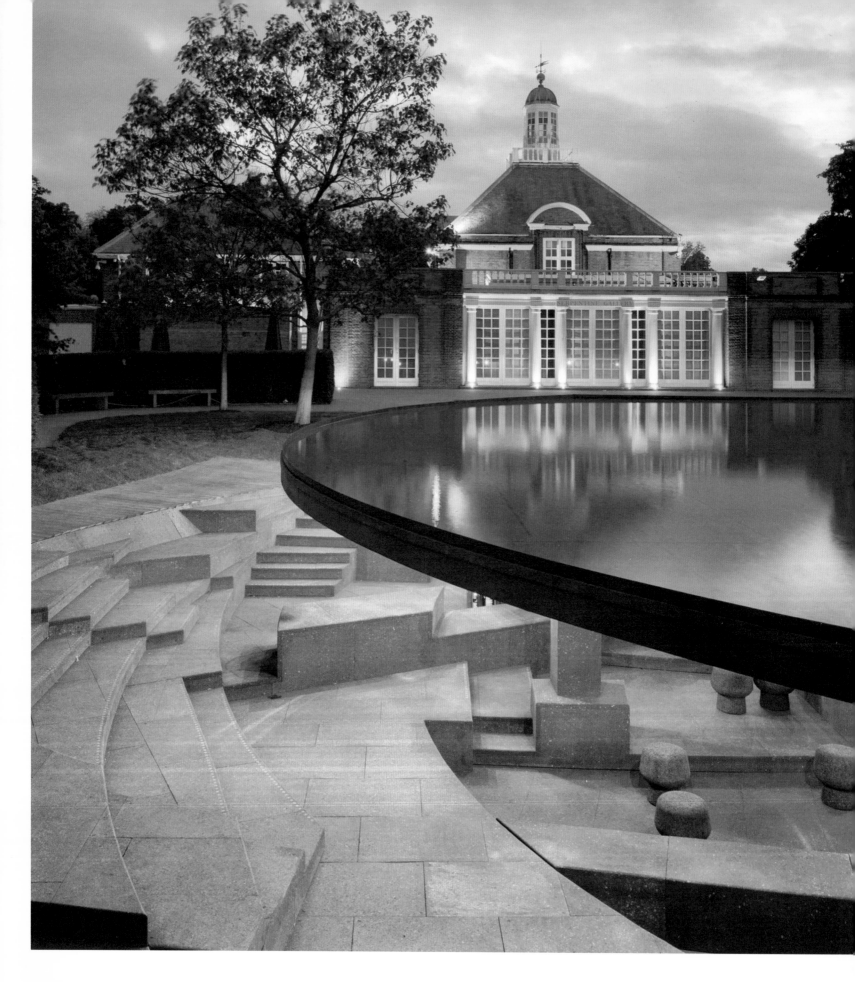

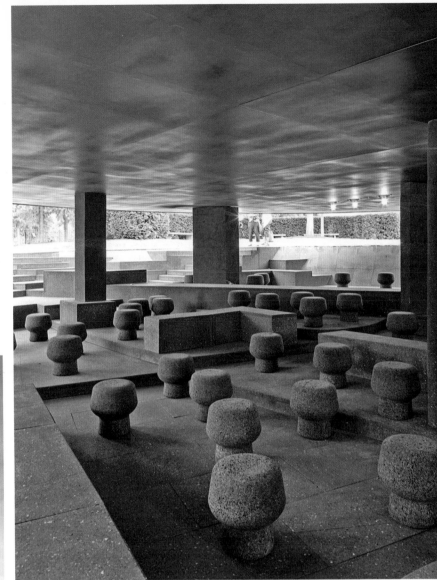

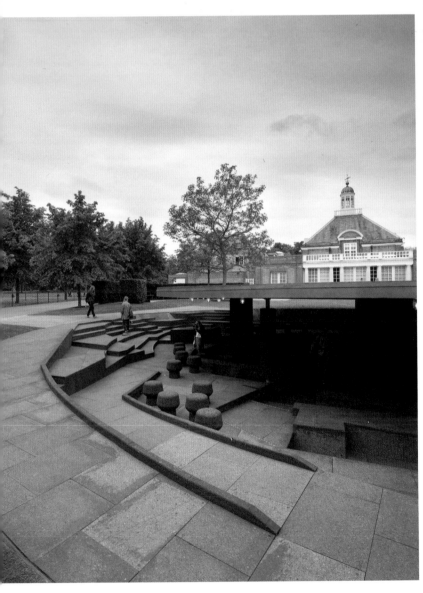

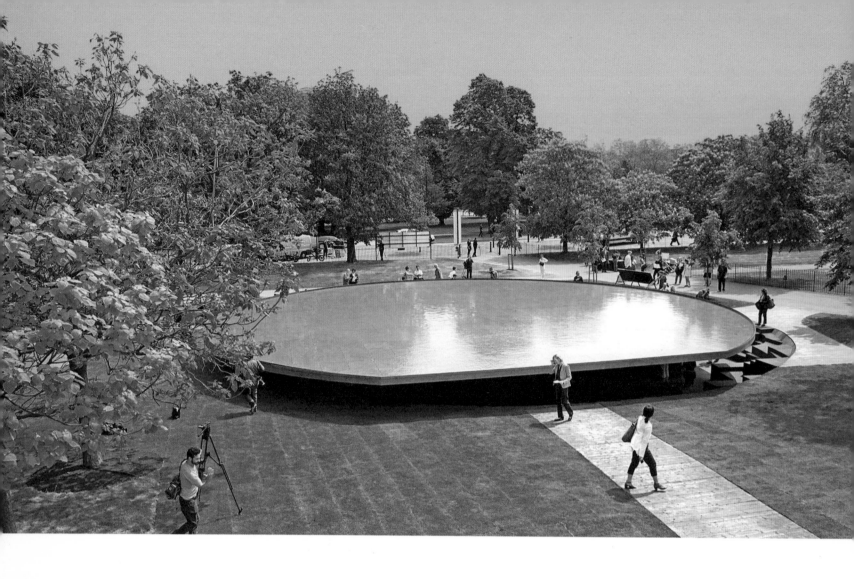

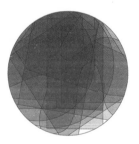

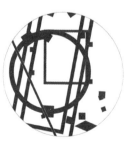

1
Footprints as topography

2
Traces of previous Pavilions

3
Excavated foundations

4
Topography and foundations

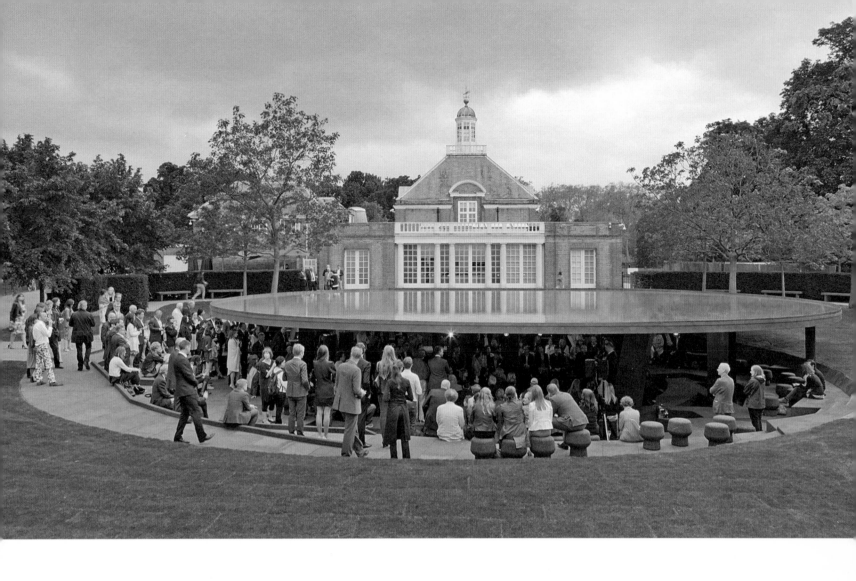

5
Cuts for circulation

6
Extrusion of fragments

7
Twelve specific columns

8
Landscape

RJUKAN TOWN CABIN

A new pavilion in town and a modern meeting
point for all ages. 24 hours a day.

Architects | Rallar Arkitekter
Project address | Torget 2, Rjukan, Norway
Client | Tinn Kommune
Gross floor area | 60 m²
Existed | June 2013–May 2015

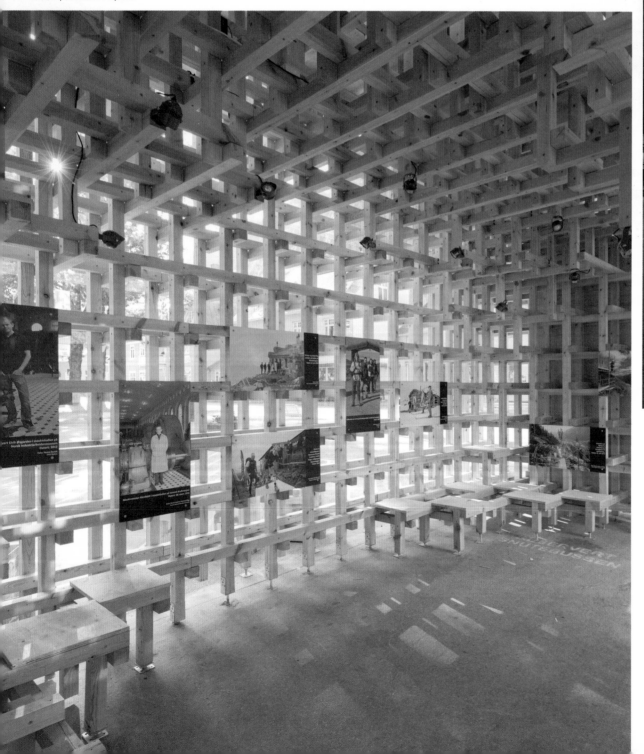

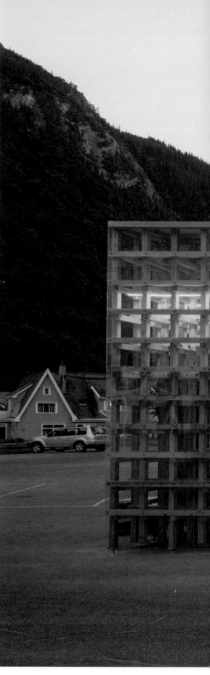

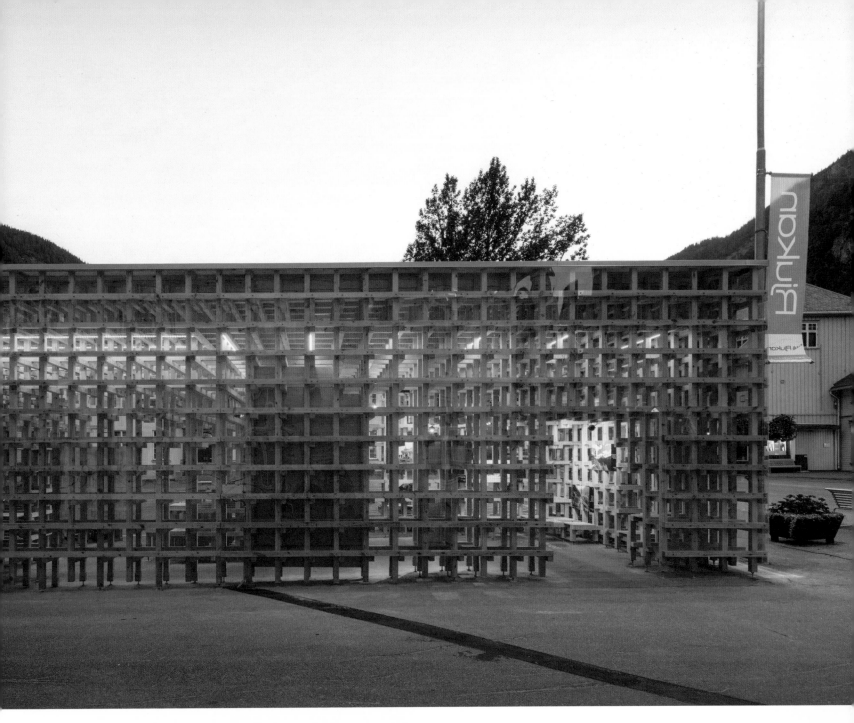

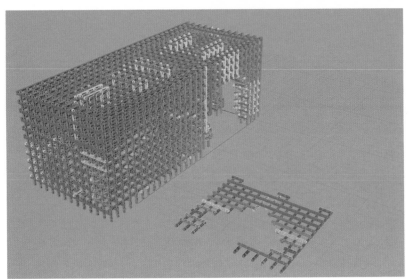

The Rjukan Town Cabin was built by 22 architect students from NTNU, and managed by the student group Rallar Arkitekter. The project is a pavilion, intended to provide the popuation of Rjukan with a new and unusual place for social gatherings. The pavilion is open for everyone, around the clock and contains an exhibition with pictures from Rjukan from both the past and present. The pavilion was built in just two weeks, but the preparations lasted for ten months. The pavilion is built of pine wood, screwed together in a three dimensional grid. The façade is covered with clear plexiglass, which offers protection from the wind. The timber construction forms an open room facing the square, and a more closed room where the exhibition is located. The whole pavilion is illuminated with LED-lights, which change color and create different ambiances in the building.

75

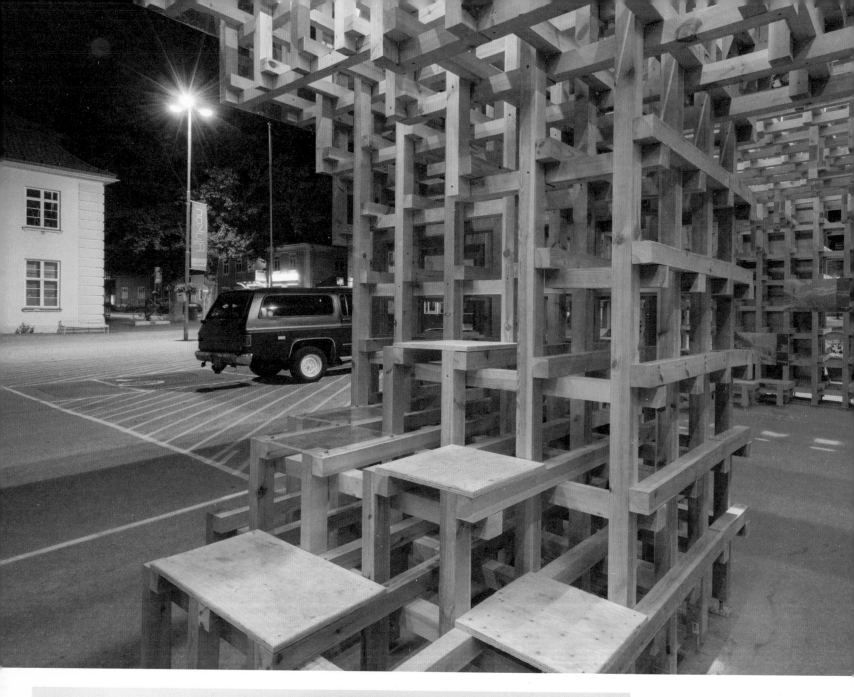

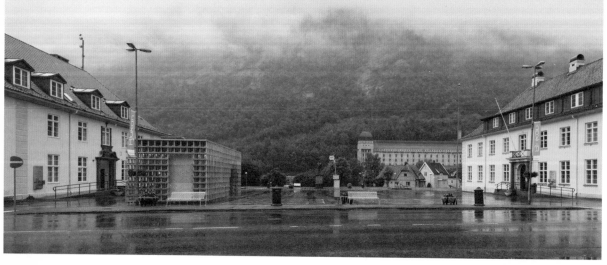

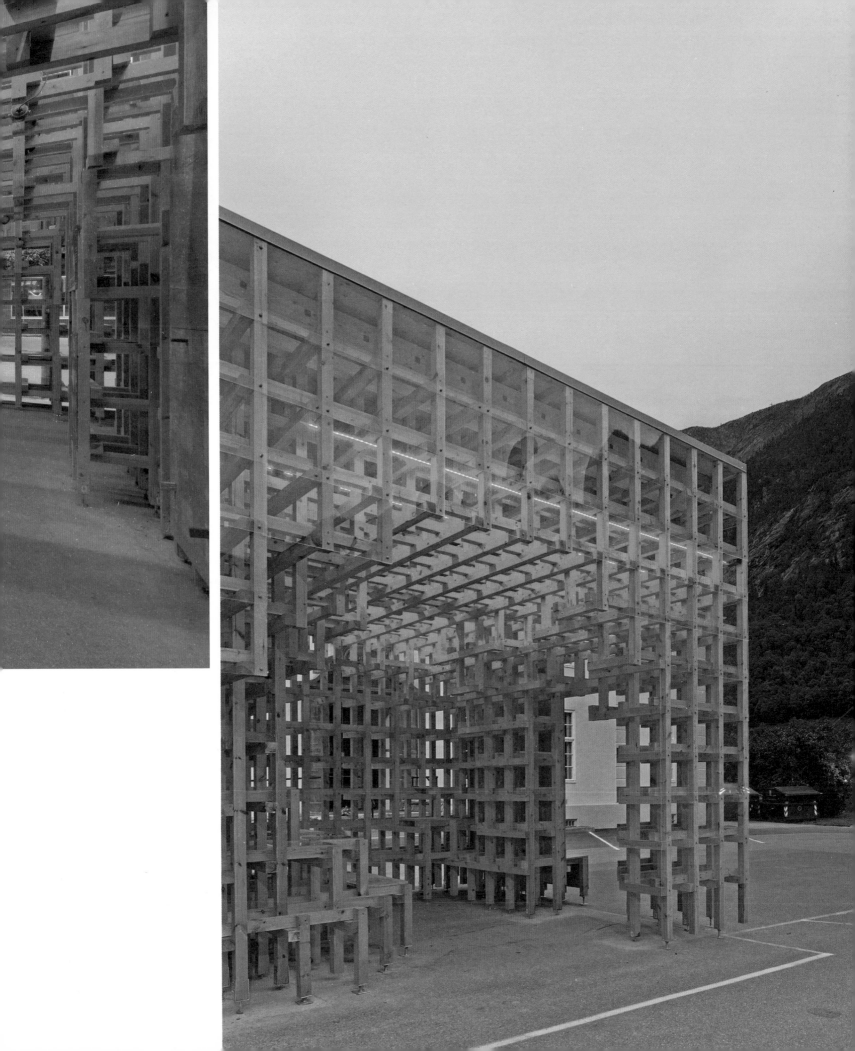

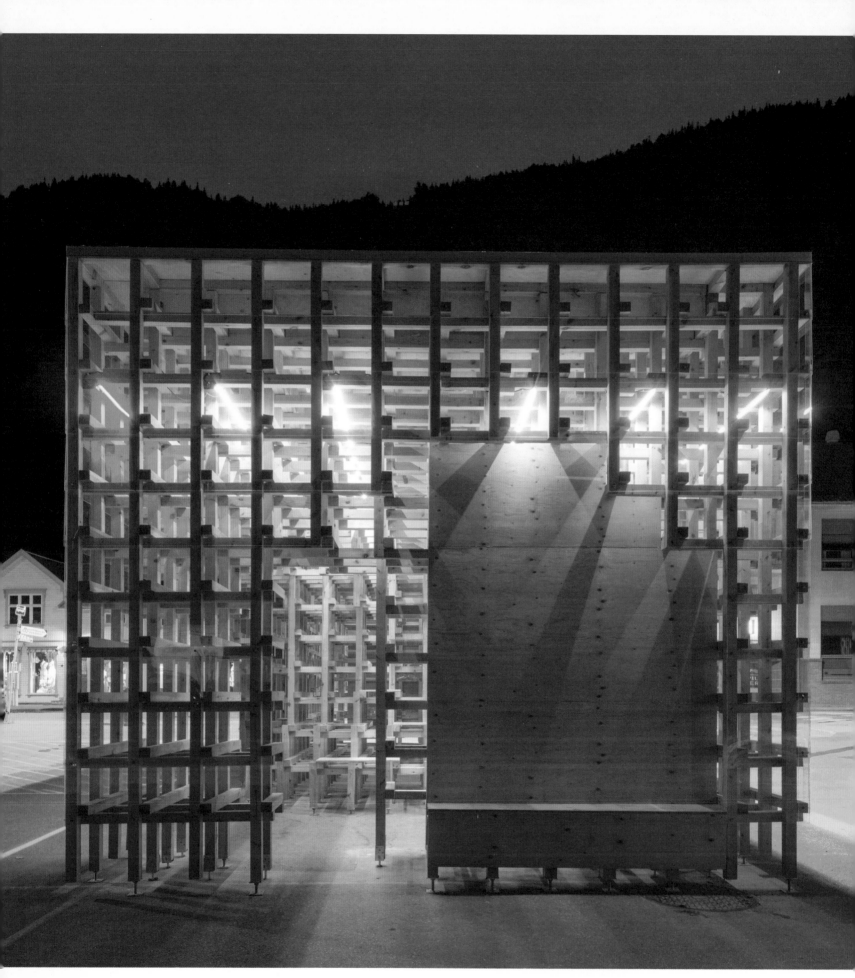

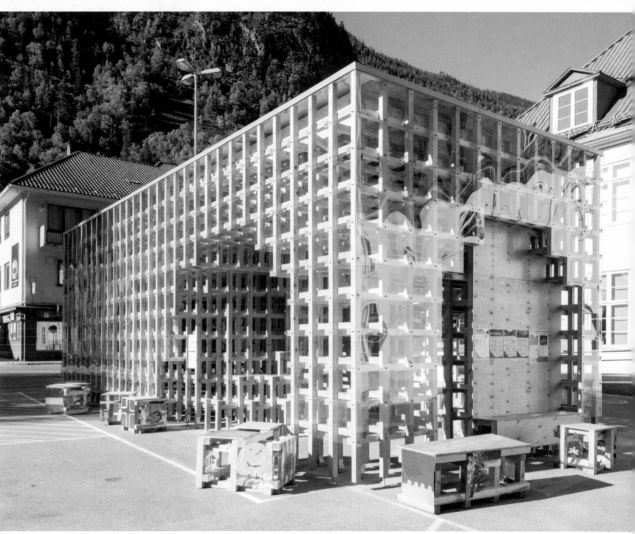

400mm

400mm

400mm

TEMPORARY BAR

Beer today, gone tomorrow. Savor the moment and celebrate life in the iconic cube of light.

Architects | LIKEarchitects
Project address | City Park, Oporto, Portugal
Gross floor area | 9 m²
Existed | 3–10 May 2008

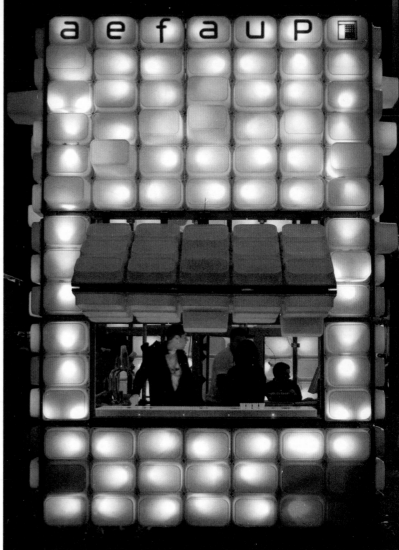

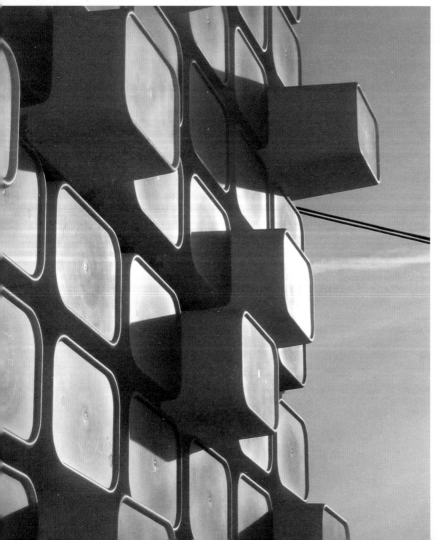

This bar was the result of a competition to represent the University of Porto's School of Architecture. The area, fast construction, and low budget were carefully considered in the design of this temporary structure that had to be built in just one week. Based on IKEA's "build it yourself" concept, this project was made out of storage containers of varying depth, which resulted in a modular building system with a highly textured skin. By placing an LED system on the interior of the boxes, the skin adopted a variety of expressions. By day, the structure appeared as an abstracted white volume and by night the LED system lit up the bar giving it an ephemeral feeling. By syncing the DJ's soundtrack with the lighting system a dynamic pulsating light box was instigated.

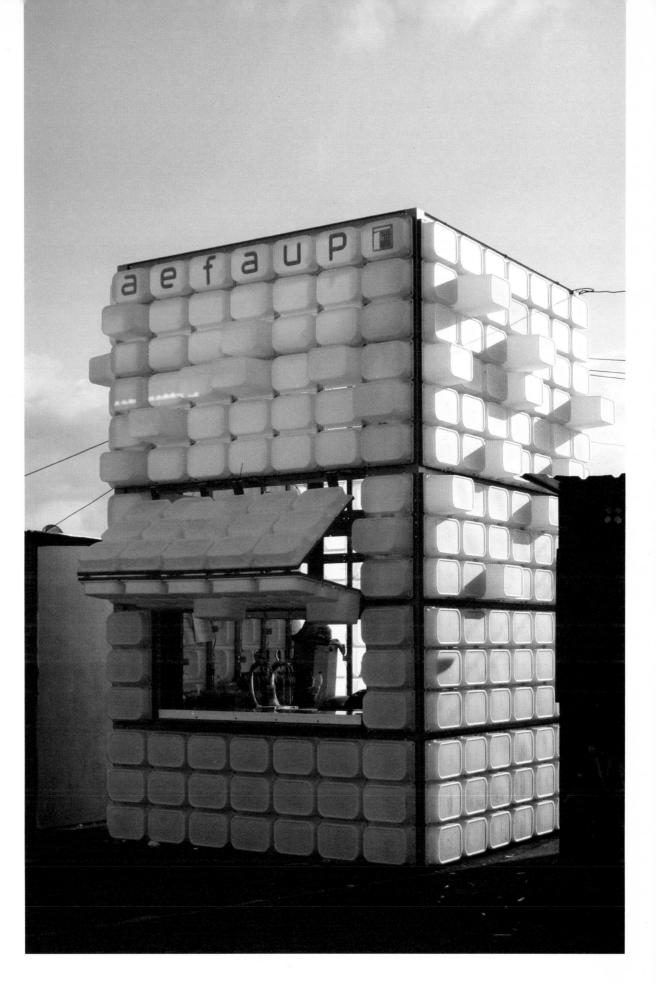

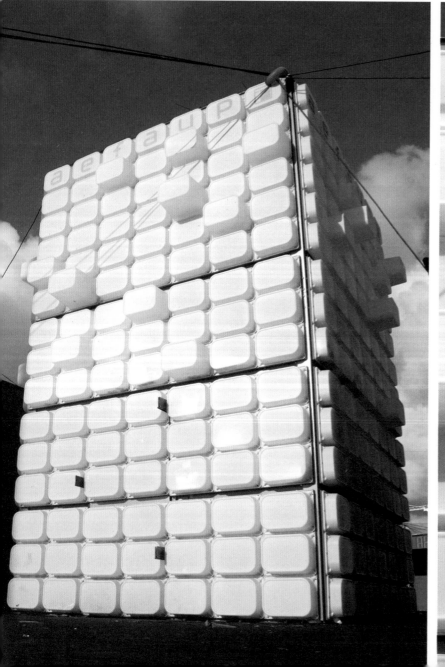

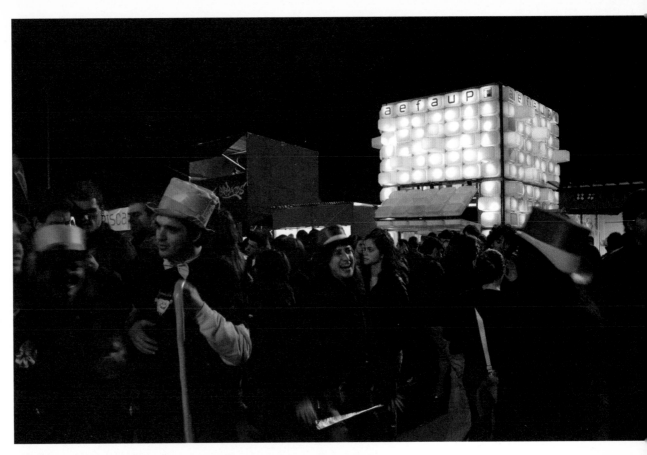

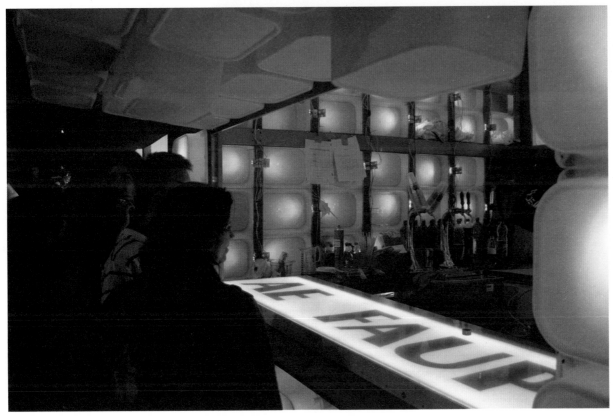

EMBEDDED PROJECT

The world is flat. At least, it is here, and just a step
can carry you across an entire continent.

Architects | HHDFUN
Project address | Shanghai, China
Client | Shanghai Electronic Art Festival
Gross floor area | 100 m²
Existed | 2–7 October 2010

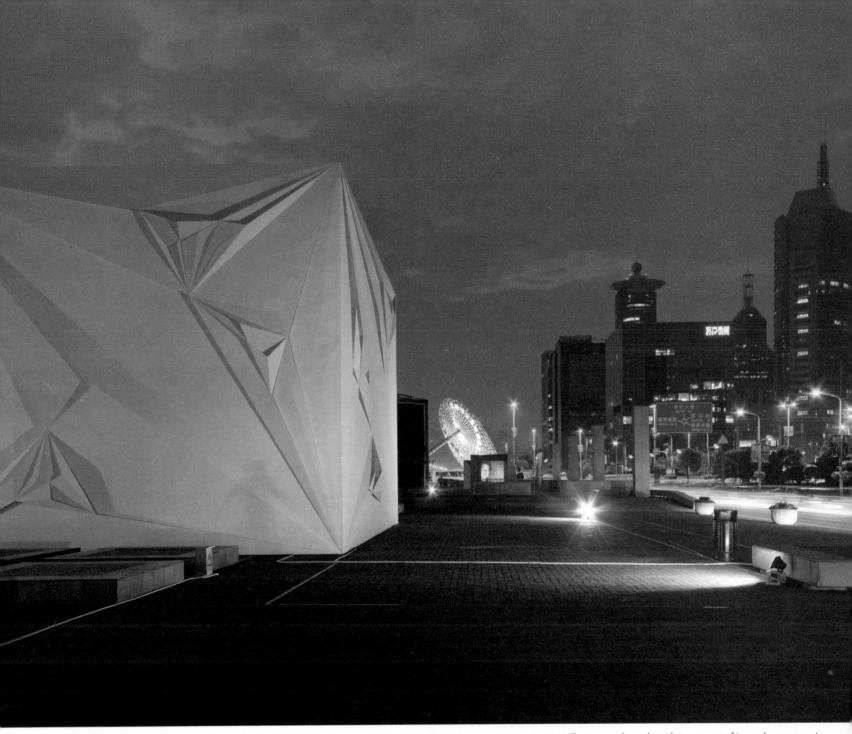

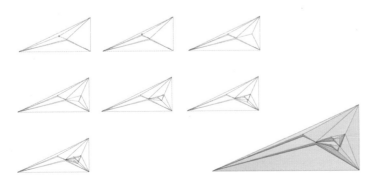

This temporary, interactive installation was based on the concept of 'complex systems' which can observe, perceive and research our living world, society and biology. Virtual architecture was embedded into various cities and regions within Google Earth and projected onto the floor, within the internal space of the installation. Motion sensors tracked the movement of the audience within the internal space, and the projectors responded according to these inputs. By using this interactive technology, members of the audience could trigger and control the projected scene by changing the displacement of their own body or altering the distance between each other within the projective regions. The audience was provided with unusual perspectives to view the globe, our city, and open fields, as well as the algorithmic architectures embedded into the Google Earth projection.

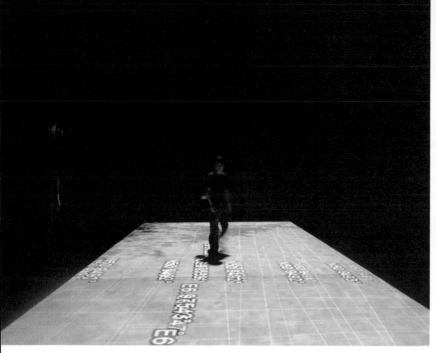
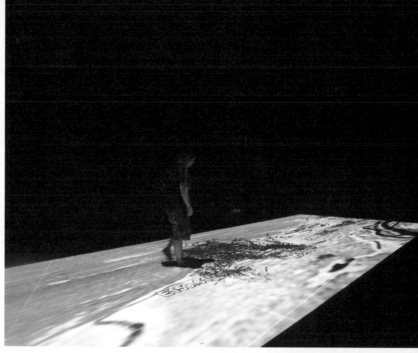
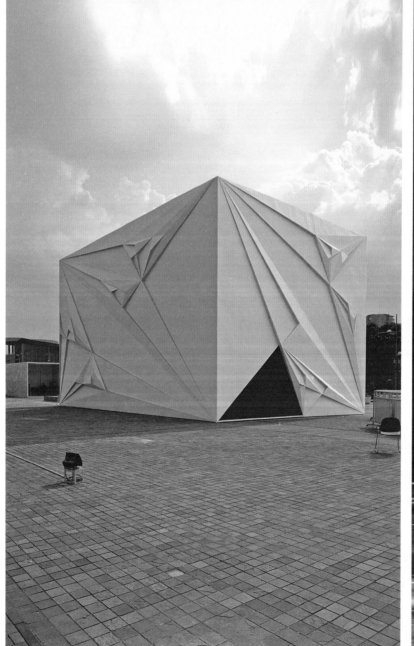

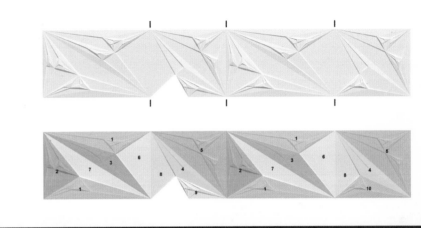

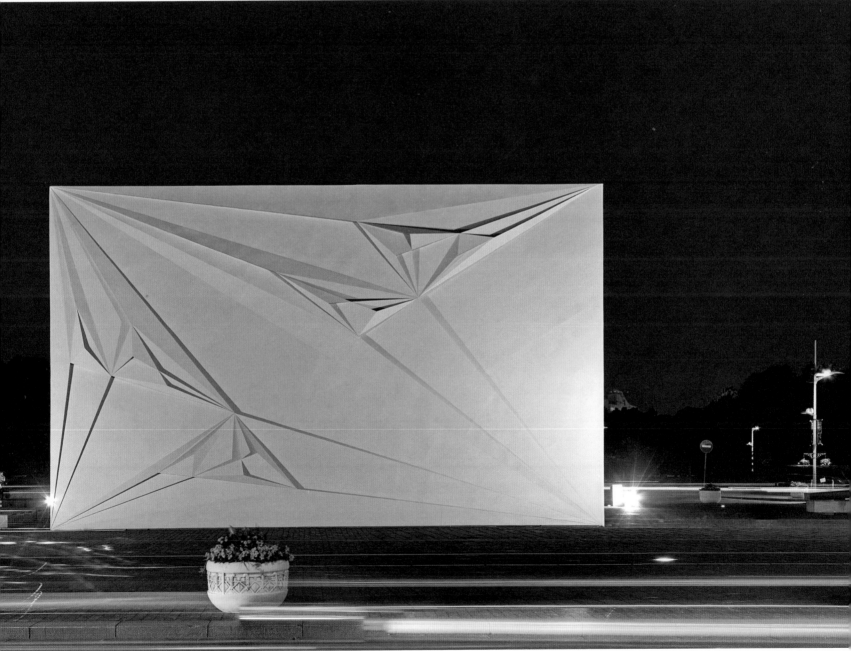

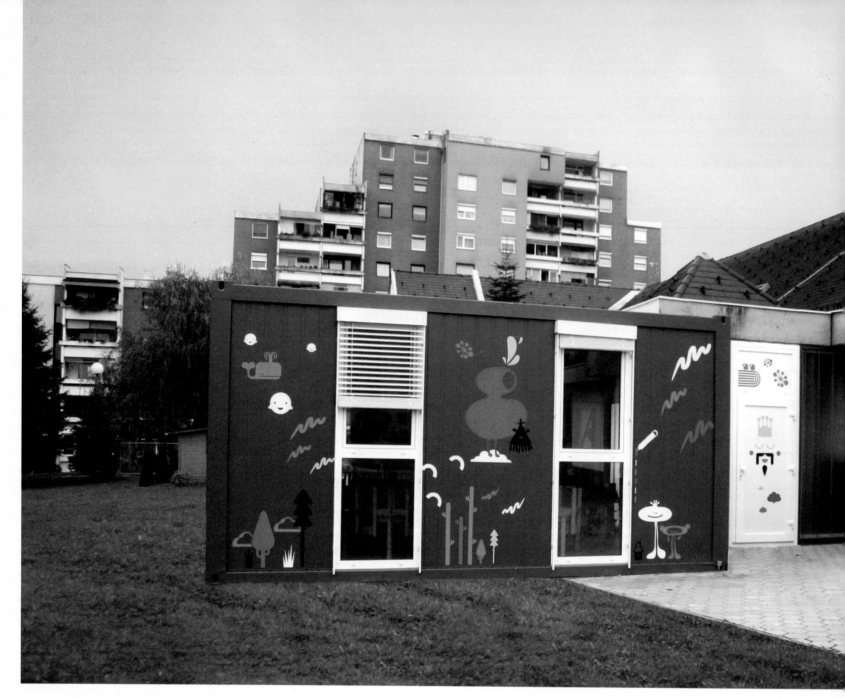

Ajda was a temporary annex to the existing kindergarten in the city of Ravne na Koroskem in Slovenia. The new unit, made from three containers, appeared to almost grow out of the old building at the entrance and, like a true parasite construction, it exploited the entire infrastructure of the existing kindergarten. In keeping with the tradition of small façade graphics typical of kindergarten buildings, sticker artists Kitsch-Nitsch were asked to disguise the container façade with colorful vinyl stickers that children could associate with. After one year Ajda was not needed anymore and its containers were recycled, but it remains as an example of how a temporary status and slim budgets can still produce a child-friendly design.

TEMPORARY KINDERGARTEN AJDA

From a symbol of the money-making world of globalization to a lively place. This is upcycling at it's best.

Architects | Arhitektura Jure Kotnik
Project address | Javornik 50, Ravne na Koroskem, Slovenia
Client | Občina Ravne na Koroškem
Gross floor area | 42 m²
Existed | 2009–2010

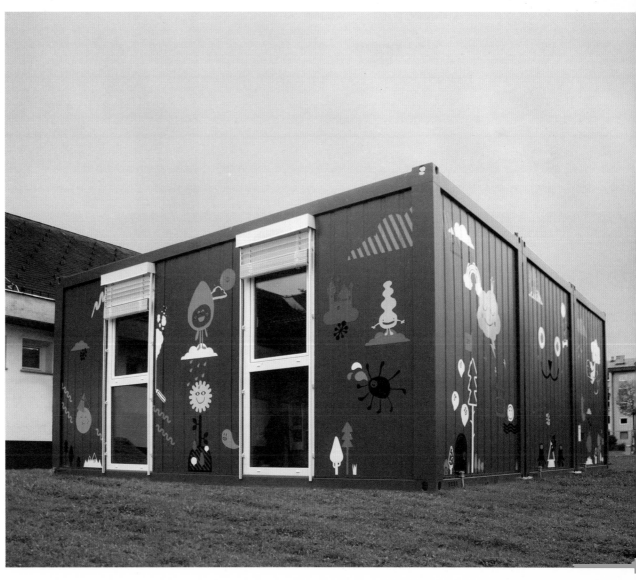

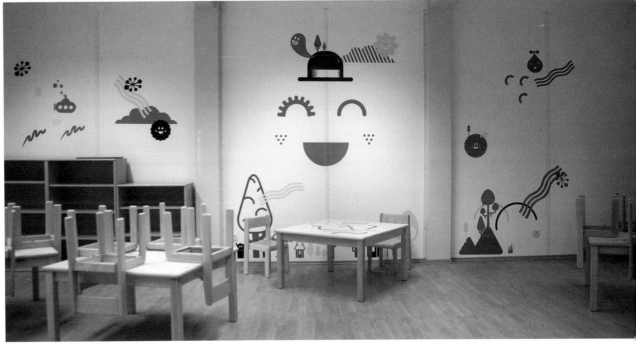

91

THE SCHAULAGER SATELLIT

Landed in the orbit of the art world. There could be
no better representative of the original Schaulager.

The Schaulager Satellite was an abstraction of the original Schaulager forecourt.
The recognizable form was duplicated to address the multiple pedestrian entries
located on either side of the Messeplatz in Basel. The specific location of the tem-
porary pavilion responded to the challenges posed by an active construction site
adjacent to the plaza. Its location was an attempt to improve the quality of a pub-
lic space compromised by heavy traffic and limited accessibility. The Schaulager
Satellite was located on a public stage constructed to cover an existing fountain.
The platform provided a venue for the Schaulager bookstore, Welcome House
and two commissioned art pieces. Large openings both above and below pro-
vided natural light, air circulation and a connection to the public space below.

Architects | Herzog & de Meuron
Project address | Messeplatz Basel/Art Basel, Basel, Switzerland
Client | Laurenz Foundation, Basel, Switzerland
Gross floor area | 386 m²
Existed | 4–17 June 2012

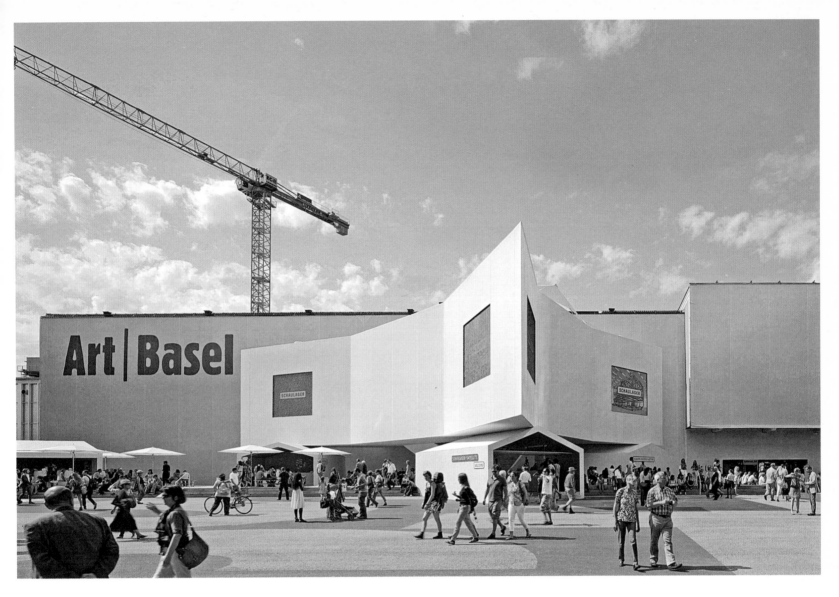

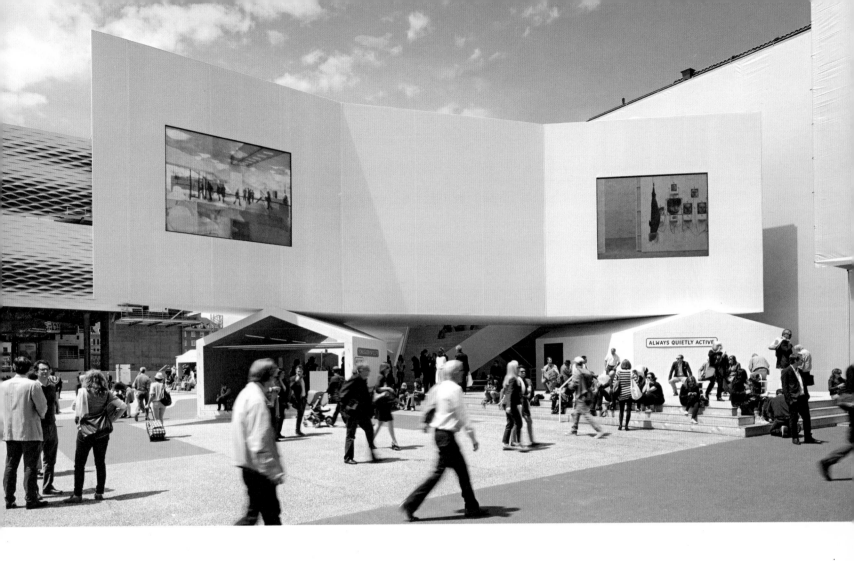

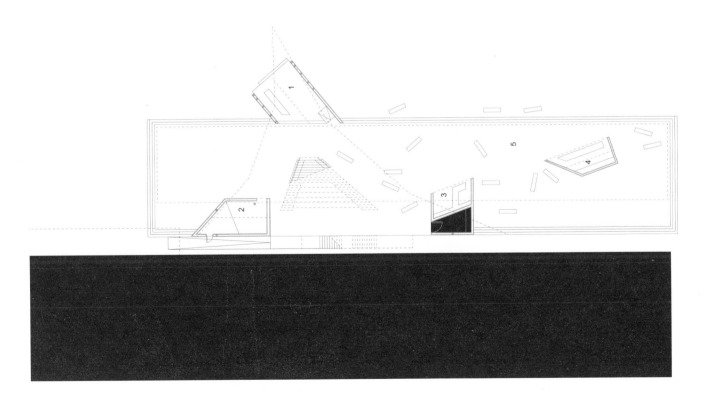

METAMORPHIC

TEMP

MANIFOLD

TEMP

M

MUTAB

MULTIFU

CLOUD PAVILION

"... what are the boundaries between nature and artificial things" asked Mr Fujimoto. Let's find it out.

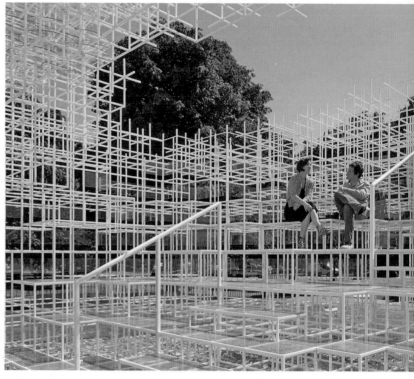

Architects | Sou Fujimoto Architects
Project address | Kensington Gardens, London, United Kingdom
Client | Serpentine Galleries
Gross floor area | 350 m²
Existed | 1 June–20 October 2013

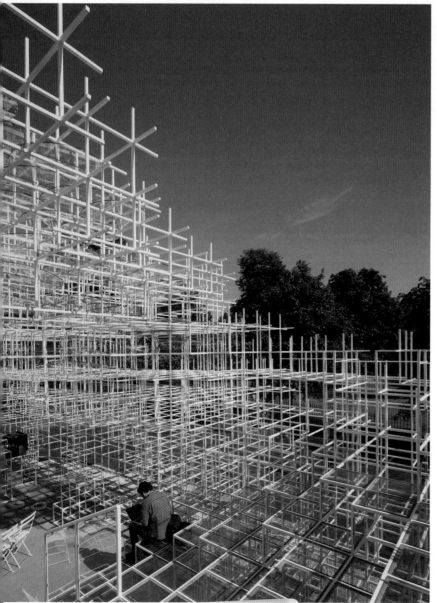

At 41, Fujimoto was the youngest architect to accept the invitation to create a temporary structure for the Serpentine Gallery. The Cloud Pavilion was constructed from white steel poles in an intricate latticework pattern that seemed to rise up out of the ground like a shimmering matrix. Occupying some 350 square-meters of lawn in front of the Serpentine Gallery, Sou Fujimoto's delicate structure had a lightweight and semi-transparent appearance that allowed it to blend, cloud-like, into the landscape and against the classical backdrop of the gallery's east wing. Designed as a flexible, multi-purpose social space, visitors were encouraged to enter and interact with the pavilion in different ways throughout its four-month tenure in London's Kensington Gardens. The delicate quality of the structure created a geometric, cloud-like form, as if it were mist rising from the undulations of the park.

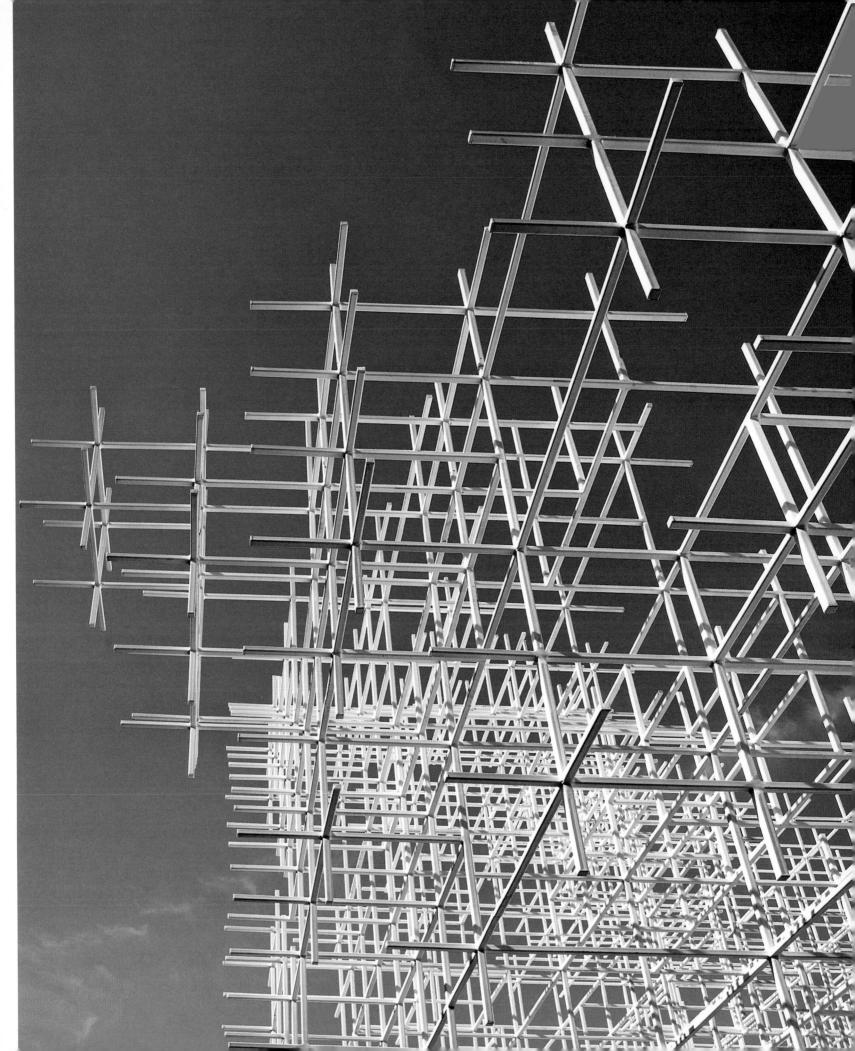

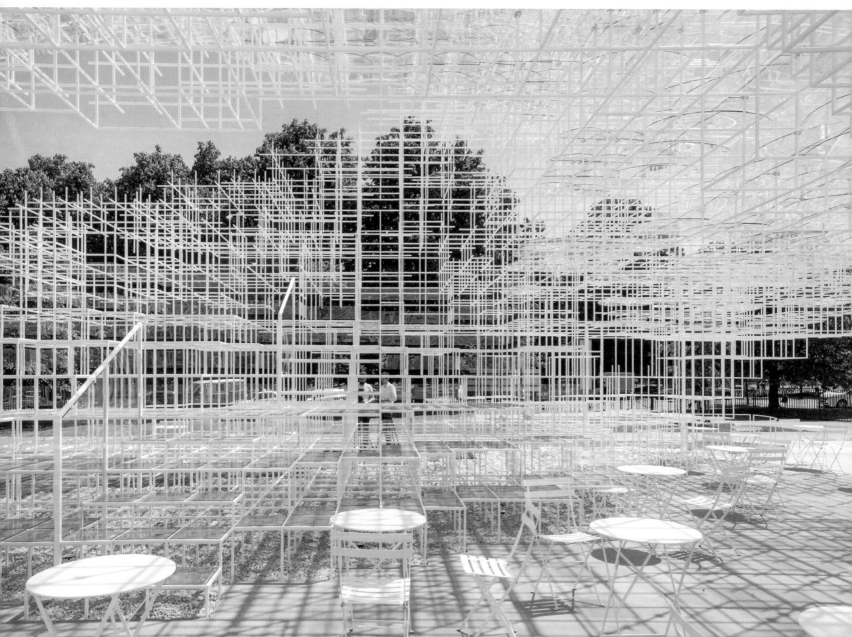

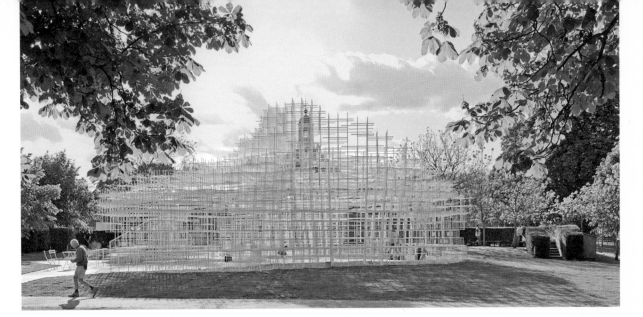

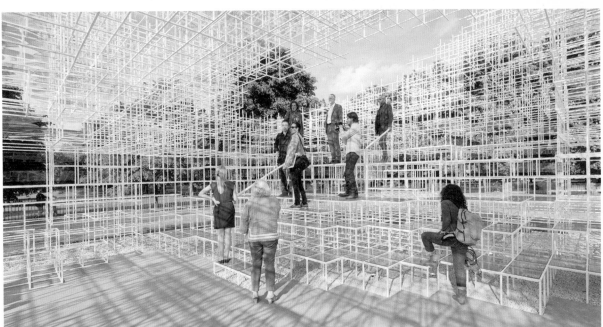

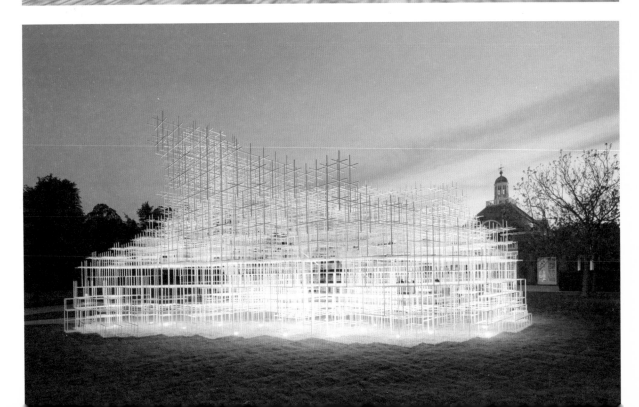

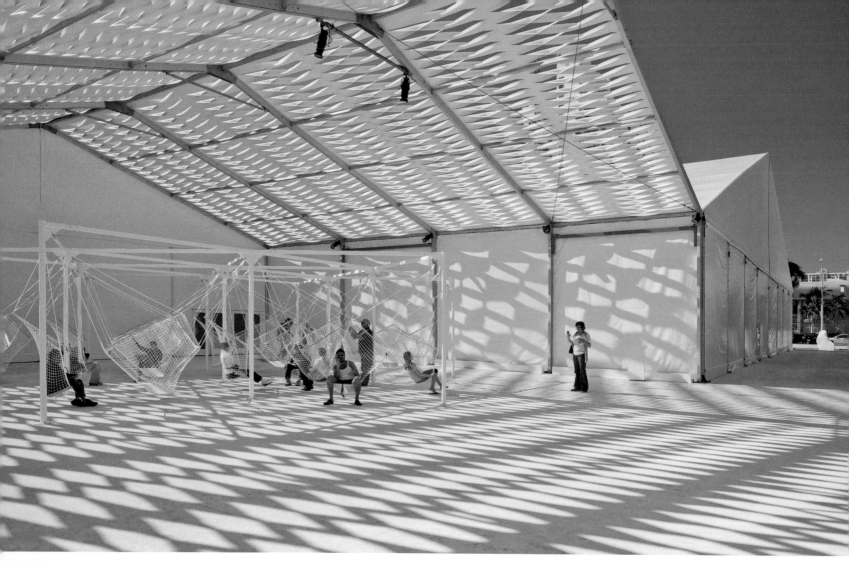

DESIGN MIAMI TENT

An iconic design for a fashionable event.

Design Miami Tent was the temporary home for Design Miami – a week-long design event focused on limited edition furniture exhibitions and a talk series examining issues in contemporary design. Tasked with transforming a pair of large event tents on a modest budget, the design strategy was to dematerialize, or deconstruct, one of the tents to create a communal vestibule for the main entrance. Standard flat vinyl tent panels were manipulated by a simple pattern of hand-cut slits, folded to simultaneously open the panels and create a taut volumetric surface. The pattern was then deployed across the tent in a gradual fade, transitioning from a flat, closed surface to an airy, latticed volume. The end result was an open-air, light-dappled courtyard which served as the entrance to Design Miami. The modest intervention transformed the tent, while allowing for a large majority of the materials to be returned to the event company for re-use.

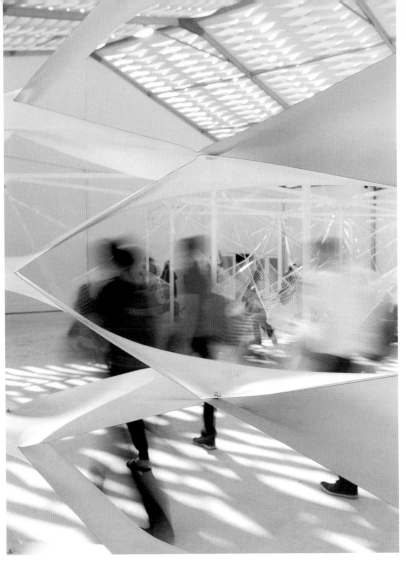

Architects | Moorhead & Moorhead
Seating installation | Konstantin Grcic Industrial Design
Signage | MadeThought
Project address | Miami Beach, FL, USA
Client | Design Miami
Gross floor area | 3,700 m²
Existed | 1–5 December 2010

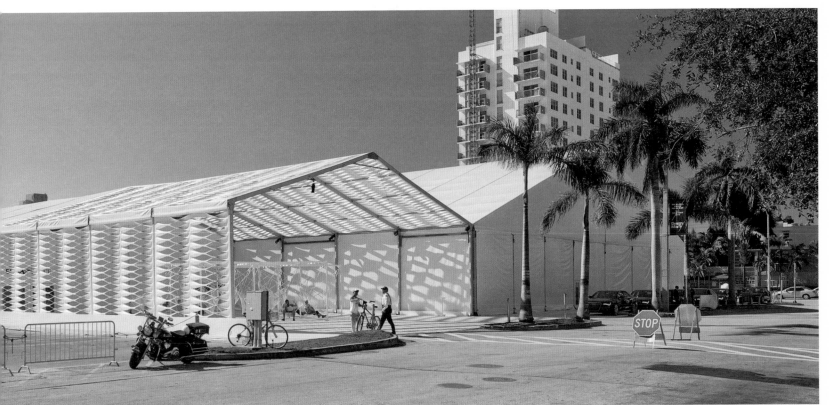

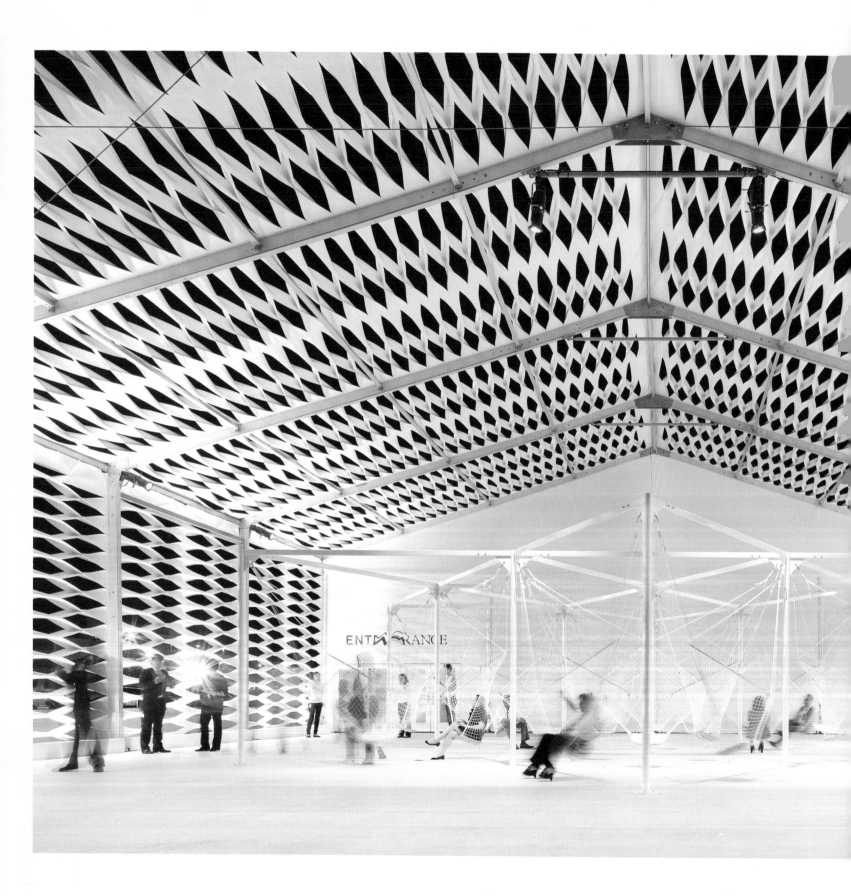

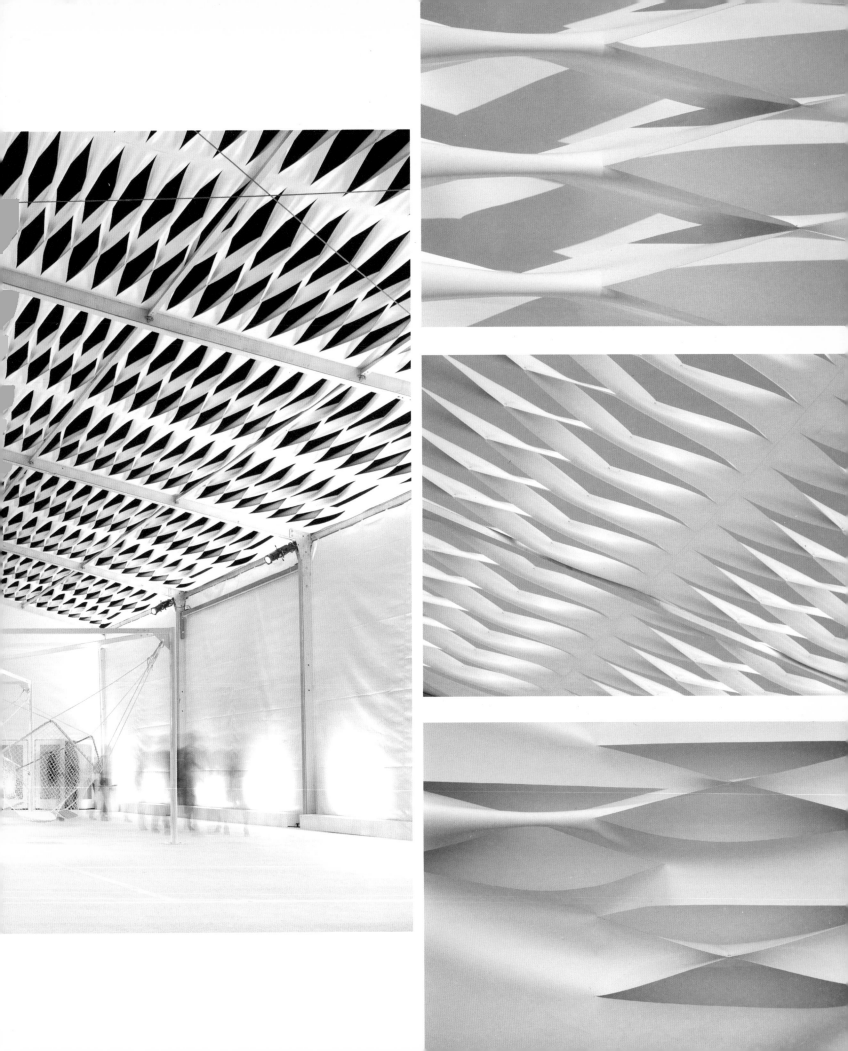

CIRCULATION PAVILION

Introducing the forest to the urban jungle.
The perfect role model for the cradle-to-cradle
concept.

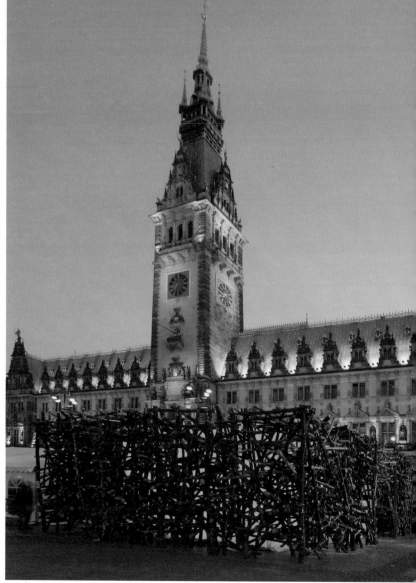

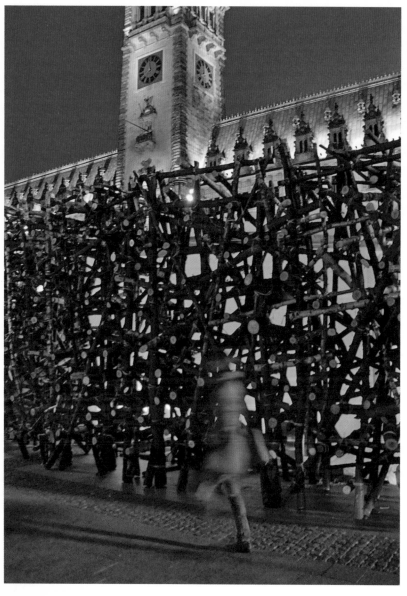

Architects | partnerundpartner architekten
Project address | Rathausplatz, Hamburg, Germany
Client | City of Hamburg
Gross floor area | 160 m²
Existed | 23–30 September 2011

This architectural office specializes in timber constructions and was responsible for constructing the circulation pavilion for Hamburg's third Climate Week. The pavilion grappled with questions about ecological construction, the biosphere and technic sphere. This was clearly demonstrated by the exterior building envelope, which was made entirely of local timber. The branch-like arrangement of the exterior shell was developed by joining the branches together to form a structural framework, which was then cut to size. This renewable building material functions as a supporting construction and gave the pavilion its unique character. At the end of Climate Week, the pavilion was dismantled, the branches were cut into smaller pieces and became part of the natural biosphere cycle.

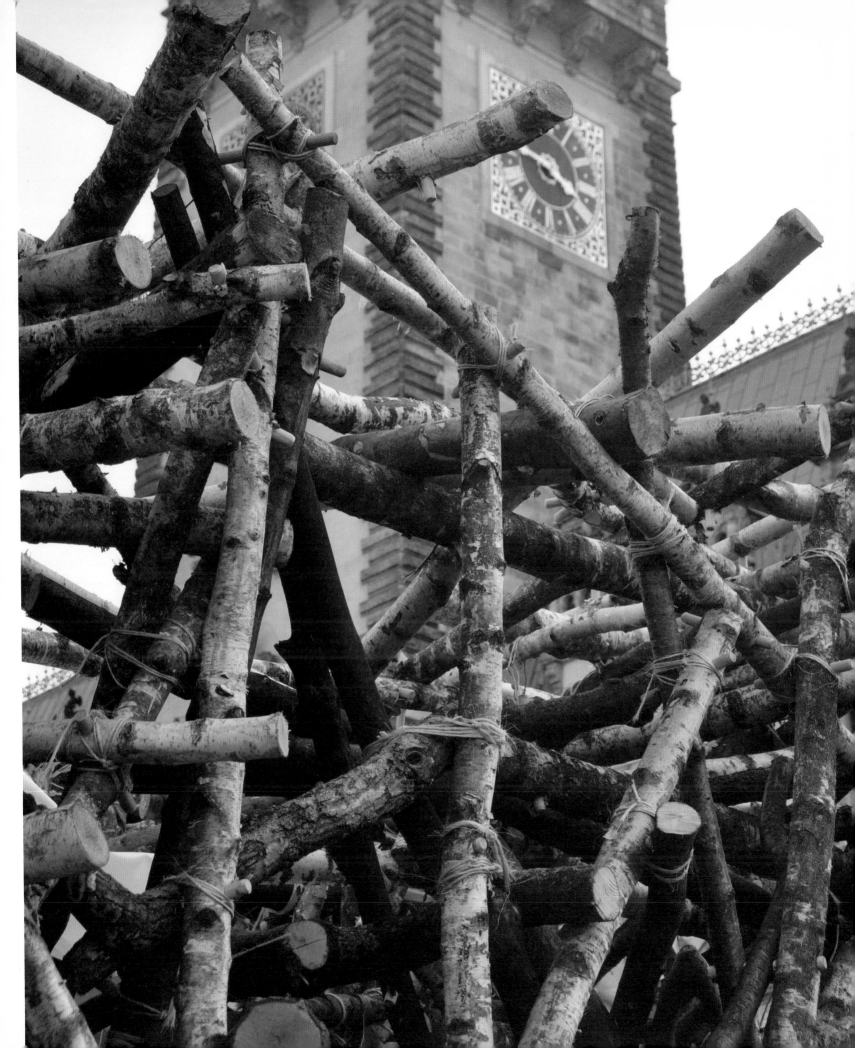

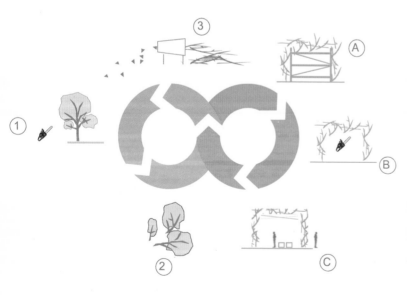
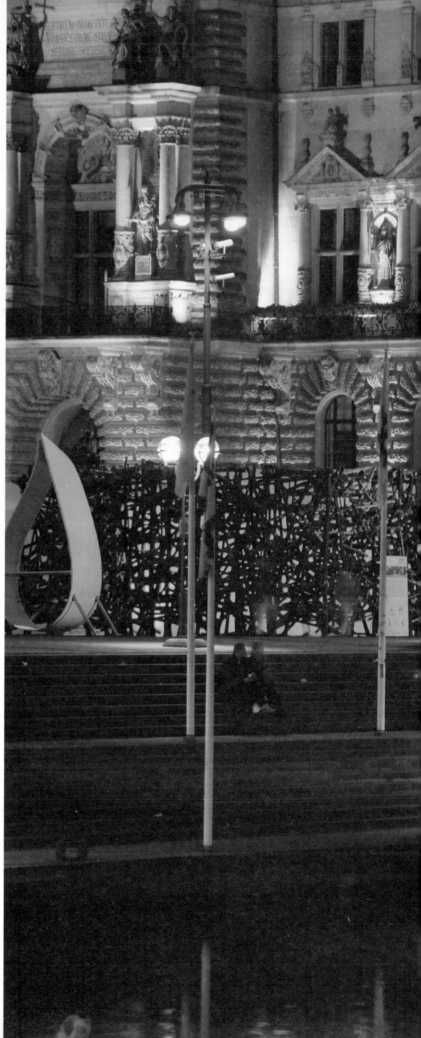

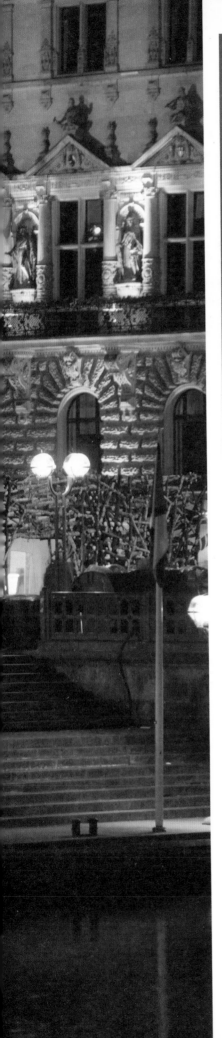

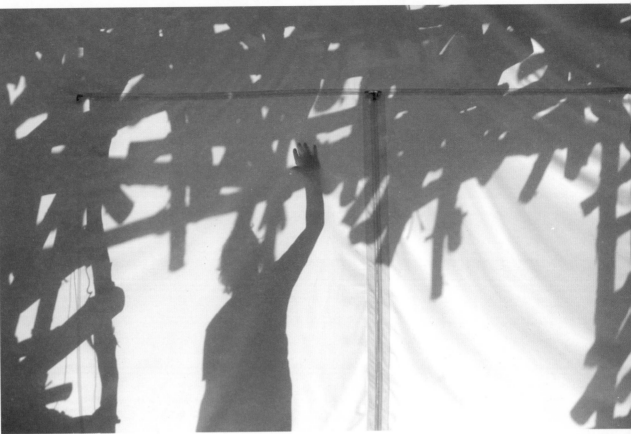

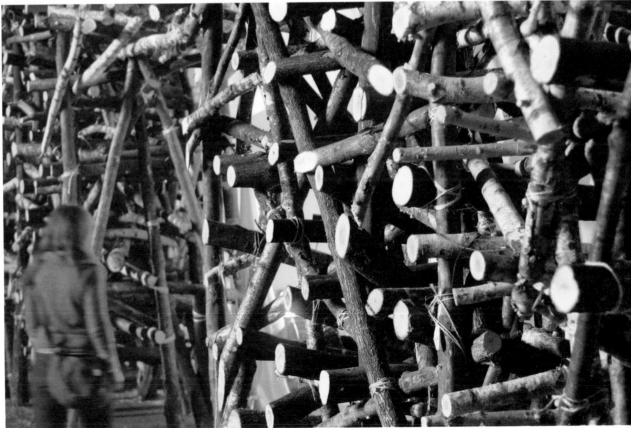

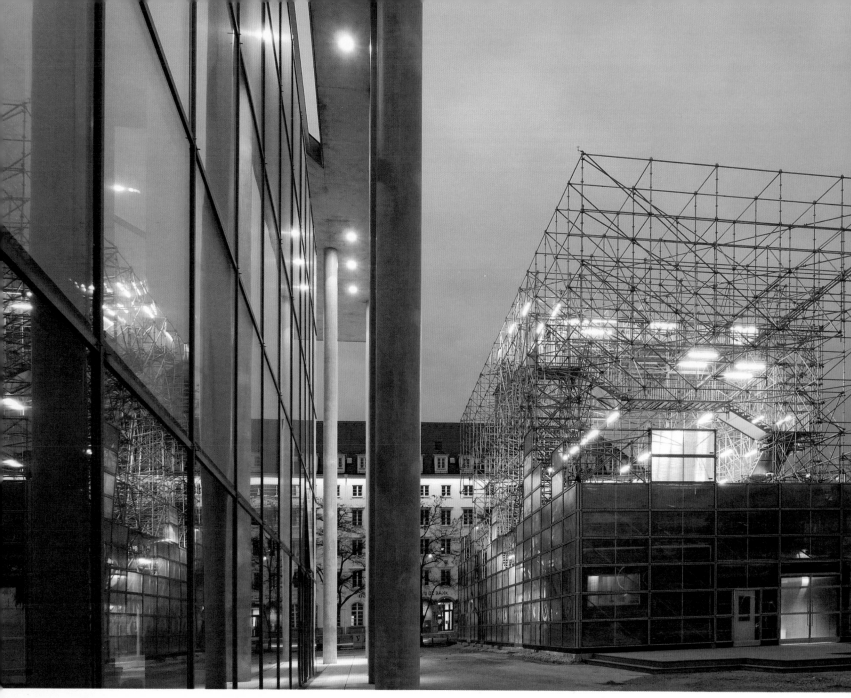

Architects | J. Mayer H.
Project address | Gabelsberger Straße, Türkenstraße, Munich, Germany
Client | The Free State of Bavaria, Department of Science, Research and Art,
Stiftung Pinakothek der Moderne
Gross floor area | 837 m²
Existed | February 2013–September 2013

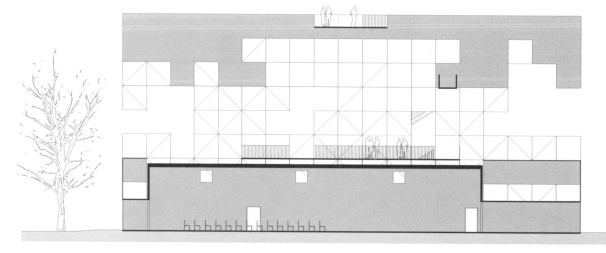

SCHAUSTELLE

A modern yet dynamic temporary solution offering flexible and innovative space for exhibitions and events

This temporary exhibition hall was built for the Pinakothek der Moderne – a modern art museum in Munich. The Schaustelle was built as a short-term solution for housing the Pinakothek's four collections during renovation works on the building, as well as offering space for exhibitions, workshops, lectures, performances, film, video and more. The first floor of the Schaustelle housed a large, flexible exhibition hall. The open scaffolding was used as a projection screen and so functioned as an additional exhibition space. The main structure was a high grid-like construction and most of the building elements used were either recycled or reused after the Schaustelle was dismantled.

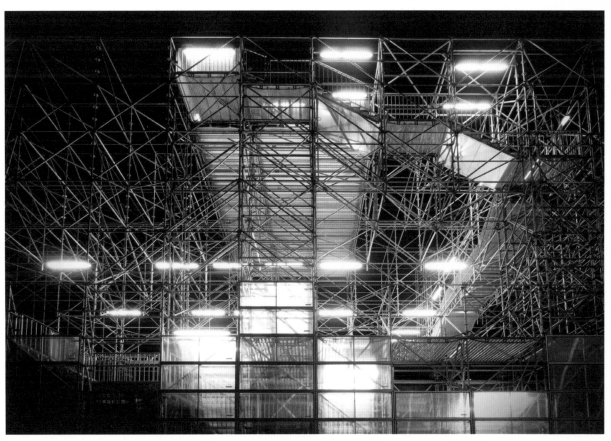

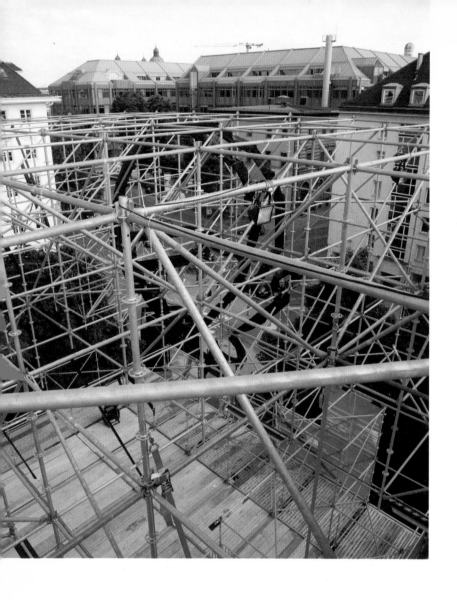

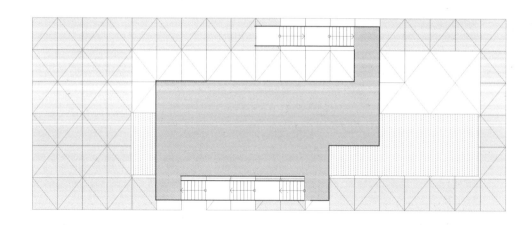

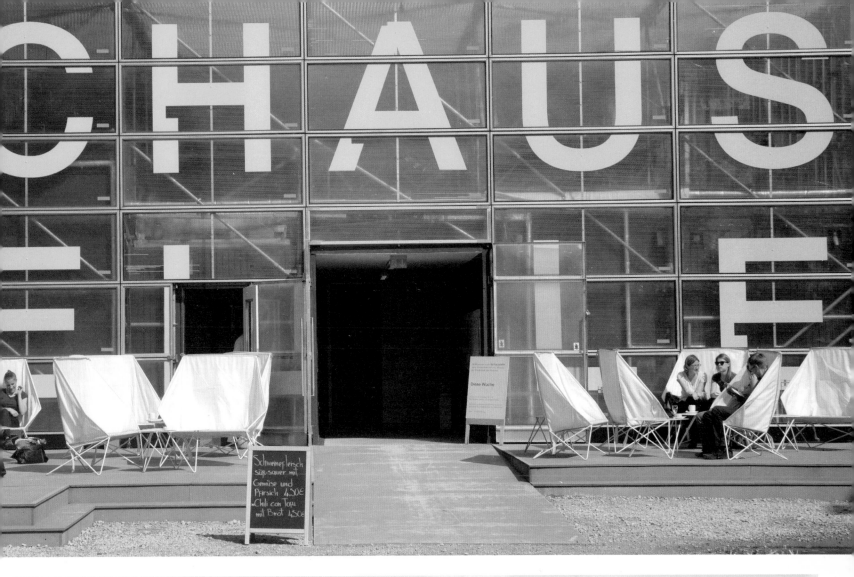

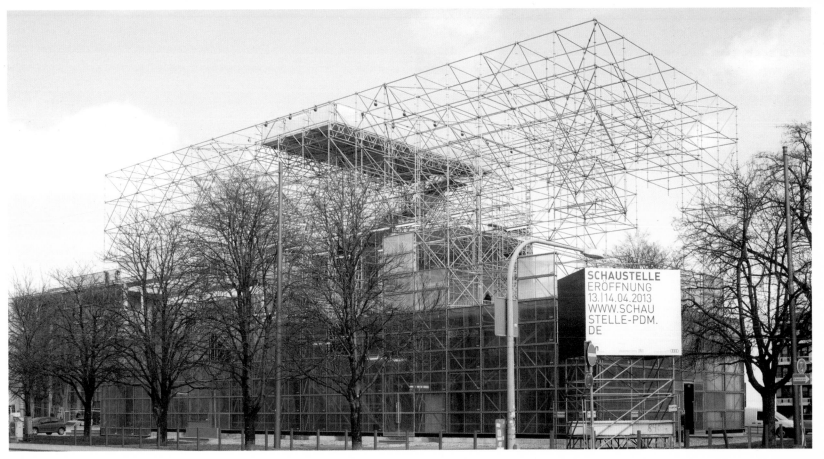

SCHAUSTELLE
ERÖFFNUNG
13.|14.04.2013
WWW.SCHAU
STELLE-PDM.
DE

SHELL.TER

Shady! How to take an everyday object and transform it into something new and unexpected.

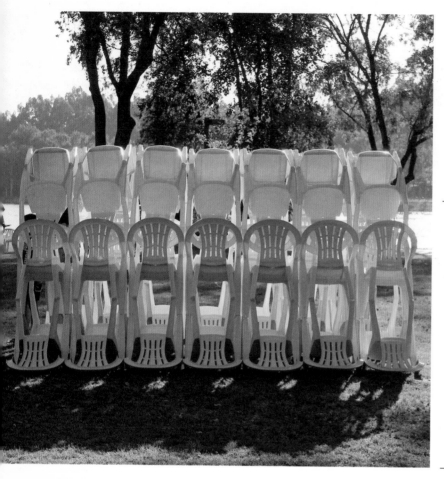

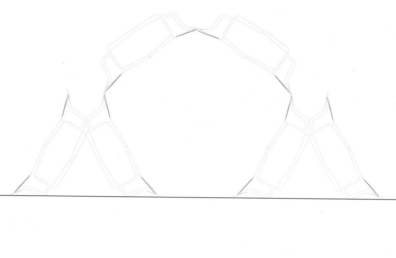

Architects | LIKEarchitects
Project address | Castelinho Park, Vila Nova de Cerveira, Portugal
Client | Canal 180
Gross floor area | 25 m²
Existed | July 2011–ongoing

The Shell.ter pavilion, a temporary installation for the Cerveira Creative Camp, was built from monoblock chairs in the gardens of a natural park in the north of Portugal during a short summer workshop led by LIKEarchitects. While this pavilion resembles the most advanced form of parametric design, the form is actually created by the relationship of the arches formed by ordinary chairs, which, rather than serving as seats, act as a shading device and backrest and create new frameworks that enhance the surrounding nature. The association of mirrored chairs and their rotation in the horizontal plane, obscures the reading of the chair as an isolated element and contributes to the creation of an enigmatic white plastic skeleton that arouses curiosity in all visitors. Shell.ter has virtually zero environmental impact, and can also be (re-) assembled every summer.

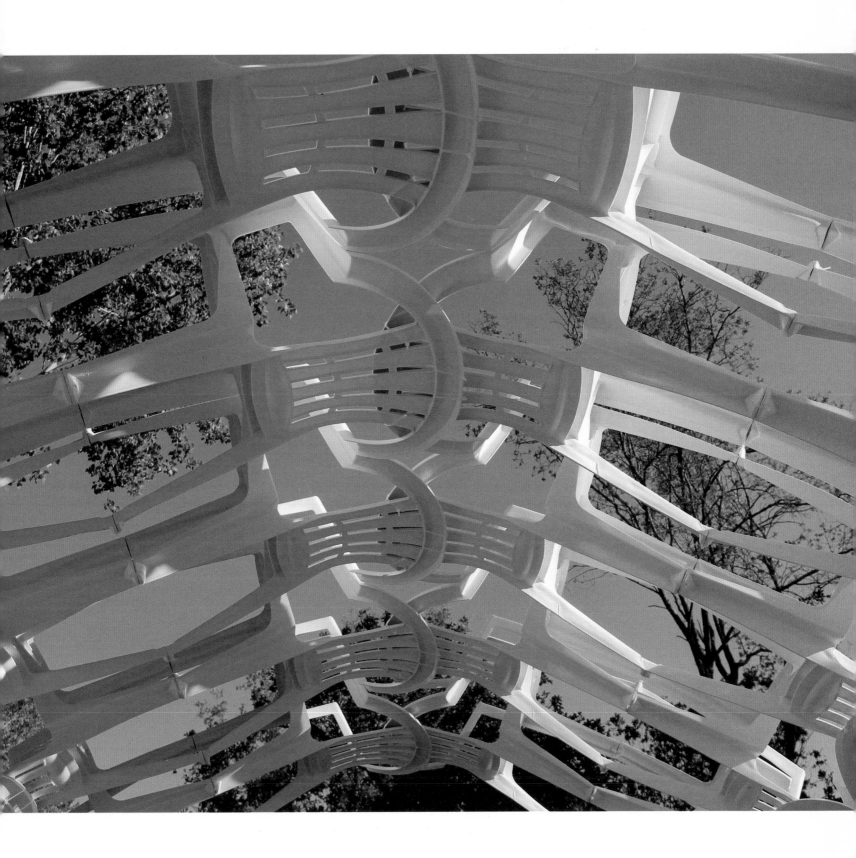

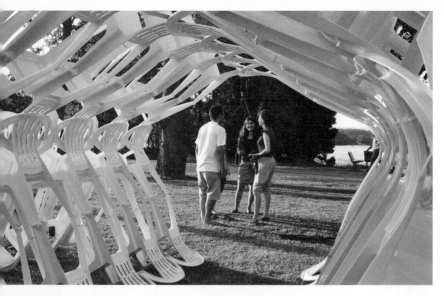

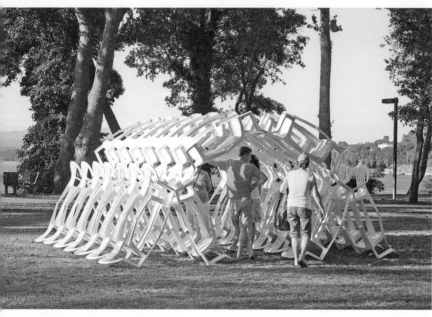

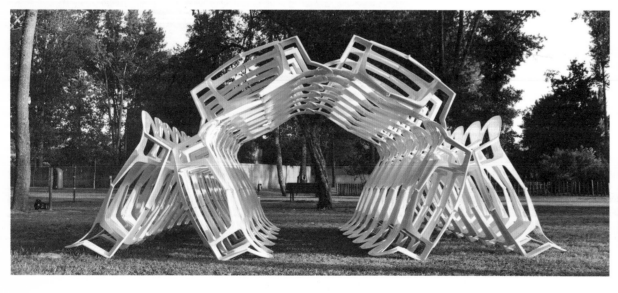

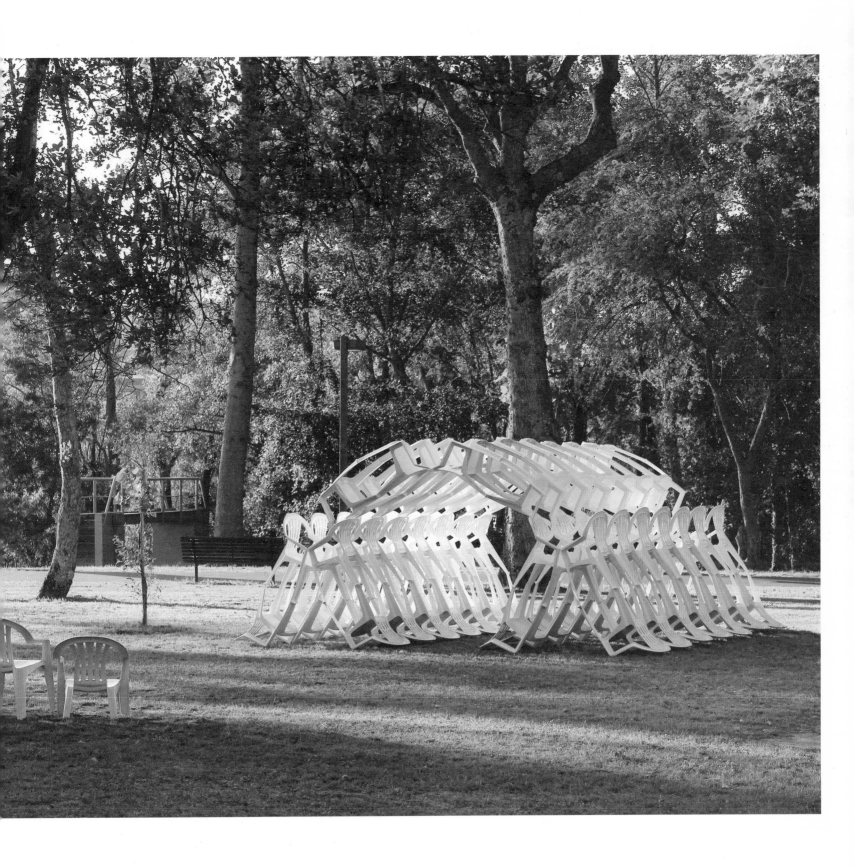

The merging of the two Aarhus city parks was a 'loud' experiment, that showed what can be achieved by letting green spaces take preference. Out of that ambition an inviting park space was created – a park that would not let itself be dominated by practical traffic 'solutions' but instead enhanced urban life in a green space between the cultural and administrative centers of the city. The angular hills functioned as mountain tops in the broad space of the park. With their flat slopes they opened to a number of interaction possibilities, planned or improvised, for relaxation or play. The water elements with their natural attraction gave new and unexpected experiences to the curious – for a moment they make people meet people, in the beating green heart of the city.

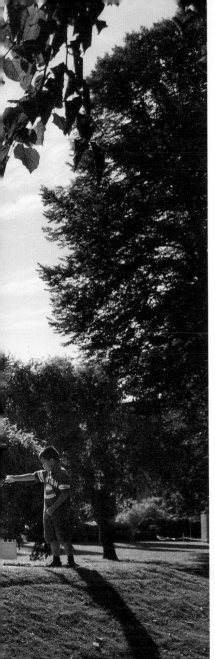

BYPARKEN –
AARHUS FESTIVAL 2012

What harmony! Just look what can be achieved
when green spaces are allowed to take preference
in the modern urban city.

Architects | Schønherr
Project address | Frederiks Allé, Aarhus, Denmark
Client | Aarhus Festival
Gross floor area | 4,600 m²
Existed | 8 August–8 September 2013

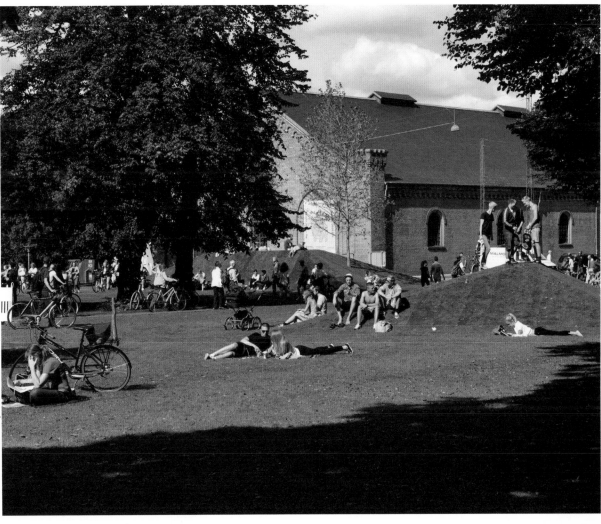

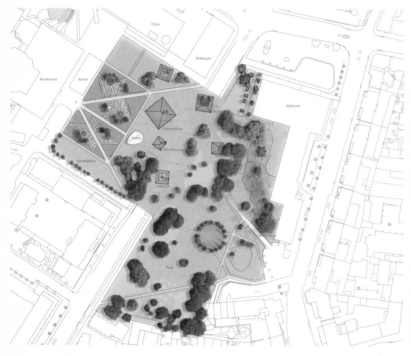

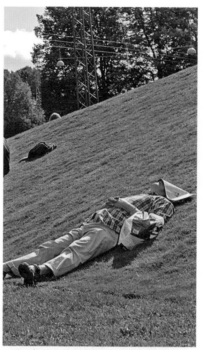

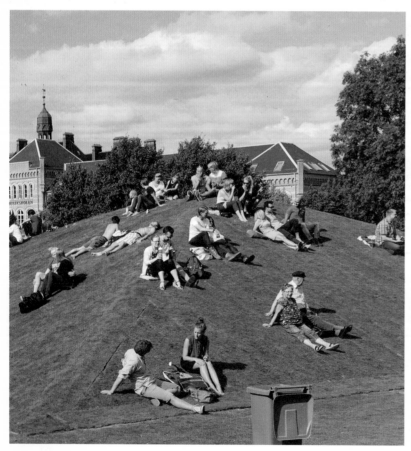

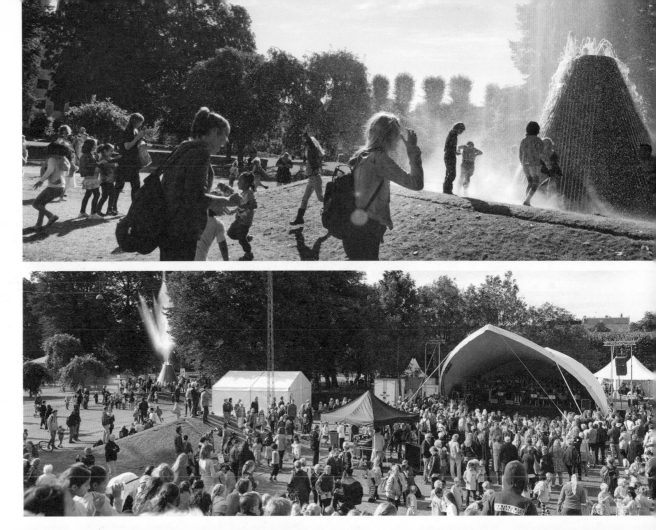

PORTABLE GALLERY

Culture on the go. Take a piece of art, three people
and a few panels and you can have a gallery; wher-
ever you want.

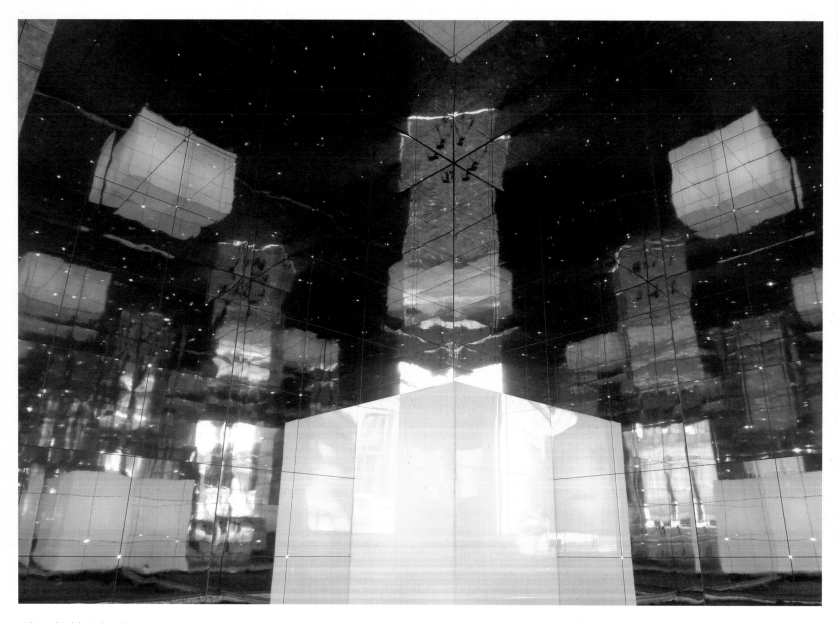

Architects | Mobile Studio Architects
Project address | various – demountable travelling mobile structure
Client | UCL Museums & Collections
Gross floor area | 5 m²
Existed | 2011–2013

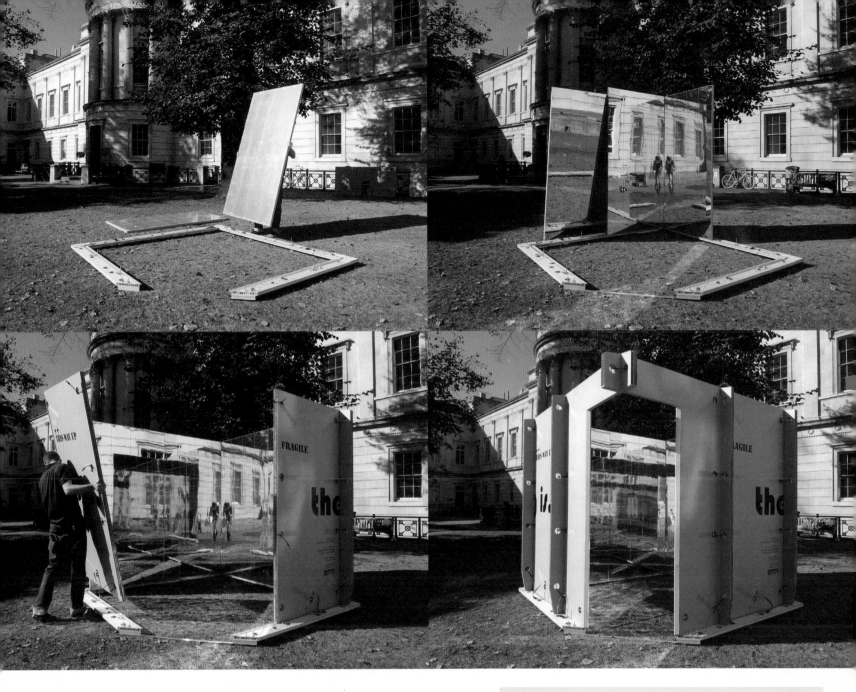

Portable Gallery was a lightweight demountable gallery commissioned by UCL Museums & Collections. It was made of a series of modular components that enabled easy installation in a host of public realm venues. The gallery was designed to display one museum artifact at a time and could accommodate up to three people. The gallery was made of composite lightweight recycled paper honeycomb panels, which were laminated with a tiled mirror finish on the internal surfaces. The interior created an illusion of being much larger than its physical size. The five-sided mirror surfaces also allowed visitors to see the museum object from all angles within the reflection of the gallery walls. The object in turn was multiplied infinitely within the space. Set within the grid of the mirror tiles were LED lights that provided ambient lighting whilst allowing visitors to get 'lost and immersed' in the experience of viewing the museum object.

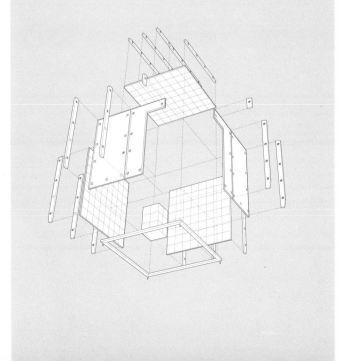

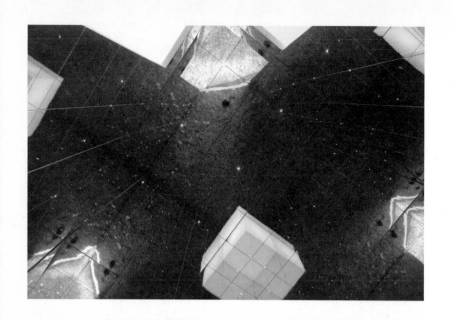

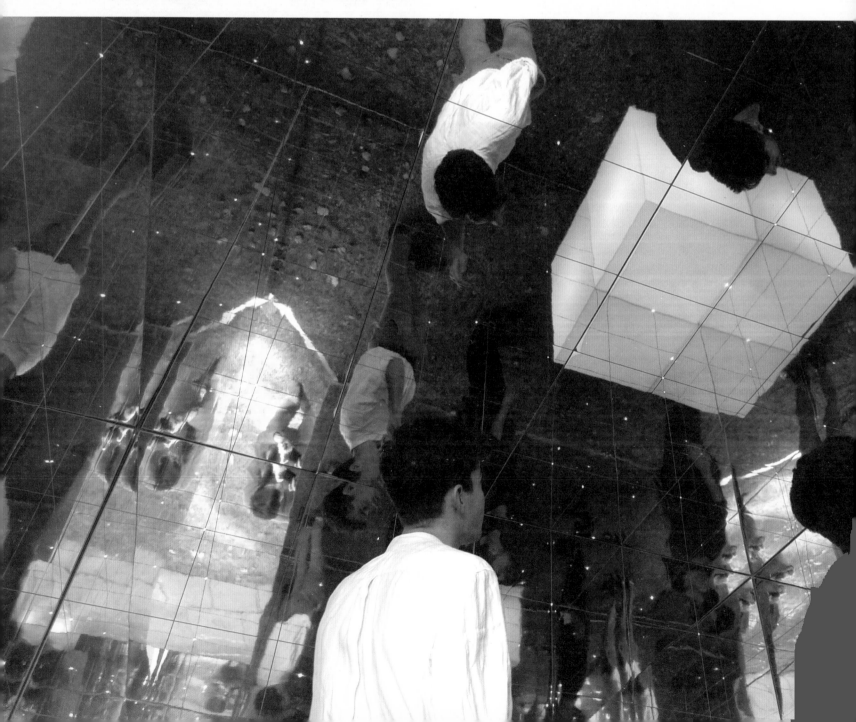

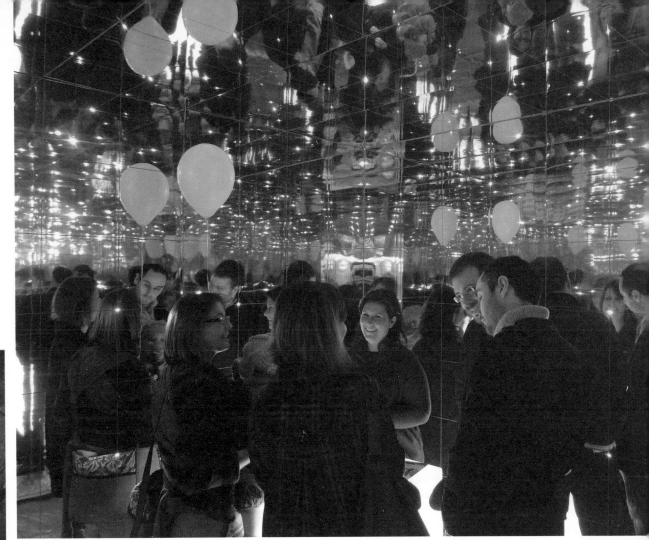

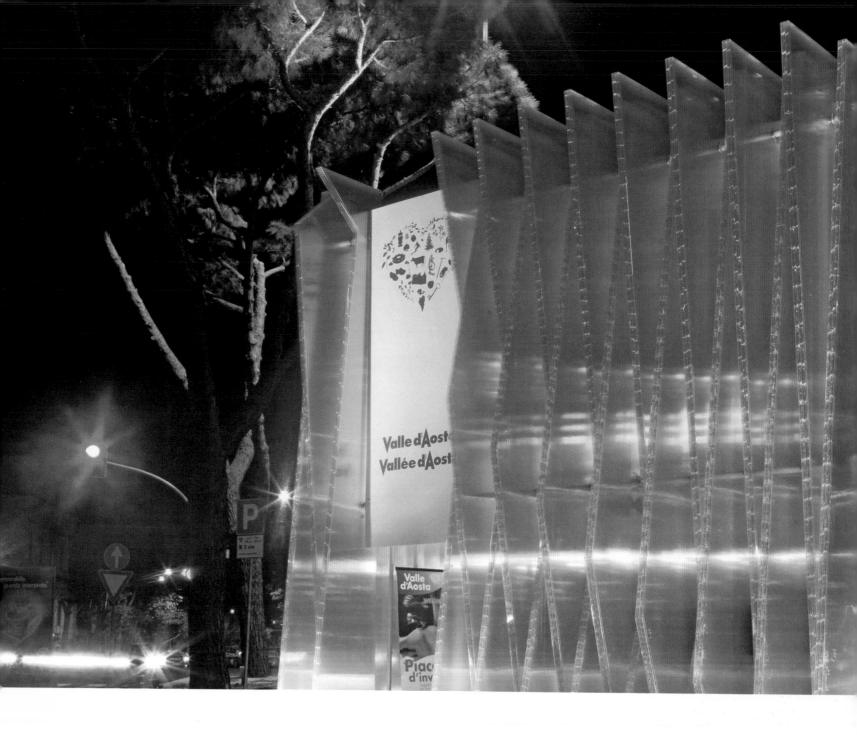

For the fifth Film Festival in Rome, Italy, Luca Peralta Studio unveiled their ephemeral architectural piece entitled Giant Ice-Cube. It was designed to promote Valle d'Aosta, a small Alpine region in north-western Italy, nestled between iconic mountains. The site in Rome designated for this piece was a road intersection resting between some of the city's strongest examples of contemporary architecture: MAXXI Museum by Zaha Hadid, Music Park by Renzo Piano, and Sport Arena by Pier Luigi Nervi. This temporary structure, inspired by Italian Futurism sculptures and paintings, is a glowing polycarbonate cube designed to be easily assembled and disassembled, made of six-meter-high blades, hung from a metal frame 20 centimeters apart. Here, tourism leaflets were delivered, regional films reviewed, and the culture specific to Valle d'Aosta displayed and promoted.

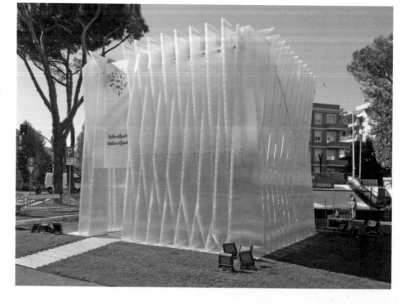

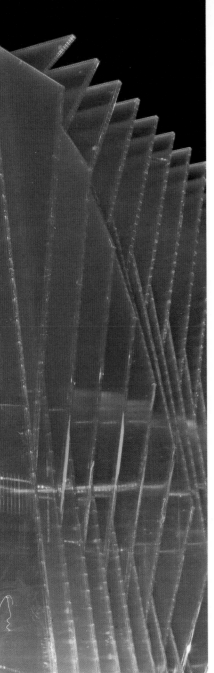

A GIANT ICE-CUBE IN ROME

Alpine culture meets Italian Futurism. A gala display
of Valle d'Aosta.

Architects | Luca Peralta Studio – design & consulting
Project address | Piazza Apollodoro, Rome, Italy
Builder and lighting designer | Luci Ombre di Diego Labonia
Client | Autonomous Region Valle d'Aosta & Interlinea Film Production
Gross floor area | 42 m²
Existed | 15 October–28 November 2010

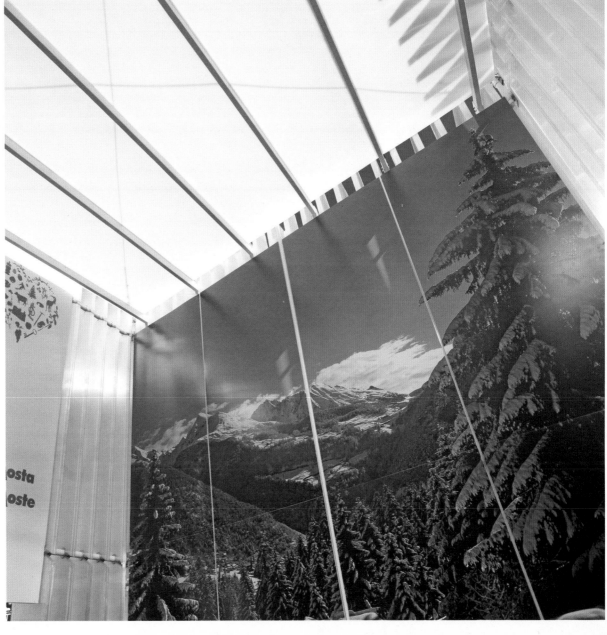

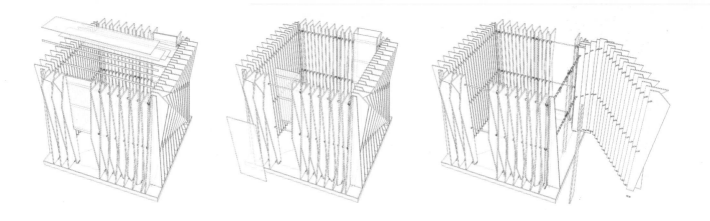

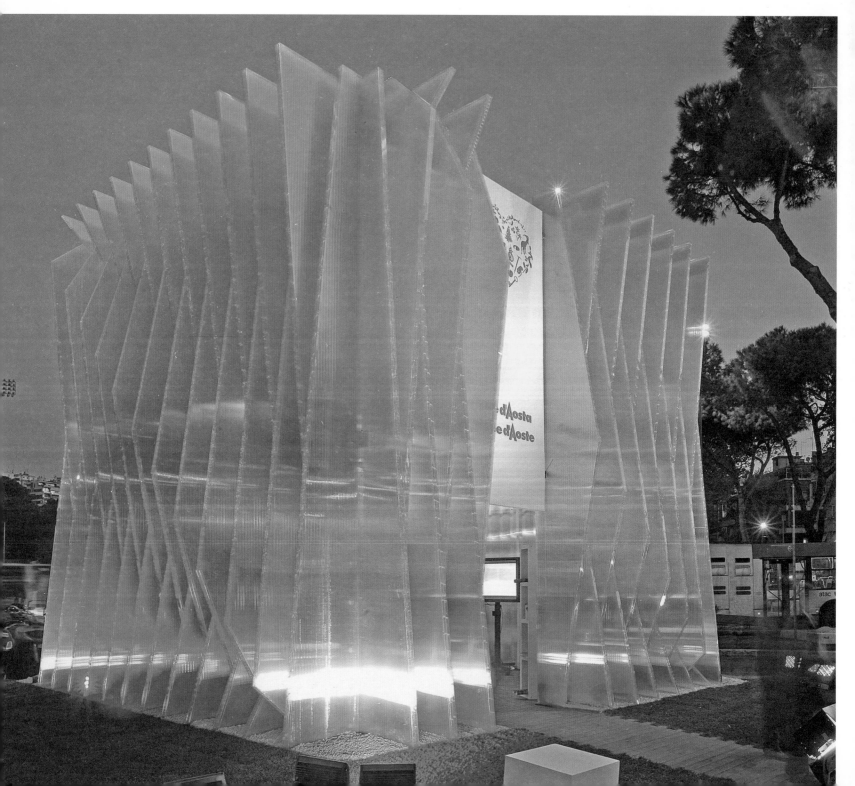

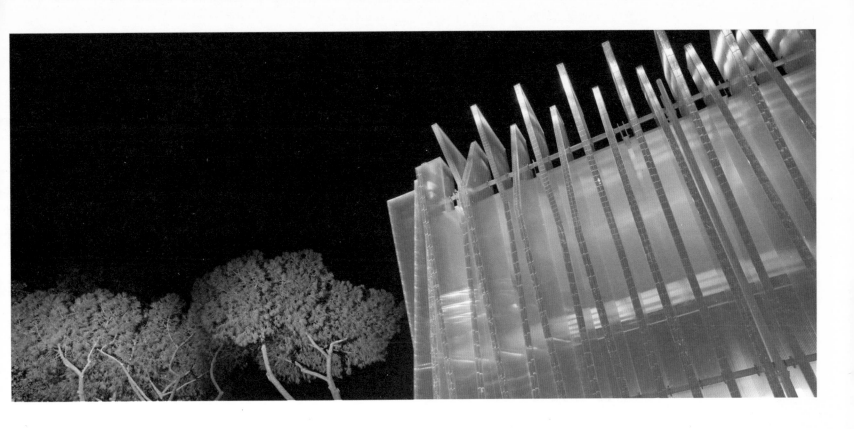

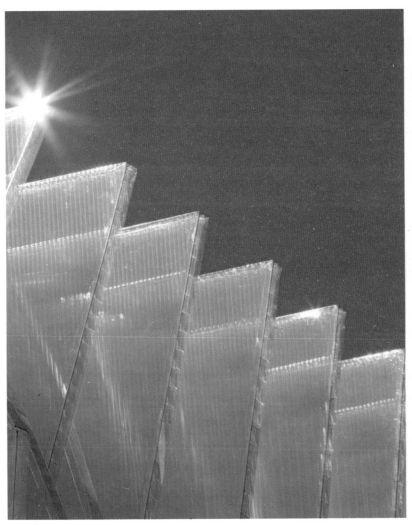

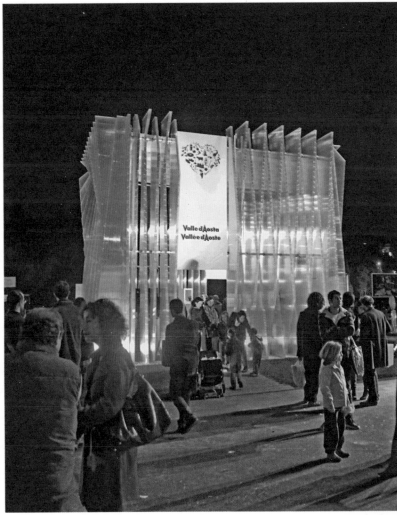

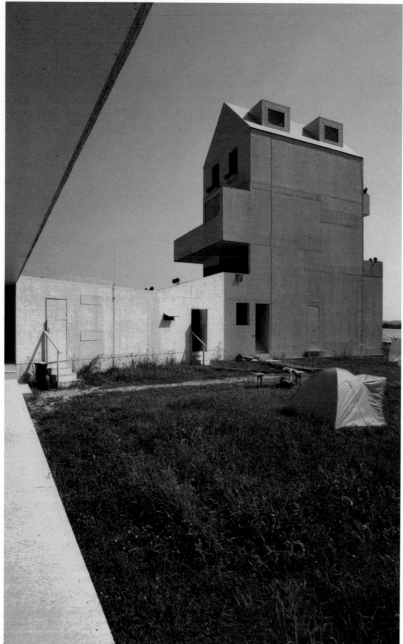

Built as part of Linz 2009, European Capital of Culture, Peter Fattinger, Veronika Orso and Michael Rieper installed a transient experiment in public space on the periphery of the city. Atop of the recently covered section of the Linz City-Highway, Bellevue – Beautiful View was positioned on the edge of the highway. To one side a view of the highway emerges, while the other side offers sweeping views of the park. Reflecting the proportions of the surrounding residential buildings, the monochrome yellow structure comprised shell protecting the functions it harbored: accommodation for guest artists, an info kiosk, a cafeteria with terrace, bicycle rental, working space, exhibition space, a media room, a library, and a public stage. Daily events turned Bellevue into a hub of artistic interaction that invited residents, passersby, and other interested parties to see, communicate, and act.

BELLEVUE – THE YELLOW HOUSE

Stop and stare! A temporary landmark offered new perspectives of Linz..

Architects | Peter Fattinger, Veronika Orso and Michael Rieper
Project address | Landschaftspark Bindermichl-Spallerhof, 4020 Linz, Austria
Gross floor area | 400 m²
Existed | June–September 2009

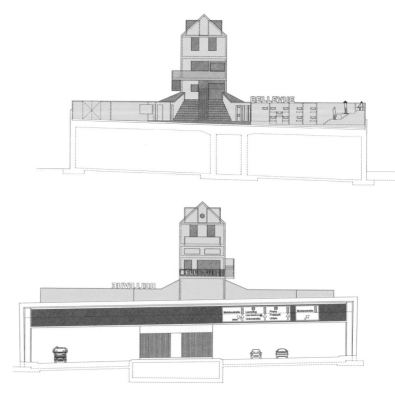

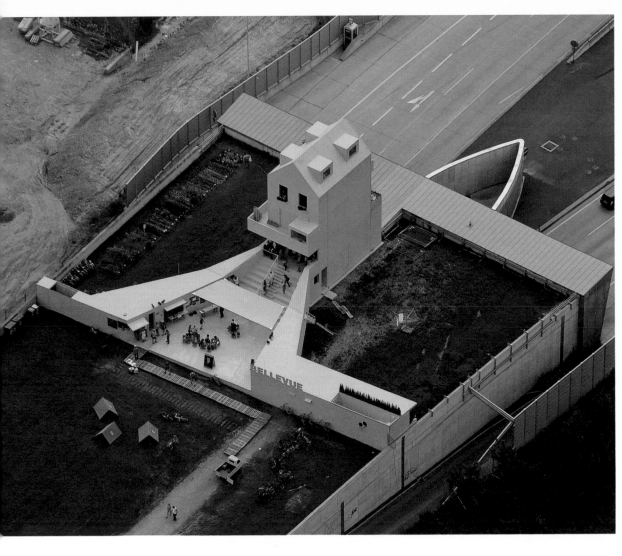

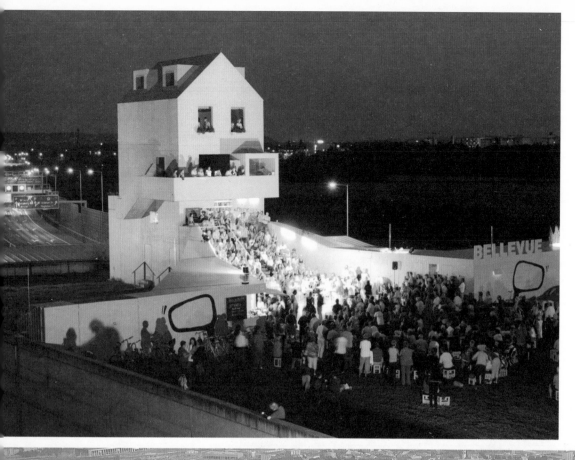

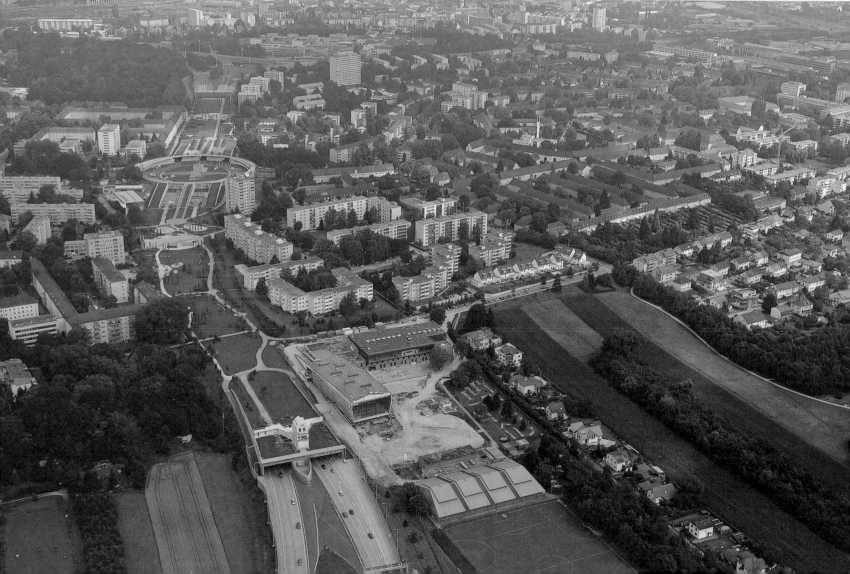

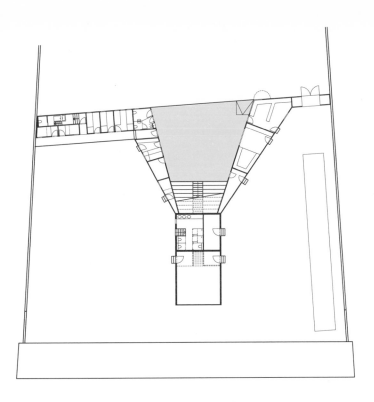

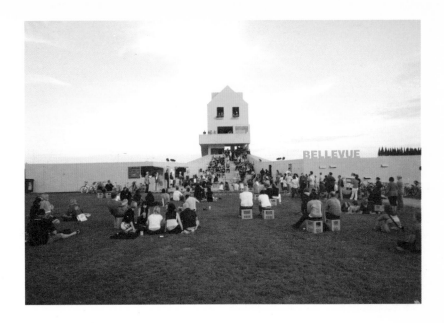

133

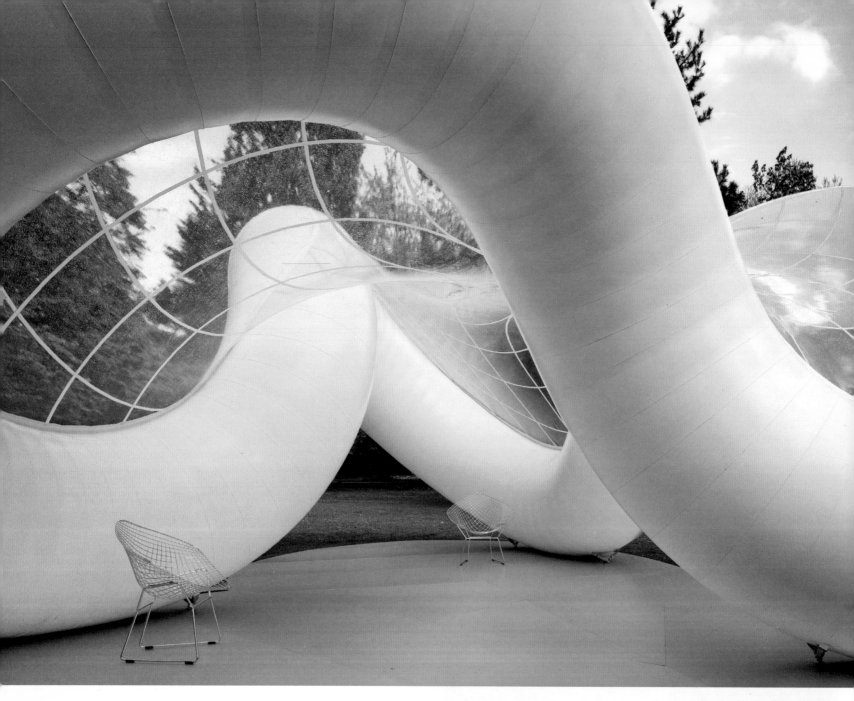

The architects proposed a pavilion that is visually and aesthetically engaging, capable of providing an ideal contemporary space, while offering a sense of tranquilty, beauty and an exceptional aesthetic value at the very heart of the Museum Gardens in London. The beauty of the shape lay in its perfect symmetry and fluidity; the pavilion was designed to appeal to a wide audience. The geometry of the pavilion blurred the notion of inside and outside, the simple act of moving through the exterior and interior spaces brought an understanding to the visitor. To achieve such an apparently complex shape, the architects united advanced tools of parametric design: in the accurate manufacturing of the pavilion using CNC cutting machines.

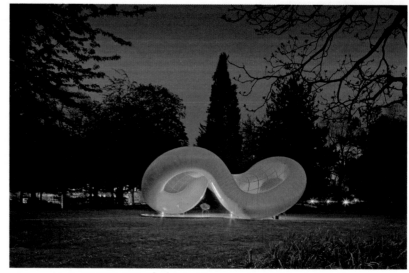

PEACE PAVILION

Twist and (don't) shout! Translating the fluidity of nature into built form, this white pavilion exudes a gentle tranquilty.

Architects | AZC
Project address | Museum Gardens, Bethnal Green, London, United Kingdom
Client | ArchTriumph
Gross floor area | 62 m²
Existed | May–June 2013

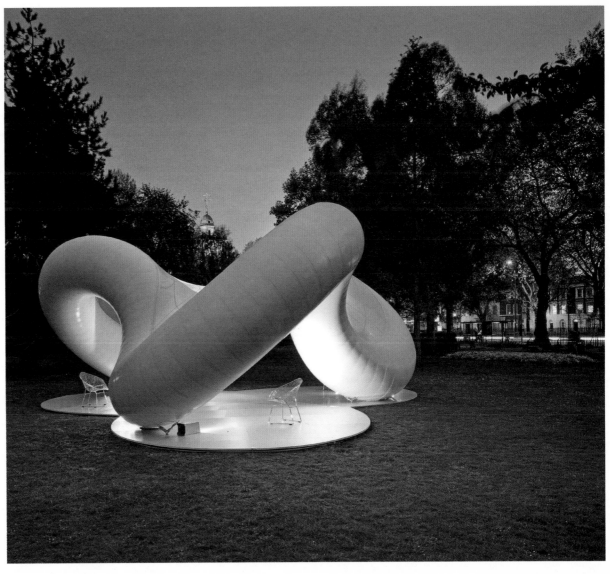

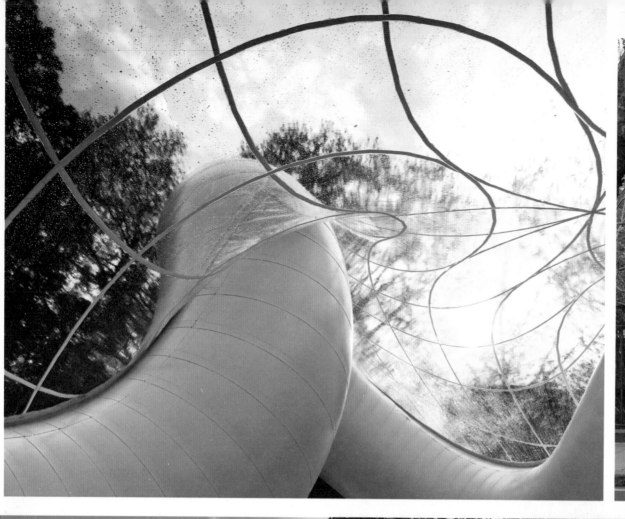

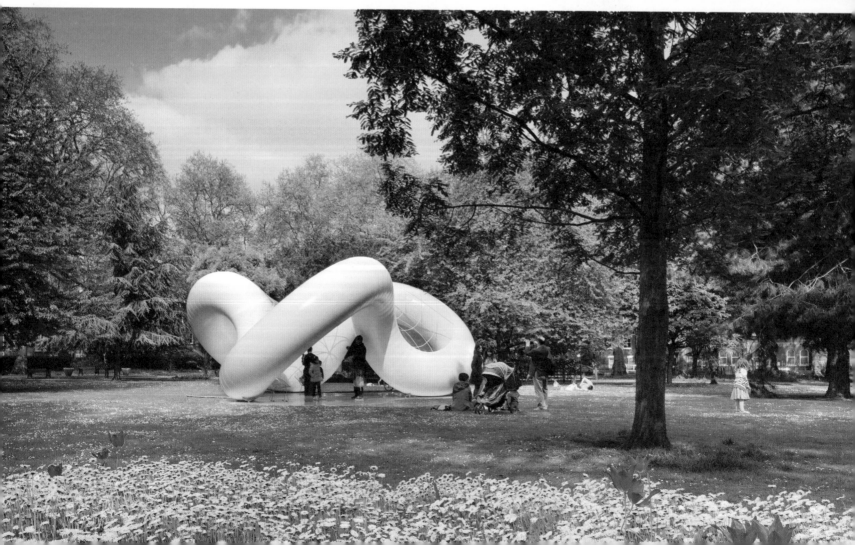

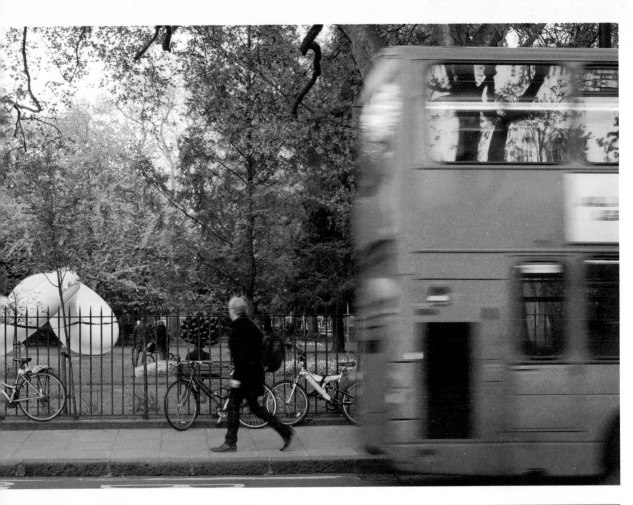

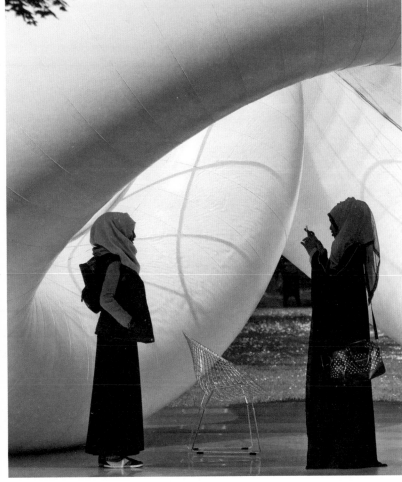

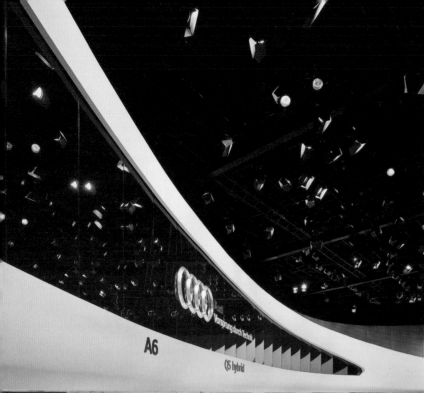

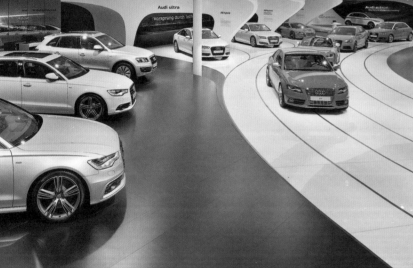

Concept and architecture | Schmidhuber
Communication and media content | KMS Blackspace
Project address | Messe Frankfurt/Main, Germany
Client | Audi AG
Gross floor area | 8,500 m²
Existed | 15–25 September 2011

The Agora is the central square of the Frankfurt Trade Fair and set the stage for Audi's very first appearance at the Frankfurt Motor Show 2011 with a separate, freestanding building – the Audi Ring. At the heart of the 100-meter-long, 70-meter-wide, and 12-meter-high trade show pavilion was an integrated driving track, where up to nine vehicles could drive simultaneously on two levels – visible also from the outside via elongated openings in the façade. The architecture was characterized by flowing forms, curved lines, and surprising transitions, incorporating façade contours, entrances, and passages into an overall concept. Together with the multi-media displays and interactive exhibits, they rendered the core brand message "Vorsprung durch Technik" (technological edge) and the future-oriented positioning of Audi into a sensual experience.

AUDI RING
AUDI BRAND PAVILION

Dynamic, beauty and power melded into one architectural icon – a perfect symbol for a great car brand.

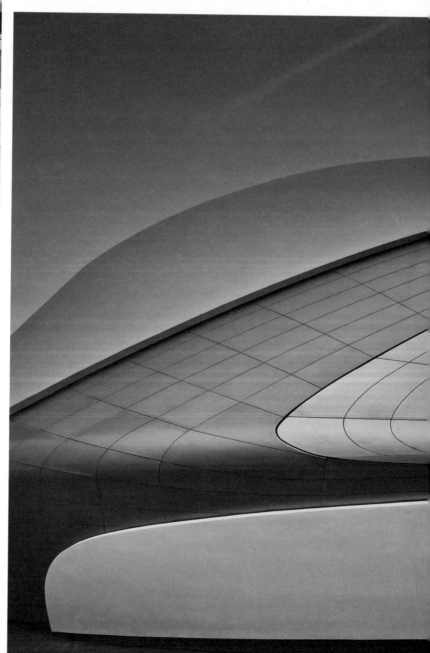

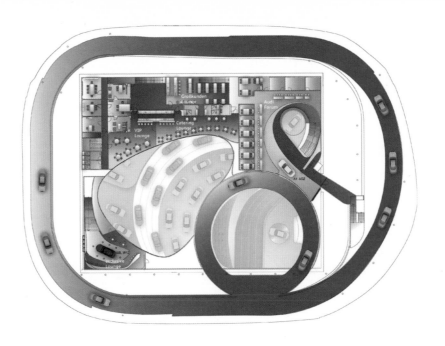

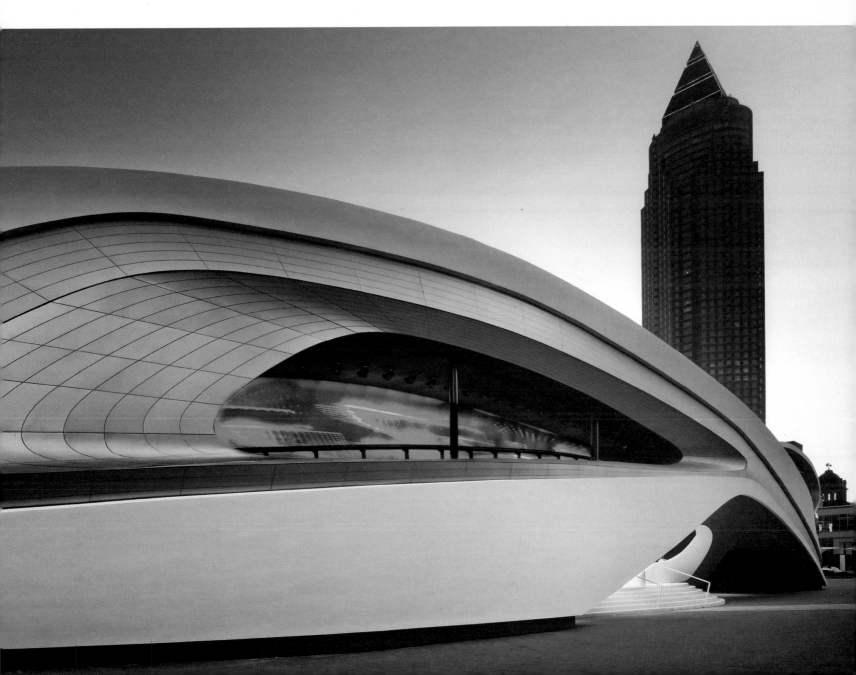

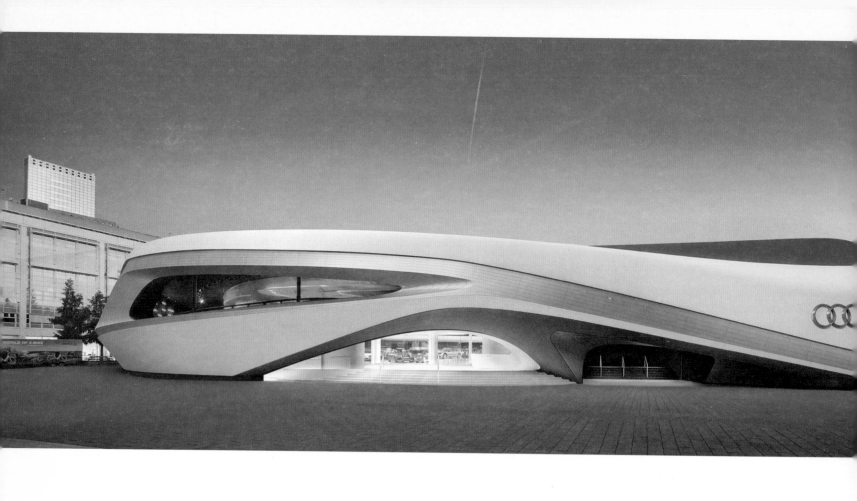

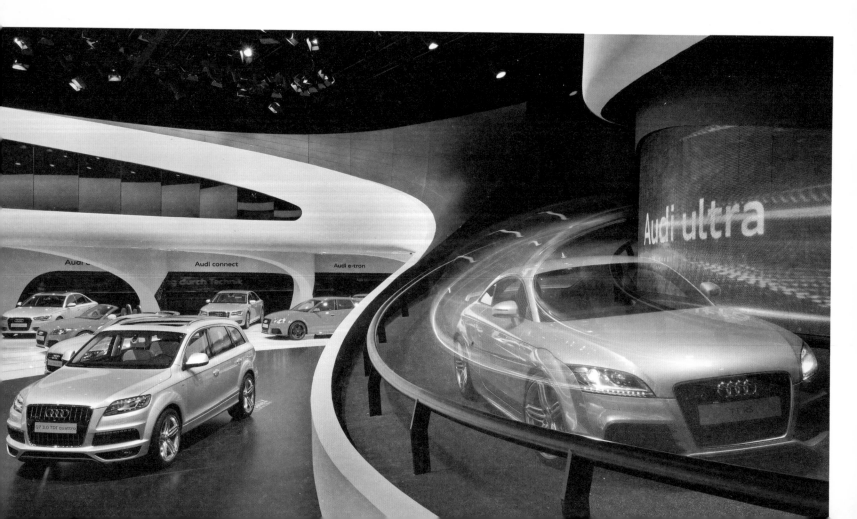

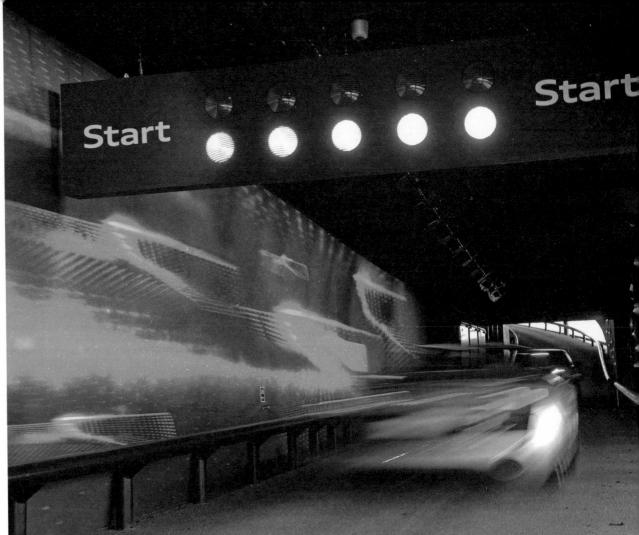

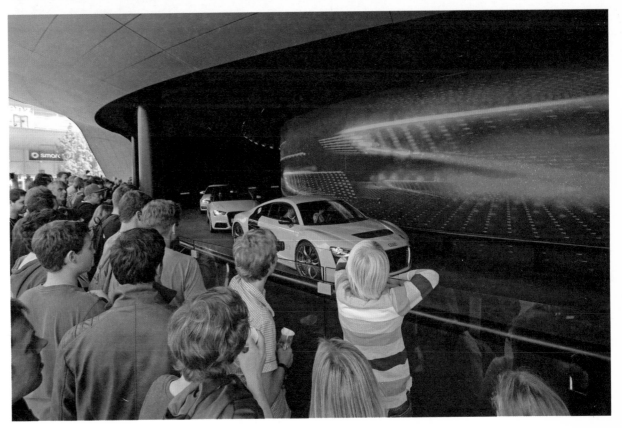

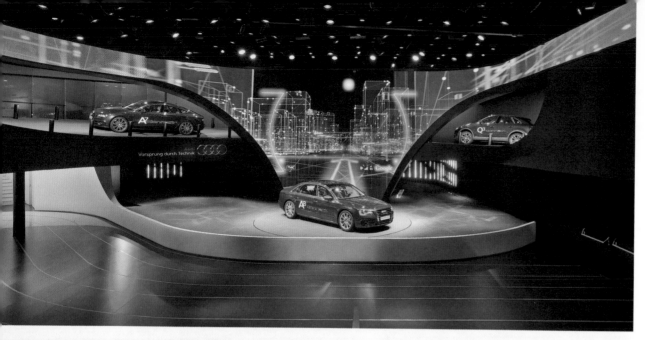

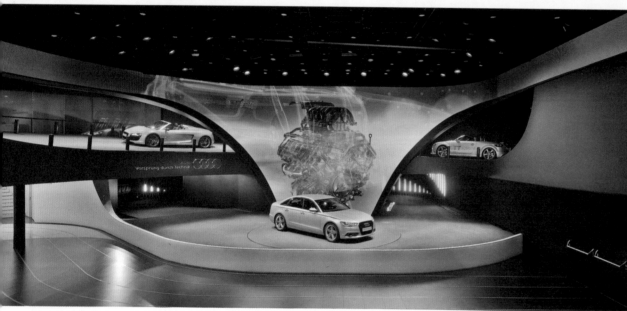

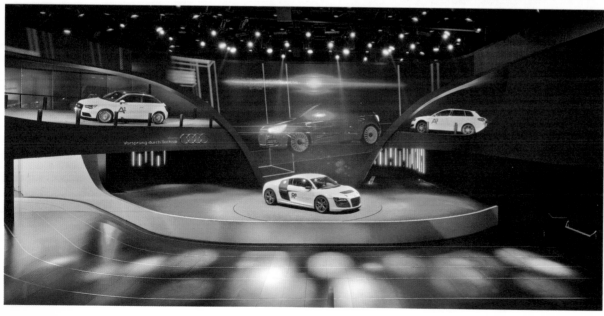

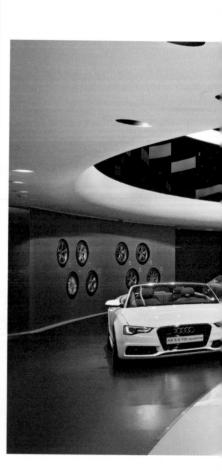

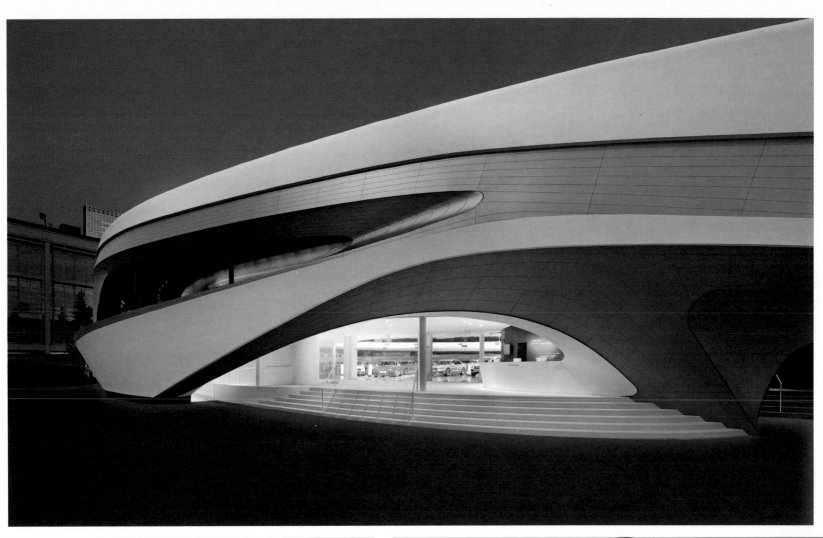

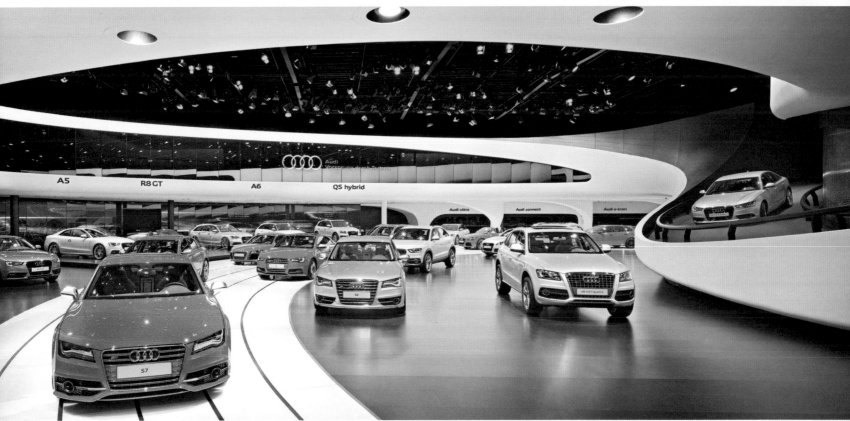

143

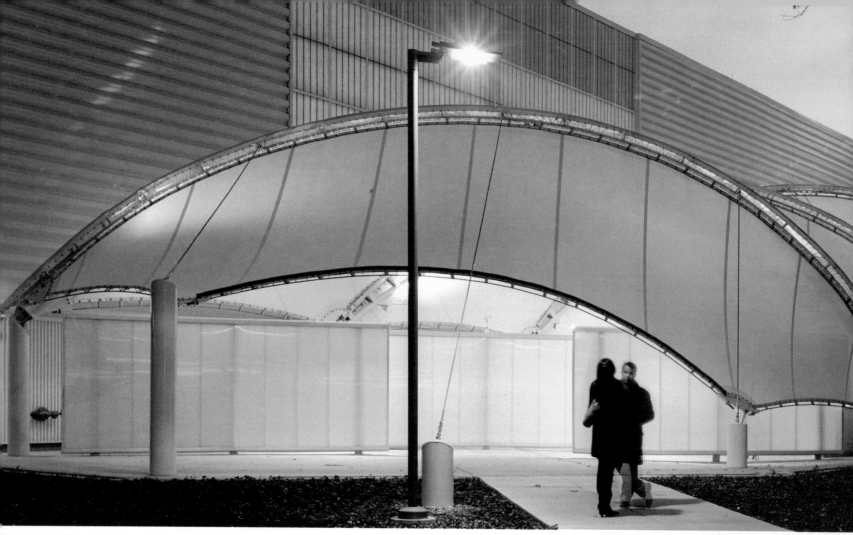

UNITED NATIONS INTERIM CANOPY

Like a giant insect, this segmented pavilion settles comfortably into its environment.

Located on the north lawn of the United Nations campus in New York City, the UN Interim Canopy is a Porte Cochere, designed by FTL Design Engineering Studio. The structure sits adjacent to the UN's new temporary General Assembly building, designed by the architects, HLW International. The structure serves as an entrance pavilion and security screen for the general assembly delegates and is designed as a transportable building intended to be moved to the General Assembly building of the campus at the completion of the UN renovation. The design explores lightness as a visual, physical and sustainable approach, using a minimum of materials to reduce its environmental impact, seeking to build a responsive structure that contain spaces which inspire, where building and people can meet. Helical arches undulate and twist along the length of the roadway gently peeling away from the main building.

144

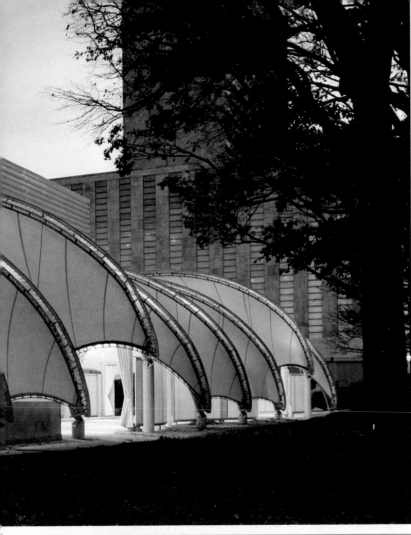

Architects | FTL Design Engineering Studio
Project address | 2 United Nations Plaza, New York City, NY, USA
Client | United Nations
Gross floor area | 1,088 m²
Existed | 2010–ongoing

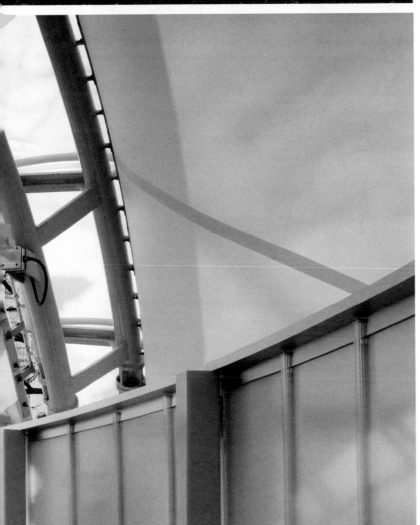

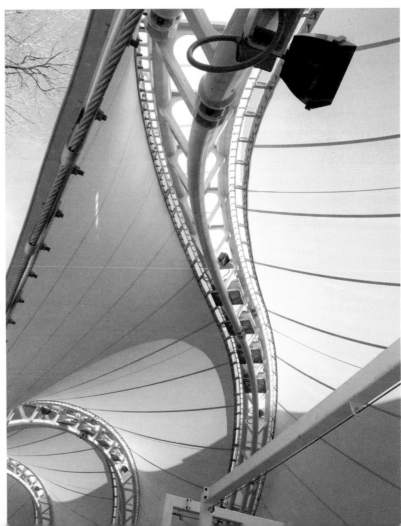

Architects | FTL Design Engineering Studio
Project address | 2 United Nations Plaza, New York City, NY, USA
Client | United Nations

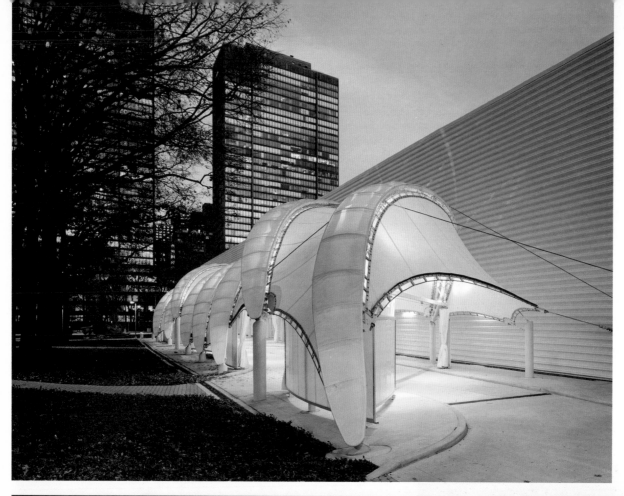

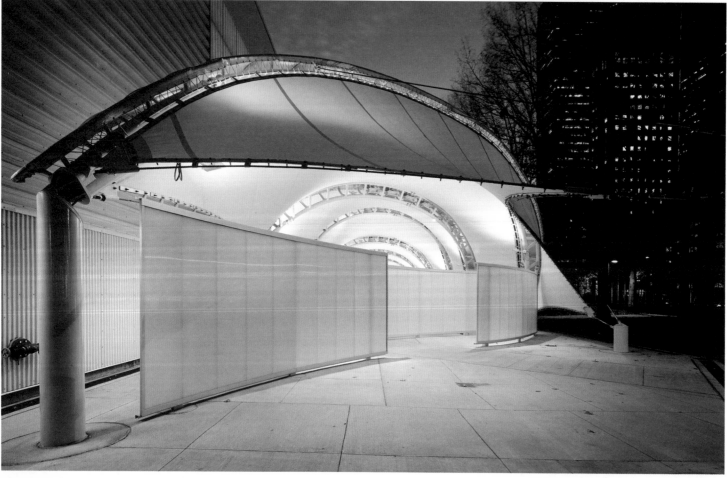

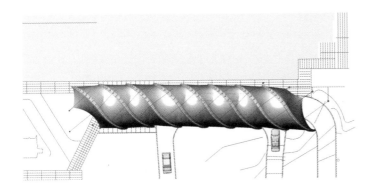

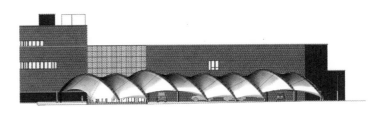

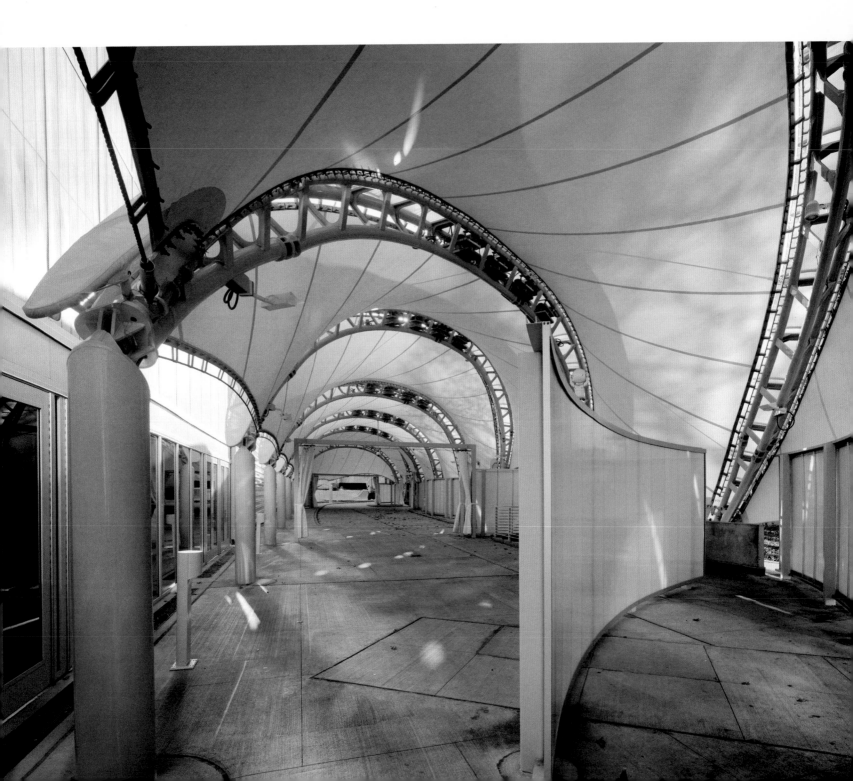

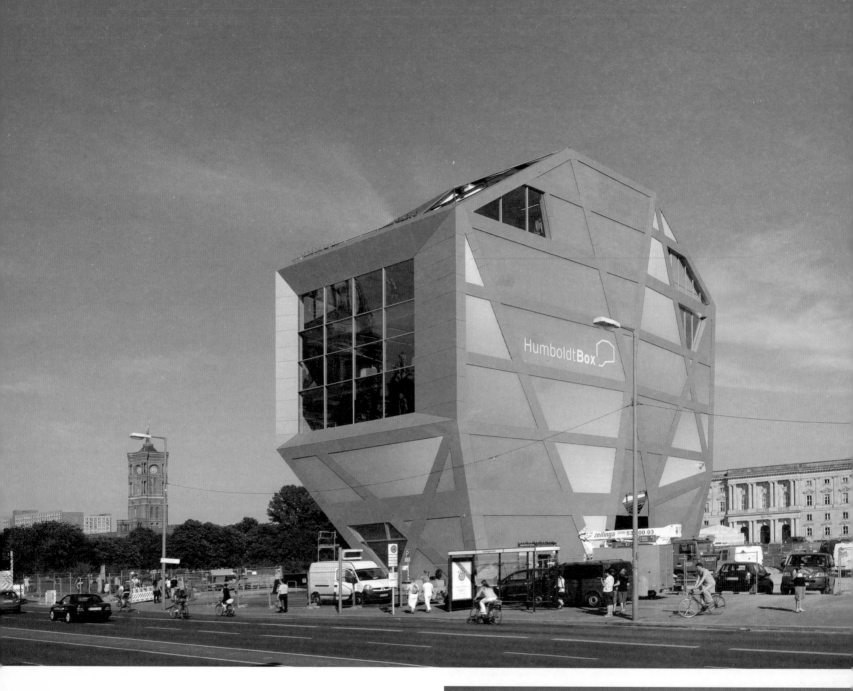

HUMBOLDT-BOX

The aliens have landed! This sculptural box is an
eye-catching addition to the historical location.

148

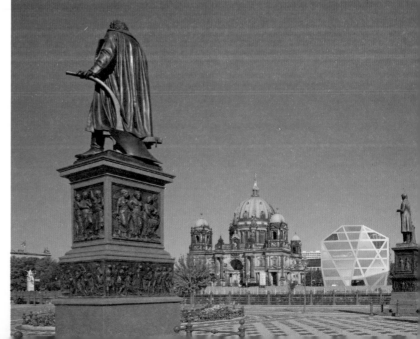

Architects | KSV Krüger Schuberth Vandreike
Project address | Schlossplatz 5, Berlin, Germany
Client | Megaposter GmbH
Gross floor area | 2,962 m²
Existed | 2011–ongoing

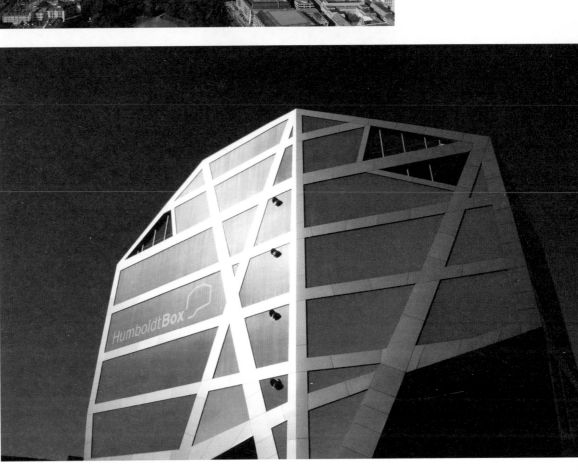

The Humboldt-Box was built to accompany the construction of the Humboldt-Forum/ Berlin City Palace and functions as an information and exhibition building. As a temporary building, this will remain for approximately eight years, before being dismantled when the construction of the Humboldt-Forum is complete in 2018. Until then, a number of exhibition and event spaces, a shop and a restaurant with panoramic terraces will be open to the public. The steel structure is the result of optimal weight distribution and creates the frame for the changeable fabric surfaces of the building envelope. The horizontal and diagonal supports cross each other to give the building its sculptural and unique character. Frame and perforation are the elements which constantly reinvent the idea of 'temporary', throughout the entire life cycle of the building.

149

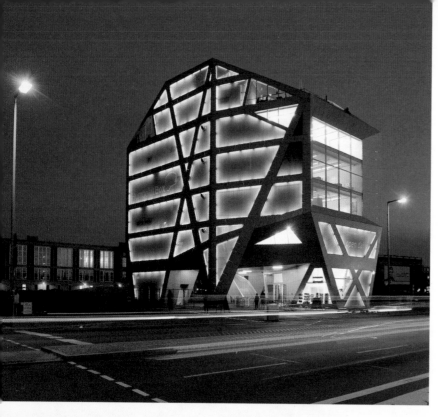

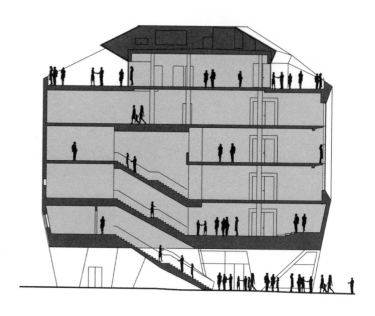

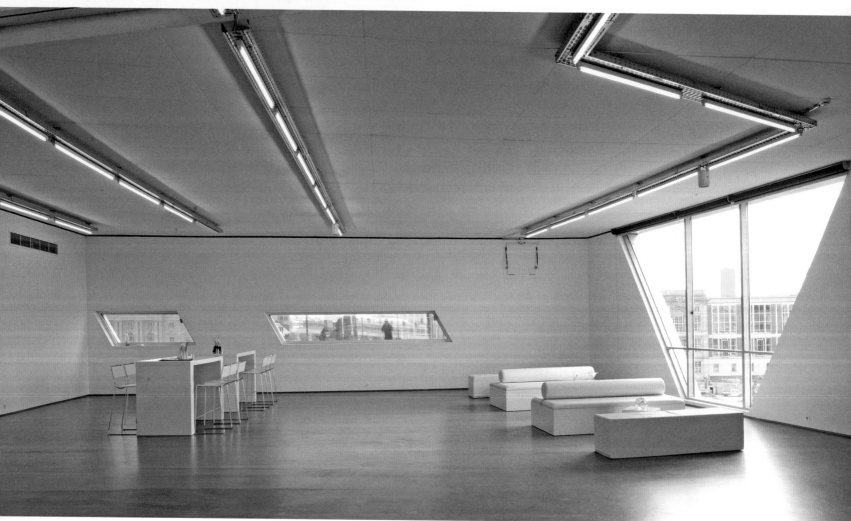

150

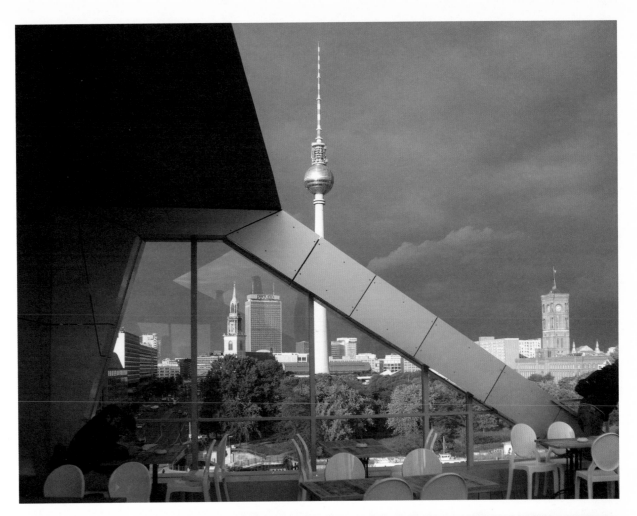

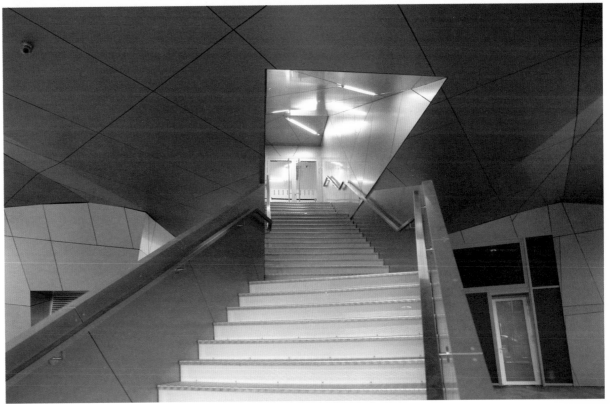

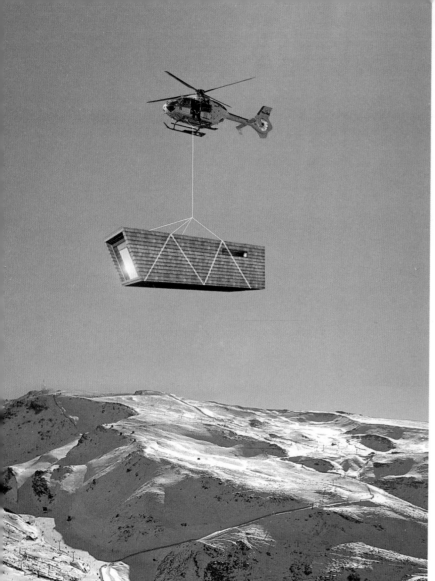

ECO-TEMPORARY REFUGE

Self-sufficient, flexible and beautiful. Such a stranger is welcome everywhere, not only in the Swiss alps.

Architects | Cimini Architettura
Project address | Swiss alps
Client | confidential
Gross floor area | 44 m²
Existed | February 2013–ongoing

The increasing popularity of this mountain as a recreational area for tourists, climbers and hikers, is having dramatic consequences on the delicate ecosystem. From year to year increased housing construction and permanent shelters in the high mountains, are the cause of permanent scars and damage. Eco-Temporary Refuge is designed to be self-sufficient, flexible and easily removable. Built in a factory and transported by helicopter, the project aims to have an almost zero impact on the environment. Eco-Temporary Refuge is equipped with four-kilowatt solar panels that can power the under-floor heating system, electrical system, appliances and system transformation of snow into drinking water. The snow layer works like thermal insulation and at the same time flows into a sewage treatment plant turned into hot water. The idea is to build a self-sufficient shelter that will not damage the site and that can be easily removed if necessary.

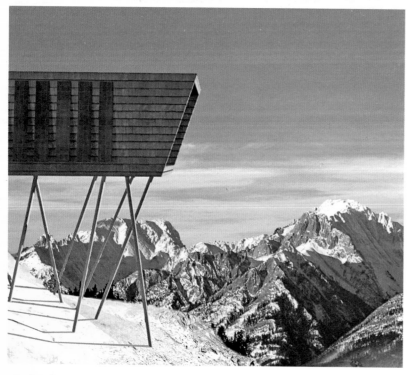

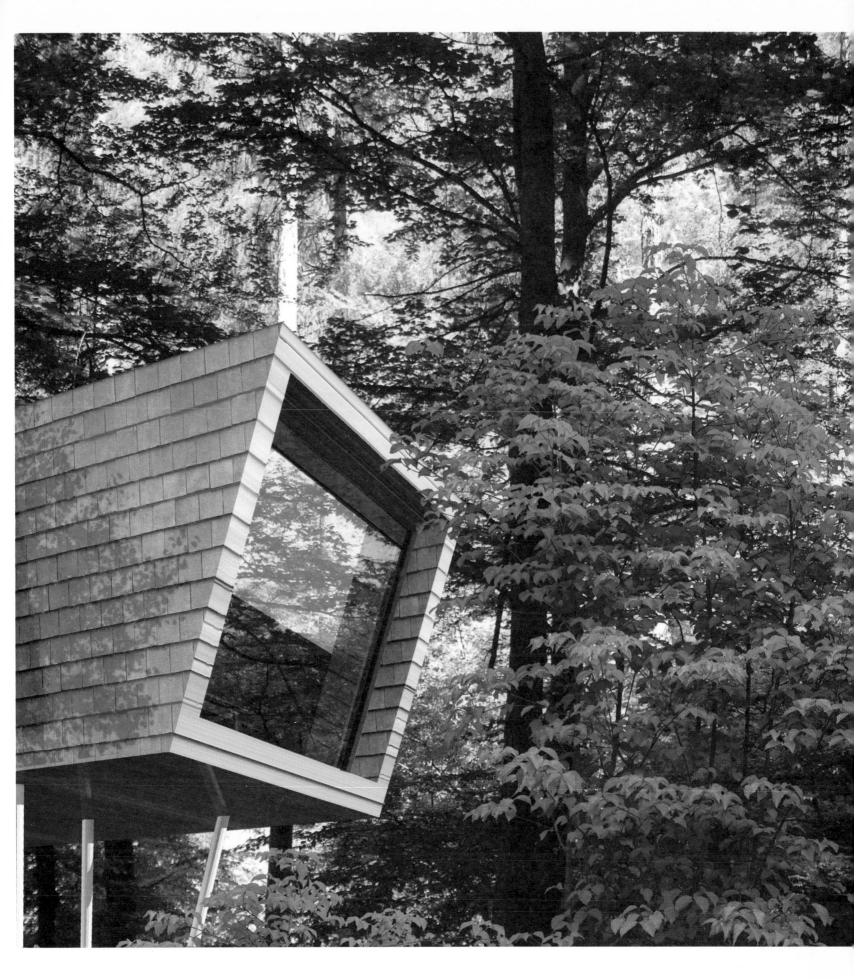

2015
2013
2014
2016

larch cladding

sheep's wool
insulation

system X-lam

solar panels
for electricity
and heating

steel columns

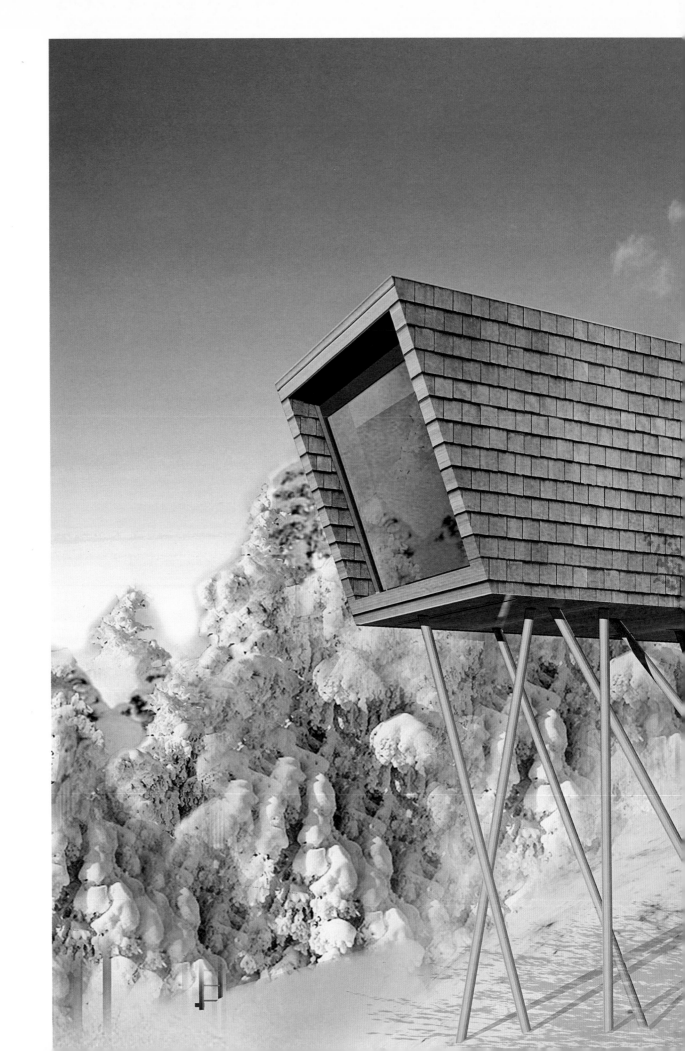

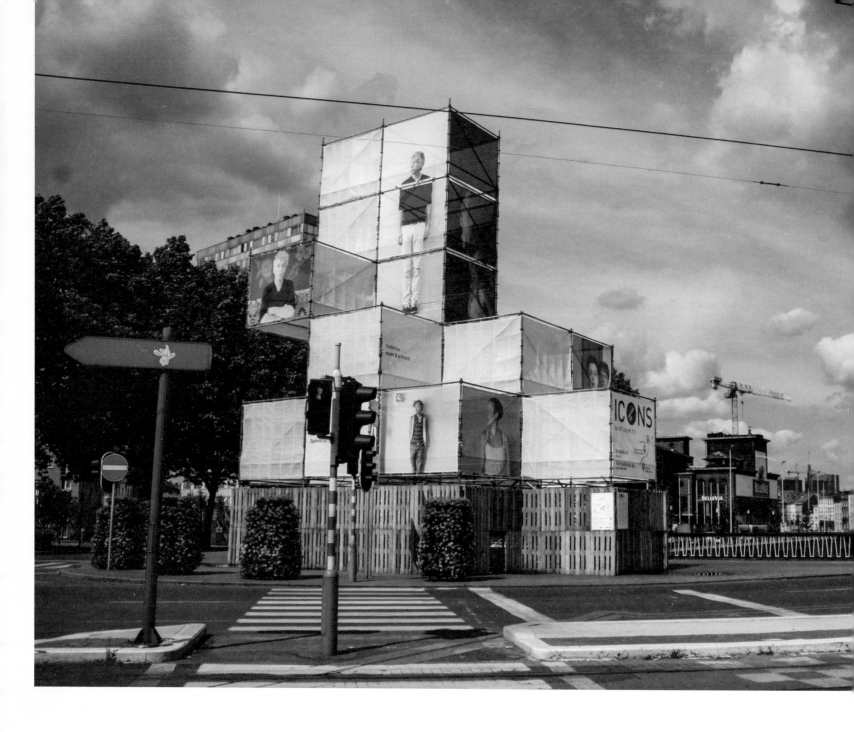

This project involved the creation of temporary structures for the Icons photography exhibition, and Delicious Kanal – a communal dining area – at various public spaces around the Kanal area in Brussels, Belgium, designed for Festival Kanal. Architecturally, these towers were a poetic, iconic, and lightweight comment on Brussels' development. The different Icon photos on the festival towers were taken by photographer Kurt Deruyter and highlighted the icons and idols of local Kanal citizens; they could be seen from various viewpoints around the city. On Car-free Sunday, the area was opened up and communal activities were organized, which attracted visitors from all over Belgium. Re-usable materials such as Euro-palettes and scaffolding were combined with lightweight printed construction site tarpaulins to create an economically and ecologically viable temporary construction.

 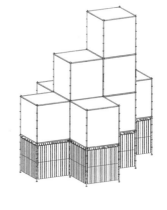

156

TOWERS FOR FESTIVAL KANAL

Eat, drink and be... iconic. An extra-special fusion of art, media, and architecture.

Architects | BC architects & studies
Project address | various locations around Kanal area, Brussels, Belgium
Client | ADT/ATO Brussels
Gross floor area | 400 m²
Existed | June–September 2012

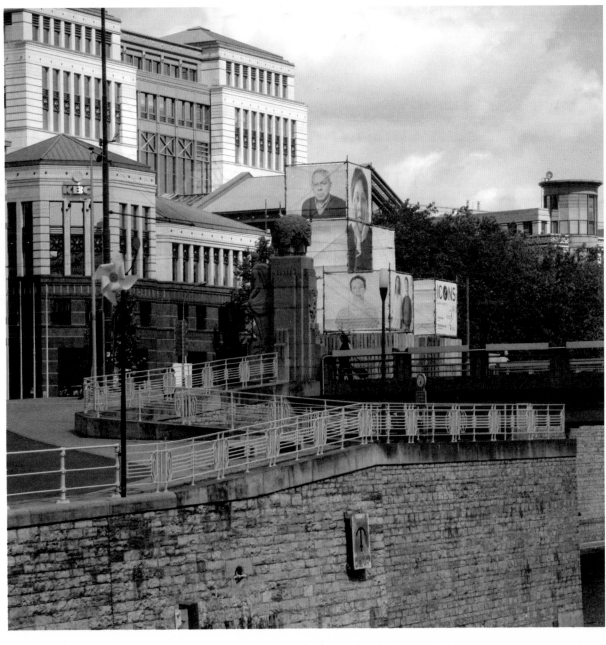

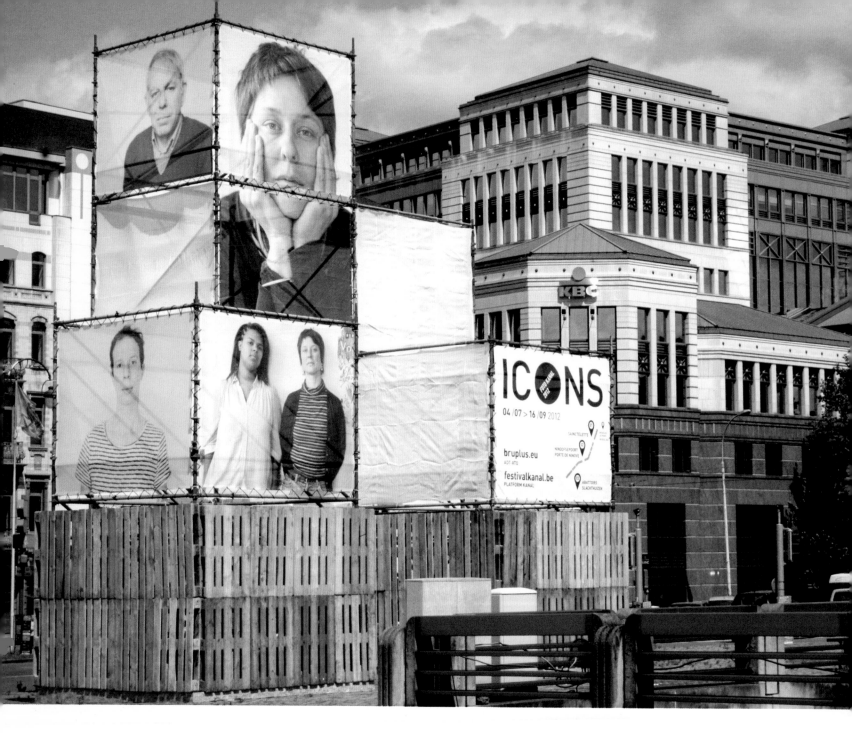

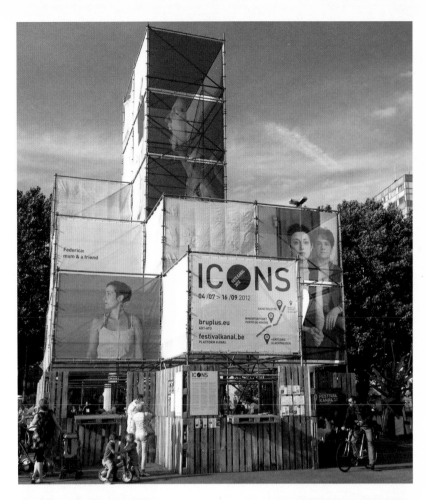

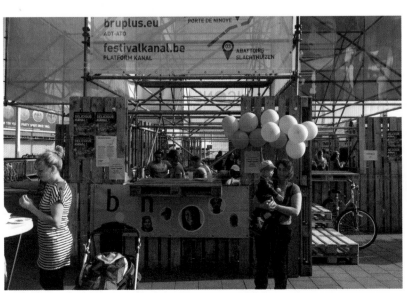

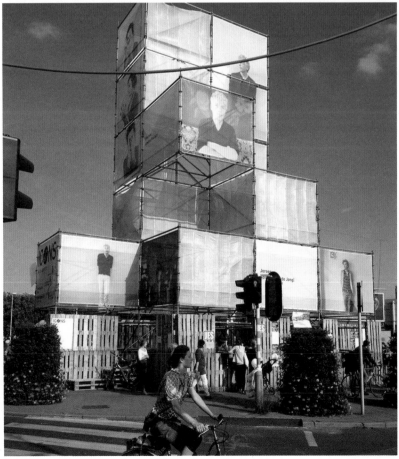

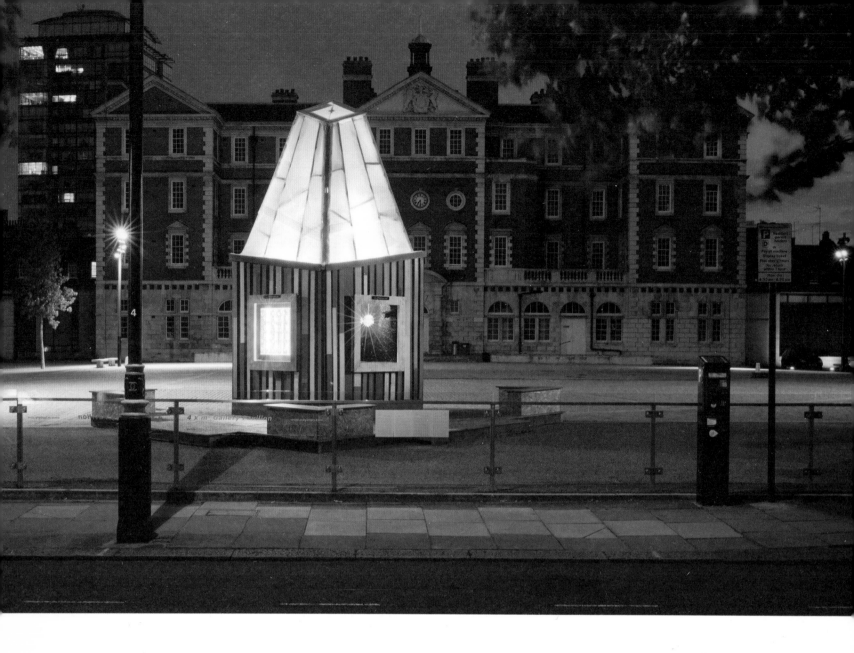

The m2 gallery was a 24-hour window gallery at the front of Quay2c Architects' studio in Peckham, London. Quay2c had a long-standing idea to extend the scope of the m2 gallery by quadrupling it as a 4 x m2 Gallery Pavilion. This finally came into being during the summer of 2011 on the Parade Ground at Chelsea College of Art and Design opposite the entry to Tate Britain, London. The pavilion was made almost exclusively of recycled and donated materials; the main structure of second hand timber and plywood, with the external boards being made of Ecosheet, a 100 percent recycled plastic equivalent to plywood. The raised area around it provided extra structural stability while also offering right angled benches at each corner to sit and contemplate the work or simply have a chat. The pavilion was constructed by Quay2c with students from the MA Interior & Spatial Design course at Chelsea and their tutor Dr Ken Wilder.

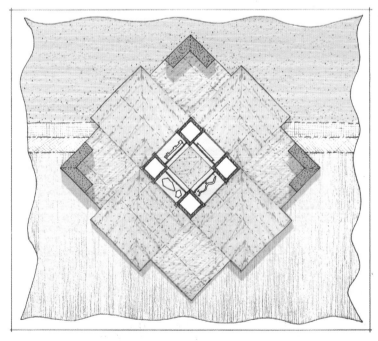

4 x M² GALLERY PAVILION

All the culture you need squeezed into a very small space.

Architects | Quay2c Architects
Project address | The Rootstein Hopkins Parade Ground 16 John Islip St, London SW1P 4JU, United Kingdom
Client | Chelsea College of Art and Design (CCAD) & m2 Gallery
Gross floor area | 6 m²
Existed | 20 July–October 2011

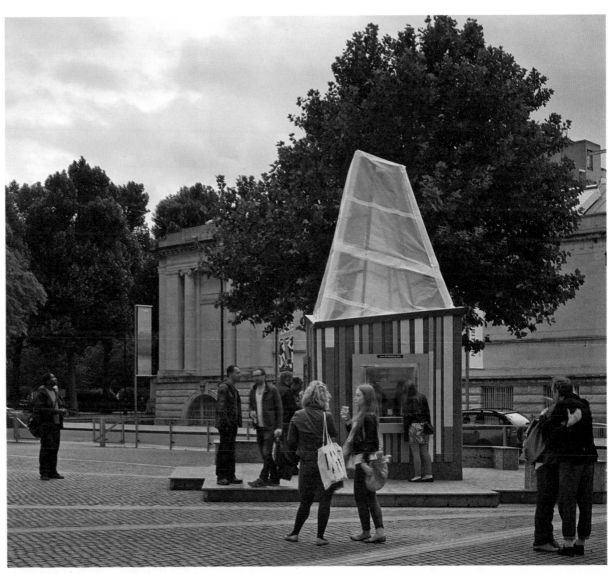

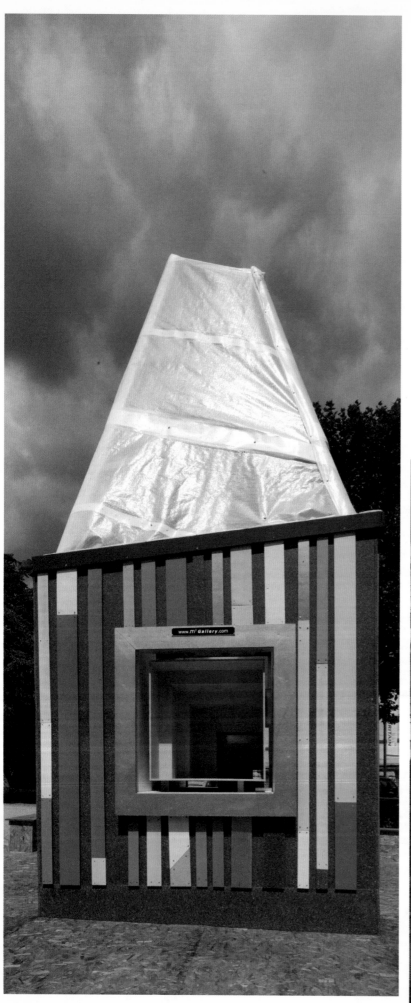

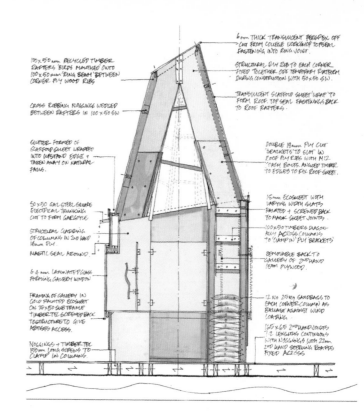

6mm THICK TRANSLUCENT PERSPEX OFF CUT FROM COLLEGE WORKSHOP TOP SEAL FASTENING INTO RING JOIST.

100 x 50mm RECYCLED TIMBER RAFTERS 'BIRDS MOUTHED' ONTO 100 x 50mm 'RING BEAM' BETWEEN CORNER PLY WOOD RIBS

STRUCTURAL PLY RIB TO EACH CORNER FIXED TOGETHER OFF TEMPORARY PLATFORM DURING CONSTRUCTION WITH 50 x 50 SW.

CROSS RIBBING NOGGINGS WEDGED BETWEEN RAFTERS IN 100 x 50 SW

TRANSLUCENT SCAFFOLD SHEET 'WRAP' TO FORM ROOF. TOP SEAL FASTENINGS BACK TO ROOF RAFTERS.

GUTTER FORMED OF SCAFFOLD SHEET WRAPPED INTO UPSTAND EDGE + TAKEN AWAY ON NATURAL FALLS.

DOUBLE 18mm PLY CUT 'BRACKETS' TO 6LM W ROOF PLY RIBS WITH M12 'COACH' BOLTS, ANGLED TIMBER TO EDGES TO FIX ROOF SHEET.

50 x 50 GAL STEEL SQUARE ELECTRICAL TRUNKING CUT TO FORM GARGOYLE.

18mm ECOSHEET WITH VARYING WIDTH SLATS PAINTED + SCREWED BACK TO MASK SHEET JOINTS.

STRUCTURAL CLADDING OF COLUMNS IN 2ND HAND 18mm PLY MASTIC SEAL AROUND

100 x 50 TIMBERS DIAGON-ALLY ACROSS COLUMNS TO 'CLAMP IN' PLY BRACKETS

6 + 4mm LAMINATE PIGLASS FORMING GALLERY WINDOW

REMOVABLE BACK TO GALLERY OF 2ND HAND 18mm PLYWOOD.

FRAMING OF GALLERY IN COLD PAINTED ECOSHEET ON 75 x 50 SUB FRAME TIMBER TEC SCREWED BACK TOGETHER/STRUCTURE TO GIVE RIBBED ACCESS.

12 No 25Kg SANDBAGS TO EACH CORNER COLUMN AS BALLAST AGAINST WIND LOADING.

165 x 65 2ND HAND JOISTS T.J. LENGTHS CONTINUOUS WITH NOGGINGS WITH 22mm 2ND HAND STERLING BOARDS FIXED ACROSS

NOGGINGS + TIMBER TEC 150mm LONG SCREWS TO 'CLAMP IN' COLUMNS.

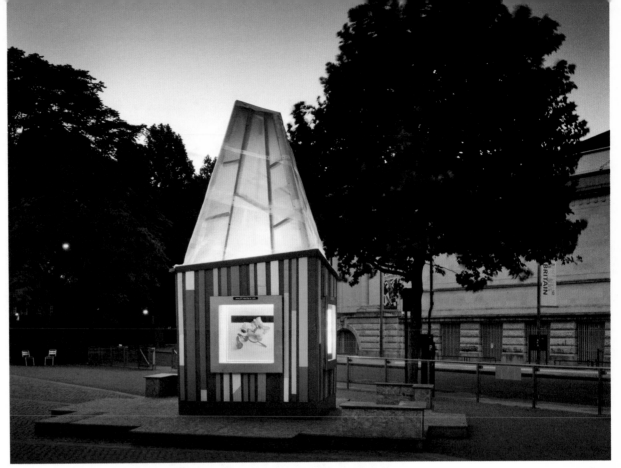

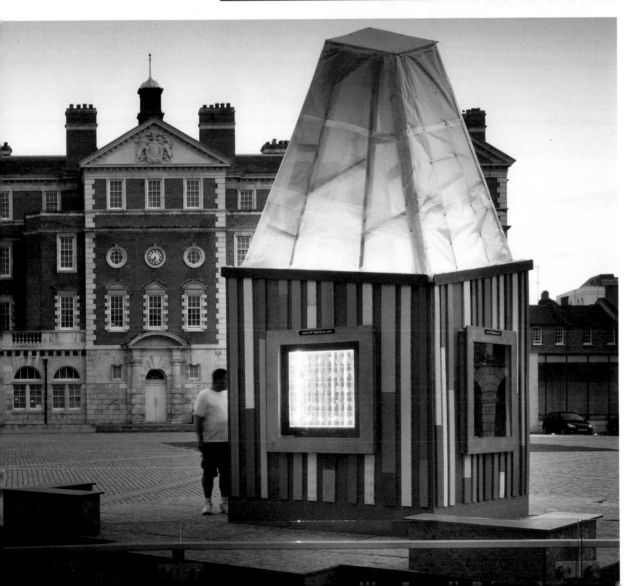

163

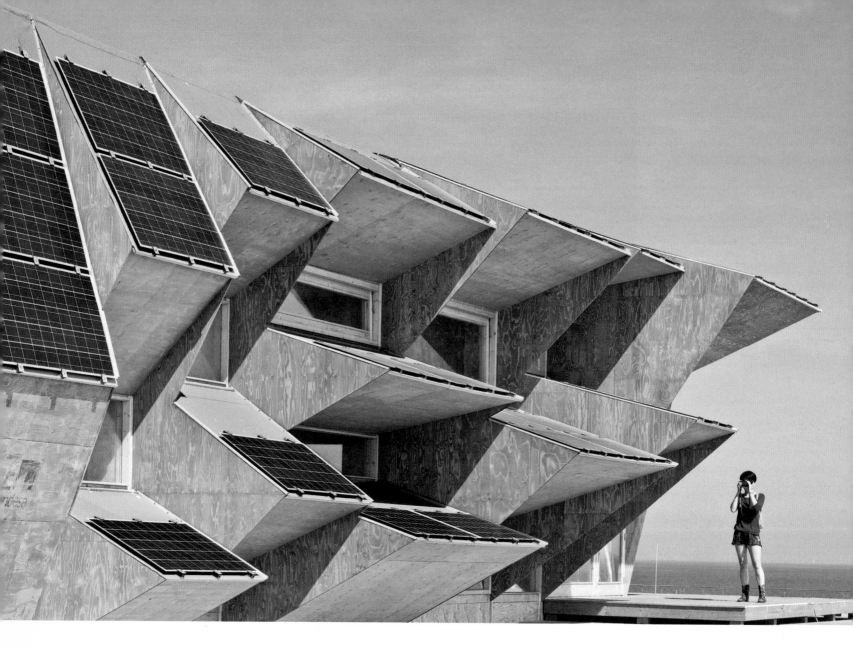

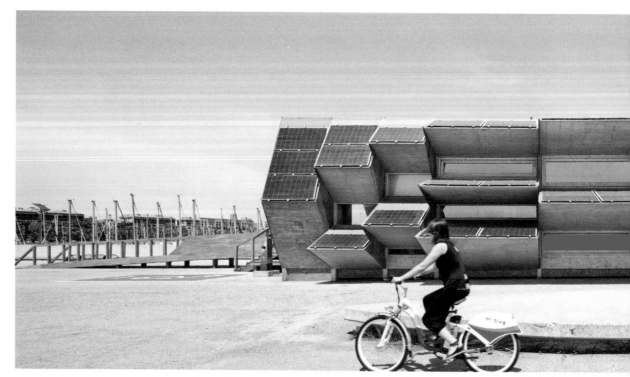

ENDESA PAVILION

Shed a little light – this innovative pavilion is powered by the sun.

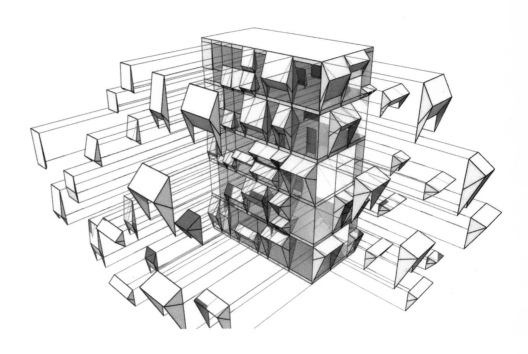

Project architects | IAAC, Rodrigo Rubio
Project address | Marina Dock, Olympic Port, Barcelona, Spain
Client | Endesa
Gross floor area | 140 m²
Existed | November 2011–ongoing

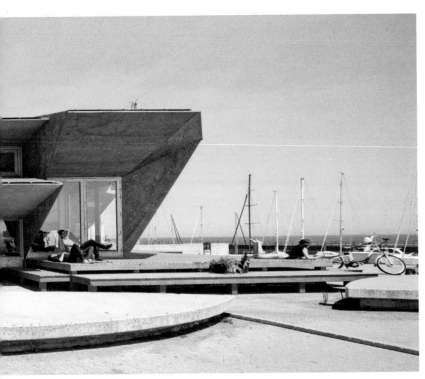

The Endesa Pavilion is a self-sufficient solar prototype installed at the marina dock, and built within the framework of the International BCN Smart City Congress. Over a period of one year this was used as a control room for monitoring and testing several projects related to intelligent power management. The pavilion is actually the result of a multi-scale construction system. The façade is composed of modular components responsive to solar gain, solar protection insulation, ventilation and lighting; a single component that integrates all levels of intelligence required. The façade reacts to the solar path, being active and permeable to the south and closed and protective to the north. The Endesa Pavilion is an accessible device, technologically soft and easy to understand. Its geometry, construction, and materials are all visible.

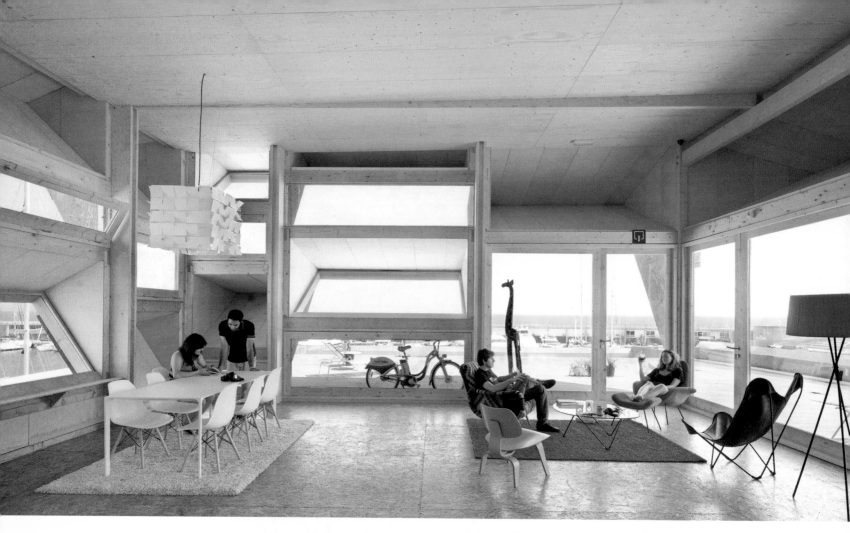

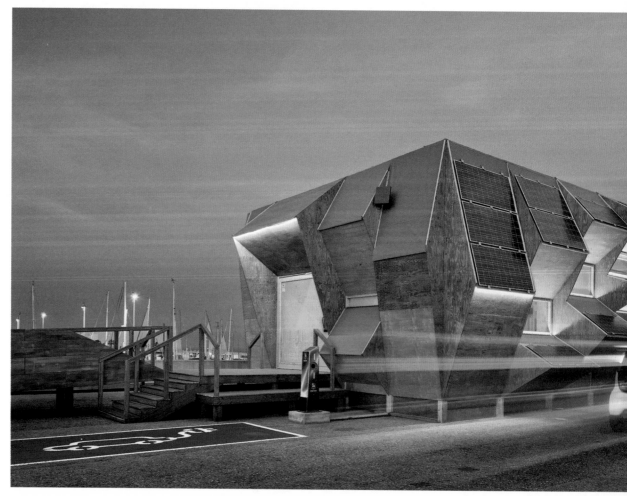

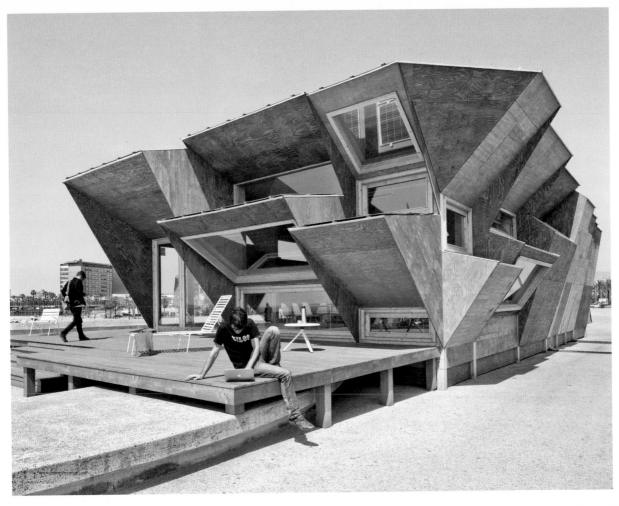

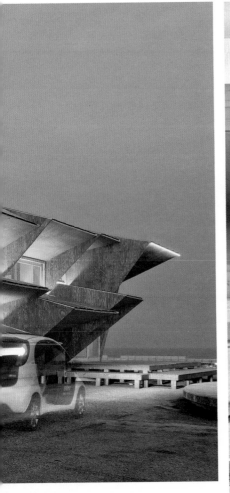

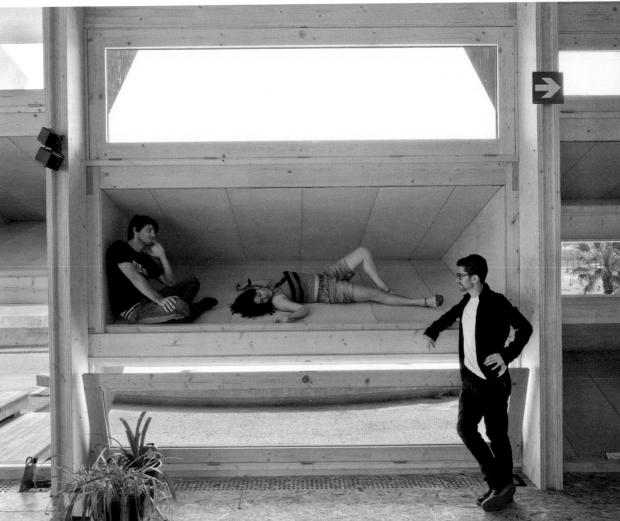

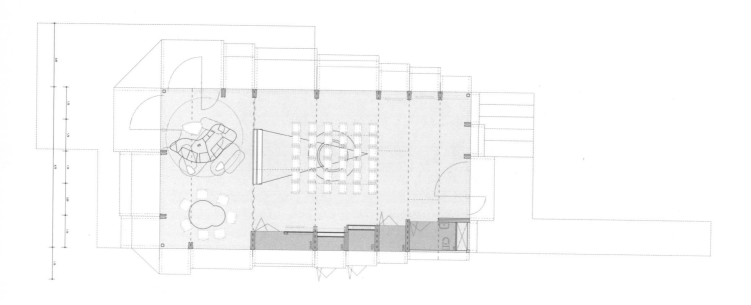

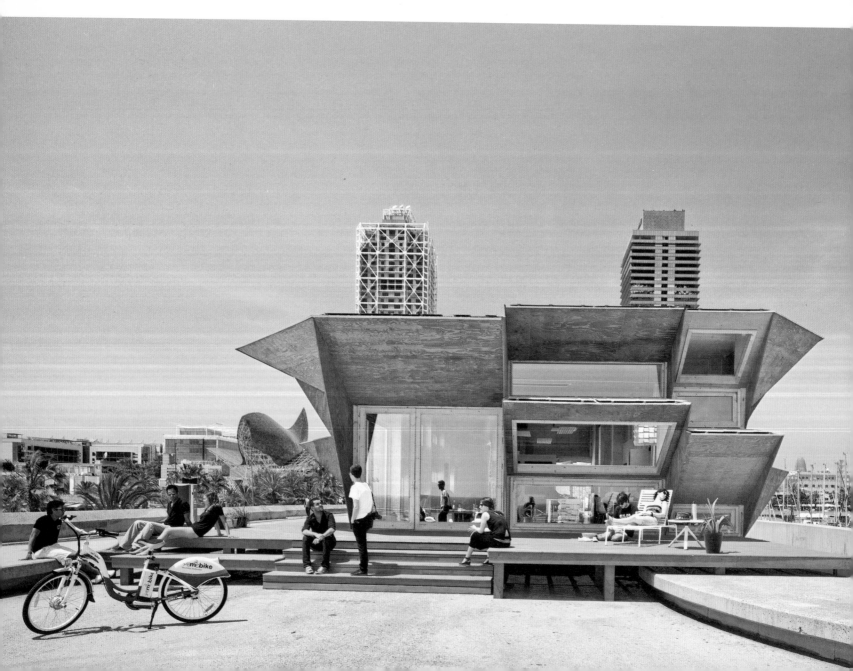

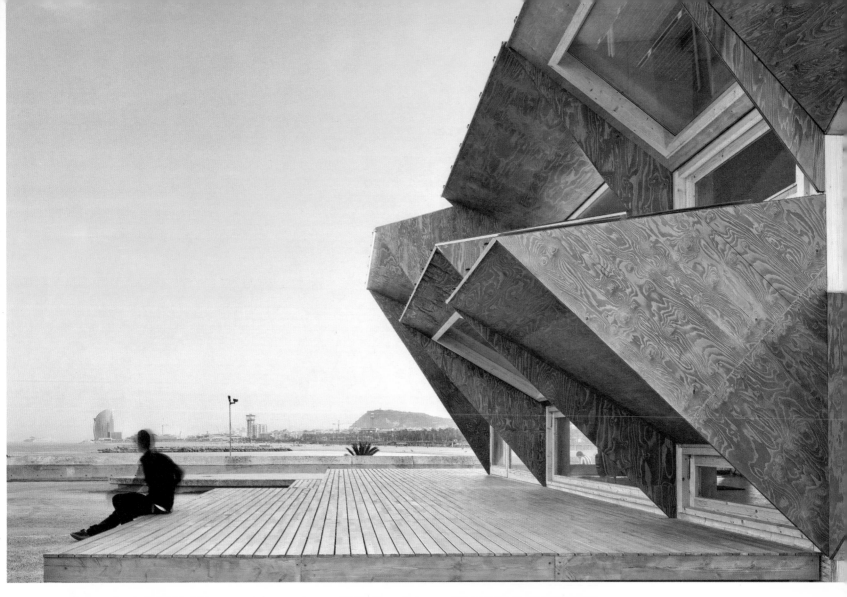

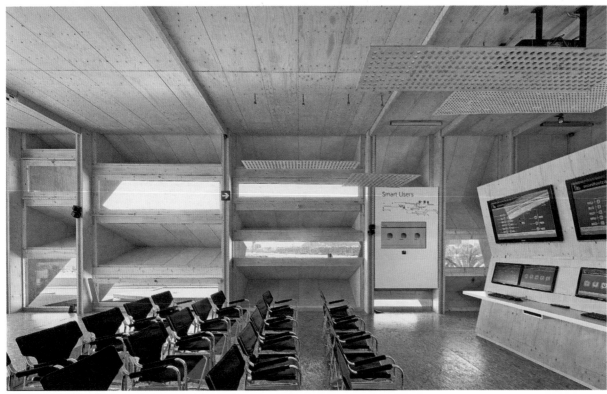

169

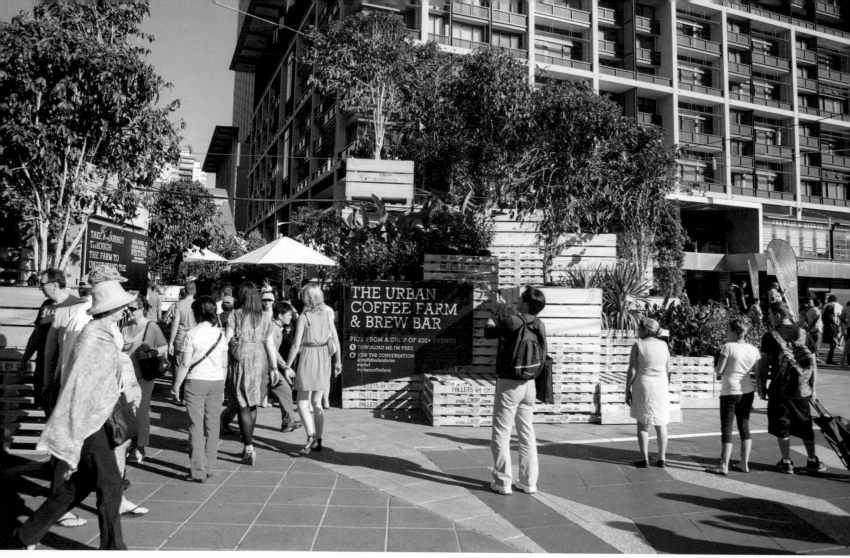

URBAN COFFEE FARM
AND BREW BAR

Sip coffee in the urban jungle. Just relax and watch the world go by.

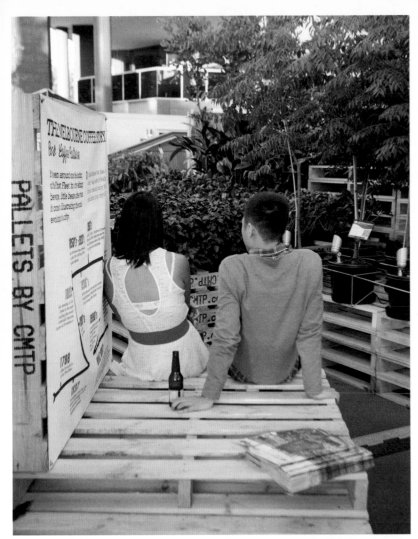

Splintering from Queensbridge Square's striking Red Stair, the Urban Coffee Farm and Brew Bar reinterpreted a terraced coffee farm in Melbourne's bustling CBD. Designed as the centerpiece of the 2013 Melbourne Food and Wine Festival, Hassell transplanted the remote environment of the world's coffee growing regions, using repurposed shipping containers, pallets and over 1,600 tropical plants and coffee trees to create an exotic 'urban jungle' for visitors to explore. The sculpted terrain integrated a Tasting Café and educational presentation zone offering a glimpse of the multi-billion dollar industry – from seedling to cup – and a chance to enjoy expertly brewed coffee in the unusually lush surrounds. Over 70,000 people visited throughout the festival – it brought the story of coffee to life, inspiring drinkers to think about its origins, production and transport.

Designer | Hassell
Project address | Melbourne, Victoria, Australia
Client | Melbourne Food and Wine Festival
Gross floor area | 800 m²
Existed | 1–17 March 2013

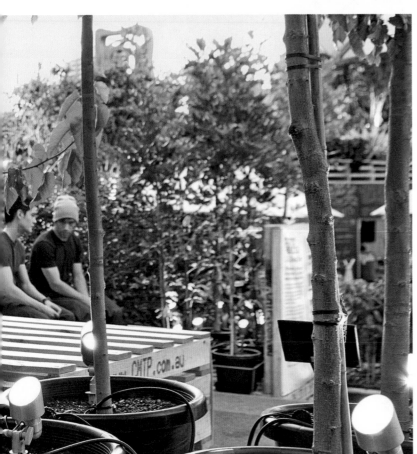

171

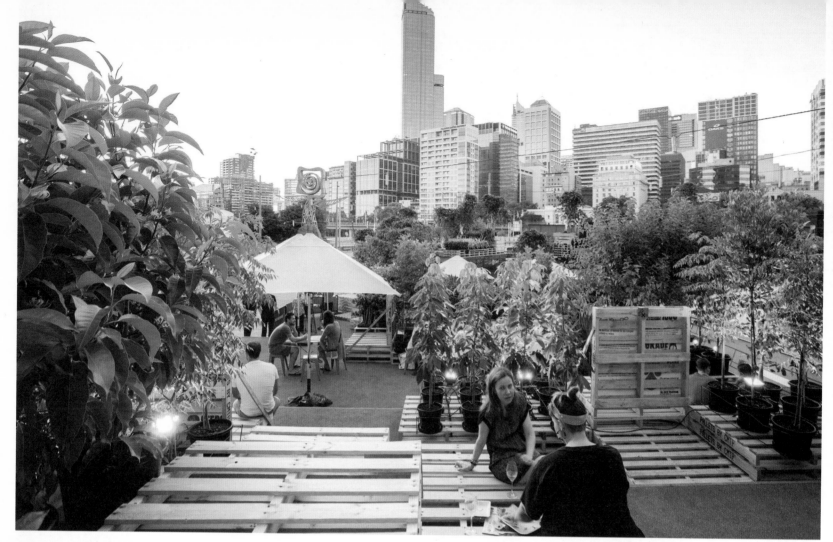

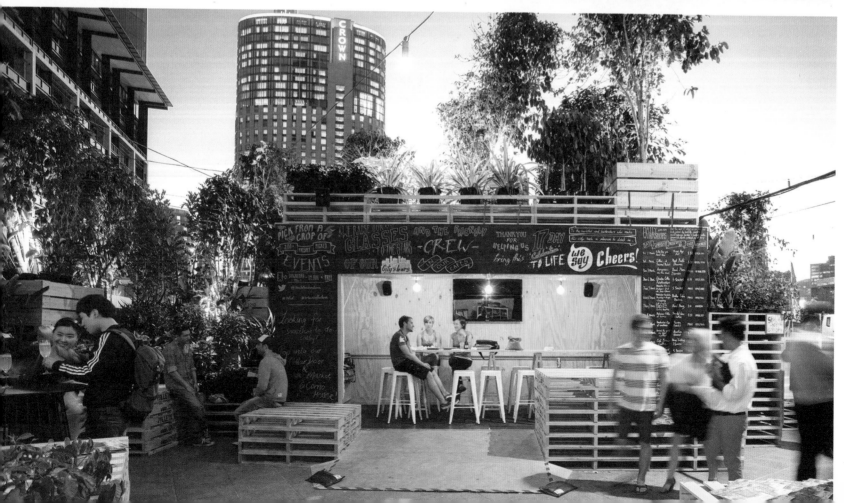

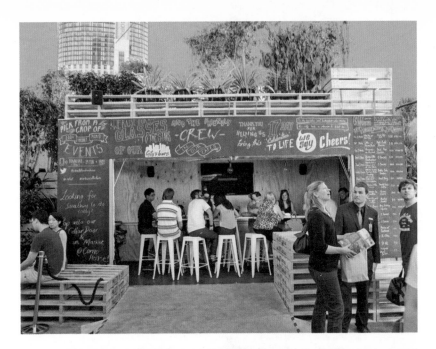

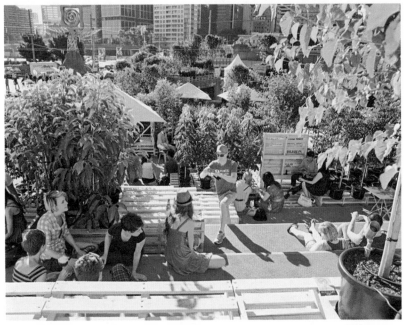

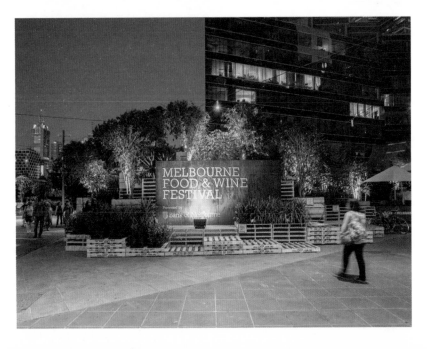

Architects | A&P – Architectures & Paysages – David Hamerman
Project address | Office de Tourisme, 55 Rue du Port, La Grande Motte, France
Client | FAV – Festival des Architectures Vives
Gross floor area | 10 m²
Existed | 19 June 2013–ongoing

La Grande Motte lies next to the Mediterranean Sea and is a testimony to the past. The iron structure is sculptural in nature and shares a strong dialogue with the nearby sea, curving over at the top like a wave breaking on the shore. The sculpture has a surprisingly soft appearance, and almost appears to move as one walks past it. The use of iron establishes a link between the sculpture and its surroundings, intricately connecting it to the place and thus establishing a work of art that occupies the space between nature and architecture.

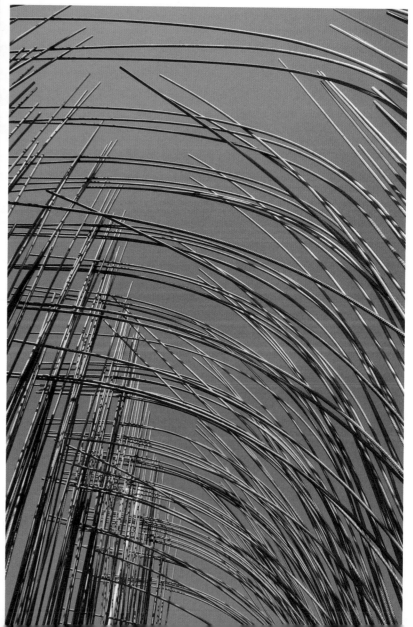

FAV PAVILION

La mémoire et la mer - steel waves that crash not on the shore, but above your head.

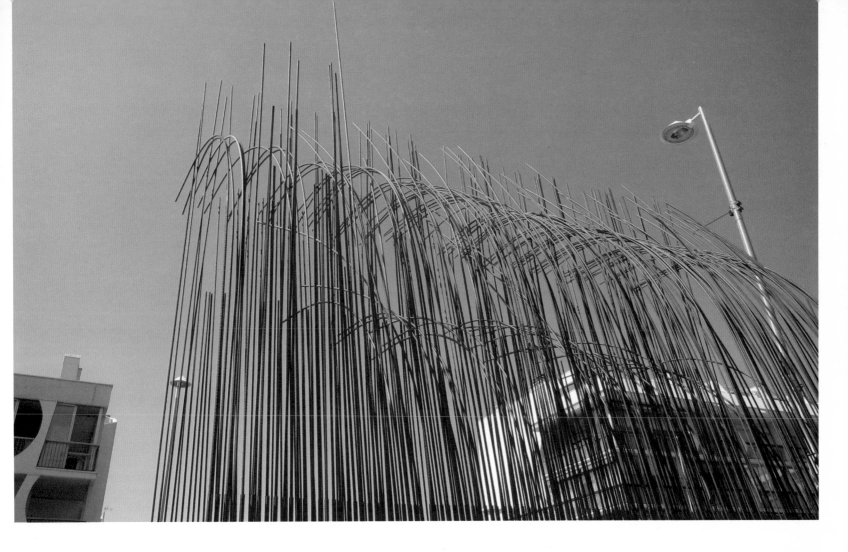

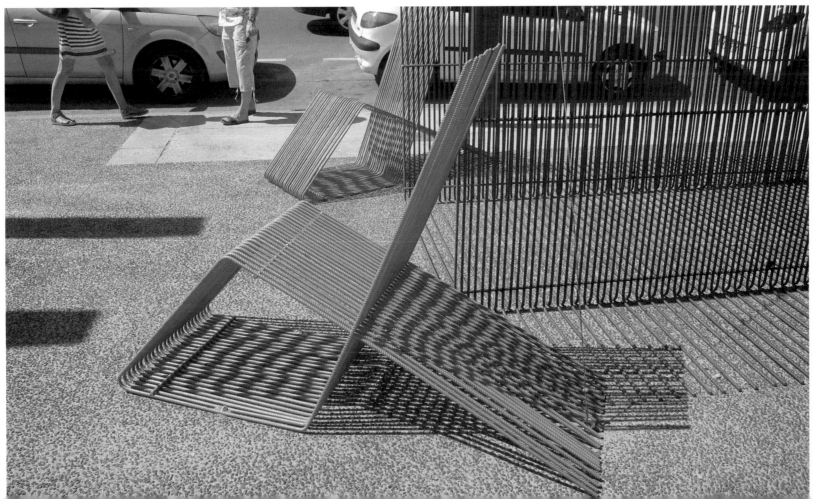

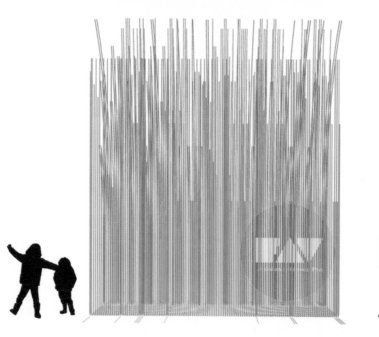

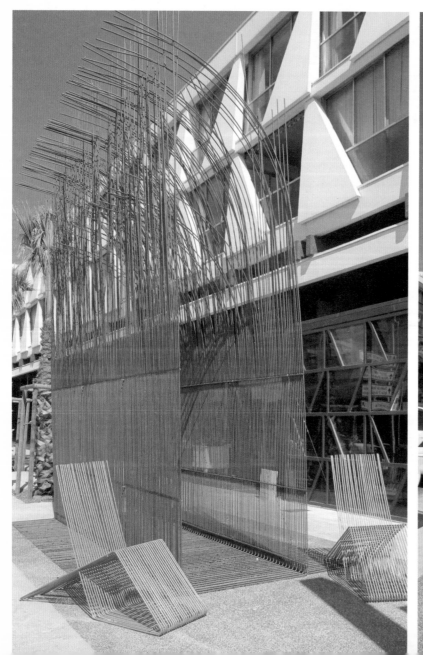

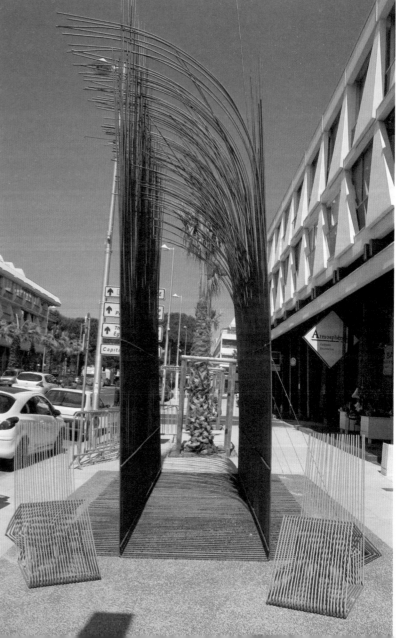

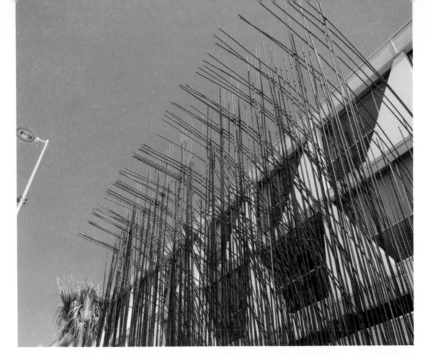

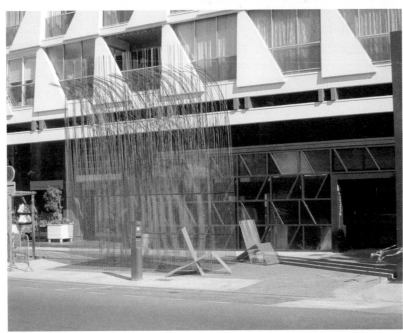

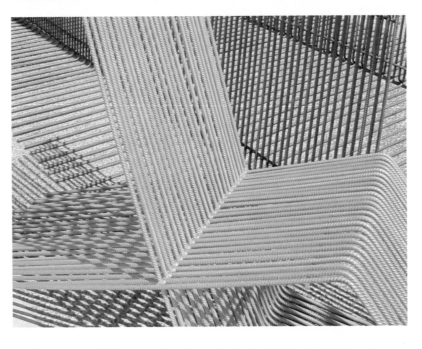

PLAYFUL

PROVISORY

TEMP

CAL

PR

PR

ECISE POLYMORPHIC

POSITIVE

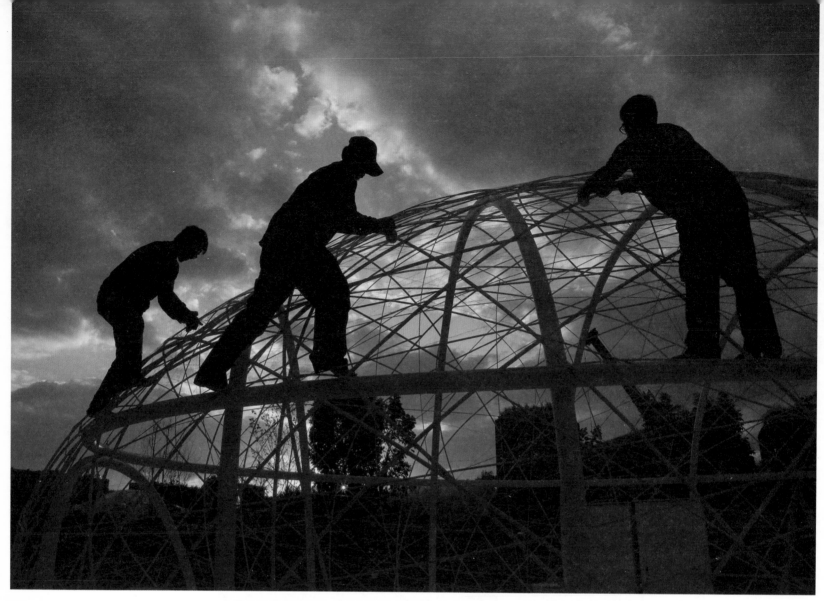

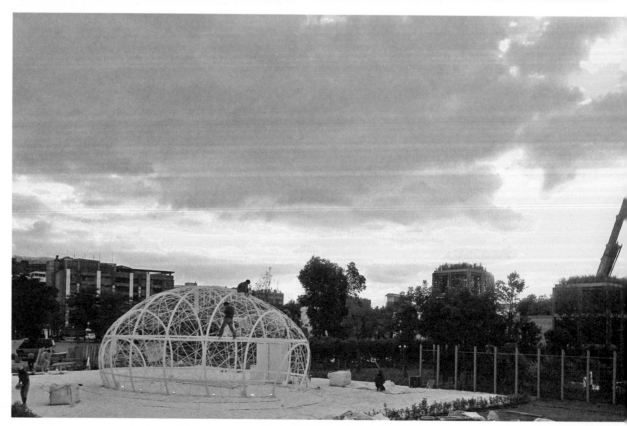

SILENT GARDEN

Will there be a butterfly? As an analogy of life, the
chrysalis works as a space to metamorphose.

Architects | studio patricia meneses
Project address | Taipei Fine Arts Museum, Global Garden Area 181, ZhongShan N. Road, Taipei, Taiwan
Client | Taipei City Government
Gross floor area | 600 m²
Existed | November 2010–March 2012

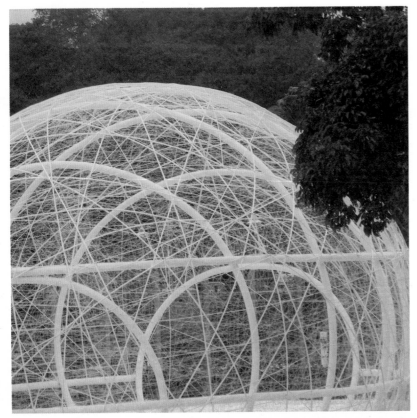

This project was based on extracting the essence of poetry. The design took the shape of a chrysalis; an analogy of life, the chrysalis works as a space to metamorphose. A silk garden, emerged from the earth as a chrysalis, a white luminous vault formed an inner space surrounded by nature. The project symbolized man's relationship with nature, and the built environment. The design is delicate and transparent, blurring the boundaries between what is natural and what is manmade. The outer shell was made woven thread and glowed at night, illuminated by the lights inside.

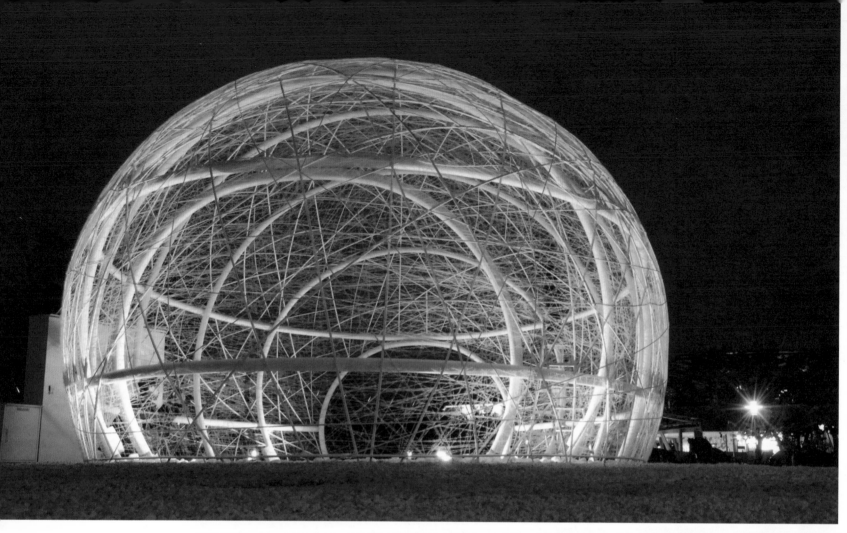

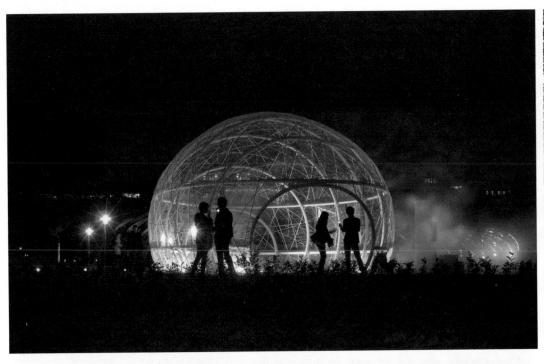
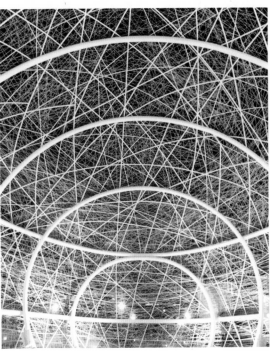

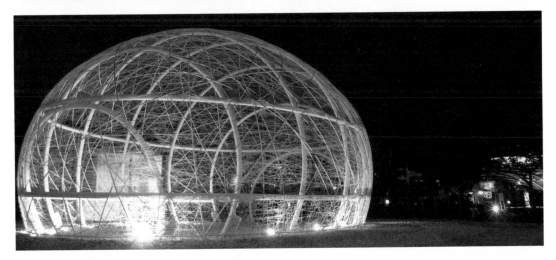

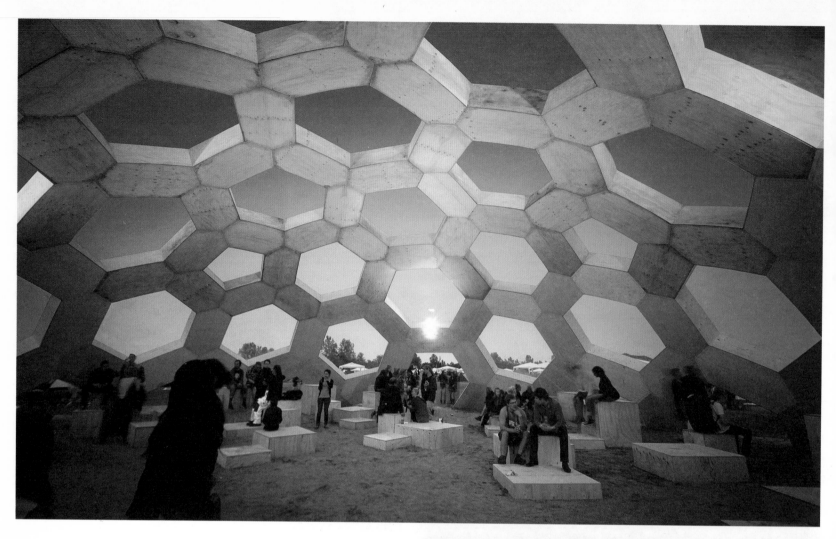

PLYWOOD DOME

Open your mind, celebrate, live. Iconic hippie architecture for the world-famous Roskilde Festival. What a match!

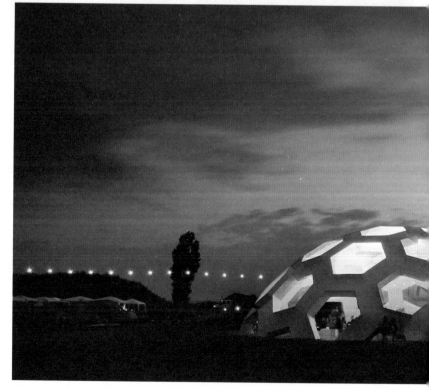

The Danish music festival, Roskilde Festival is a festival that promotes alternative lifestyles, raises awareness of environmental issues, and showcases alternative architecture on its grounds during festival days. These factors made it the perfect location for the construction of this dome. Built with a modular construction, the dome was put up for eight days, during which time it was the center of a diverse range of cultural events. During the day, a stage inside the dome hosted spoken word presentations, story telling and live drawing events. The Dome was clean, white and freshly painted at the opening of the festival, though after four days of parties, events and general high spirits, it needed a bit of a revitalization. The Danish collective of artists Ultragrøn gave the Dome a thorough going-over by painting it as one large color wheel for the last four days of the festival.

Architects | Tejlgaard & Jepsen
Project address | Roskilde Festival, Roskilde, Denmark
Client | Roskilde Festival
Gross floor area | 299 m²
Existed | 10 days in July 2011, 2012 and 2013

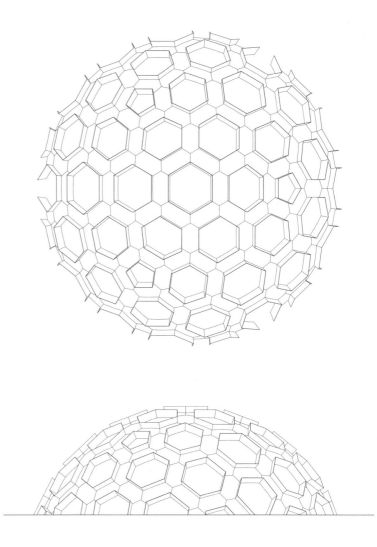

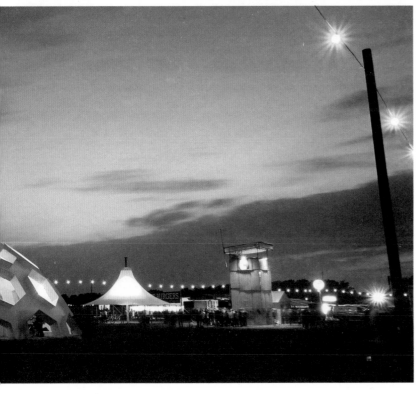

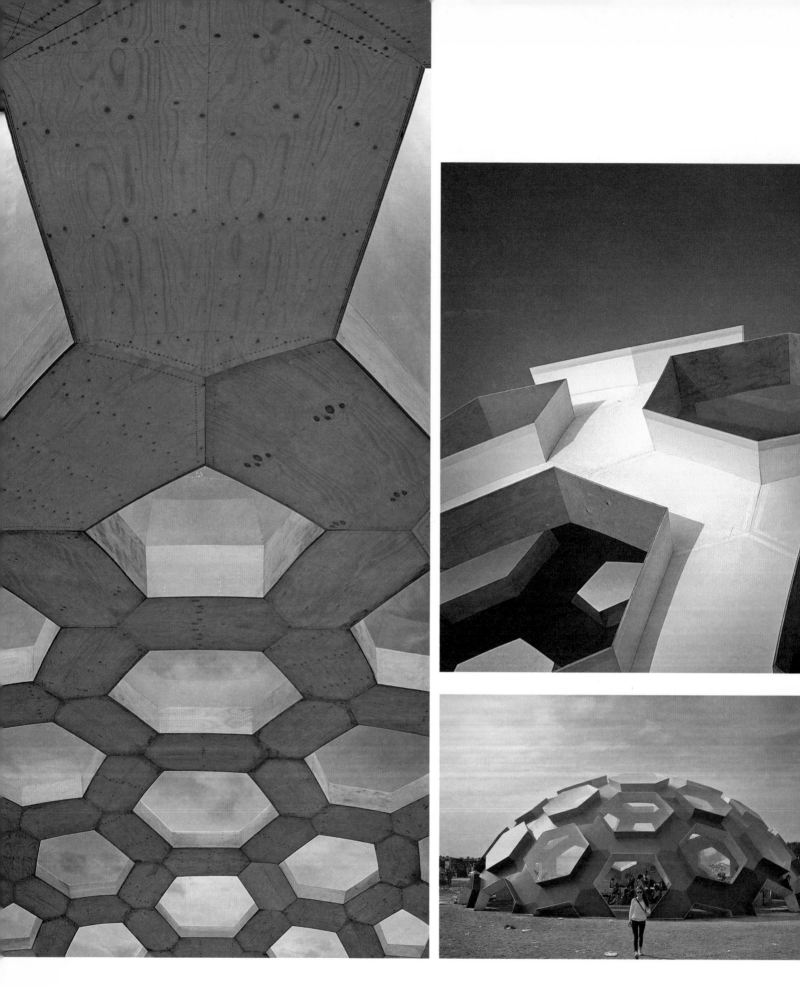

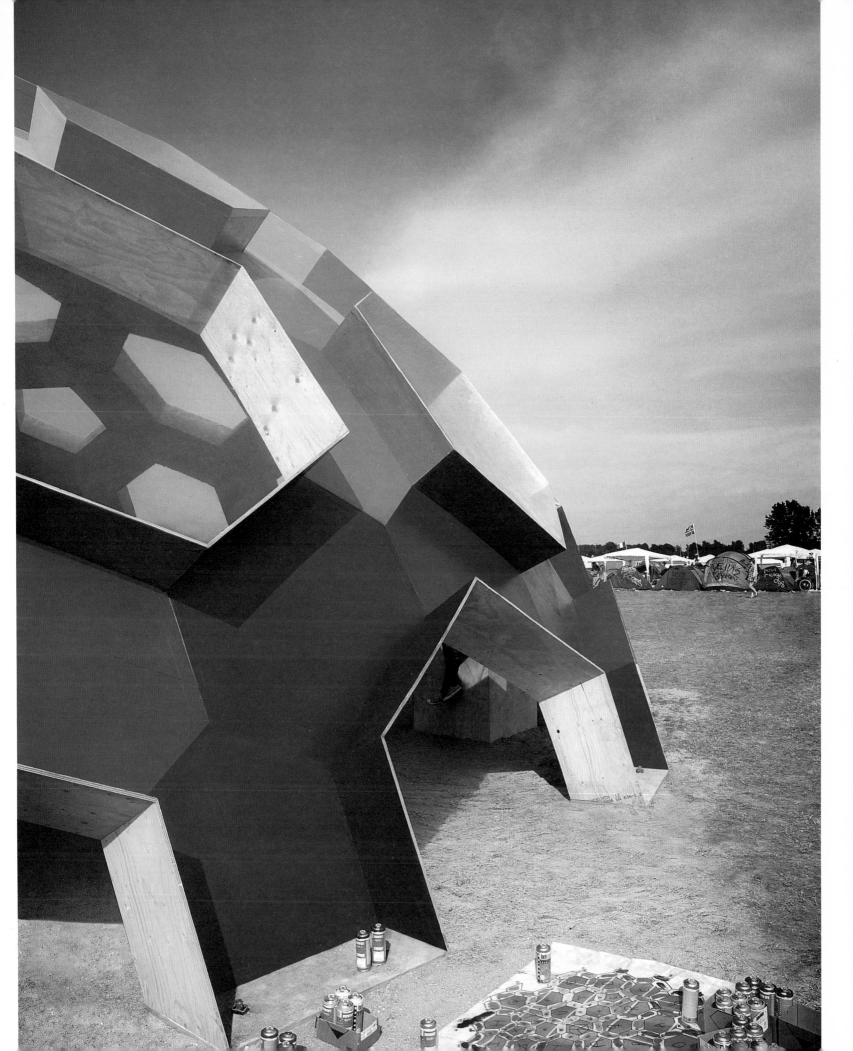

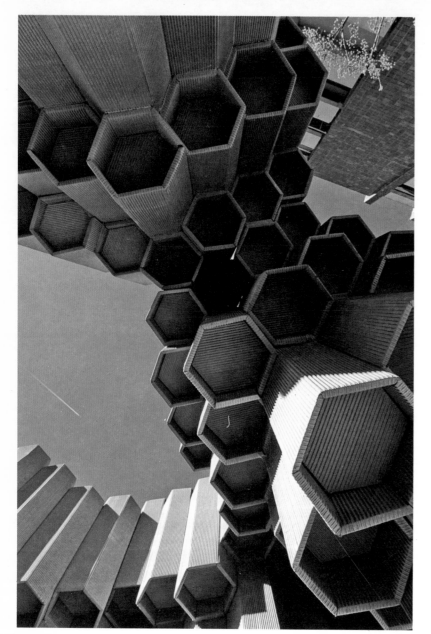

Architects | bipolaire arquitectos, pink intruder – Miguel Arraiz García/David Moreno Terrón
Project address | Calle Castielfabib, Valencia, Spain
Client | asociación cultural falla castielfabib marqués de san juan
Gross floor area | 130 m²
Existed | 14–19 March 2013

Each year the city of Valencia hosts Las Fallas. A five day festival of fire, Las Fallas sees artisans, artists and sculptors create story-high puppets – representing figures from pop culture, satirical comment and Spanish traditions – which are then set ablaze on the final night of festivities. This contribution to the festival was intended to promote interactivity. The designers created a grotto, assembled from some 3,000 corrugated cardboard tubes that were arranged into stalagmite and stalactite-like constellations. Devised as a contemplative space to escape the noise and fireworks, the pavilion allowed festival-goers to move freely, entering and leaving at will.

A BATTLE IS RAGING EVEN IF YOU'RE NOT AWARE OF IT

Is it a beehive? Is it an anthill? No, it's a small piece of tranquility right in the middle of the city. A place to escape the hustle and bustle and just 'be'.

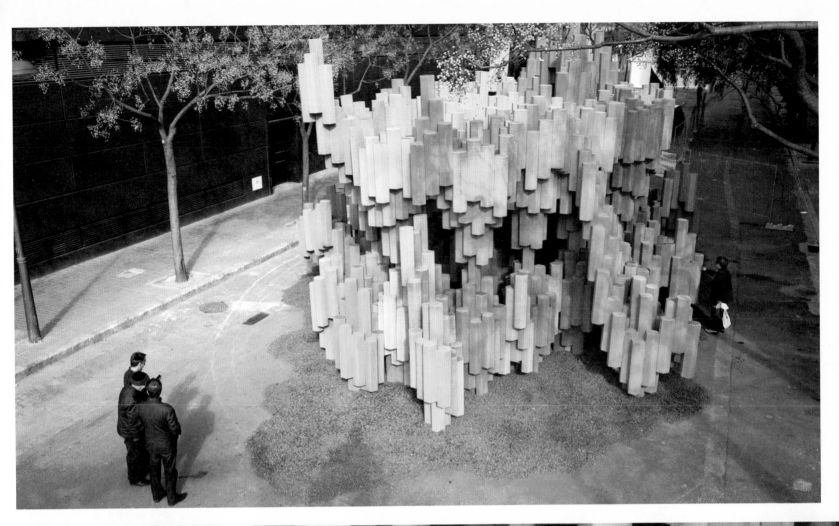

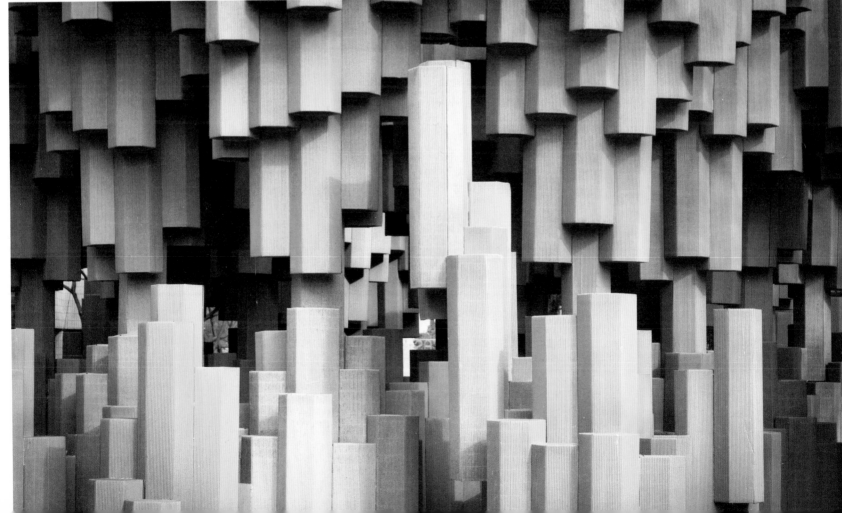

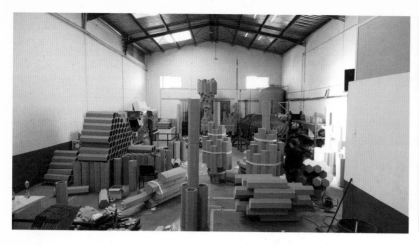
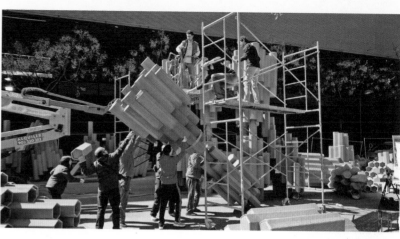
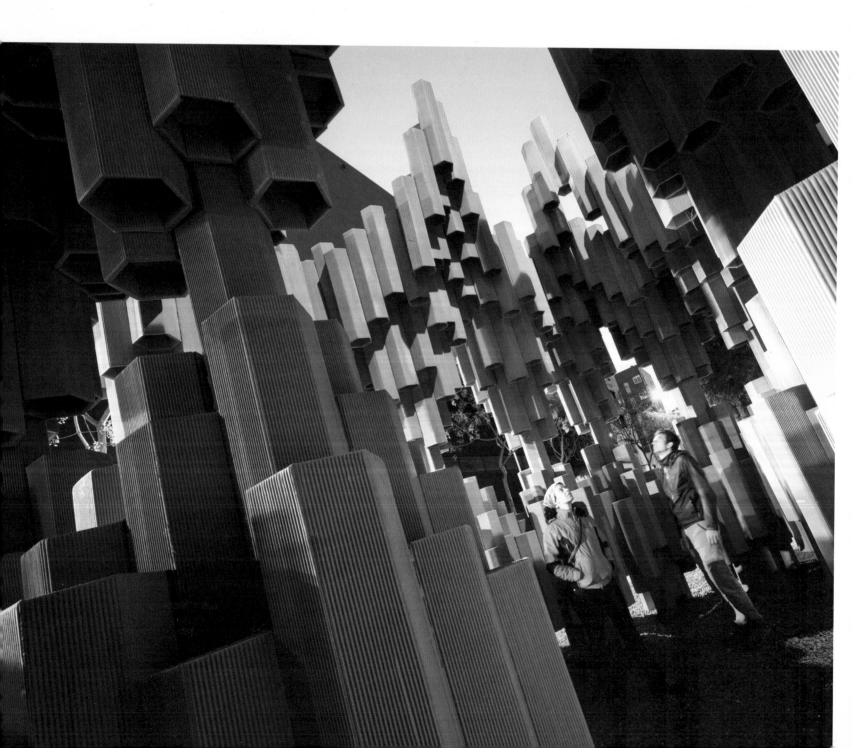

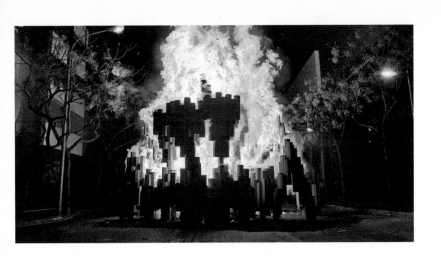

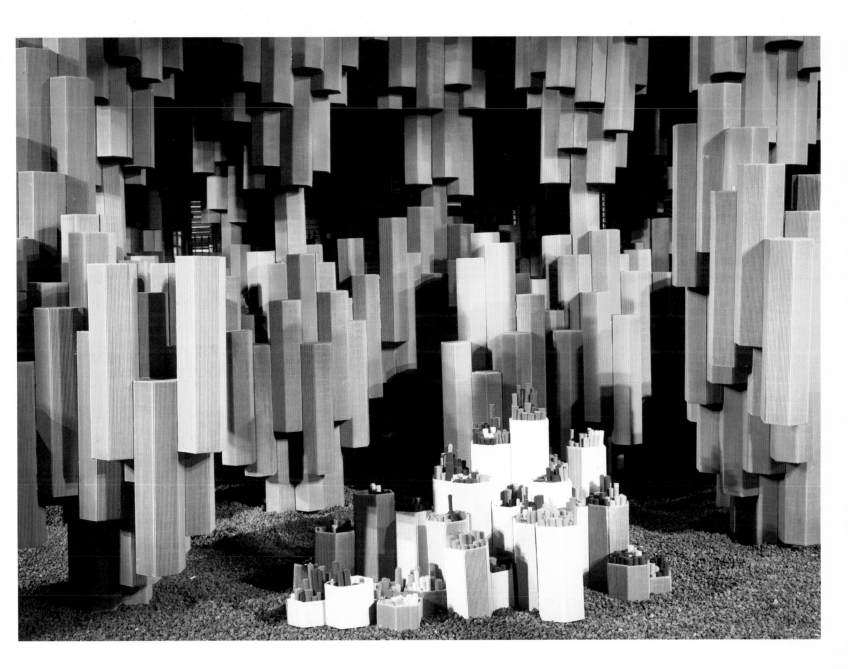

DOME OF VISIONS

A soap bubble on the shore and an artists' space in Copenhagen's harbor.

Architects | Tejlgaard & Jepsen, NCC, Next
Project address | Copenhagen harbor, Denmark and Aarhus harbor, Denmark
Client | NCC
Gross floor area | 350 m²
Existed | March–May 2013 in Copenhagen, June–October 2013 in Aarhus, March 2014–March 2015
Copenhagen Harbor

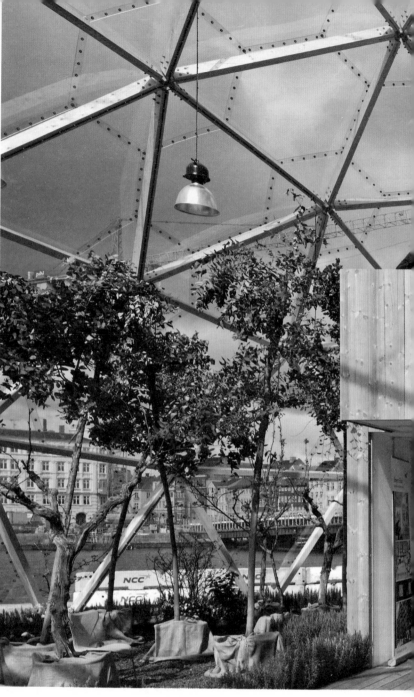

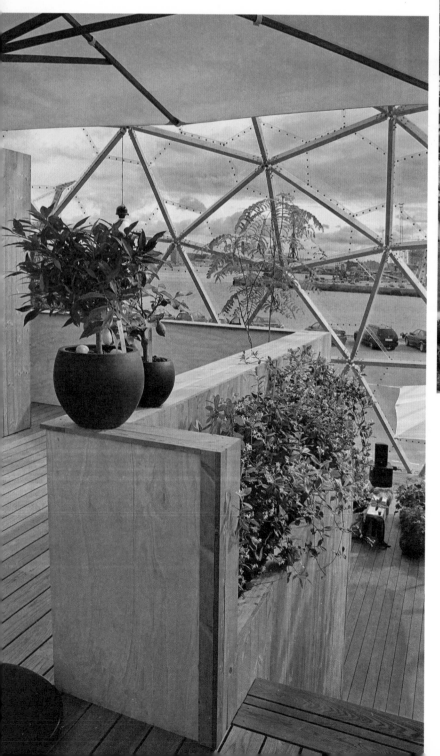

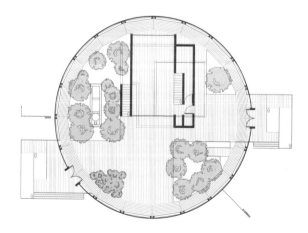

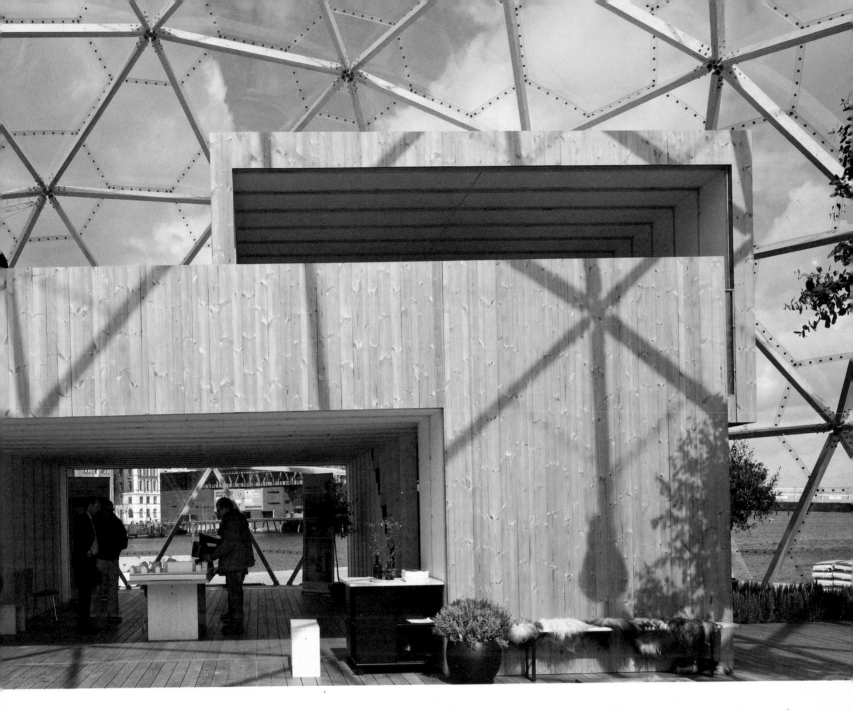

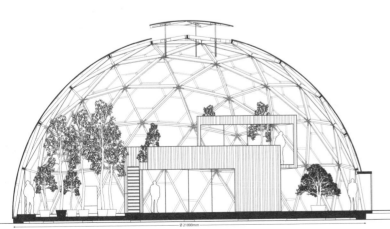

The Dome's fascinating and soap bubble-like look makes it an real eye-catcher, drawing both tourists and Danes to its location in the Copenhagen harbor, squeezed in between the world renowned restaurant Noma and Danish architect Nicolai Eigtved's old warehouse. The Dome of Visions was designed by the Danish architects Kristoffer Tejlgaard and Benny Jepsen and constructed in collaboration with NCC. The Dome of Visions invites artists from all over Europe inside and has already accommodated German eurotrash pop, an audio-accompanied and live transmitted space travel, modern dance performances, classical music as well as other artistic and cultural experiences. Dome of Visions also host debates on the future of sustainable and environmentally sound housing. This is achieved by talking to and showing the representatives from the Danish building sector the benefits of building in breathable materials.

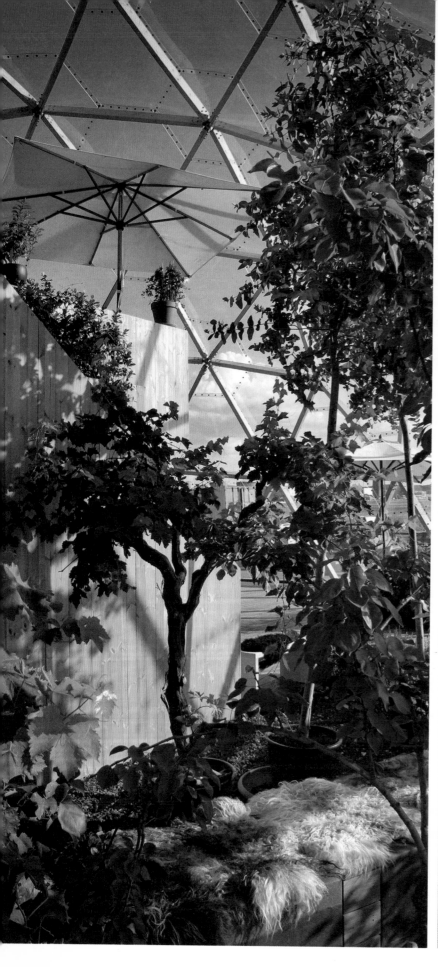

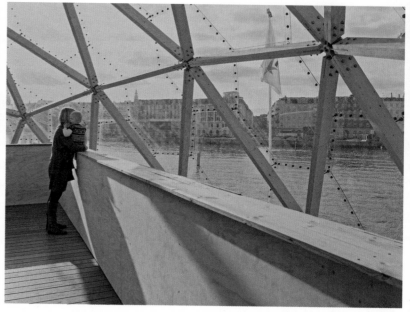

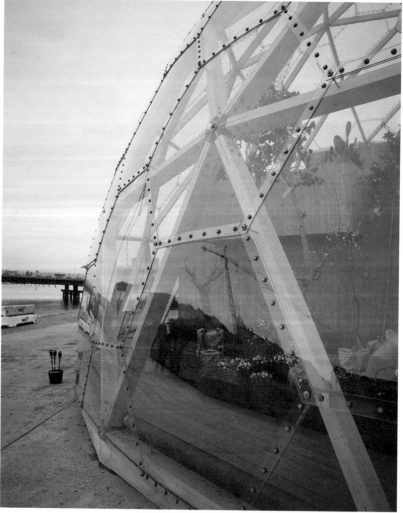

194

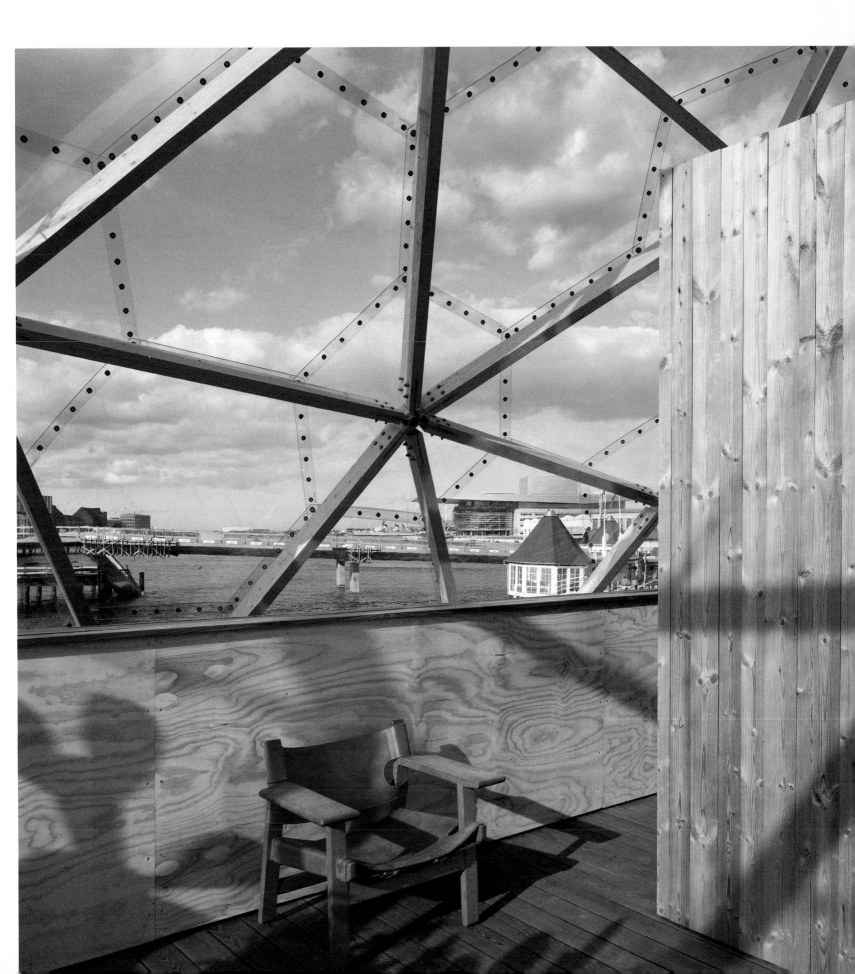

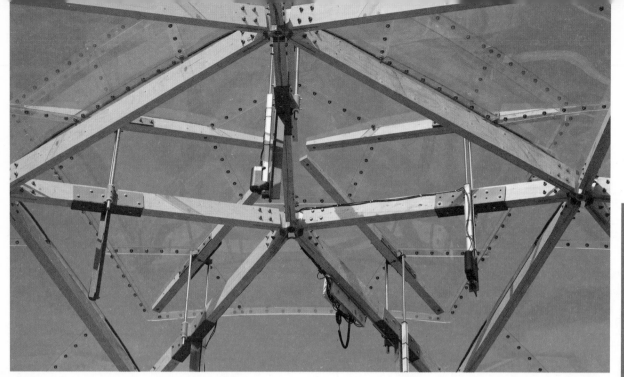

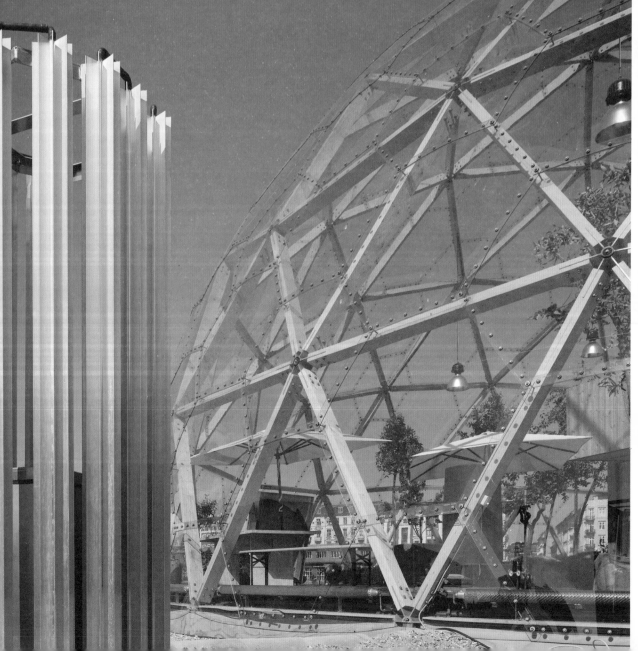

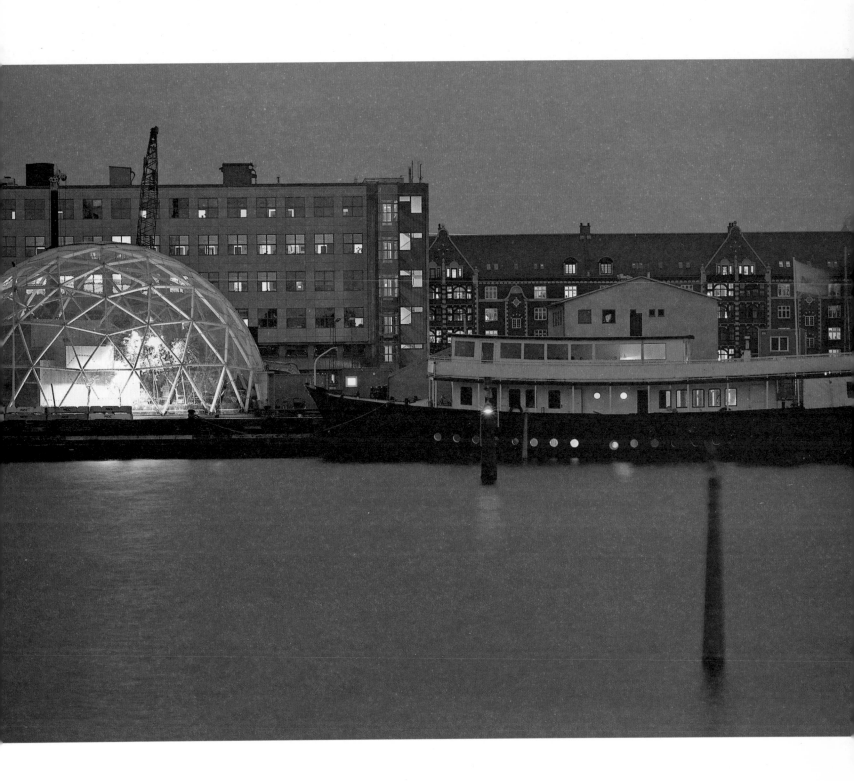

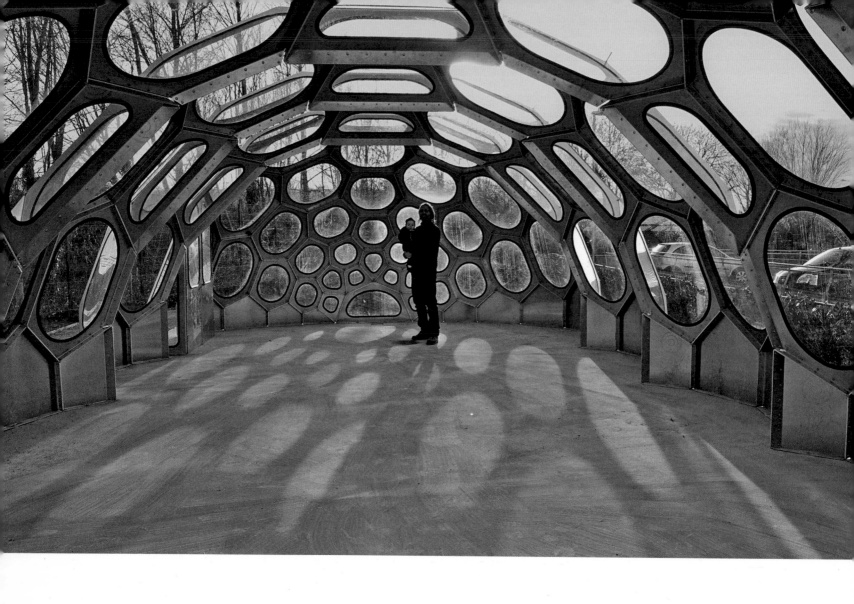

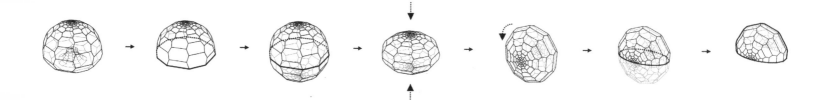

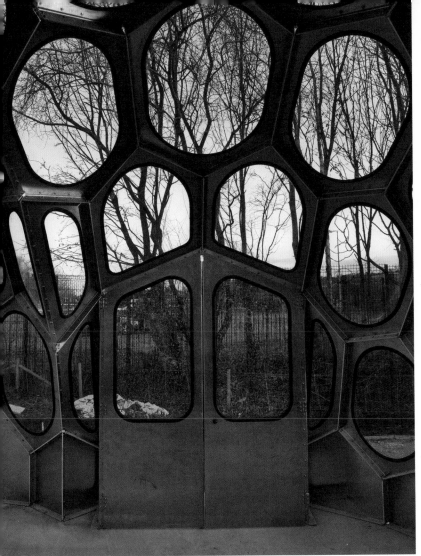

SPACEPLATES GREENHOUSE

Spaced out! This cool greenhouse creates the perfect environment for green-fingered students to grow plants all year round.

Wedged on on a small piece of land between large parking lots, the Spaceplates Greenhouse Bristol functions as a class room and growing space for horticulture students and their teachers, enabling them to study and grow plants all year round. The late Danish engineer Ture Wester identified an unexploited potential in using pure plate structures for constructing doubly curved surfaces of all sizes. This project takes up that challenge by means of a rigid, lightweight, self supporting, modular building system. Being a pure plate structure, there are no other structural members than thin plates of four-millimeter aluminum. No underlying lattice structure and no complicated detailing. The plates have been bent at all edges to achieve a simple, mechanical assembly method. While the design and the production require digital technology, the structure itself can be assembled using only hand tools.

Architects | N55, Anne Romme
Project address | South Bristol Skills Academy, The Boulevard Hengrove Park, Bristol, United Kingdom
Client | South Bristol Skills Academy
Gross floor area | 72 m²
Existed | 2012–ongoing

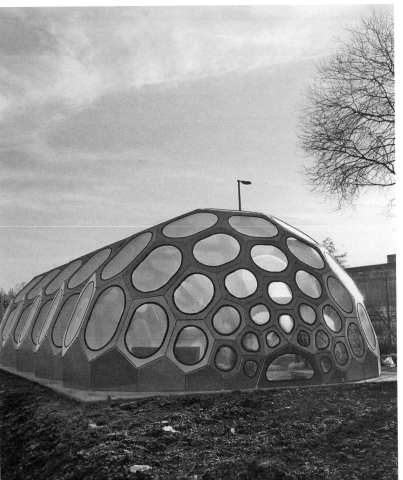

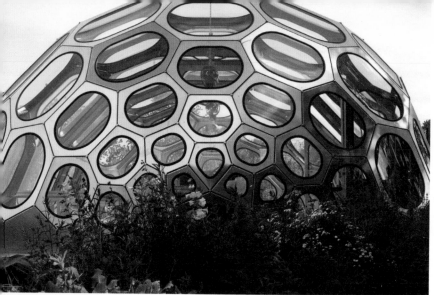

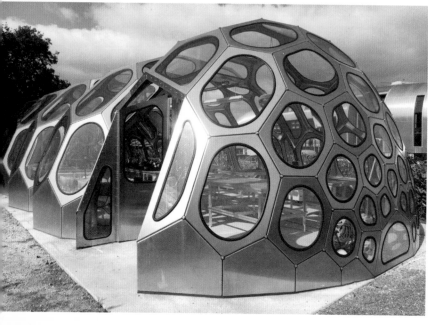

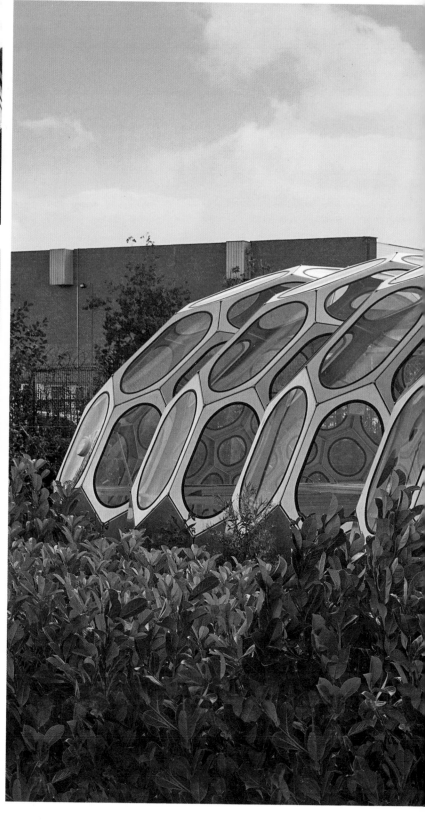

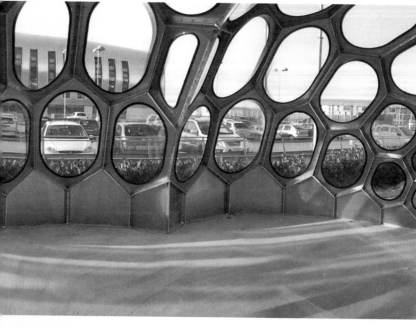

200

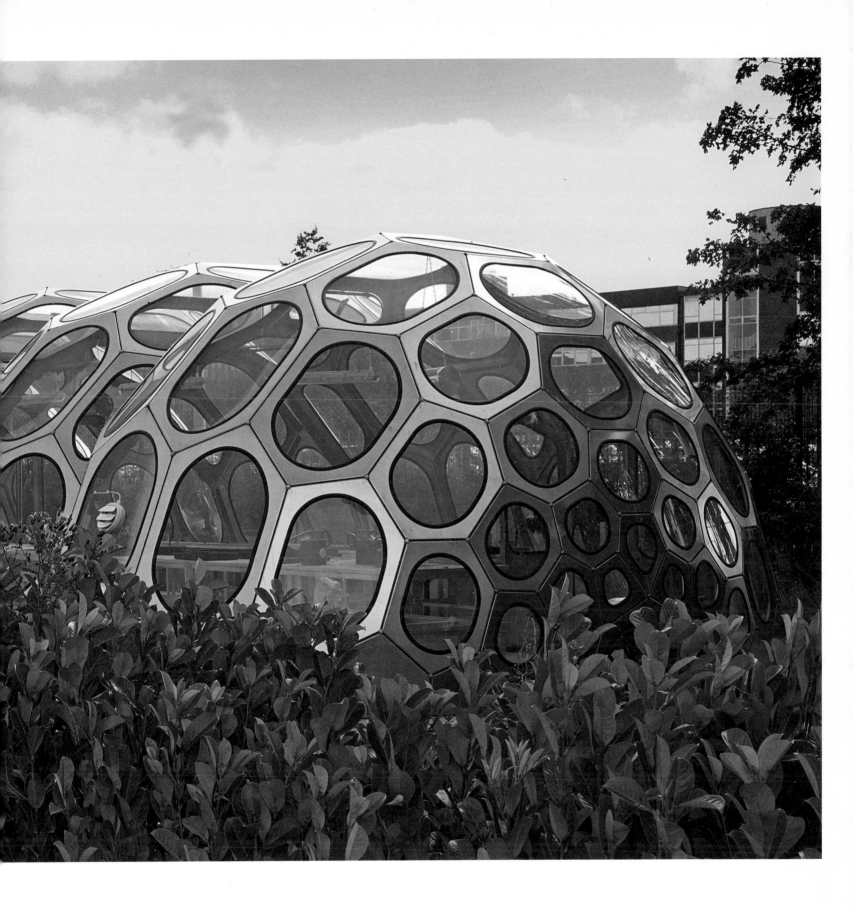

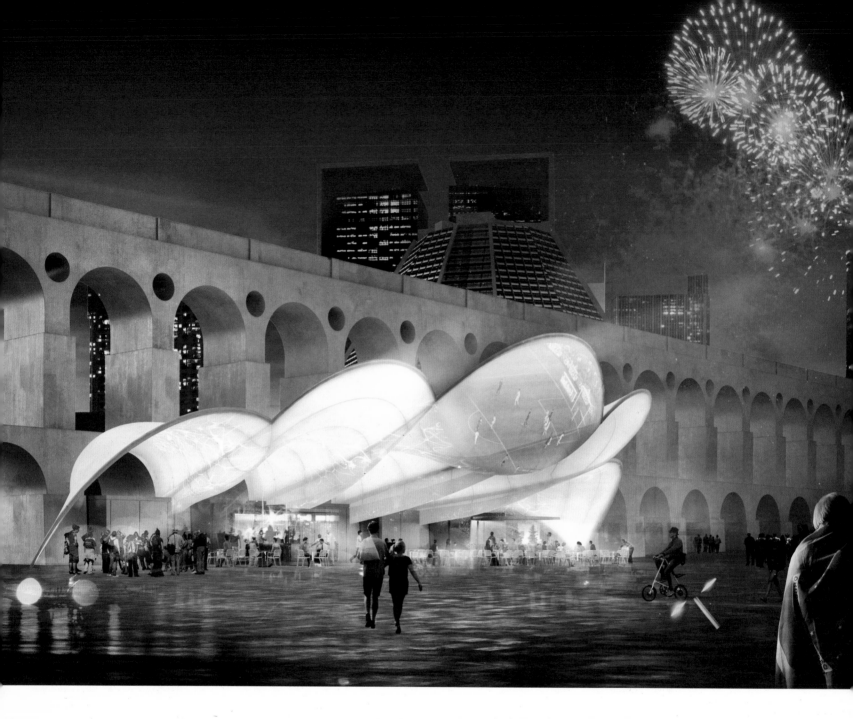

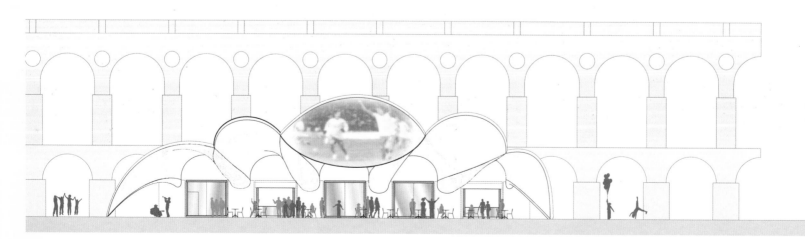

202

WING OF GLORY – PAVILION FOR THE 2014 FIFA WORLD CUP

All in one rhythm; even the architecture. Symbolizing the World Cup's spirit, Wings of Glory merges seamlessly with the historic Arcos de Lapa.

This project won first prize at the Symbolic World Cup Structure Competition. The structure doesn't just stand somewhere in the middle of the square like an alien object, but rather seeks to establish a coherent link with the structuring spine and main landmark of the site, the Arcos de Lapa. The aqueduct physically supports the structure, but also defines its initial profile. The wing profile stems from the regular, semi-circular arches shapes and then evolves freely as it gets further from the aqueduct. The wing itself is made of an inflated fabric membrane supported by a light tubular aluminum frame in order to cause minimal stress and impact on the aqueduct pillars. All of the functional spaces are housed in boxes that slide between the arches. Instead of installing a traditional large screen, the membrane itself acts as a projection screen, offering a large viewing area in its central part.

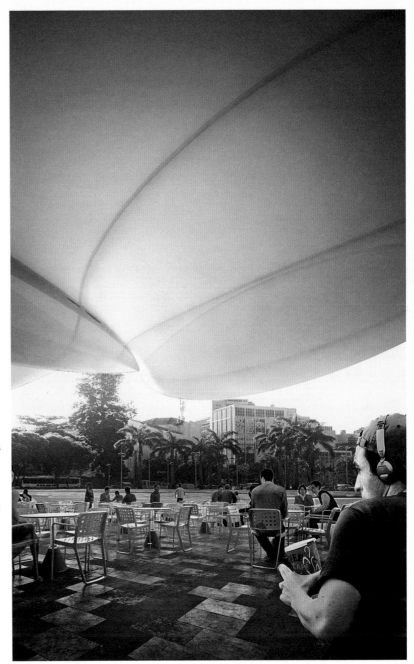

Architects | mekene
Project address | Lapa square, Rio de Janeiro, Brasil
Client | AC-CA
Gross floor area | 400 m²
Existed | June–July 2014

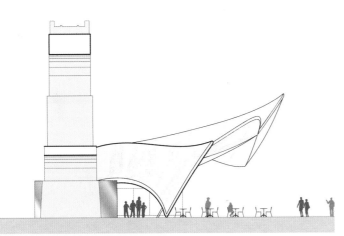

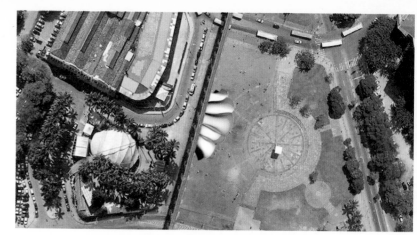

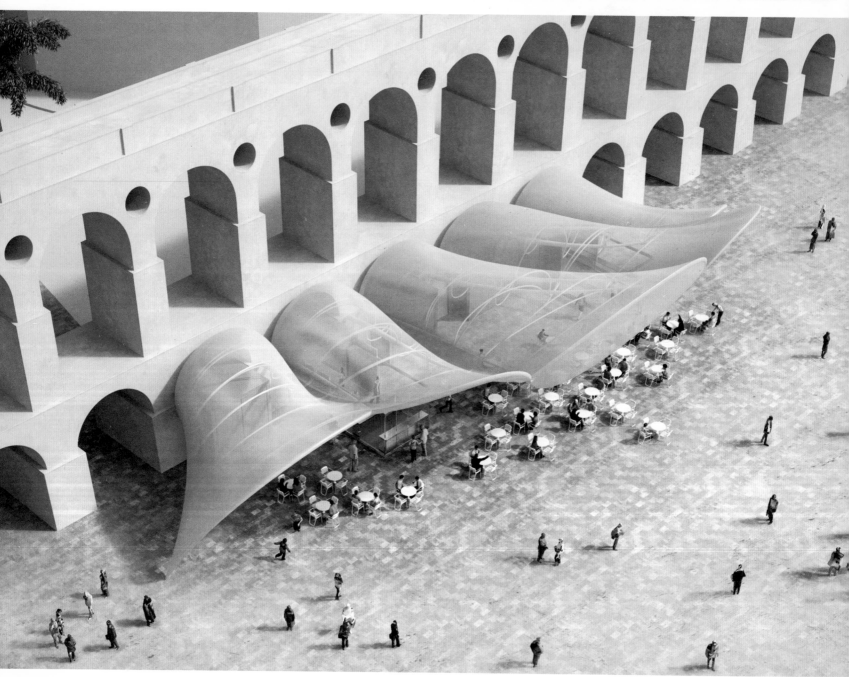

204

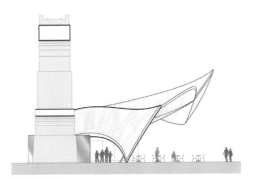

1 Information area
2 Souvenir shop
3 Café and snack
4 Projection screen
5 Storage
6 Office
7 Plant
8 Changing Room
9 Toilets

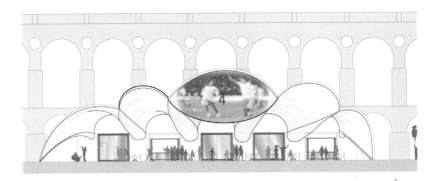

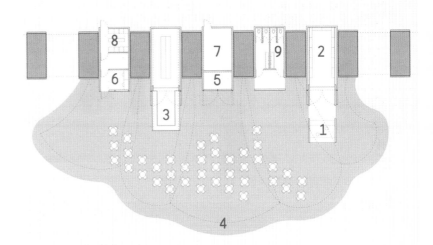

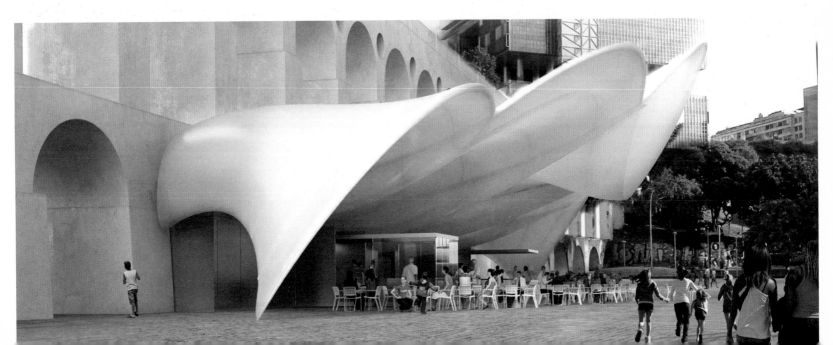

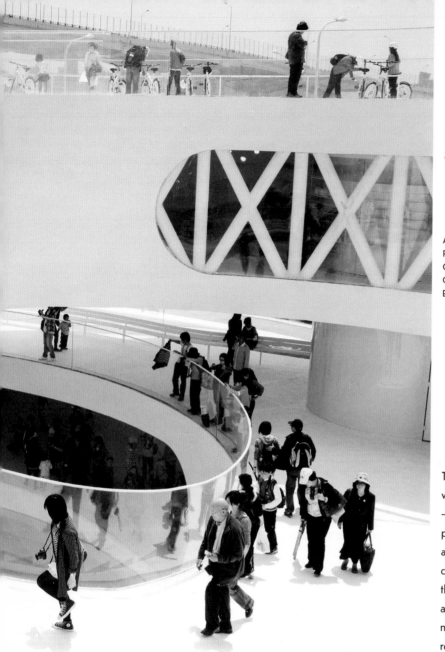

DANISH PAVILION – EXPO 2010 SHANGHAI

BIG's educational mandate: Promoting pedal power all over the world.

Architects | BIG
Project address | Shanghai, China
Client | Erhvervs-og Byggestyrelsen, Denmark
Gross floor area | 3,000 m²
Existed | 1 May–31 October 2010

The Danish pavilion not only exhibited Danish virtues: Through interaction, visitors were able to actually experience some of Copenhagen's best attractions – the city bike, the harbor bath, the playground and picnicking. The bike is a popular means of transportation and a national symbol – common to Denmark and China. In recent years, however, it has had a very different fate in the two countries. Visitors could move around the pavilion on city bikes that were free for the guests to use. The building was designed as a double spiral with pedestrian and cycle lanes leading from the ground and through curves up to a level of 12 meters and down again. The polluting activities in Copenhagen's harbors were replaced by harbor parks and cultural institutions. In the middle of The Harbor Pool at the center of the pavilion, The Little Mermaid sat exactly as she usually sits in Copenhagen.

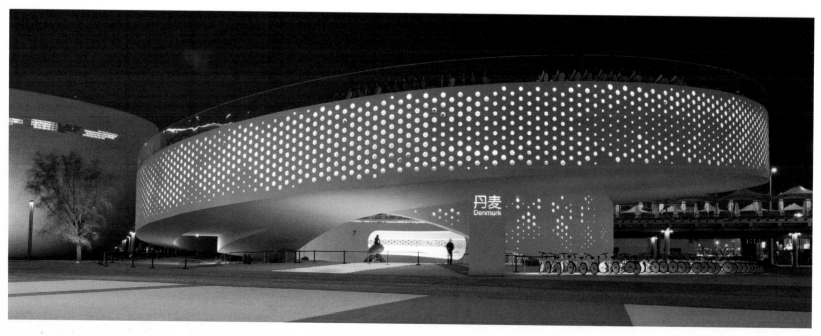

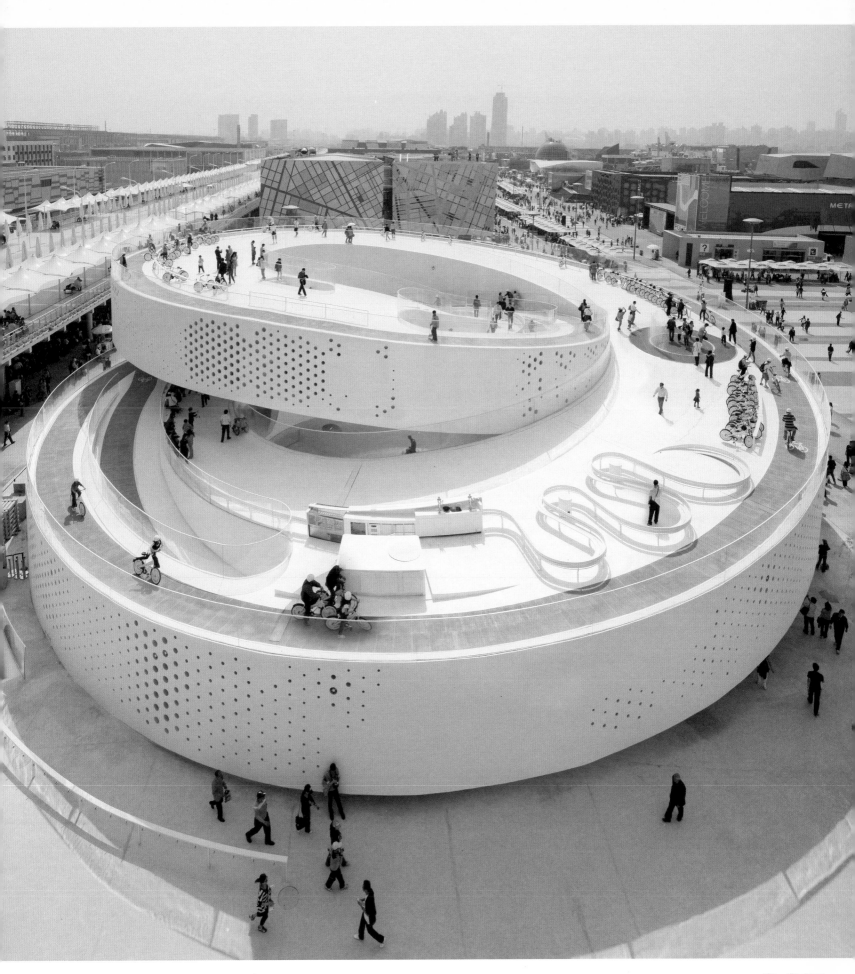

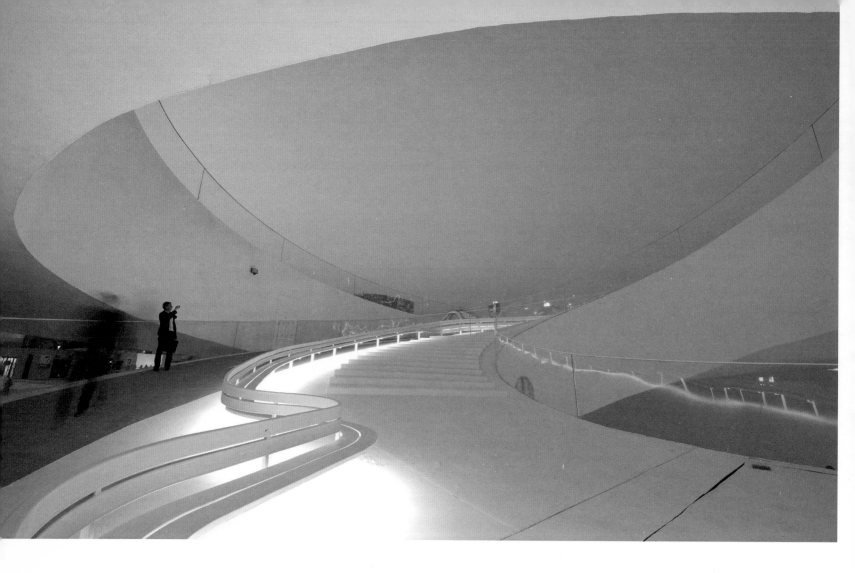

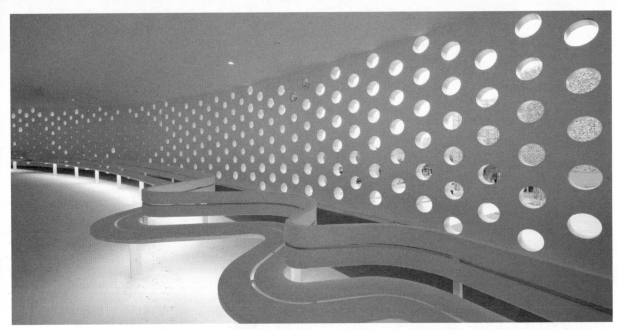

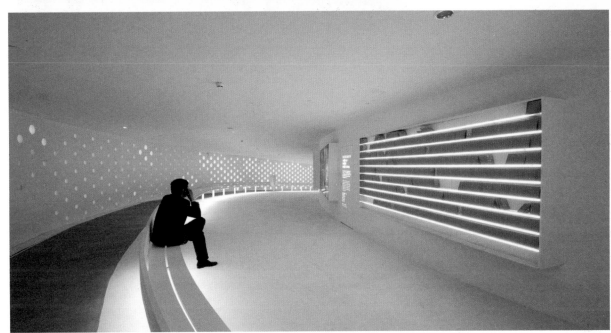

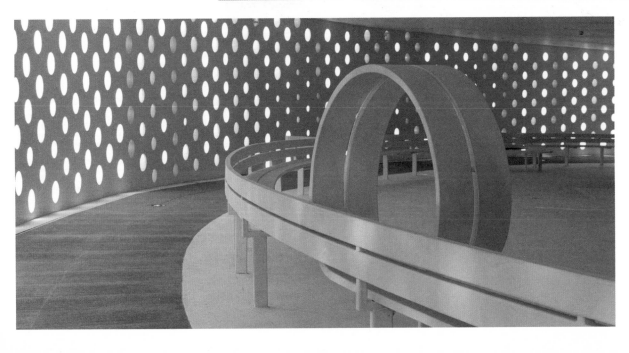

209

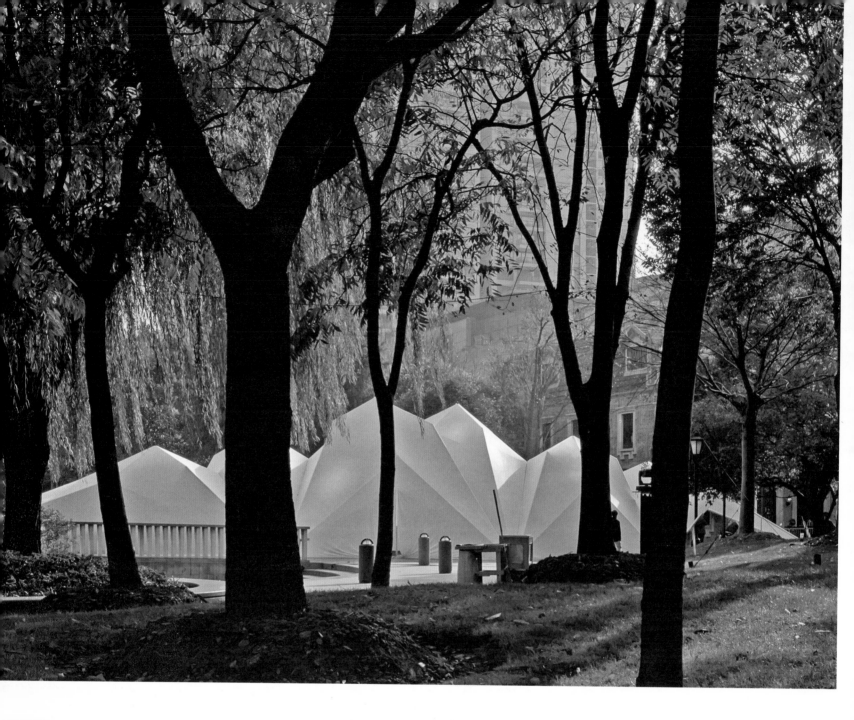

HHDFUN architects, Beijing, presented a transformable temporary structure for the JNBY and Cotton USA fashion show, held in Shanghai, which had an ability to take on numerous different forms. The unique structural design was created based on the formation of origami triangles, combined with the use of the latest parametric design tools and topological analysis. The whole structure consisted of six inter-locking components, sharing three varied designs. Each design was achieved from a process of continuous deformation and manipulation of one triangular surface, resulting in a shape that corresponds to the overall layout. The archways have dimensions that correspond to other archways and so increasing the number of possible overall forms. Once fully constructed, the form can span a total sheltered area of 150 square meters.

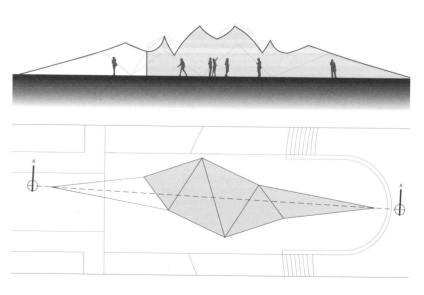

JNBY

Oh my, origami. Fold it, shape, it, twist it, build it. There are no boundaries in architecture when there are none in your mind.

Architects | HHDFUN
Project address | Shanghai, China
Client | JNBY
Gross floor area | 150 m²
Existed | October–November 2010

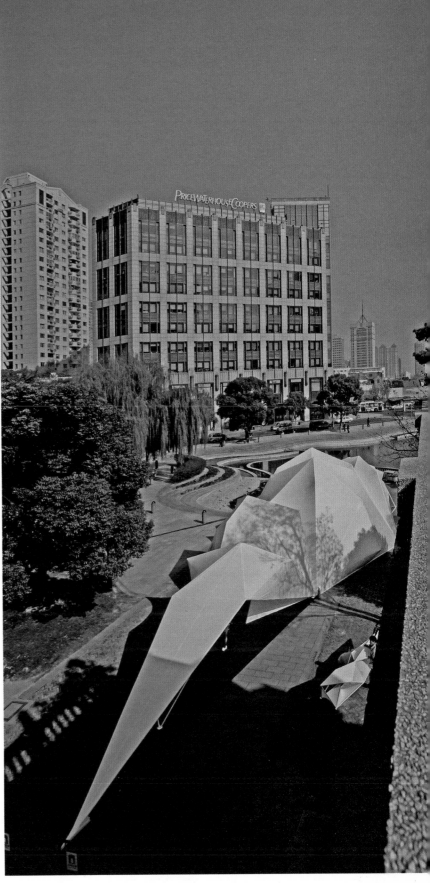

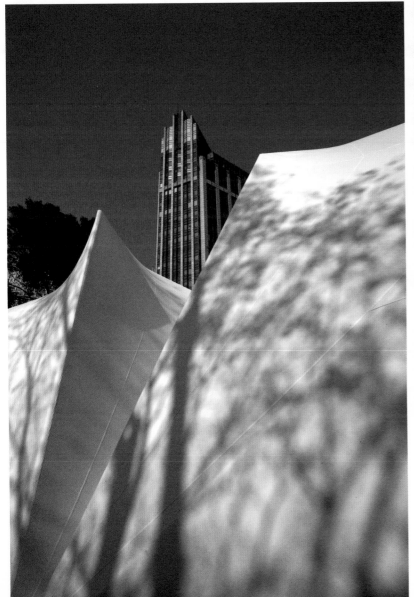

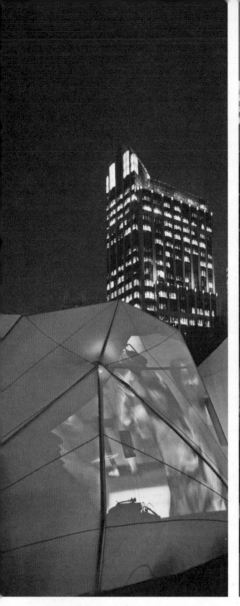
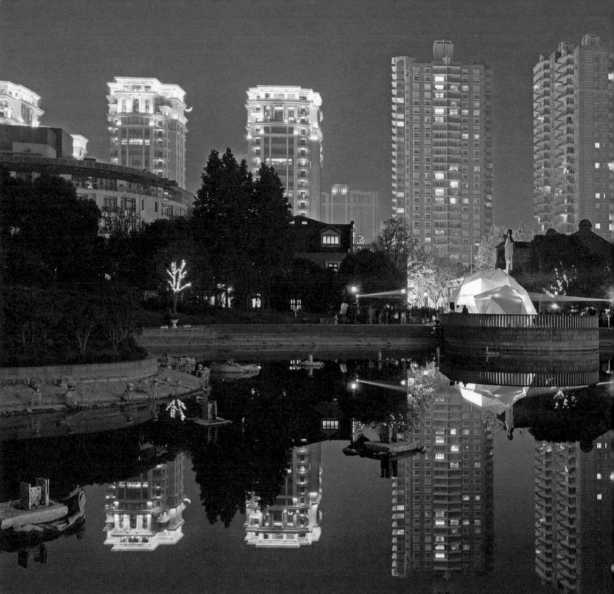
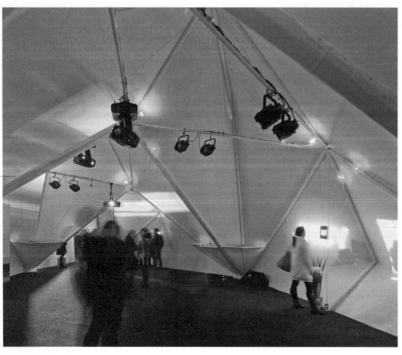

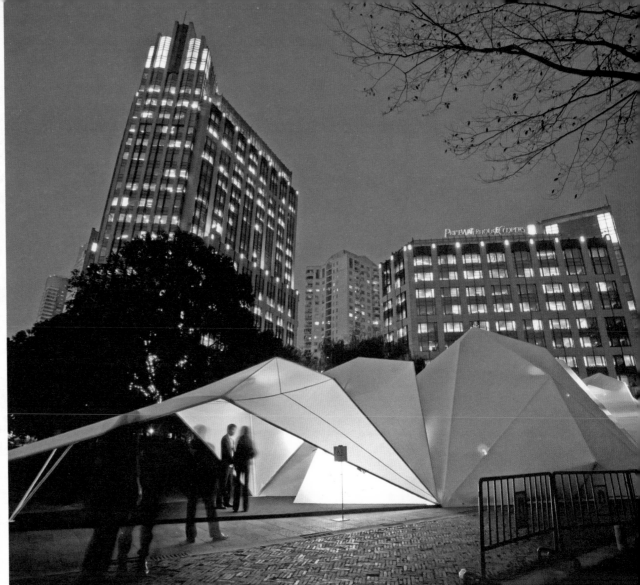

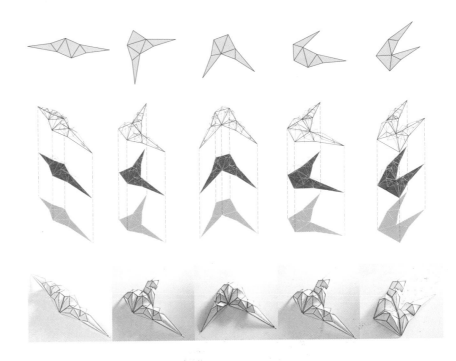

MEHRZELLER

Is it a car? Is it a caravan? No it's a flexible, funky and unendingly cool mobile paradise.

Architects | Nonstandard
Project address | anywhere
Client | confidential
Gross floor area | 12.2 m²
Existed | 2008–ongoing

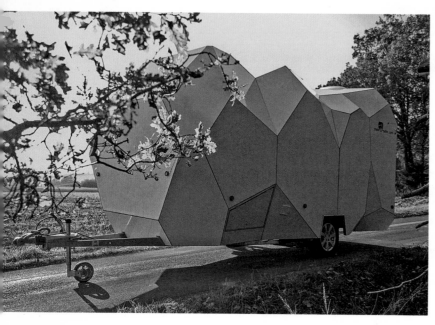

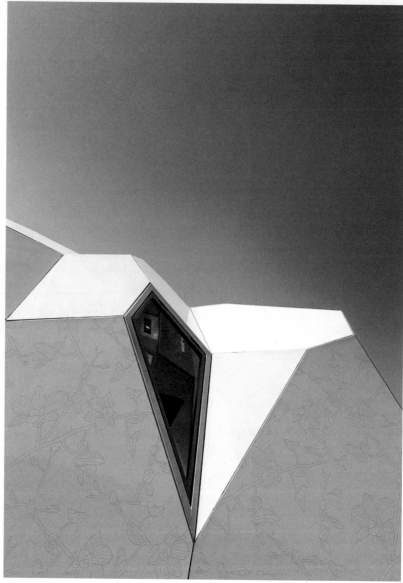

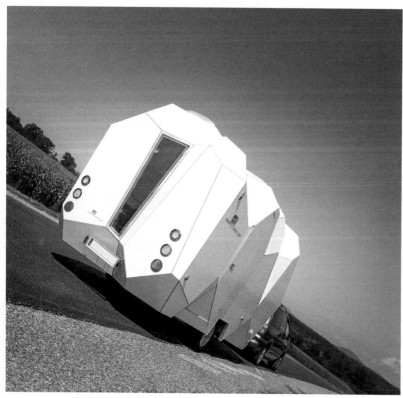

Mobility, together with work and living, have taken on increasingly important roles in our modern fast-paced world. Modern society revolves increasingly around the idea of the modern nomad and firmly rooted patterns are changing. This design responds to these changes and offers both mobile and flexible solutions for individuals. The parametric design methods allow the combination of various spatial functions. Furnishings blend with the exterior shell, creating a new spatial effect. The design flows directly into the productions. Mehrzeller presents a new generation of mobile living.

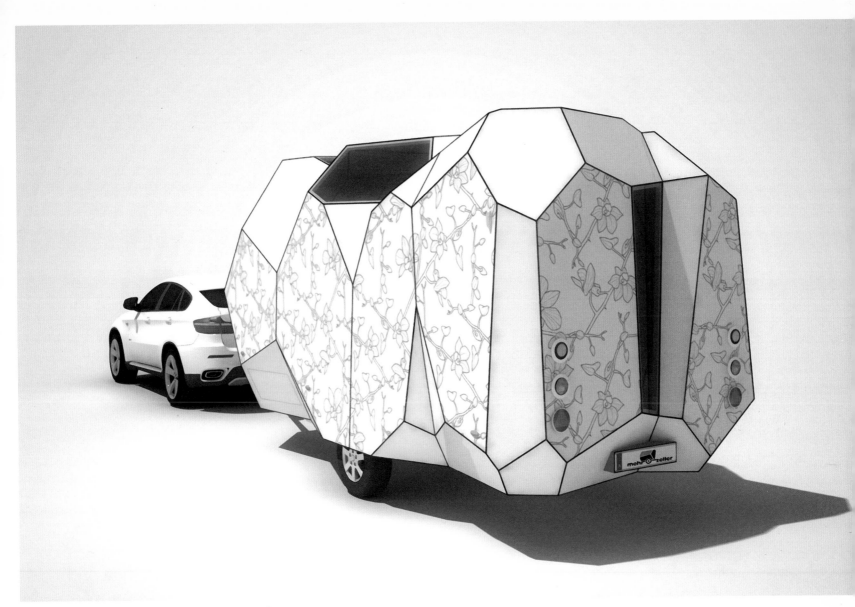

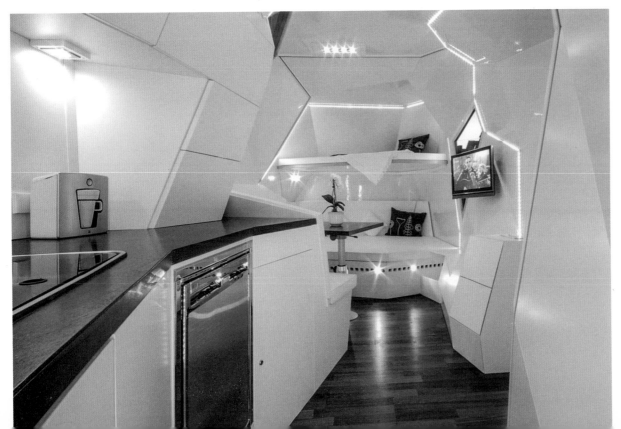

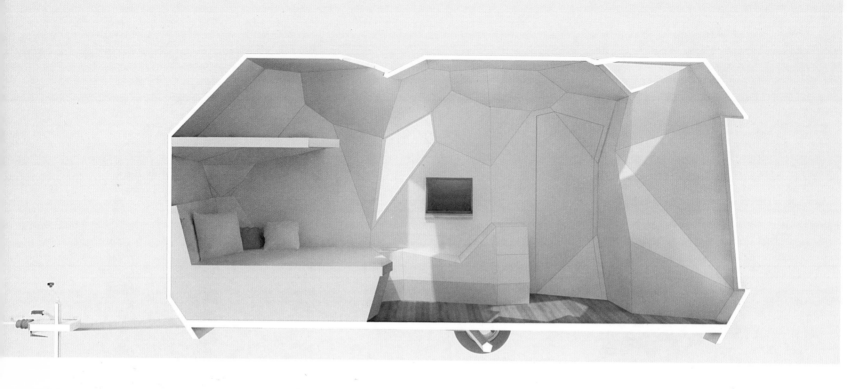

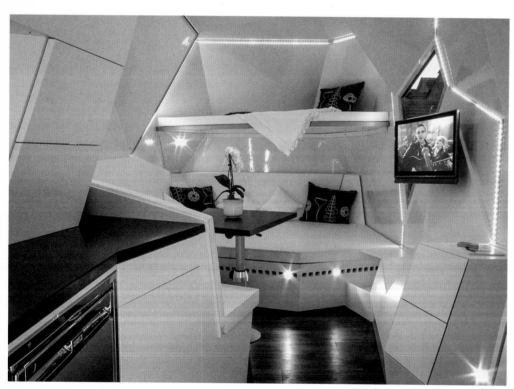

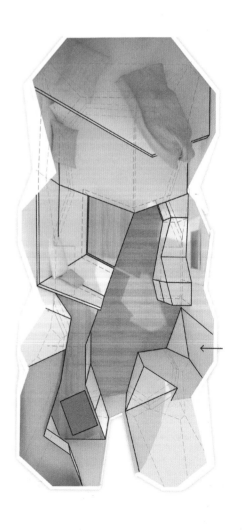

216

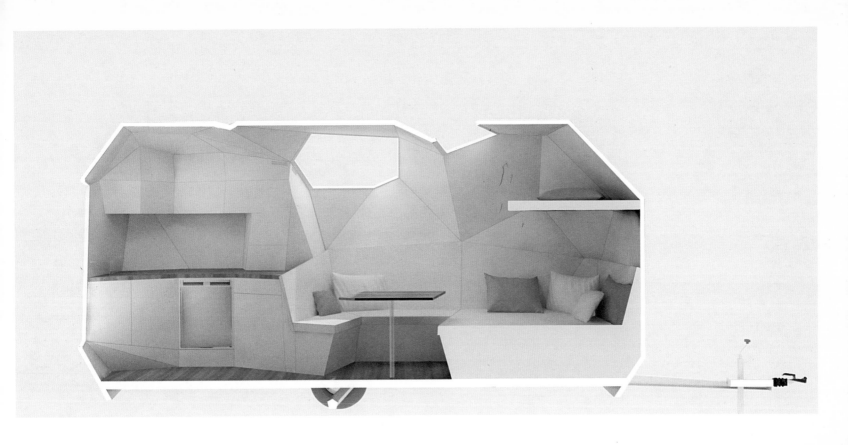

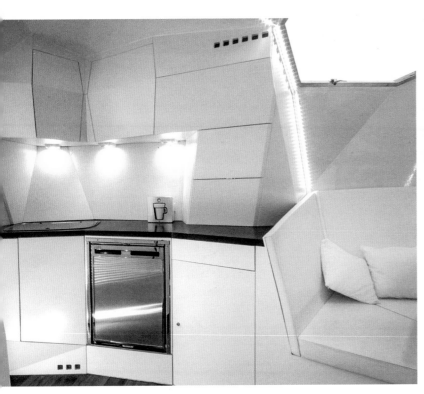
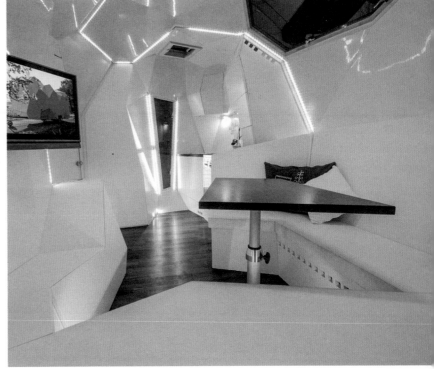

217

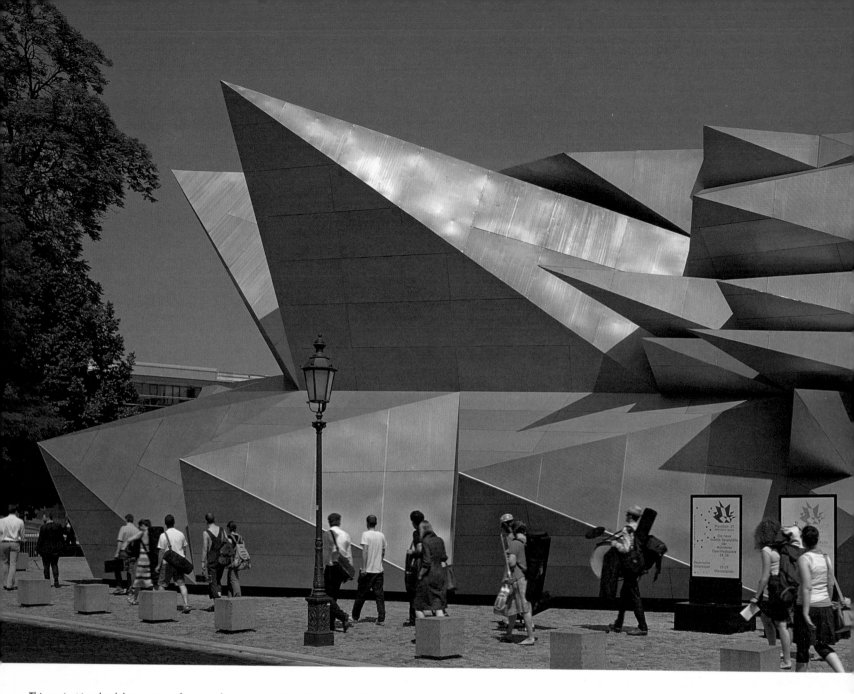

This project involved the creation of a space for experimental performances of the Bavarian State Opera. Mass and therefore weight are the decisive criteria for good acoustics. The conception of the Pavilion 21 Mini Opera Space had to be a lightweight construction that would also meet the acoustic requirements of a concert hall. As a starting point towards the abstraction of music into spatial form, a sequence from the song Purple Haze by Jimi Hendrix and a passage from Don Giovanni by Mozart were transcribed. Through the analysis of frequency sections from these pieces of music and through the combination with the computer generated 3D model, the sequences were translated into pyramidal spike constructions. In order to implement the objectives of the interior spatial acoustics, the interior wall and ceiling surfaces were fitted with a combination of perforated absorbing and smooth reflecting sandwich panels.

218

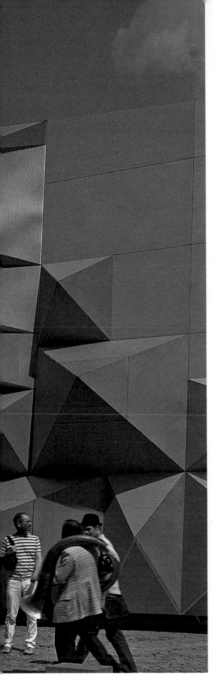

MINI OPERA SPACE

One for Jimi, one for Wolfgang Amadeus.
Soundscaping perfection!

Architects | Coop Himmelb(l)au Wolf D. Prix & Partner
Project address | Marstallplatz, Munich, Germany
Client | The Free State of Bavaria represented by The Bavarian State Opera Munich, Germany
Gross floor area | 560 m²
Existed | 2010

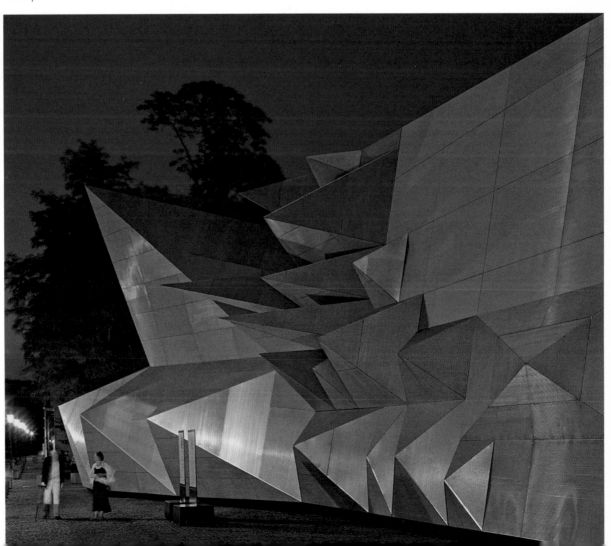

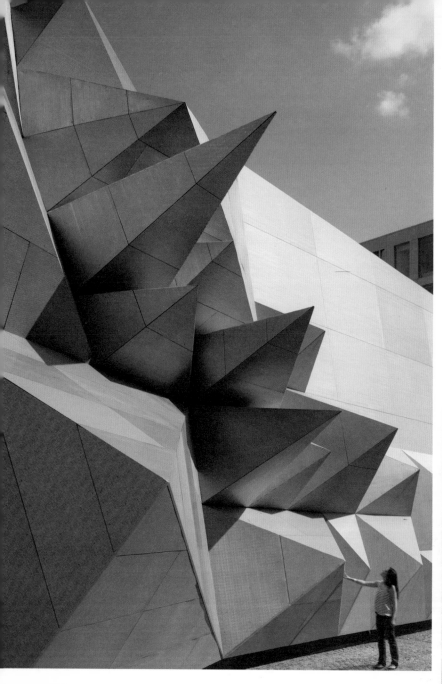

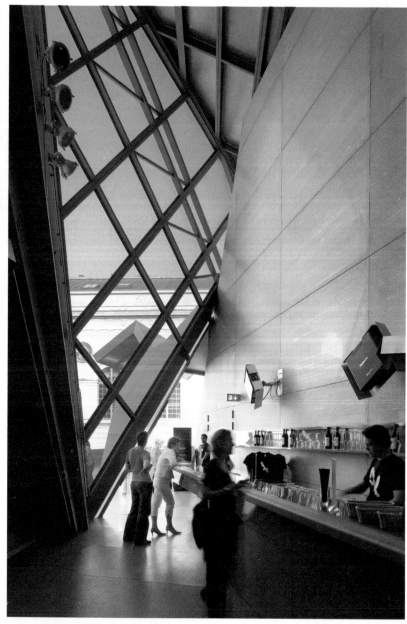

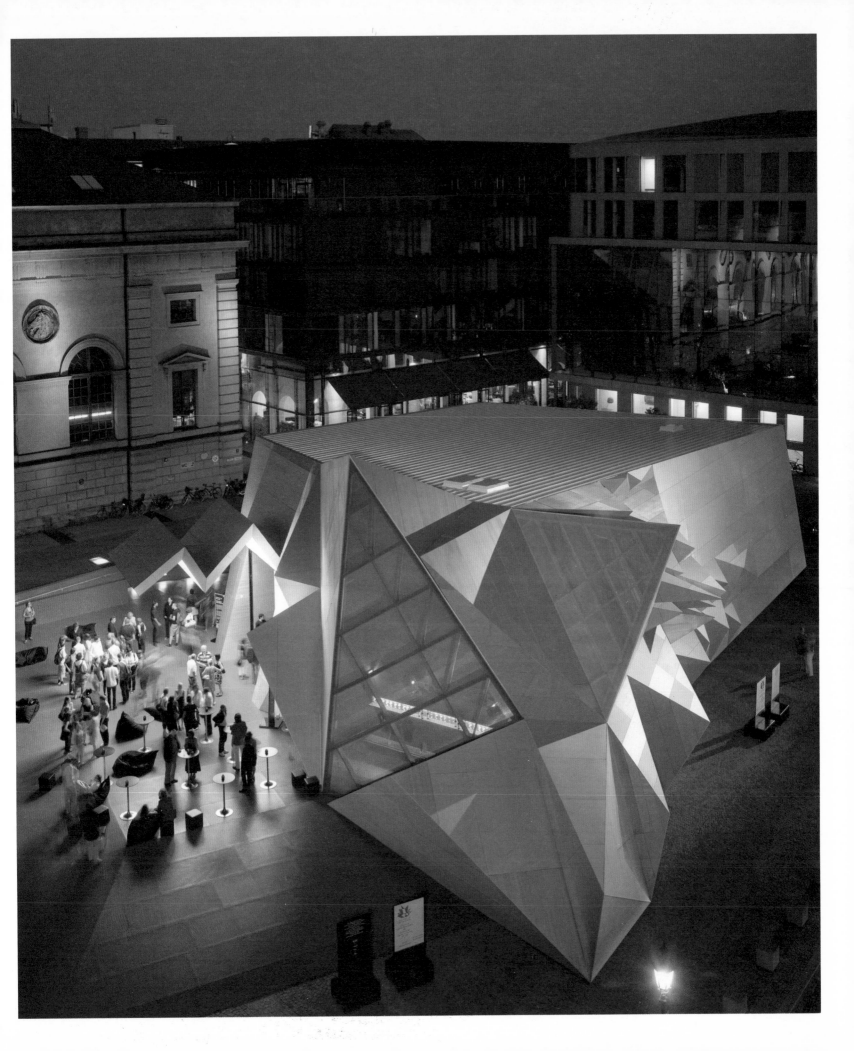

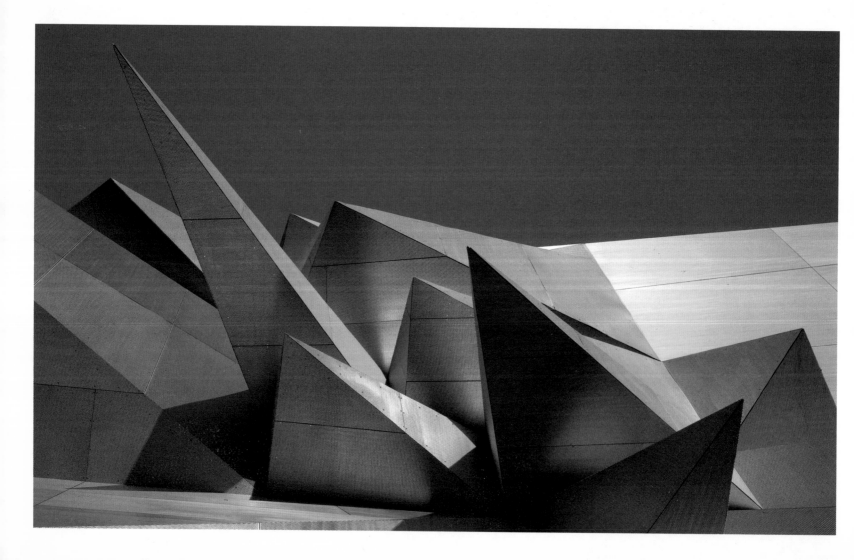

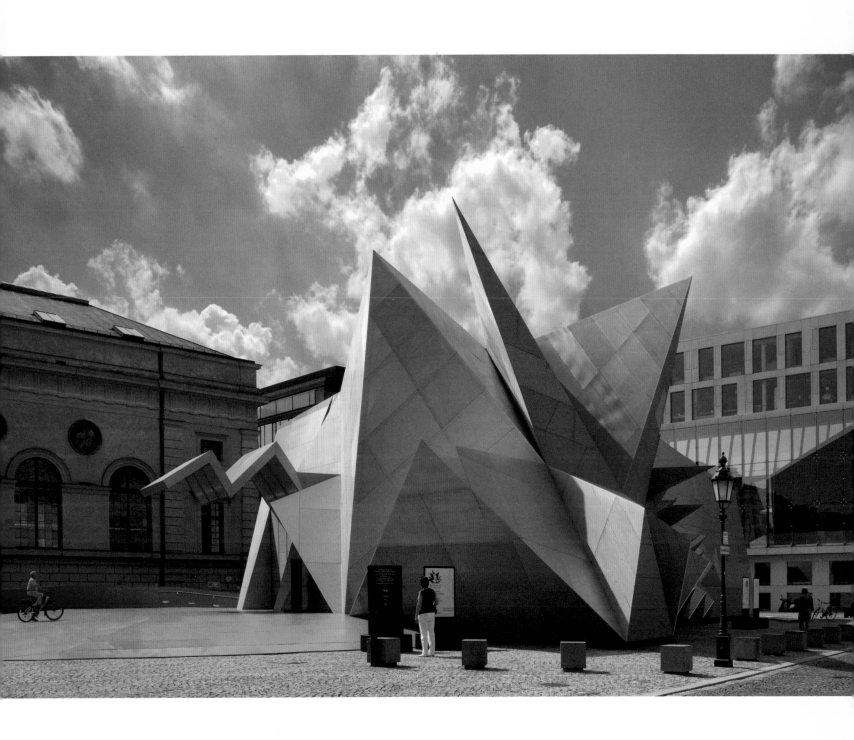

223

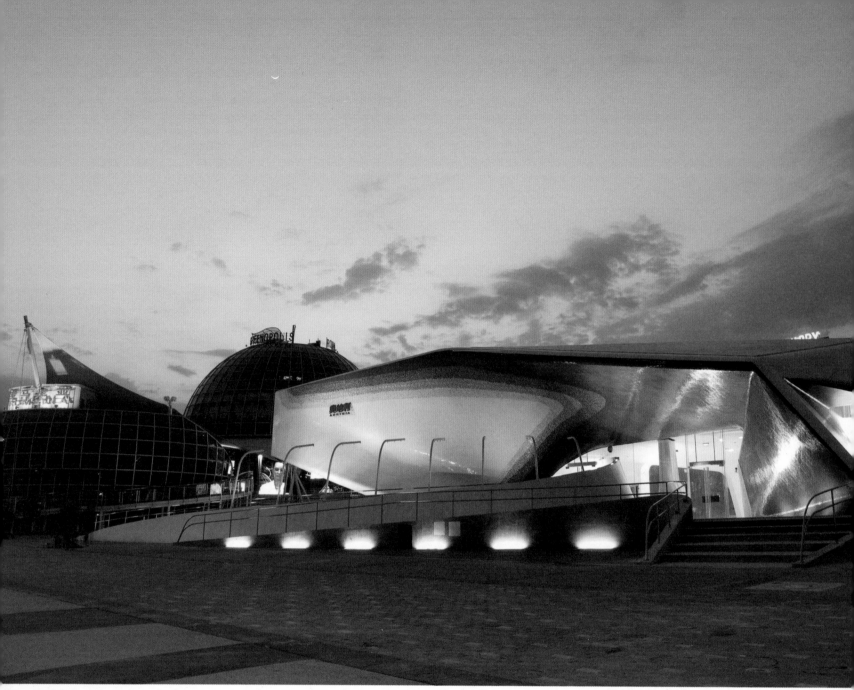

Architects | Zeytinoglu, SPAN
Project address | Shanghai Expo 2010, zone C, site W01, Shanghai, China
Client | Expo Office Austria
Gross floor area | 2,227 m²
Existed | April 2010–November 2011

The driving force behind the design concept of this pavilion can be described as a sound that reflects the harmonic continuity of the form of the volume and seamlessly joins spaces together. The shape of the space was distorted from the inside to the outside, from the main space – the music hall – to the building envelope. This created pockets that wrapped around the main space and further areas. Each pocket housed one of the functional areas, and each was incorporated into the main structure to form a coherent whole. The central space permitted the alternating presentation of various events. The skin of the main space is itself was used for projected presentations. These projections allowed visualizations along the irregular surfaces, which reinforced the seamless transition between the various spaces.

AUSTRIAN PAVILION – EXPO 2010 SHANGHAI

Welcome to the future. A kaleidoscope of Austrian culture packed in an organic form coming together in a gleaming red and white.

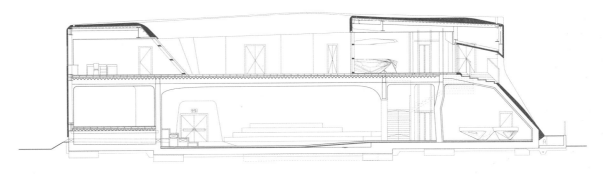

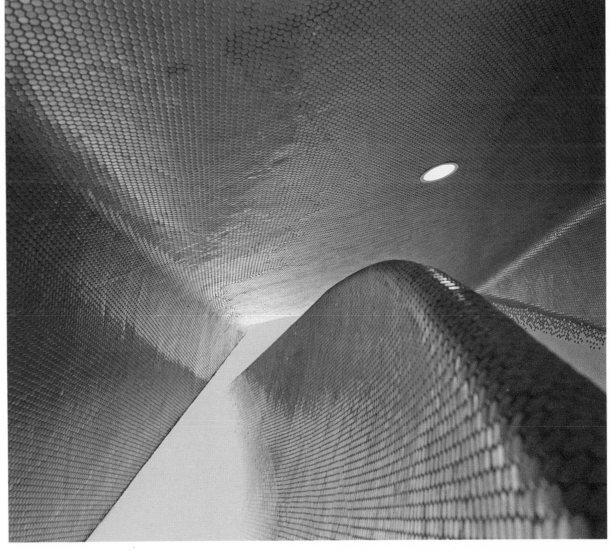

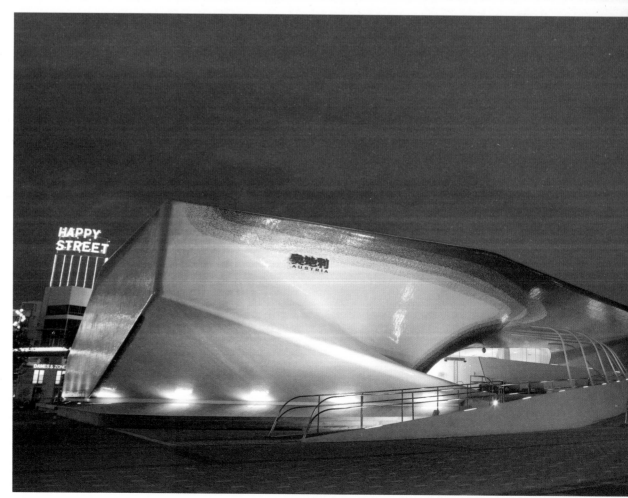

226

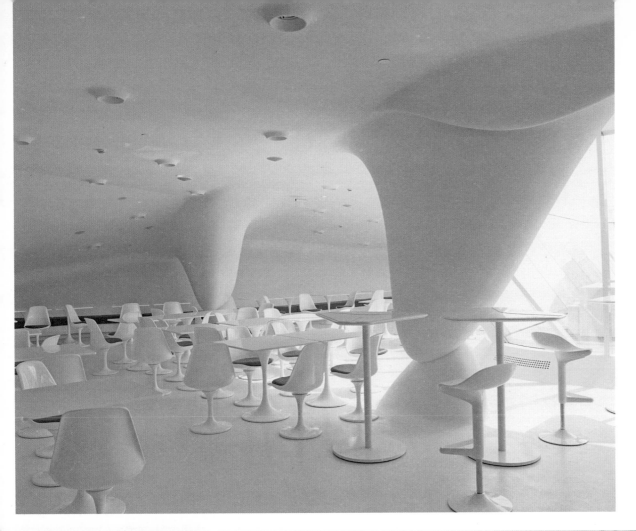

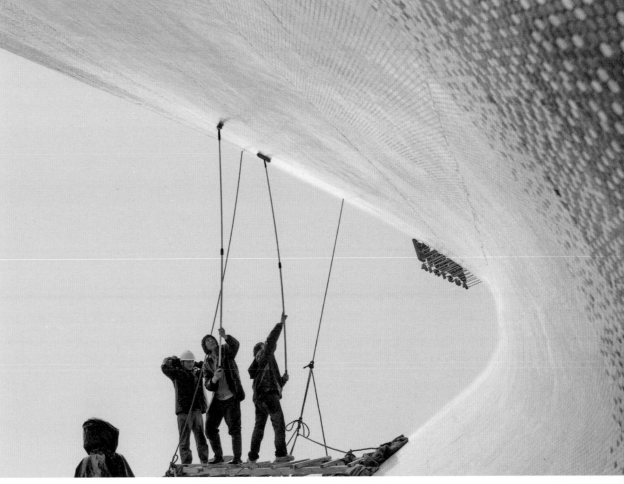

THE SHED

Less of a building and more a work of art, The Shed is an advertisement for art and culture.

Architects | Haworth Tompkins
Project address | South Bank, London, United Kingdom
Client | National Theatre
Gross floor area | 628 m²
Existed | February 2013–March 2014

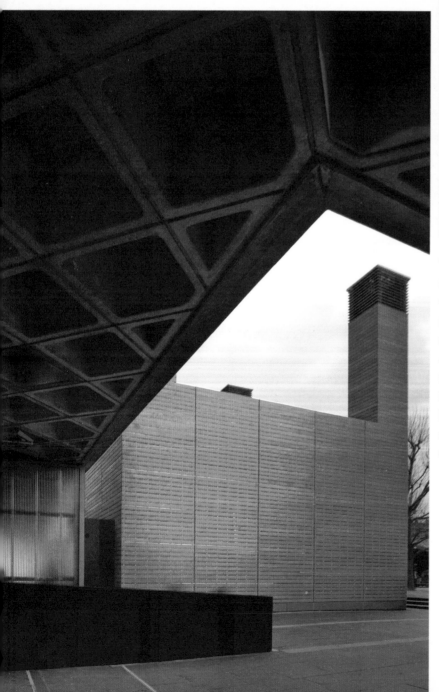

The Shed was a temporary venue for the National Theatre on London's South Bank. It provided the National Theatre with a third auditorium while the Cottesloe Theatre was closed for a year during the NT Future redevelopment, also designed by Haworth Tompkins. Its simple form housed a naturally ventilated 225-seat auditorium made of raw steel and plywood; the rough sawn timber cladding was a reference to the National Theatre's iconic board-marked concrete, and the modeling of the auditorium and its corner towers complemented the bold geometries of the National Theatre itself. Its temporary nature permitted a structure that was intended less as a building and more as an event or arts installation – a vibrant intervention on London's South Bank that entranced, and sometimes bewildered, passers-by for a period of twelve months.

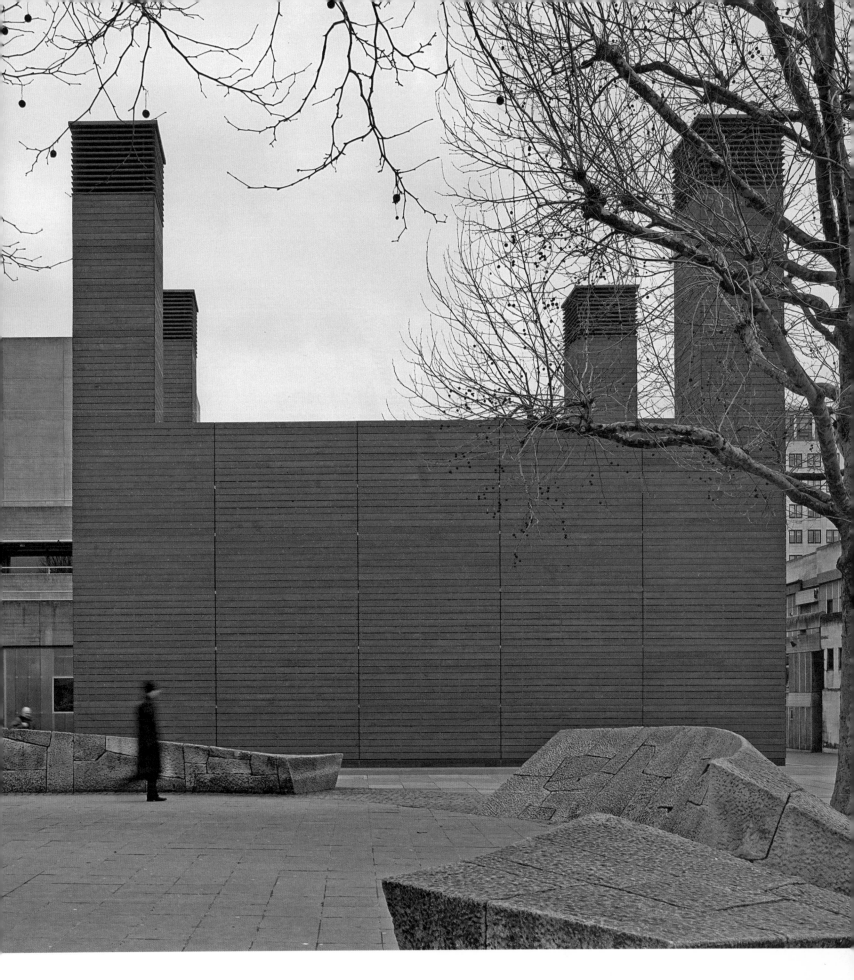

229

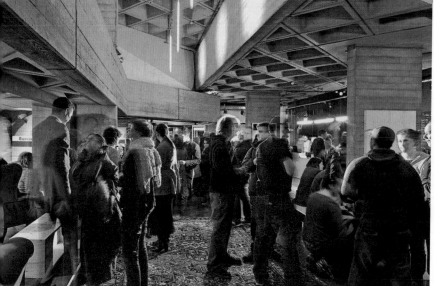

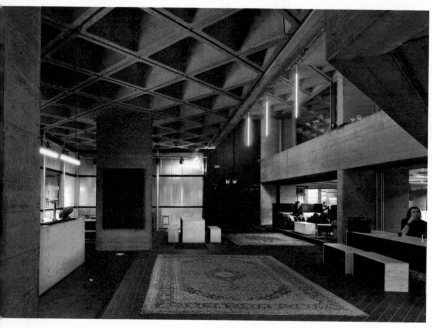

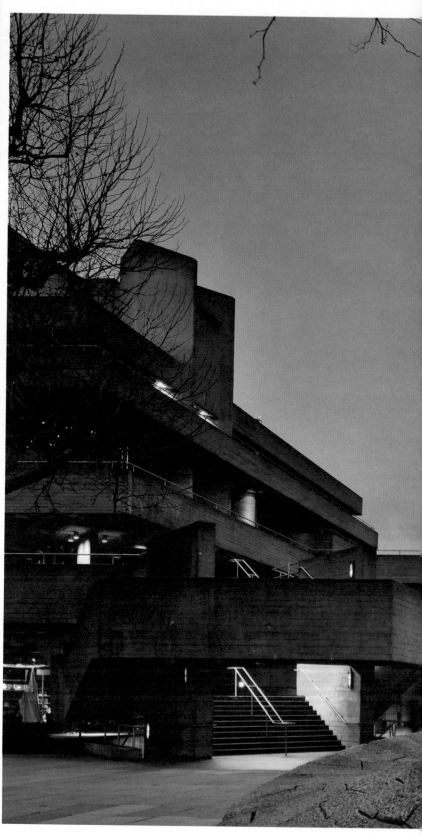

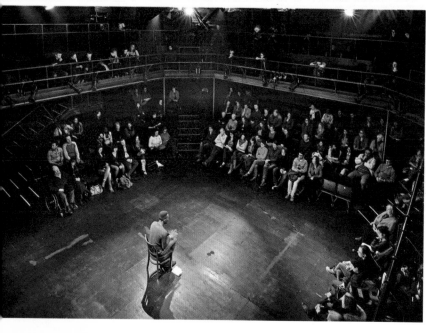

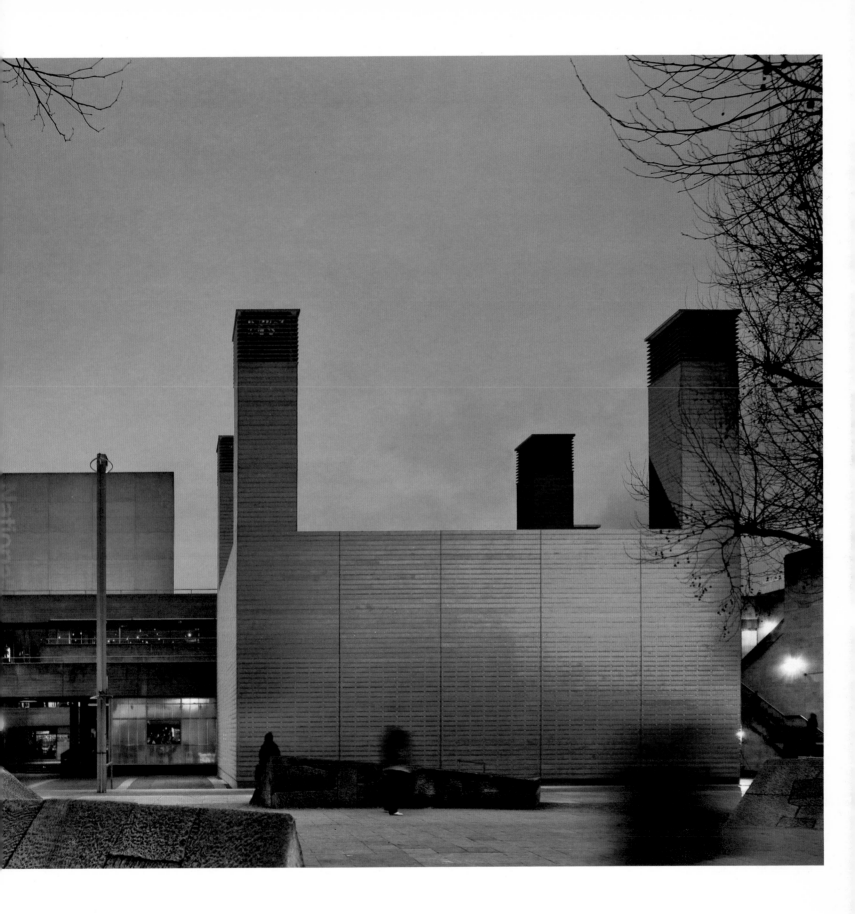

231

THE RED SUN PAVILION

Modern, stylish, simple – temporary architecture at its best.

The design for the 2010 Serpentine Pavilion – The Red Sun Pavilion – deliberately contrasts lightweight materials and cantilevered structures. The striking red of the design contrasted to the green of the surroundings. The color choice reflected various iconic and quintessentially 'English' elements, such as London's red buses, post boxes and phone boxes. The building comprised bold geometric forms, retractable awnings and a freestanding wall that rises to a height of 12 meters. The interior and exterior spaces were flexible and operated as public space, café and a venue for Park Nights – an acclaimed program of talks and events.

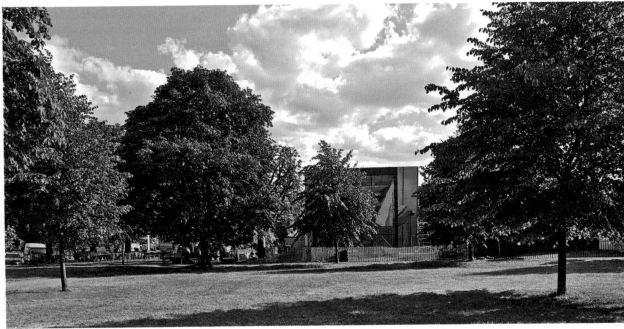

Architects | Ateliers Jean Nouvel
Project address | Kensington Gardens, London, United Kingdom
Client | Serpentine Galleries
Usable floor area | 500 m²
Existed | 10 July–10 October 2010

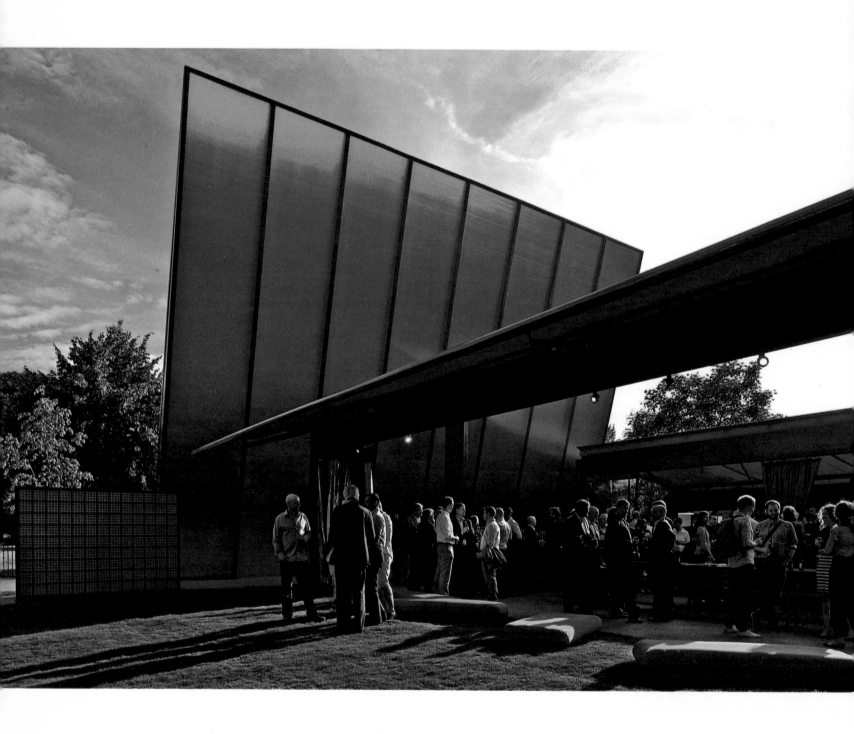

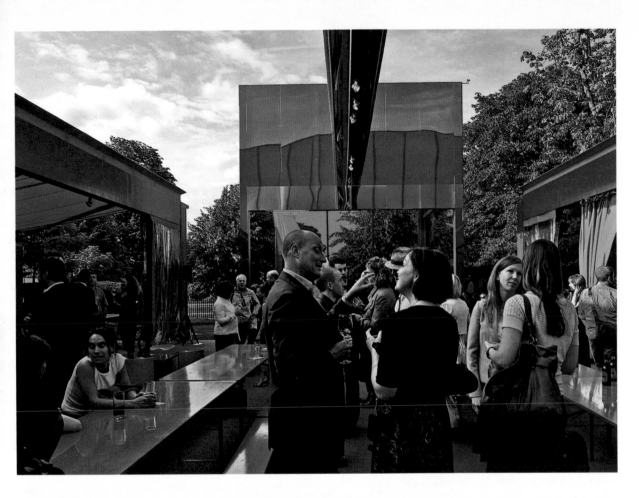

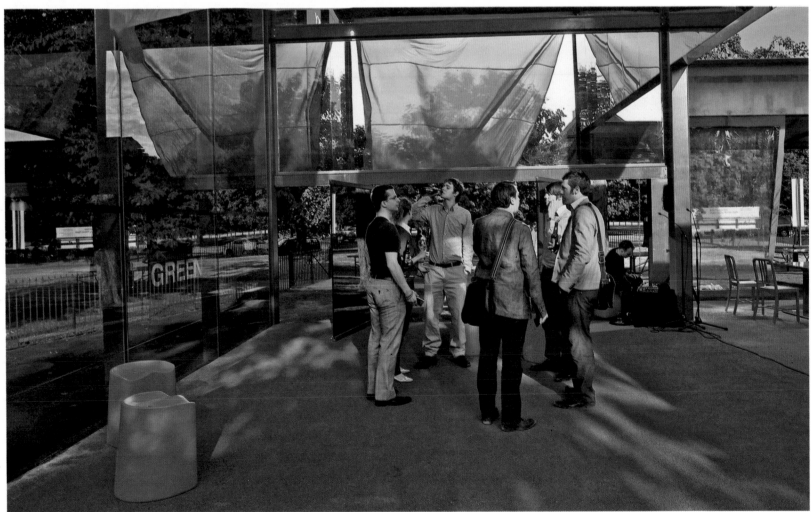

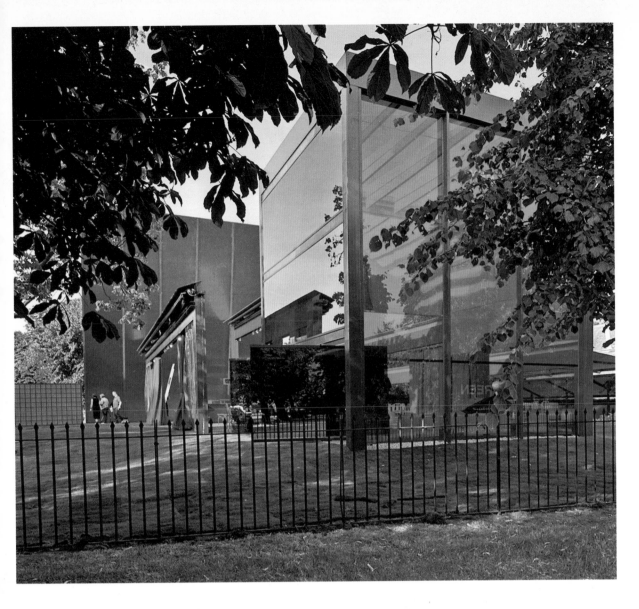

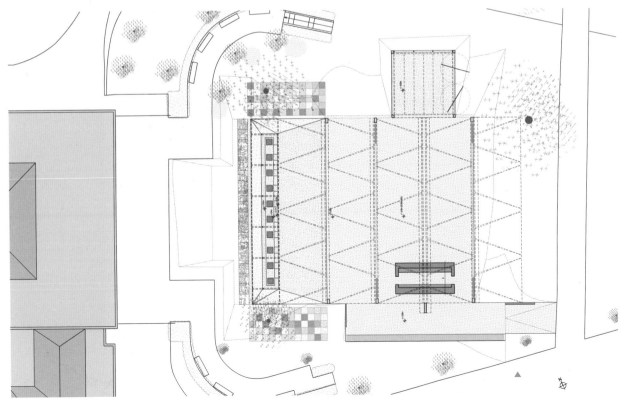

237

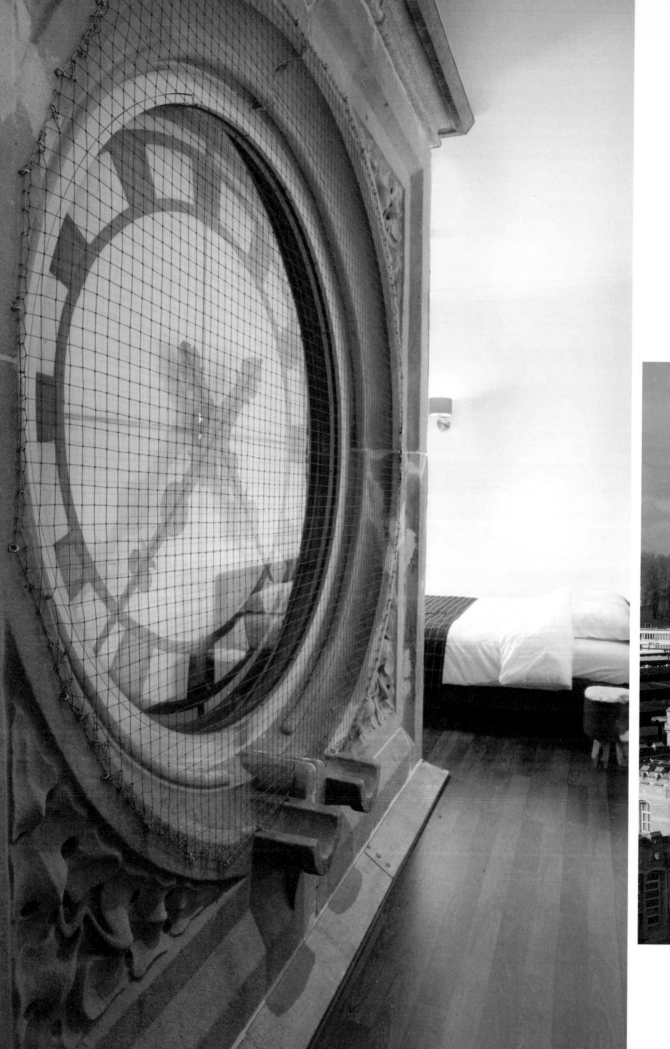

HOTEL GENT

Hickory dickory dock, the hotel surrounds the clock... Sleeping next to an historical icon. Giving hospitality a new dimension.

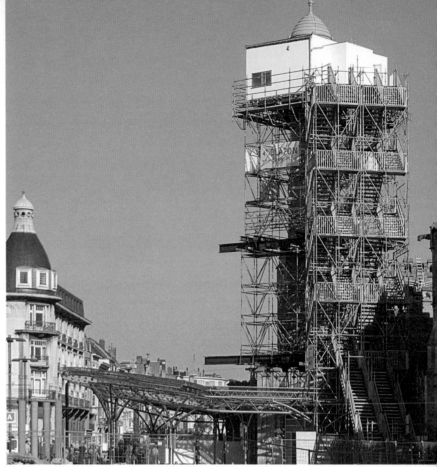

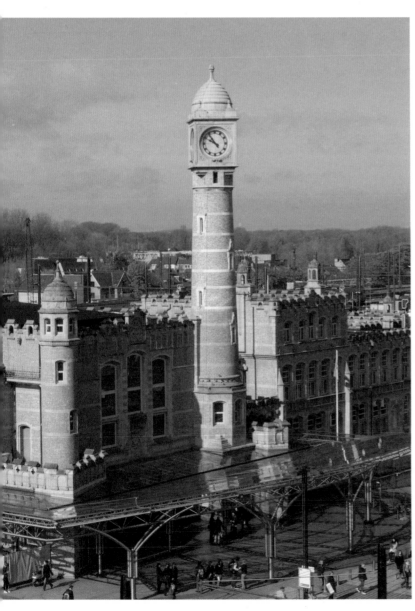

Architects | Tazu Rous (alias Tatzu Nishi)
Project address | Koningin Maria Hendrikaplein, Ghent, Belgium
Assistance | Mutsumi Urano
Client | RACK / Stedelijk Museum voor Actuele Kunst
Gross floor area | 50 m²
Existed | 12 May–16 September 2012

Hotel Gent was built to honor the 100th anniversary of the Gent Sint-Pieters railway station in Belgium. Open for just a limited time, the project was built around the station's old clock tower, and the interior design honors this historical element. The hotel offered stunning views of the city from its 23-meter-high vantage point, giving visitors first-hand experience of the city of Ghent.

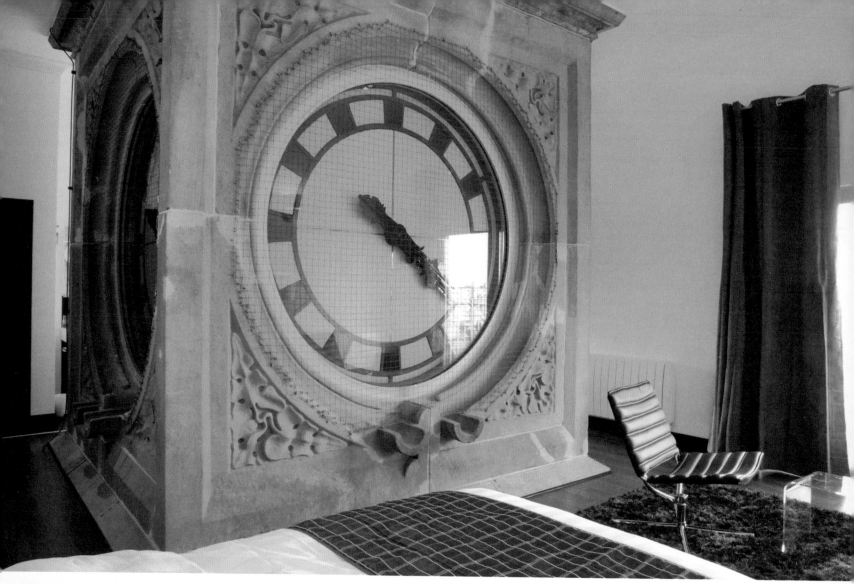

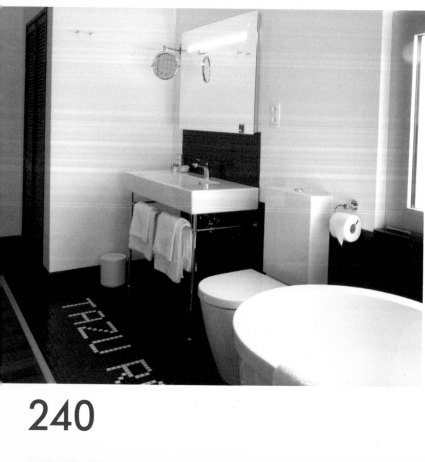

240

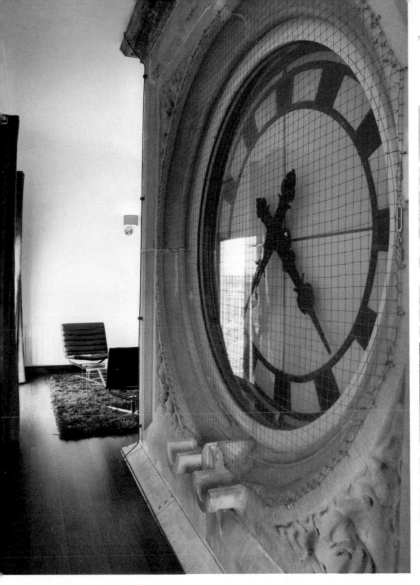

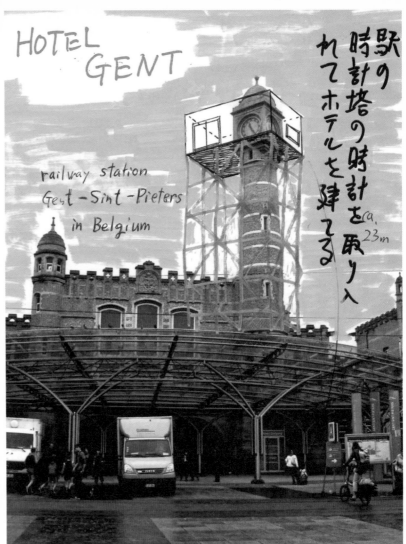

HOTEL
GENT

railway station
Gent-Sint-Pieters
in Belgium

駅の時計塔の時計を取り入れてホテルを建てる

ca.
23m

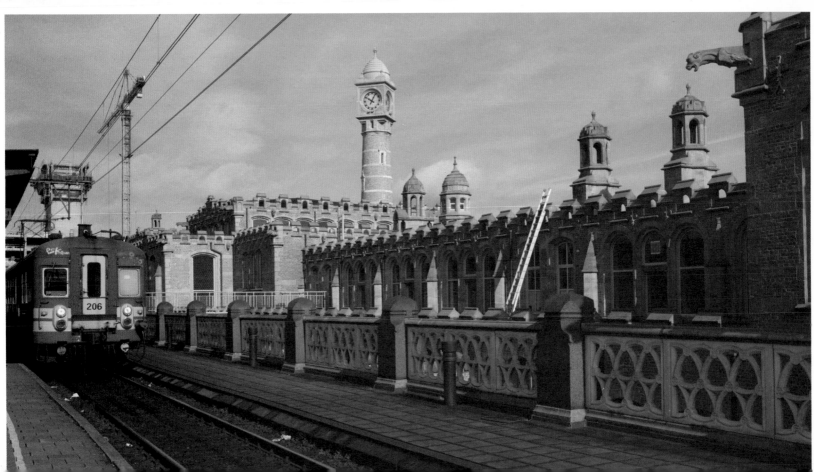

PEOPLE'S MEETING DOME

A window here, a wall there. The geodesic dome
construction kit: Taking something good and
making it perfect.

Architects | Tejlgaard & Jepsen
Project address | Allinge, Bornholm, Denmark
Client | Denmarks Public Housing (BL)
Gross floor area | 212 m²
Existed | one week in June 2012 and 2013

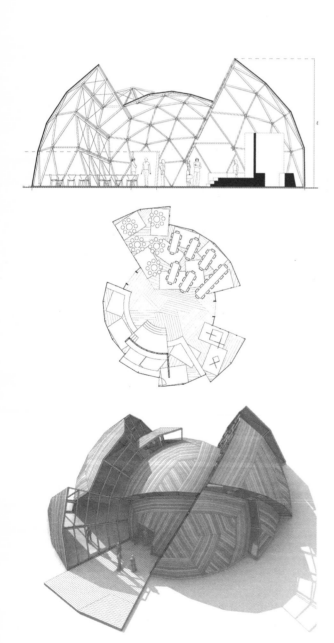

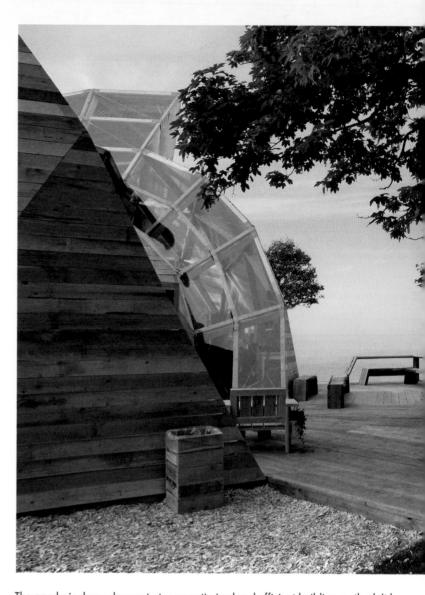

The geodesic dome demonstrates an optimized and efficient building method. It has
all the advantages of being rationally and mathematically generated, but it is sadly
lacking many of the qualities associated with good architecture. The ambition was to
understand the construction principles of a geodesic dome and then deconstruct its
geometry. The deconstruction unlocked the shape, so that the dome could be shaped
by its site and features. It formed niches, crevices and corners, defining, opening and
hiding. The architects proposed a system of steel nodes that connected with the wood
to build the complex lattice structure. The system is designed so that it is possible
to vary the skeleton. It can be adapted to the given parameters, disassembled and
placed in a new design, with new parameters. Windows and openings can be placed
freely and no interior load-bearing walls are needed.

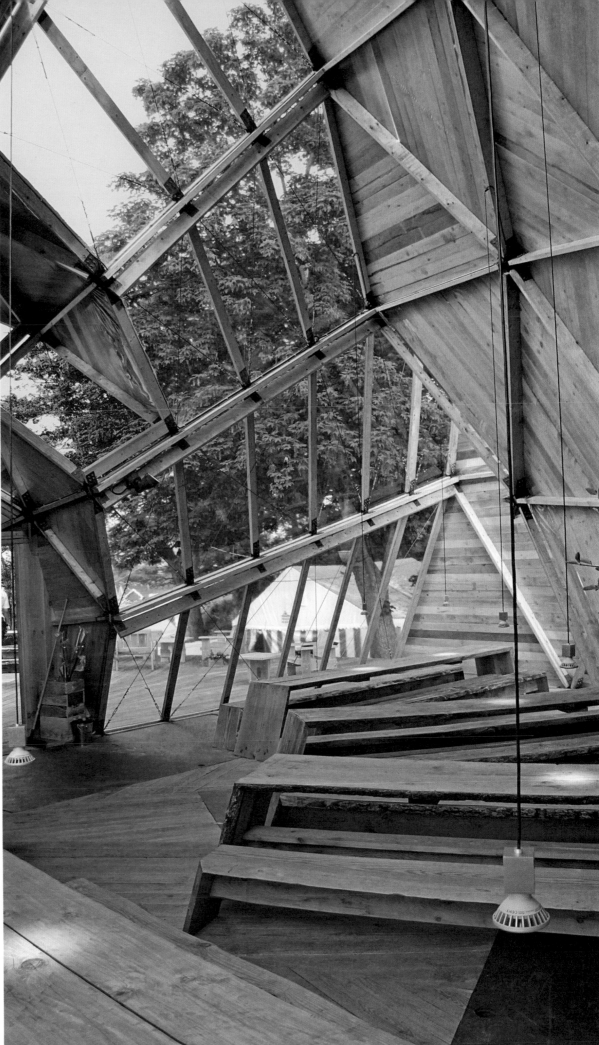

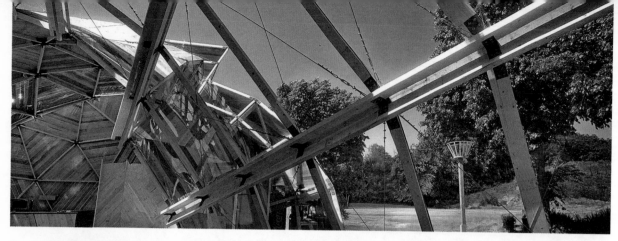

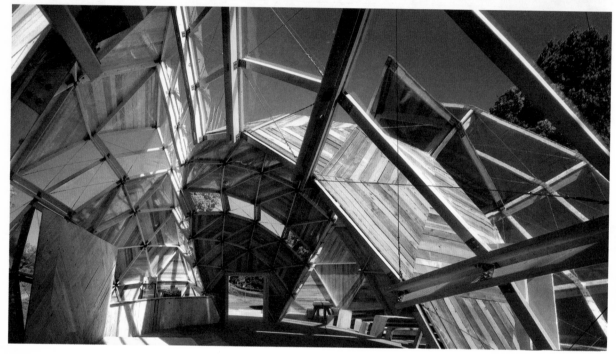

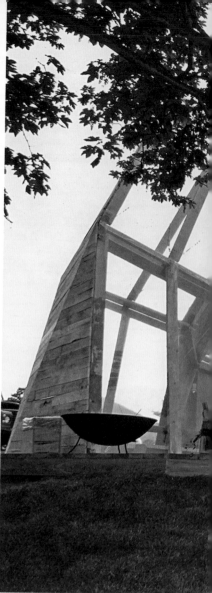

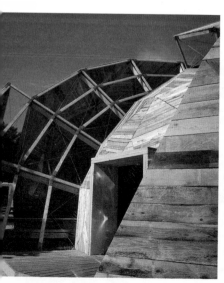

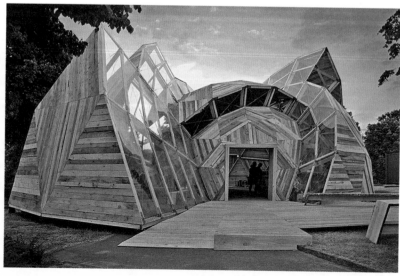

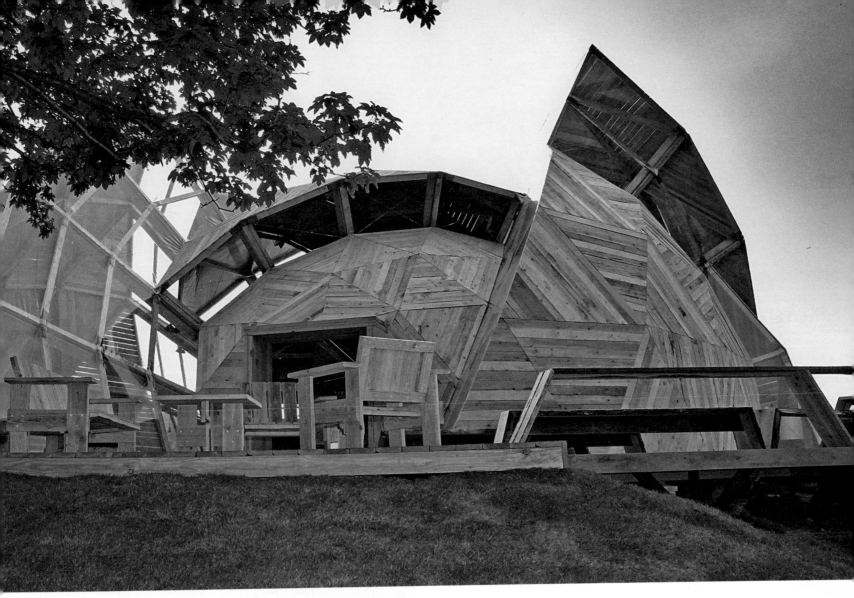

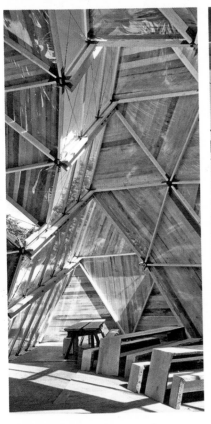
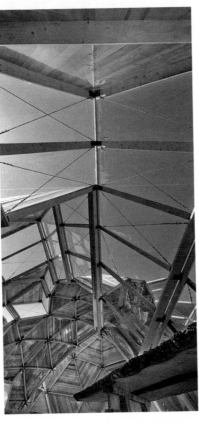

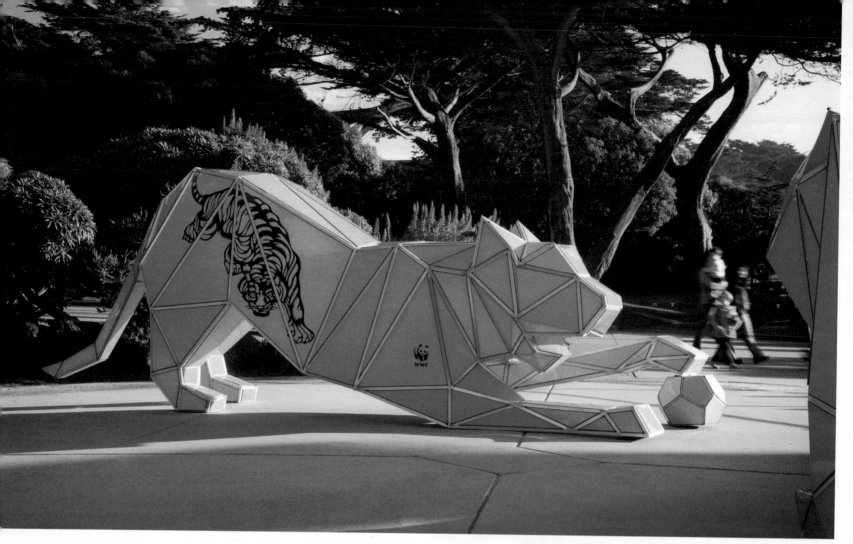

These two Digital Origami Tigers started their world travels playfully celebrating Chinese New Year at Customs House, Sydney; went to Kuala Lumpur as part of KL Design Week; then Berlin for the WWF awareness campaign; Singapore as part of the i-Light Marina Bay Festival; to the USA; and to the Amsterdam Light Festival. The crouching digital tigers combine ancient lantern making methods with cutting edge digital design and fabrication technology, bringing east and west together through tradition and innovation. The big cats were a collaboration between LAVA and Customs House to mark the lunar year of the tiger and raise awareness of the endangered status of tigers. The tigers are inspired by "zhezhi", a Chinese term for paper folding, more popularly known by its Japanese name "origami". Pulsating low energy LED lighting brings the sculptures to life.

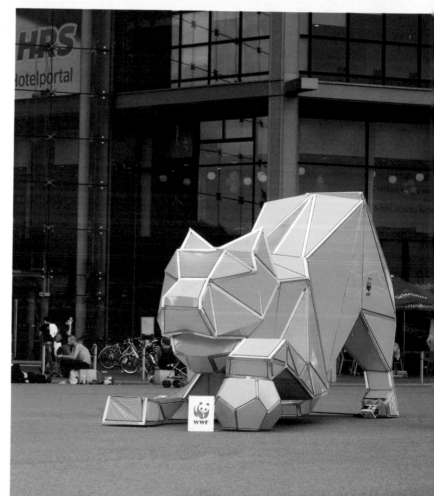

DIGITAL ORIGAMI TIGERS

This work of art really brings the urban jungle to life.

Architects | LAVA – Laboratory for Visionary Architecture
Project address | Sydney, Australia; Kuala Lumpur Malaysia; Berlin, Germany; Singapore; San Francisco, USA;
Amsterdam, The Netherlands
Client | Customs House Sydney
Size | 2.5 meters high, 7 meters long
Existed | 2010–2014

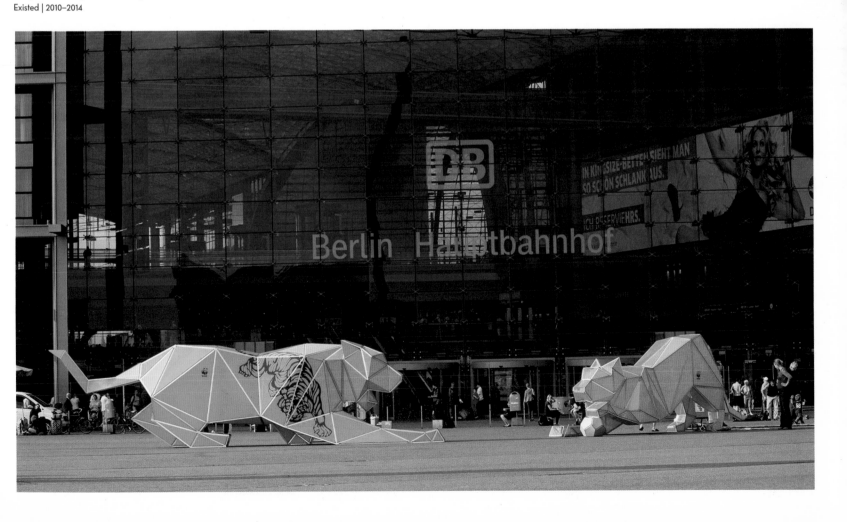

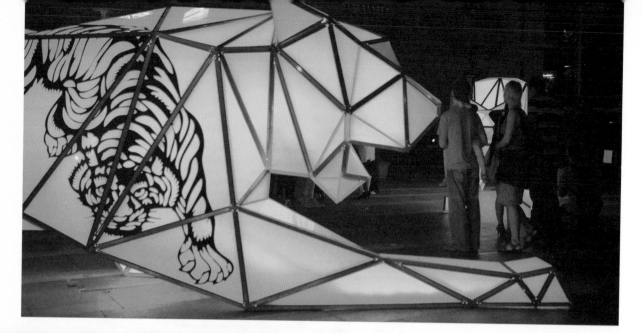

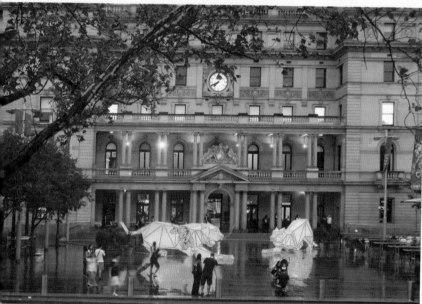

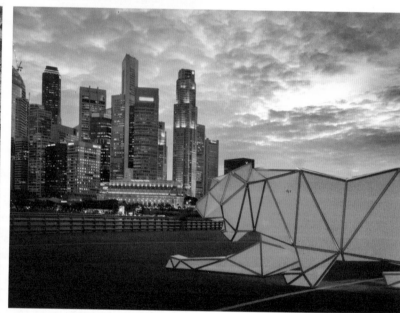

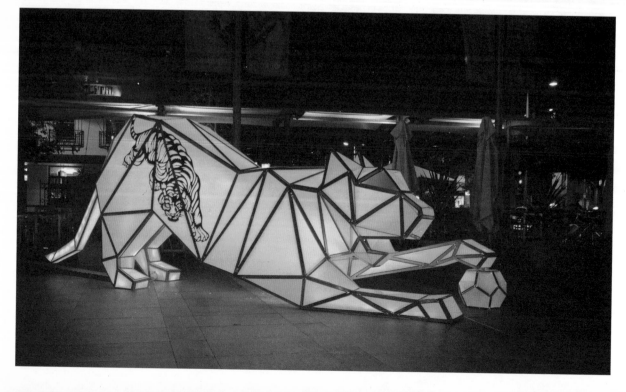

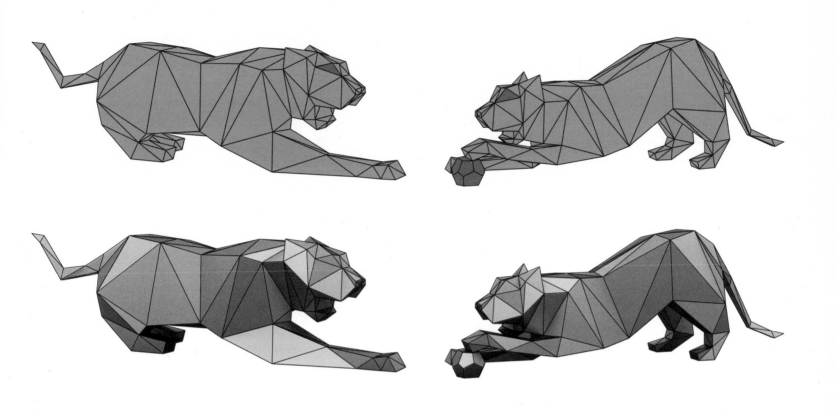

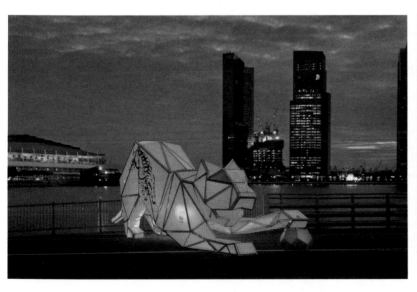
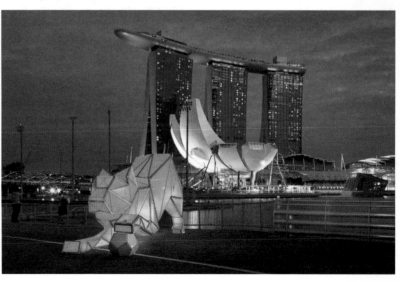

249

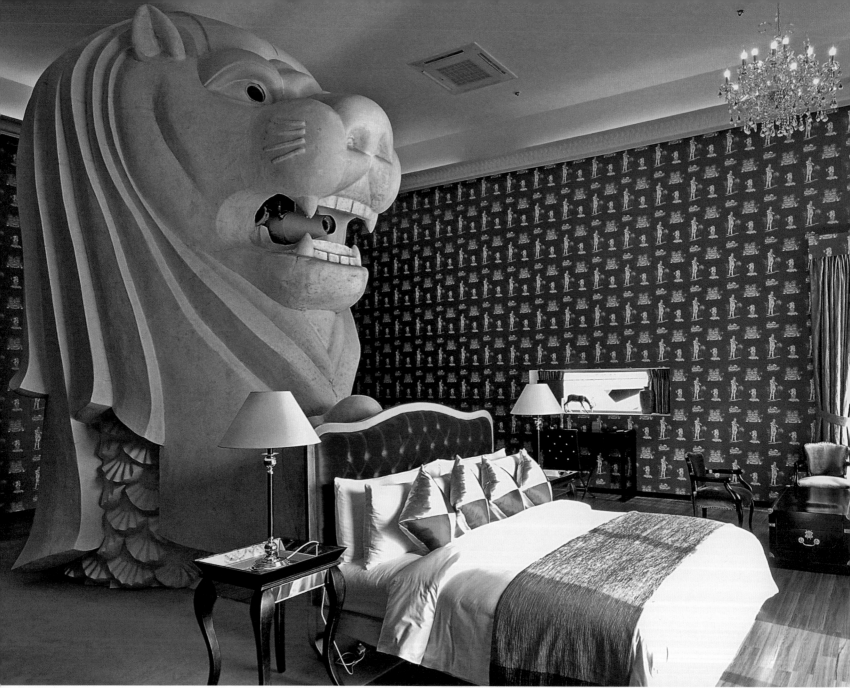

The Merlion Hotel surrounded the Singapore Merlion monument and enabled visitors to really experience this iconic figure. In order to include the huge Merlion into the room, the hotel was perched on scaffolding, raised four meters above the ground. The hotel housed a guest room, reception, and bathroom. The upper part of the Merlion was positioned behind the bed and looked like part of the decoration. The hotel was open to the public during the day but reserved for paying guests at night. Costs were kept low in comparison to nearby hotels.

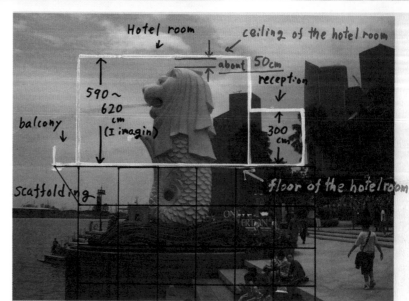

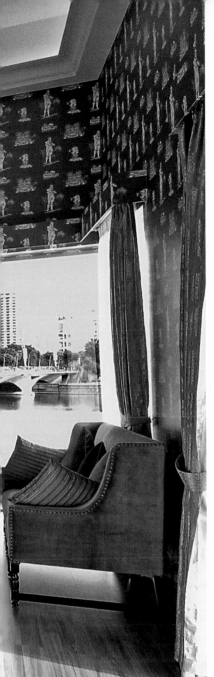

THE MERLION HOTEL

A monumental idea. Spend the night
being watched over by one of Singapore's
most iconic figures.

Architects | Tazu Rous (alias Tatzu Nishi)
Project address | Marina Bay, Singapore, Singapore
Assistance | Mutsumi Urano
Client | Singapore Biennial
Gross floor area | 100 m²
Existed | 11 March–15 May 2011

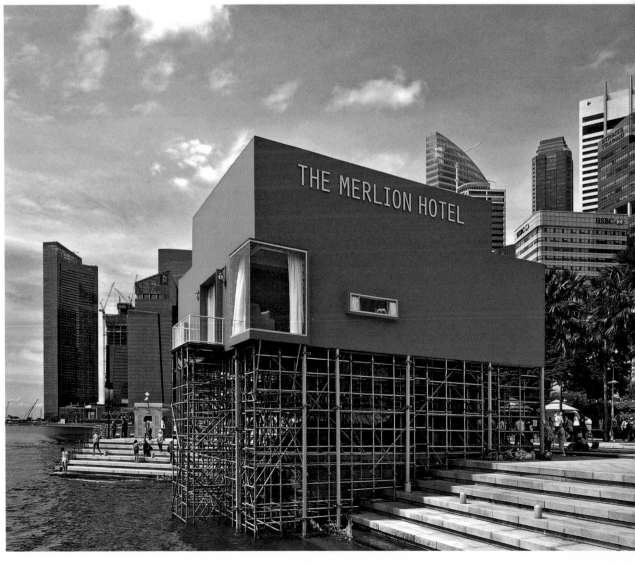

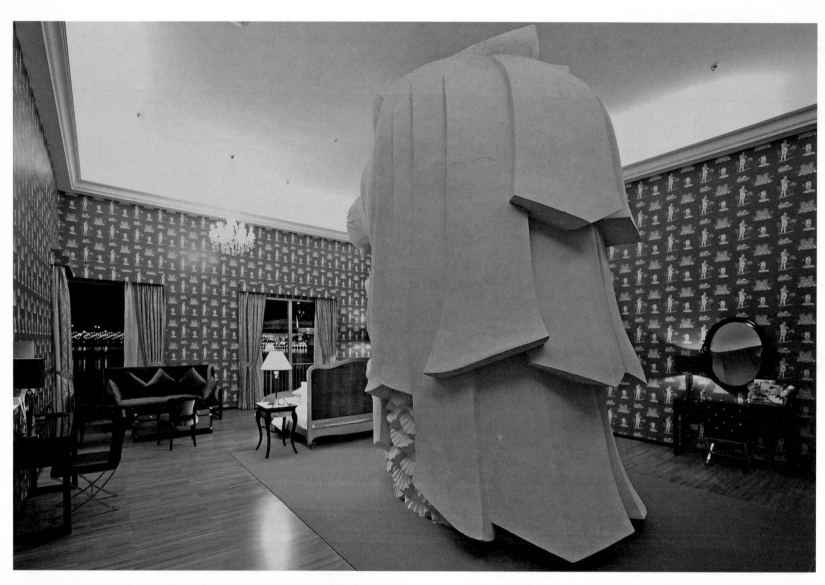

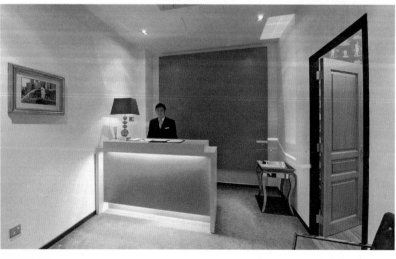

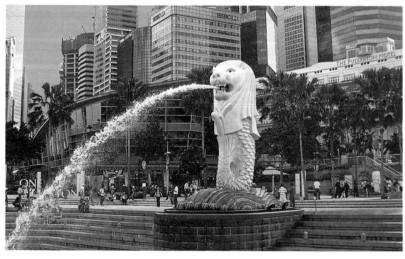

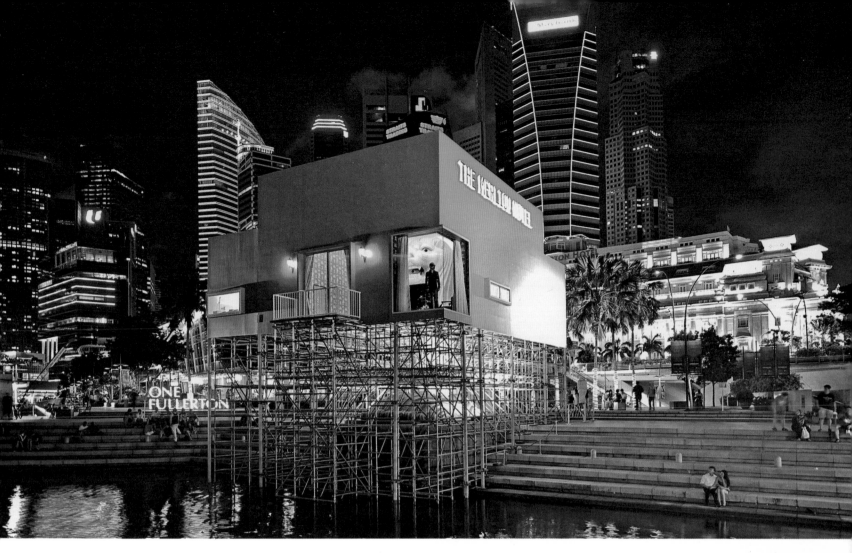

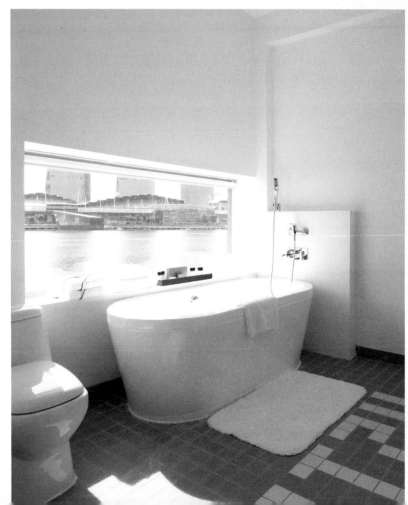

INDEX

ADT/ATO Brussels 156–159
Diogo Aguiar 80 a., 82 r.
Noel Arraiz García 188–191
Iwan Baan 207
Dennis Bangert 110, 111
Per Berntsen 74–79
David Biene 246 b., 247
Helene Binet 229
Patrick Bingham Hall 248 m. r., 249
Tom Bisig Fotografie, Basel 92–95
Christian Bøcker Sørensen 47
Roland Borgmann Münster 10–13
Zoë Braun/Artur Images 14–20
Vid Brezočnik + Kitsch Nitsch 88–91
Florian Claar 39
Anthony Coleman/
 www.anthonycoleman.com 160–163
Keith Collie 34–37
Martin Dam Kristensen 118 a., 120, 121 a.
Tjeerd Derkink, Hengelo 60–63
fabriK°B, Berlin 42–45
Peter Fattinger 131 b., 132 a., 133
Sou Fujimoto Architects/
 photographer Iwan Baan 98 r., 101
Francisco Gimenez and Patricia
 Meneses 180–183
Adriá Goula 164–169
Sergio Grazia, Paris 134–137
Tim Griffith 246 a.
F. Hafele 64, 65 b., 66, 67
Yusuke Hattori 250, 251, 252, 253 a.
Herzog & de Meuron (plans) 93, 95
© Herzog & de Meuron and
 Ai Weiwei/photographer
 Iwan Baan 68–73
Hufton+Crow, London 30–32
Hufton+Crow/Artur Images 24–29
Hanne Hvattun 206 a.
Andreas Keller, Altdorf 138–143
KSV, Torsten Krüger 151 b.
Thomas Mayer, Neuss 192–197
Chee-Kit Lai, London 122–125
Markus Lanz 112 b.
Duccio Malagamba 218–223
João Marques 114–116 m., 117
J. Mayer H. 112 a.
Peter Murphy 248 a., m. l., b.
nArchitects 38, 40, 41
Sandra Neto 80 b., 81, 82 l., 83
Tatzu Nishi 253 b.r.
Nonstandard 214 a. l., 215–217
Leif Orkelbog-Andresen 206 b., 208, 209
Orproject/Vitor Gabriel 20–23
Karsten Pagel 148, 149 a., 150

Franc Pallarès López 56–59
Dirk Pauwels 238–239 m., 241
Alessandro Peralta, Cagliari 126–129
Heimo Pertlwieser/
 Stadtplanung Linz 131 a., 132 b.
Paul Raftery/Artur Images 100
Anne Romme 198–200 b.
Philippe Ruault 232–237
Raimo Rudi Rumpler 130
Bonnie Savage, Melbourne 170–173
Schønherr 118 b., 121 b.
Singapore Biennale 253 b. l.
Thomas Spier/Artur Images 98 l., 99
Michael Stavaridis 102–105
Hilde Strobl, Architekturmuseum
 TUM 113
KSV, Bertram Vandreike 151 a.
Eva Vieira 116 a., b.
Philip Vile 228, 230 l., 231
Zhenfei Wang 84–87, 210–213
Oliver Wolf 214 a. r., b.
Jamie Woodley
 Photography 200 a., m., 201
Woodruff/Brown Architectural
 Photography 144, 146, 147
Nikita Wu 50–53
Maria Ziegelböck 224–227

All other pictures were made available by
the architects and designers.

Cover front: Hufton+Crow, London
Cover back: Iwan Baan

IMPRINT

The Deutsche Nationalbibliothek lists this publication in the Deutsche Nationalbiblio-
grafie; detailed bibliographic data are available in the Internet at http://dnb.dnb.de

ISBN 978-3-03768-169-5
© 2014 by Braun Publishing AG
www.braun-publishing.ch

1st edition 2014

Editor: Editorial Office van Uffelen
Editorial staff and layout: Lisa Rogers, Georgia van Uffelen
Graphic concept: Michaela Prinz, Berlin
Reproduction: Bild1Druck GmbH, Berlin